Tempest
&
Exodus

Tempest

&

Exodus

The biblical exodus inscribed on an ancient Egyptian stele.

Ralph Ellis

Edfu Books

Adventures Unlimited

Tempest & Exodus
First published in 2000 by Edfu Books

Published in the U.K. by:
Edfu Books
PO Box 165
Cheshire
CW8 4WF
info@edfu-books.com
U.K.

Published in the U.S.A. by:
Adventures Unlimited
PO Box 74
Kempton, Illinois
60946
auphq@frontier.net
U.S.A.

Prototype edition Nov 2000
revised
First Edition Aug 2001

U.K. paperback edition
ISBN 0 9531913 89

U.S.A. paperback edition
ISBN 0 932813 984

Printed in the United Kingdom by T. J. International, Padstow

Muse

Take handfuls of ashes of the furnace, and
let Moses sprinkle it toward the heaven ...
And it shall become small dust in all the land of Egypt.

Description of Thera eruption,
Exodus 9:8

Sing heav'nly muse, that on the secret top
Of 'Oreb, or of Sinai, didst inspire
that shepherd, who first taught the chosen seed
In the beginning how the heav'ns and Earth
Rose out of chaos: Or if Sion hill
Delight thee more, and Siloa's brook that flowed
Fast by the oracle of God...

Paradise Lost
Milton

To those who may be tempted to believe that seeking the truth may result in divine retribution – no self-respecting god would be either that petty or that evil.

Acknowledgements

My thanks have to go to Chris Ogilvie-Herald, the co-author of *Giza the Truth*, who passed a copy of the *Tempest Stele* paper by Foster and Ritner to me one day. It seemed like a small gesture between friends, but it turned out to have rather more fundamental consequences for both history and theology.

Thanks also go to the following. Jane Tatam, who has to interest the media and sort out the UK distribution. Daria Renshaw, my editor, who did a marvellous job sorting out the multitude of confusing names and terms in the text. Finally, many thanks to David Hatcher Childress at Adventures Unlimited, who has done some sterling work in controlling the USA distribution.

Ralph Ellis
November 2000
Cheshire.

www.edfu-books.com

Contents

Introduction

Eager scribes

Chris Ogilvie-Herald, co-author of *Giza, the Truth* was poking around the library of the Egypt Exploration Society one day, when he happened upon a copy of *Texts, Storms and the Thera Eruption*, by Ritner and Foster; a booklet concerning the translation of the inscription on a stele of Ahmose I. Chris' prime interest was the meteorology of Egypt, but knowing my interest in the Hyksos period he popped a copy in the post to me as well. It was rather fortunate that his eagle eye had spotted the pamphlet, because it was to lead to a whole new avenue of research for me.

The book *Jesus, Last of the Pharaohs* was primarily a comparison between the Hyksos exodus out of Egypt and the Israelite exodus out of Egypt. To me, the parallel texts were far too close to each other to be the result of coincidence: they had to be one and the same event. The only real problem with the whole thesis, however, was the fact that outside the biblical-type texts, there is little or no historical evidence for the Israelite exodus. Even some Jewish historians have been inclined to regard the biblical exodus as a fable, inspired by ancient myths and some eager scribes.

So, the arrival of the pamphlet from Chris was quite an extraordinary and fortuitous event. My eyes were immediately drawn to a few paragraphs in the translation of the stele, for they were familiar – but why should the long lost scribblings of an ancient Egyptian scribe appear familiar to me? It was, temporarily, a little baffling. Was this quote something I had read about regarding the Hyksos pharaohs in Egypt? Was it from the many Egyptian text books that littered my office? Then the penny began to drop. I had seen these paragraphs before, not in a book on Egyptology but in the Bible.

I was somewhat taken aback, for this biblical quotation detailed

0. Introduction

events that occurred during the biblical exodus of the Israelites. Here was quite possibly the historical evidence for the exodus that had been sought after by so many people for so long. The *Tempest Stele*, as it came to be known, had been translated and pored over by Egyptologists and historians alike for over 30 years, yet nobody seems to have noticed the fact that a large section of the text was identical to sections in the Torah, Bible and Koran. It seemed impossible that these people had not spotted it before but, there again, perhaps they were not in the right frame of mind to accept such a finding, even if it were noticed.

The result of this observation was to spawn a new line of enquiry, into the biblical texts, that would bear much fruit. It was to place the biblical texts into their true context; to lay bare the physical realities of the events that initiated the biblical exodus and the writing of the texts that went with this event. Those texts – the Torah, Bible and Koran – have influenced the lives of nearly half the world's population, so it is only right that the followers of these religions are at last able to see the real foundations of their belief systems.

Notes to the reader

a. Because of the radical nature of this book, it has been necessary to highlight the difference between standard orthodox assumptions and those generated by my lateral view of theology. Throughout this book, therefore, I have used curved brackets () to denote orthodox assumptions and square brackets [] to denote my radical new assumptions. I hope that this serves to clarify the text.

b. As readers of the book *Jesus, Last of the Pharaohs* will have noticed, the history of the biblical exodus is not quite as it seems. Not only were the circumstances and nations involved not quite as advertised in the Bible, but, in fact, there were two exoduses from Egypt. Because there is no longer one definitive Exodus to refer to, the term exodus has been left in lower case.

c. The references in the text are numerous. To ease the problem of continuously referring to the reference section at the back of the book, some references have been prefixed. Prefixes are as follows:

B = Bible, K = Koran, J = Josephus, T = Talmud,
M = Manetho, N = Nag Hammadi.

Chapter I

Origins

The night was perfectly still, with hardly a breath of wind to stir the dust. A ruddy-looking crescent Moon hung motionlessly near the western horizon and gave us just enough light to see without torches. With my guide, Abdul, I was making a perilous midnight ascent up the rocky flanks of Mt Sinai, the sacred mountain of the Torah and Bible. The dusty sand that had been blown over the rocks was clinging to our shoes and clothing, making the ascent both slippery and dangerous, for the mountain side that we were on was precipitously steep. We stopped for a rest on a particularly narrow section of ledge and, looking down the mountain's steep flank, I could see in the pale moonlight the undulating desert floor, stretching off towards the horizon. The scene was not only beautiful; it was almost surreal.

The night was still quite warm after the burning heat of the day and my brow was beginning to sweat profusely. I mopped my forehead and wiped a dewdrop from my nose – an action which merely succeeded in plastering my face with a dusty grime. I transferred my gaze to the rock-face that soared above me. Somewhere here, on this precipitous northern flank of Mt Sinai, there was rumoured to be a sacred cavern that plunged deep into the mountain side. If my hunch was correct, and if my guide was as knowledgeable as he made out, then we would not only discover a sacred recess in the mountain side, but the location of this cavern might also solve some of the ancient riddles from the accounts of the Torah, Old Testament and Koran.

Luck was with us on this night and, as I stumbled up and over a particularly large boulder, an inky-black rocky hole suddenly appeared in front of us. It was impossible to see how deep it was, as the Moon's feeble glow hardly penetrated the fist few meters of the cave, but the cooler air

1

1. *Origins*

that occasionally drifted out of the blackness indicated to me that this was not simply a small niche in the rock-face. I drew my torch out of a pocket, aimed the beam inwards and took the first few steps into this sacred mountain. The cave was obviously quite deep, for the beam could not illuminate the back wall. I turned to my guide for reassurance. With a flick of the finger and a wide grin, he indicated that I should go inside.

It was a largish cave of about head height, with a smoothish sandy floor, and initially the way was easy. But suddenly, the passage narrowed and steepened and I found myself bent double, crawling up and over some boulders and then down a steep incline. My guide seemed happy that we would not get trapped in this remote dungeon, so I continued on. This part of the cave was definitely man-made, or at least artificially widened, as tooling marks could be clearly seen on the side-walls and ceiling of the passage; obviously we were not the first to have come this way. Down and down into the bowels of the mountain we slipped and slid; legs aching, head crashing against the low ceiling. Eventually, the passageway that we were in levelled out and then suddenly, we were inside a large cave.

I turned to Abdul to show my surprise and his gnarled and bronzed face beamed back another huge smile; no doubt he had taken other 'tourists' on this little expedition and noted their surprise too. Here, seemingly right underneath Mt Sinai – the sacred mount for Moses and the Israelite people – there was a rough cavern carved into the bedrock limestone. The cave seemed to be about twice as broad as it was long, about six by twelve meters in length and breadth, and some five meters high. As I moved the beam of my torch around the walls, I could see that the chamber was highly irregular in its dimensions, with the rocky floor sloping upwards to my left and right. There seemed to be various niches and benches cut unto the rock, and in the middle of the chamber was a deep well, unguarded and ready to entrap the unwary. Did Moses really come down this tortuous passage and into this rugged cave to collect the sacred tablets of stone from 'god'?

But surely Moses was *on* Mt Sinai, not in it, so what was I doing in this deep underground cavern? It is easy to miss small points if the detail of a text is thought to be inconsequential, so it is an often overlooked fact that Moses did not simply climb up Mt Sinai to receive the ten commandments from god, he actually descended into the mountain itself:

> And the Lord said unto Moses, Come up to me <u>into</u> the mount, and be there: and I will give thee tables of stone, and a law, and commandments which I have written; that thou mayest teach them.

1. Origins

> And Moses rose up, and his minister Joshua: and Moses went up into the mount of God. [B1]

Note the continual use of the term 'into', a phrase that will be confirmed later from other contemporary texts. This is an unusual piece of detail in the story that is unlikely to have been fabricated or placed in the text in error. The deliberate use of the preposition 'into' means that Mt Sinai must, therefore, have possessed a cave deep inside this mass of rock that towered over the surrounding landscape; a chamber where Moses met and conversed with the deity. I truly believe that this very rocky cavern that I was standing in, was that very same cave that Moses had stood in some 3,700 years ago. Here was the very epicenter of the events that would eventually spawn a belief system that would influence more than half the world's population, and the presence of this cave is actually a small and insignificant detail of the biblical translation that may yet turn out to have profound consequences.

Homeland

I shall come back to the story of Mt Sinai later in the book, as there is a fantastic story that will eventually unfold from these pages; for the Mt Sinai that resides in the Sinai Peninsular, of orthodox teaching, was not the real Mt Sinai of the exodus. Only now, after years of patient study and with fresh eyes to bear on a hoary old subject, has the real truth started to emerge.

This process of revelation could only begin when the real roots of Judaism were at last researched from an independent viewpoint. There was never any point in poring endlessly over the Torah or Talmud, looking for divine insights into the history of Judaism; as much of these valuable works have been amended and adapted to suit the era of each new edition. The only way to see through these amendments and alterations was to go back to the very land where Judaism sprang from, to see what original tales were told there of these events.

The homeland in question, of course, was not Jerusalem, but Egypt. I started this research process with the book *Jesus, Last of the Pharaohs*, but as I was keying in the text at lightning speed, it became apparent that there was a lot more data than could be included in a single volume. The book *Jesus*, therefore, made a quick dash through the whole of the Bible and beyond, looking at the major topics in each of the biblical eras. But there was an obvious need to look at one particular era in much greater detail and to wring out all the new truths that it contained.

1. Origins

That era for further research was to be the exodus. The exodus, I believe, was the pivotal point in Israelite history that formed and precipitated the Judaic religion as we know it. Had the Israelites been allowed to stay in Egypt, they may well have been content enough to live their lives in relative anonymity; and in this case, the Torah (Old Testament) may never have been written. But the great biblical exodus and all the privations that were suffered by the people who were involved in that momentous event, was perceived to be a great injustice to the Israelite nation, inflicted by their 'cruel' and 'oppressive' Egyptian overlords. While the Israelites had always been a highly religious people, it was this perceived persecution that bonded the new nation into an incredibly tightknit community, and it was this persecution that triggered the emerging Judaic religion – which, I will show, was a gross distortion of the original Israelite beliefs.

The paradox that has to be overcome before embarking on this search for the historical truth, is that origins of this religion were not Judaic; in fact, they were pure Egyptian. As already covered in the book *Jesus*, the biblical patriarchs were not simple shepherds, they were the Hyksos, the Shepherd Pharaohs of Egypt; the very pharaohs who fought a long and protracted civil war with the Theban pharaohs and their people. Thus, although there were theological differences between these people that triggered this bitter conflict, the religion of the Hyksos/Israelites was originally substantially the same as the religion of their perceived oppressors, and this fact explains many of the conundrums to be found in the Bible.

I would liken the social differences in Egypt at this time to the situation in modern Northern Ireland. It is beyond dispute that the religions of the two communities in the province are substantially the same and yet, the small doctrinal difference between the Catholics and the Protestants, which are almost invisible to outside observers, have precipitated hundreds of years of sectarian conflict.

So were the Hyksos people in Egypt actually the original Israelites? This theory is highly likely to be true, and the similarities between these nations can be clearly seen in the large number of parallels between the events that are detailed in the history of the Hyksos exodus and the similar biblical exodus. They can also be seen in the similarities between the Hyksos people and the Israelites themselves. It might be worth recapping some of the similarities, which are explained in much more detail in the book *Jesus*.

* * *

1. Origins

In the following list:

a. = Items from the various religious texts about the Israelites.
b. = Items from historical accounts about the Hyksos, mainly from the books of the ancient historians Josephus and Manetho.

a. The biblical patriarchs were both shepherds and kings.
b. The Hyksos were also Shepherd Kings.

a. The Israelites introduced religious innovations into Egypt.
b. The Hyksos introduced religious innovations into Egypt.

a. They had a vast army. (Abraham had 318 army officers and about 10,000 men.)
b. They had a vast army (with chariots, horses and body armour).

a. They adopted Egyptian names and customs. (Joseph was Sothom Phanech or Ptah-seph, Moses was either Moses or Osiris-seph.)
b. They adopted Egyptian names and customs.

a. They were 'skilled in astronomy and science'.
b. The celebrated *Rhind Mathematical Papyrus* is a Hyksos document. The document, although found in Thebes, was dated to the 33rd year of Aauserra; this dating of the papyrus to the reign a Hyksos pharaoh clearly shows it to have originally been a Hyksos document. [2]

a. They ruled Egypt. (Joseph was chief vizier to pharaoh; Moses was the adopted son of a pharaoh; Abraham was also a king.)
b. They ruled Egypt as pharaohs.

a. Many plagues afflicted the Egyptians.
b. According to the *Tempest Stele*, many plagues may have afflicted the Egyptians.

a. There was a famine.
b. There was a famine. (Manetho.)

a. They were involved in a war with the Egyptians. (The Israelites killed thousands of Egyptians and destroyed their cities.)
b. They were involved in a war with the Egyptians. (The Hyksos killed thousands of Egyptians and destroyed their cities.)

1. Origins

a. There was a great exodus of the Israelite shepherds.
b. There was a great exodus of the Hyksos Shepherds.

a. They left the Egyptian Nile Delta region.
b. They left the Egyptian Nile Delta region.

a. The number fleeing was about one million.
b. The number fleeing was about one million. (Manetho.)

a. The fleeing Israelites were chased by a pharaoh.
b. The fleeing Hyksos were chased by a pharaoh. (Manetho.)

a. The sea withdrew for the fleeing Israelites.
b. Seas withdrawing is a known event with a tsunami.

a. The Israelites destroyed many towns in Palestine.
b. The Hyksos were a large army on the retreat; some towns inevitably got destroyed.

a. The shepherds went to Jerusalem.
b. The Shepherds went to Jerusalem. (Manetho.)

a. If the Hyksos exodus were the biblical exodus, then the conventional date for the events of the biblical exodus cannot be correct. But there was another exodus that could have caused some confusion for the biblical compilers – the exodus of the patriarch Jacob (c. 1500s BC).
b. The Hyksos pharaoh of the exodus was probably Jacoba (c. 1550-1650? BC). See the book *Jesus* for further details.

Quite often, the historical and biblical records are regarded as being completely separate, perhaps even incompatible with each other. But as can be seen, there are great similarities to be found between the two different records of these exodus events and great similarities between the two cultures, too. It is highly significant that these accounts agree so closely and this list of areas of agreement will continue to grow inexorably, as this radically new version of history unfolds.

The true origins of these Hyksos people are still uncertain but they are believed to have been Asiatics and, in a similar fashion, the Bible asserts that the Israelites were originally descended from Chaldee or Babylon. According to the classical interpretation, it would appear that at

some point in the seventeenth or eigh
invasion of northern Egypt occurred and
the Hyksos/Israelite peoples. However, ir
evidence unearthed that places the true (
Israelites firmly in Egypt.

reverence for
differences b
which star
from
de

The original belief systems of the
but if they *were* from Babylon, we have a
that they would have brought with ther
rather surprisingly, have had a great (
religion of their 'new' homeland. They would
the Egyptian Sun-god Ra, whom they called *Shamash*; indeed, the
similarity would have been very striking to the new 'immigrants', for the
Chaldean god *Shamash* was often depicted as a winged Sun-disk, which is
exactly the same as the depictions that the Egyptians used for Ra.

A rather surprising illustration of this similarity between these two
cultures can be found in that very name for the Sun-god. If the Israelites
were the descendants of the Hyksos, then the Israelites would have been
equally acquainted with the Sumerian Sun-god *Shamash*. It so happens
that the Hebrew word for the Sun, as used throughout the Old Testament, is
Shemesh (שֶׁמֶשׁ). In mitigation, it has to be said that, while *sham* does
mean 'summer' in Egyptian, the fact that this word does not transliterate
very well into the ancient Egyptian language, may actually indicate that
Shemesh is a post Babylon-captivity intrusion into Hebrew.

While the Hyksos may have been familiar with Sumerian beliefs,
they would have been equally comfortable with the Israelite rituals.
Perhaps more surprisingly, bearing in mind the basic tenets of modern
Judaism, it would seem that the Israelite beliefs were also very similar to
Egyptian/Hyksos beliefs. The Koran makes the religious practises of the
early Israelites perfectly clear when is says that:

> When Abraham beheld the rising Moon, he said: 'That is my god.' But
> when it set, he said, 'If my Lord does not guide me, I shall surely go
> astray.' Then, when he beheld the Sun shining, he said: 'That must
> be my god, it is the largest (heavenly body).' K3

Abraham was debating which of the heavenly bodies was to be his
supreme god and having rejected the Moon-god, the Egyptian Djeheuti,
he settled upon the Sun-god Ra. It would appear that all of these nations
– the Theban Egyptian regime, the northern Hyksos and the Israelites –
were all very familiar with and worshipped the Sun-god Ra. In fact, it would
appear that all of these nations shared a common religion and a common

1. Origins

a solar deity; but if that were so, then what were the
between northern and southern Egypt that caused the friction
ed the Hyksos civil war?

e initial proposal will be that the Egyptian religion had drifted away
its core tenets over the millennia, and had evolved a plethora of
migods to explain the position and significance of the Egyptian people in
the wider world and the cosmos. But there was a small band of
fundamentalist priests who were determined to drag the rest of the
priesthood and their divergent rituals back towards the original
'monotheistic' beliefs. It was this religious schism and not a passive
invasion of Asiatics, I believe, that was the cause of the Hyksos civil war.
This may have been one of the reasons for the biblical Abraham's people
not knowing the name of the great Judaic god, Yahweh:

> And I appeared unto Abraham, unto Isaac, and unto Jacob, by the
> name of God Almighty, but by my name Yahweh was I not known to
> them. B4

So, why did Abraham's followers not know the name of their own god? It is
quite possible that the secret and separate nature of Egyptian religion from
the common people lay behind this ignorance. The real name of 'god' may
have been a genuine secret to all but the highest in the priesthood, and so
the common people may not have known what the priesthood called him.
As will be shown in chapter V, this tradition was perpetuated in the early
Israelite religion too, but a good example of this secrecy can be seen in
the early chapters of the Bible, where Abraham called his god 'God
Almighty' or *El-Shaddai* (אל שדי) in the Hebrew, meaning 'god the
destroyer'.

Surprisingly enough, the very similar word in the ancient Egyptian
language, *shadj,* also means 'carnage' or 'slaughter', and so we have a
direct translation between the two languages. It should be pointed out,
however, that the Hebrew concept of this god as a wilful annihilator may be
in error. Although the Egyptian word does mean 'carnage', it also has
numerous connotations to the cutting of meats and of sacrificial breads;
El-Shaddai may simply have inferred the 'god who requires sacrifices'.
Because the name of god was a state secret in Egypt, the people simply
used a nickname that was based upon the ritual sacrifices made to that
god. Abraham's followers may have been well acquainted with the
nicknames, but they were not so conversant with the real name of
Yahweh.

1. Origins

Fig 1. Shadj – slaughter or sacrifice?

The two small quotes just given are good evidence of the secrecy that shrouded these early religions, and they also demonstrate that the Judaic religion as we know it, did not extend back into the dim and distant past of Abraham's ancestors. Abraham's [the Hyksos'] belief system involved the god Ra, as did the Theban theology; and yet there still must have been fundamental differences between the northern Hyksos/Israelite people and their southern Theban counterparts to have precipitated such a bitter and protracted war.

Those differences *were* centered upon a rejection of polytheism by the Hyksos, as I suspected; and I think the fundamental roots of those differences can be found not only in Egypt, but also in the Koran. The prime tenet of the Koran revolves around the claim that Abraham [the Hyksos pharaoh Mam-aybre] did not indulge in idolatry. Specifically, the claim is also made that the images of the gods did not speak, and so by inference we can assume that the Theban statues of the gods were empowered to speak by their priesthood:

> (Abraham) said to his father and to his people: 'What are these images to which you are so devoted?' They replied, 'They are the gods our fathers worshipped.' (Abraham) said: 'Then you and your fathers are in the grossest error' ... 'I am no idolater'. [K5]

> (Abraham said) 'Ask them if they can speak.' They said to Abraham, 'You know they cannot speak.' (Abraham) answered: 'Would you worship that ... which can neither help nor harm you? Shame on you and your idols!' [K6]

Additional reasons as to why Abraham should be considered to have been in Egypt (and a Hyksos prince) when this discussion took place will be aired later, but the subsequent reaction of his opponents in trying to kill him and his supporters is undoubtedly reminiscent of the civil war between the Theban and Hyksos regimes. Note also that Abraham was potentially fighting against his father here. Just as I have speculated in the book *Jesus*, the Hyksos dispute was not just a civil war but a highly personal

1. Origins

one, too; the prince was pitched into a dispute and a battle against the reigning monarch – his father. If this was so, and if Abraham was a Hyksos prince as I have maintained, then the Hyksos dispute with Thebes was probably not caused by waves of immigrants flooding into the Nile Delta.

What we appear to have, instead, is a royal schism in the Two Lands, caused by a religious dispute between related royals. This is a scenario that has not only been a regular feature of recent European history – with royal cousins thrashing out their differences on the fields of Flanders – it is also very similar to the Egyptian dispute between Thebes and the Amarna regime of the rebel pharaoh Akhenaton. Indeed, both of these Egyptian disputes look as though they may have had identical causes. Both Abraham and Akhenaton were fighting against idolatry and both wanted to centralize the religion around the monotheistic core beliefs of the Sun-god, in the guise of Ra, Adhon or Aton. It has to be pointed out that I am not insinuating here that Abraham *was* Akhenaton; just that they were both of the same Hyksos religious faction, that they were ancestrally related, and that they were both fighting the same battles against the same forms of idolatry.

Indeed, many of the recent European wars have been caused by exactly the same religious dispute. The fundamental royal schism of the last 500 years or so involves the irrevocable split between the Catholic and Protestant faiths and, in turn, the nub of this dispute was that the Catholics were accused of idolatry. The ghost of Akhenaton looms large over Martin Luther. This religious schism not only precipitated the English Civil War, but several wider European conflicts too. It may have been the Virgin Mary who was being idolized instead of Isis but, nevertheless, history was merely repeating itself, as it is often wont to do.

In both of the Egyptian disputes, it seems likely that the Theban priests were indulging in a more popularist form of the Egyptian religion. Like the New Testament Saul, they had invented new gods and idols to worship and, according to the Koran, some of these gods were being empowered with speech by the priests: no doubt this was to dupe the credulous population into parting with ever greater tithes for the temples. Amongst many other notables – Abraham [Mam-aybre], Akhenaton and Henry VIII, in their respective eras – were all leading a royal crusade against this same kind of theological corruption and in Egypt, it was this action that was to precipitate the Hyksos civil war.

But the evidence for the causes of this dispute, which have been presented thus far, may seem rather scanty and so it is probably worth looking at some of the original Egyptian literature to see what it says about these times and events.

1. Origins

Scribes

The first thing to note is that much of the ancient Egyptian literature that has survived the millennia is hardly controversial, nor is it derived from the king's private chambers or the priests' sacred cloisters. Instead, much of the material that has been discovered is simply tutorial copying exercises for students. Being such, we are hardly going to discover dramatic and secret truths of the Egyptian religion in them, but they are interesting enough texts despite their mundane origins. The most illuminating part about these texts, however, is the way in which they occasionally dovetail closely with some of the biblical passages.

The most famous example of this involves the biblical Ten Commandments. As has been pointed out in many other works, these ten rules of Mosaic Law sound rather similar to the *Declaration of Innocence* in the Egyptian *Judgement of the Dead*; the only real difference is that the Ten Commandments speak of the future – 'Thou shalt not' – whereas the ancient Egyptian equivalents talk of the past – 'I have not'. But is this really evidence of a common bond between the biblical and Egyptian texts?

Unfortunately, a set of moral rules derived by any nation in any era are likely to have many similarities, so I shall pass on this particular issue. Let us instead take a look at the simple tale of the *Two Brothers*, which was written in about the nineteenth dynasty (c. 1250 BC). In this story, the younger of the brothers, Bata, stayed with his sibling's family and worked in the fields. Then, one day, the wife of the older brother made a pass at his younger sibling:

> 'Come, let us spend an hour lying together. It will be good for you, and I will make fine clothes for you.' Then the youth became like a leopard in his anger ... 'Look, you are like a mother to me; and your husband is like a father to me. He who is older than I has raised me. What is this great wrong you said to me?'

The youth goes off to work in the fields, but back in the house the wife has begun to plot his downfall.

> Now the wife was afraid on account of the speech she had made. So she took fat and grease and made herself appear as if she had been beaten ... Her husband said to her, 'Who has had words with you?' She said to him, 'No one except your young brother. When I came to take seed to you, he found me sitting alone. He said to me, "Come, let us spend an hour lying together, loosen your braids".'[7]

1. *Origins*

The result of this charade is predictable enough. The elder brother tries to kill his sibling for the perceived wrong to his wife and a great fight ensues. The story then takes off on a rambling mythical journey, until the two brothers are finally reconciled. The story above is, of course, identical to that of Joseph in the Torah. Joseph, on his famous return to Egypt, was effectively an orphan and so it fell to Potiphar, a captain of the pharaoh's guard, to raise him as both slave and 'son'. But, in a similar fate to Bata, Potiphar's wife makes a pass at Joseph:

> And it came to pass after these things, that his master's wife cast her eyes upon Joseph; and she said, 'Lie with me'. But he refused, and said unto his master's wife, 'Behold, my master worries not what is with me in the house, and he has committed all that he has to my hand ... but thou, because thou art his wife – how then shall I do this wicked thing, and sin against God?'

Joseph had rejected the advances of the lady of the house, but in a rather familiar refrain, she plots his downfall. When her husband returns she said to him:

> The Hebrew servant, which thou has brought unto us, came in unto me to mock me. And it came to pass, as I lifted up my voice and cried, that he left his garment with me, and fled out. [B8]

The inference is that Joseph had made a pass at *her* and only her timely screams had managed to frightened him away. The husband is predictably horrified and Joseph is thrown into jail.

The Egyptian version of this story was written around the time of Ramesses; that is, slightly after the second exodus from Egypt, according to the chronology in the book *Jesus*. In this case, it would appear that the biblical version of the story predates the secular version, although since most of these Egyptian stories have been copied and re-copied through enormous spans of history, this does not preclude there being an earlier Egyptian version that has not yet been discovered. But although these two stories appear to be copies of each other, the material is so predictable and obvious that these events could have happened in hundreds of court intrigues throughout man's entire history. In short, they may be entirely separate accounts.

If we are to find something that is evidential of a biblical story or a biblical influence, then the subject matter needs to be rather more unique than a simple girl-meets-boy story. Then, a snippet of the kind of detail I

was looking for sprang off the pages of this very same tale. During the fabulous ending of the story of the *Two Brothers*, the king makes a sacrifice of a bull. The detail from this sacrifice is interesting:

> And when (the bull) had been sacrificed ... he shook its neck and let fall two drops of blood beside the two doorposts of his majesty.

In the story, both the door of his majesty and the great portal of the pharaoh are anointed with sacrificial blood, and it is clear that this is a traditional custom. The biblical version of this act involves a pivotal moment in the history of the Israelites – the passover:

> Then Moses called for all the elders of Israel, and said unto them, 'Draw out and take you a lamb according to your families, and kill the passover (lamb). And ye shall take a bunch of hyssop, and dip it in the blood that is in the basin, and strike the lintel and the two side posts with the blood that is in the basin ... For the Lord will pass through to smite the Egyptians; and when he sees the blood upon the lintel, and on the two side posts, the Lord will pass over the door, and will not suffer the destroyer to come in unto your houses to smite you'. [B9]

Although the Egyptian version of this tale is not exactly a biblical quote, we are on much more fertile ground because this directly infers that the Israelites were following the standard Egyptian practice of anointing the doorposts with sacrificial blood. The only difference being that the Israelites used the blood of a lamb and not that of a bull. The reason for this slight difference is fully explained in the book *Jesus*. Although the blood of a lamb may physically appear to be rather similar to the blood of a bull, they were symbolically quite different and this symbolism was all based upon the signs of the Zodiac. The Theban Egyptians still venerated the Apis bull [Taurus], while the Israelites/Hyksos had moved on to the ram [Aries].

While again this similarity does not make this sentence a direct Egyptian quote from the Bible (or visa versa), it is interesting to note that the Israelites had performed this small detail that was unique to the Egyptian religion.

Blood

Thus far, we have seen similar social and religious customs, but there has not, as yet, been a similar real historical event. What I was looking for was

a peculiar national event that has been reported in the Bible; one that could perhaps also be found in the Egyptian record somewhere. I was looking for something like the river Nile turning red during the plagues; now surely, if this were a real event, it would get a mention somewhere in the Egyptians' annals:

> 'Go to Yabu and bring me red ochre in great quantity!' The red ochre was brought to him, and the majesty of this god ordered the Side-Lock wearer of On to grind the ochre, while the maidservants crushed barley for beer. The red ochre was put into the beer mash, and it became like human blood; and even seven thousand jars of beer were made ... Now when the day dawned on which the goddess would slay mankind ... the (beer) was poured out. Then the fields were flooded three palms high with the liquid ... [10]

Now this is more interesting. The passage is a quote from *The Destruction of Mankind* and here we see a tale of a vengeful 'god' who is plotting to kill mankind. The people are fleeing into the desert and the 'gods' chase and slay them. Finally, a peculiar ruse is devised to save mankind, whereby the fields (or perhaps that should be the irrigation canals through the fields), are turned red through the use of vast amounts of red ochre. This somehow pacifies the 'god' through intoxication and so 'mankind' survives to tell the tale.

Is this not all rather familiar? In the Bible, we have a vengeful 'Lord' (the pharaoh of Egypt) who is plotting to destroy 'mankind' (the Israelites). The Lord (the pharaoh) does indeed eventually chase some of his victims across the desert to kill them and one of the unusual methods deployed by Moses to stop all this happening was to turn the river Nile red.

> And Moses and Aaron did so, as the Lord commanded; and he lifted up the rod, and smote the waters that were in the river, in the sight of Pharaoh, and in the sight of his servants; and all the waters that were in the river were turned to blood. [B11]

Note that we are not just talking of creating a red coloration here; both of these passages specifically refer to blood being created. Indeed, the root of the Hebrew word for blood, *dam* (דם), is also derived from the root of the word for making a red colour, *adam* (אדם). As an aside, this is also the root of the name of the biblical Adam. In addition to this linguistic synchronicity, the 'god', on seeing the fields flooded with this red-ochre 'blood', is pacified through intoxication, and the root of the Hebrew word for blood is *damam* (דמם), which means to pacify.

1. Origins

Surprisingly enough, this same linguistic pun works in the original Egyptian version too. The Egyptian word for making a red colour is *djash*, from which can be derived the word *djasher*, for blood. But since the 'god' became intoxicated on a red-coloured beer poured on the ground, we also find that a red drink is called *djasert*, an outflow of water is *djash-djash*, and to be drunk is *djash*. Not only would it seem that both the Israelite and Egyptian scribes enjoyed a good pun in their tales, but it is also becoming apparent that there are many similarities between the Hebrew and ancient Egyptian languages – similarities that some authorities would rather turn a blind eye (or deaf ear) to.

Djash – red colour, *intoxicate,* *blood.*
Fig 2.

If it is not too much of a digression, some of these ancient Egyptian puns may still survive in the modern era. The modern reference to overpaid executives being 'fat cats' may well stem from the fact that a 'good harvest' and a 'large cat' or 'lion' sound very much the same in Egyptian – *Maau*, a word that was obviously derived, in the feline context, from the sounds that a cat makes.

Getting back on track and looking again at the biblical account of the plagues, the biblical text may initially read as if the [Theban] pharaoh wanted to keep the Israelites as slaves, whereas the implication in the *Destruction of Mankind* story seems to be that the 'Lord' was actually trying to kill them; but this difference may just be a gloss provided by the biblical scribes. In the book *Jesus*, a convincing argument is made that the biblical exodus was actually the Hyksos exodus from Egypt; but the latter was, of course, a full-blown civil war, with many major battles being fought between the two sides. In this case, the 'persecution' of the Israelites was not quite as one-sided as the Bible tries to make out and so the quote from the secular Egyptian document may not be too far wide of the mark – the [Theban] pharaoh was definitely on the trail of Hyksos blood.

There are other facets of this tale that are interesting and deserve further investigation. The location for the red ochre is given as being *Yabu* (Eabu) and this is taken by all the various translators as meaning the southern lands of Elephantine and Nubia. But the location of *Yabu* sounded distinctly biblical to me. As will be shown later in this book, the Hyksos were

known as the *Eamu* (*Yamu*), the Great Pyramid was the *Eakhu* (*Yaku*), and Thoth (Djeheuti) was known as *Ahu*. As the Hyksos/Israelite people were both resident in Heliopolis at the time, a reference to *Yabu* in this era could actually refer to a location close to Heliopolis.

Egyptian history appears to confirm this when it records that the prime name for the temple of Heliopolis was *Yanu* (*Eanu*). Suddenly, instead of looking south to the lands of Nubia and events that occurred in Thebes, we are looking to the north, to Heliopolis and all the events of the Israelite exodus. [12]

This reasoning is further confirmed in the next sentence of *Destruction of Mankind*, where the person asked to crush the ochre is called the 'Side-Lock wearer of On'. Now this phrase may take a little explaining. The city of On was, of course, the biblical name for Heliopolis, so here is the second piece of concrete evidence that suggests that Yabu may actually lie in that region. The side-lock wearer is often thought to denote a youth. But the command in the text is direct from the god Ra himself and he is hardly going to be ordering the lowest of the initiates at the sacred temple to perform this important function of crushing the red ochre. This reference to a side-lock wearer has to infer the rank of high priest of Heliopolis, and the author's notes accompanying this particular passage agrees with this view. The translator, M. Lichtheim, says that this phrase is indeed a reference to the high priest of Heliopolis.

Egyptian priests often sported shaven heads and wore long curly side-locks of hair, hence the term 'side-lock wearer'. This custom is self-evident from the depictions of priests on the walls of the great temples all over Egypt. But this observation simply strengthens the links between this Egyptian quotation and the Israelites, for the modern-day orthodox Jew will still wear the same hair fashion, some 3,500 years later. The Jewish curly side-locks are probably well known as a fashion, but in addition, many Jews will also sport a shaven forehead and crown; it may not be the fully shaven head of the high priest of Heliopolis, but it is incredibly close.

Perhaps more importantly for the connection with the Israelites, however, is the fact that both Joseph and Moses were high priests of Heliopolis themselves. Joseph lived in Heliopolis, married the daughter of a high priest, was second in command to the pharaoh and also owned a priestly stole – his famous 'coat of many colours' or many ornaments. Moses, likewise, was intimately linked to the court of the pharaoh. He was brought up in the royal court and, according to Josephus, he was in line for the kingship of Egypt. On the other hand, according to Manetho, he was yet another Israelite high priest of Heliopolis:

1. Origins

It is said that the priest that gave (the Hyksos) a constitution and a code of laws was a native of Heliopolis, named Osarseph after the Heliopolian god Osiris, and that when he went over to this people he changed his name and was called Moses. J13

The *Destruction of Mankind* story is found in many New Kingdom tombs, but from its style it is thought to have been first written in the Middle Kingdom. My chronology for the Israelite people is that, being identical to the Hyksos people, they first 'arrived' in Egypt in either the thirteenth or fourteenth dynasties (1780s to 1680s BC). In later chapters, we shall see Egyptian literature that places the Hyksos back as far as these very early dynasties. The first 'true' Hyksos pharaoh is not recognized in the classical texts until Sheshi of the fifteenth dynasty (c. 1650 BC). This late arrival of the Hyksos on the historical stage may have been due to a theological rift between Sheshi and his father, Nehesy, that made this new fifteenth dynasty uniquely Hyksos; but the Hyksos may have been a powerful faction prior to this time. See the book *Jesus* for more details.

Whatever the case, if the *Destruction of Mankind* story was really written at around the twelfth to fifteenth dynasties, as the translators infer, this would be at just the right kind of era for the Israelites/Hyksos to have been resident in Heliopolis. Here, then, is our first taste of real biblical material being incorporated into secular Egyptian stories, or vice versa. The Egyptian story not only has a parallel in the Bible, but its mention of Yabu and Heliopolis places it in the correct location, too.

In which case, bearing in mind the new biblical perspective to this story, we might make a stab in the dark as to what this peculiar story was really all about. It details the attempt to destroy mankind by a god. Since the pharaohs were known as gods, this has obvious parallels with the biblical persecution of the Israelites by the pharaoh. Turning the river red with blood, and the fact that this blood was faked, has obvious military propaganda implications. We shall see more examples of this later, but it would appear that the Israelites were well versed in the art of subversive military propaganda; some of it was overt, some more subtle, but all of it was quite ingenious, as we shall see.

Just as the Egyptians had a custom of cutting off the hands from the dead of a battle to show the numbers slain, perhaps the Israelites were trying to make the same kind of demonstration to their southern pharaoh enemy. The actual battle was probably just a small skirmish, as was often the case in these times; but to impress their southern foe of their great victory, Moses has vast quantities of thick, clotting, fake blood made up by mixing red ochre with beer mash. During one of the conferences that

took place between Moses and the southern pharaoh, as will be covered in detail later in the book, this fake blood was poured over the ground and into the rivers. Moses then turns to his foe and says something like 'look what we have done to your army/people, we can do it again if you wish'.

The Egyptian version of this tale says that the 'god' was pacified or intoxicated by this action and although this was probably just a linguistic pun on the word *djash*, perhaps one's foe just might be pacified and made to be 'nauseous' if they were taken in by such a gory trick. Accordingly, the texts say that the Egyptians could no longer drink the water, but that the Israelites, according to Josephus' *Antiquities*, could.

> The river ran with bloody water at the command of 'god', insomuch that it could not be drunk ... for the water was not only the colour of blood, but it brought upon those that ventured to drink it, great pains and bitter torment. Such was the river to the Egyptians; but it was sweet and fit for drinking to the Israelites. [J14]

Once more, such a strategy of misinformation and propaganda is likely to have produced these very same results. The Egyptians would experience revulsion at the thought of drinking the blood of their compatriots; while the Israelites, knowing this was purely a ruse, would happily gloat and drink the water. Indeed, if Josephus' text can be read as being a verbatim report, his very language seems to confirm my supposition. 'The colour of blood' may infer a red-ochre dye rather than real blood; and the phrase 'it brought great pains and bitter torment' does not sound so much like a stomach upset as it does a lament for the lost souls whose blood is supposedly being poured into the river.

Egyptologists and Jewish historians alike have all despaired of finding any real evidence of the biblical events in Egypt, and many have declared that most of these biblical events must therefore be myths or fabrications. But here, in black and white, is a piece of biblical history sitting in the Egyptian tomb of none other than the pharaoh Tutankhamen. By way of squaring the circle, it should be noted that Tutankhamen was one of the New Kingdom pharaohs who decided to re-use the title *Hyk,* meaning Hyksos; it forms a part of his full birth name of 'Hyksos ruler of Upper Egyptian Heliopolis'.

In a later chapter, the peculiar nature of this tale may be explained further. The 'redness' of the biblical Adam is matched by the 'redness' of Esau, the brother of Jacob. Clearly, the colour red was deemed to be important in these ancient tales and the detail of this story may also be

explained in terms of the emblems of Egypt. Upper Egypt was deemed to be white, while Lower Egypt was deemed to be red, and so I will propose later that these tales of blood and redness may also be intimately connected to the Hyksos rule of Lower Egypt. Such an explanation may seem to indicate that the whole story was a simple fabrication, but equally, these strange events may also have been a part of an elaborate ritual or even a ruse to convince the population of the Hyksos' divine right to rule Lower Egypt.

Yabu

This all rather suggests that my identification of Yabu being a location close to Heliopolis is correct; but how can this be? Egyptologists have pored over these texts for centuries and their considered opinion is that Yabu was most definitely Elephantine, so how can I, a mere alternative researcher, overturn decades of painstaking research? The answer is that one needs to be able to understand what the text is talking about before making the translation, otherwise the result will be no better than a stab in the dark. This apparent catch-22 can only be solved by having a similar known text to refer to, or to know the main thrust of what the scribe was trying to say when he wrote the original piece.

In the case of the name for the location known as *Yabu*, it is my rather bold assertion that I not only know where this place was, but also what this name was supposed to represent and how the very glyphs themselves were invented. This explanation, therefore, takes us back to the very beginnings of Egyptian history; to a time when an astute scribe sat at his desk and invented some of the fundamental glyphs of the Egyptian language.

The glyphs that describe the name of the location of Yabu are the same as for Elephantine, except that the latter location normally has an elephant for a determinative glyph to conclusively show that Elephantine is meant by the name. The only real difference between the two words is the stress on the first letter; Yabu was spelt *Eabu* whereas Elephantine was spelt and pronounced as *Abu*. The difference lies in the first glyph and Yabu tended to use the glyph for 'east' (*Eab*), whereas Elephantine used the similar 'lollipop' glyph (*Ab*), which apparently has no known meaning. These two determinatives look and sound a bit similar, but they are not the same. The two names are spelt as follows:

* * *

1. Origins

Fig 3. Yabu and Abu (Elephantine).

Note how the location of Elephantine, a distinctly Egyptian location, has the 'three-hills' or 'foreign-lands' determinative glyph – this will be important in later chapters.

The first glyph in Yabu is the symbol meaning 'east' (the compass direction); and it is difficult to see how this glyph would apply to Elephantine, which resides in the south. So how did Elephantine become 'east'? Now the nice thing about glyphs is that they not only have a literary meaning, but a pictorial one too, and it is through the latter that we can begin to glimpse the original location of Yabu.

The hieroglyphic symbols for the points of the compass are rather interesting, for they are quite complex and have definite meaning. North was *mehti*, presumably derived from a determinative and word used for the flooding of the Nile, because the effects of the inundation were much more prominent in the Delta region. South was *quemai* or *res*, terms that while being pronounced quite differently were spelt much the same, both using the rush or sedge glyph that was seen to be the 'plant of the south'. These points of the compass were therefore using glyphs that had some relevance to the directions in which they pointed. It would be reasonable to assume that the directions of east and west followed the same logic, but unfortunately the glyphs used in these examples are so unique and complex that nobody has ever deciphered them before.

North – mehti; *south – res;* *east – eabtet;* *west – amentet.*
Fig 4.

Although it is not too surprising that the glyphs at the beginning of the words 'east' and 'west' have remained enigmas, it is unfortunate. The central theme for the whole of Egyptian theology may well revolve around these very glyphs and so their translation will underpin many of the claims made in later chapters.

1. Origins

The glyph for west is pronounced *amentet* and it not only means 'west', but also the 'right-hand side'. For west to equate with the right, the word assumes that one would be facing or travelling to the south. The first glyph ⊤ , that replaces the usual simple glyphs, is pronounced *amen* and it is through the origins of this one glyph that the origins of Egyptian theology itself can be glimpsed. The pronunciation of *amen* might also suggest a link with the god of Amen-Ra, so we may be looking for a link to the solar deity or to the Sun itself. An alternative pronunciation for this glyph is *men*, which in turn has connotations of 'monuments', 'blocks of stone' or 'mountains'. So, the initial image that this glyph leaves us with is of a massive stone monument or mountain, connected in some way with the Sun.

The imagery does not end there, however, for the *amen* glyph ⊤ , is composed of several sub-elements and perhaps the most important of these is ⊤ . This segment of the glyph has it own pronunciation and meaning, a fact which confirms the fact that the complete *amen* glyph has been built up from various smaller elements. This first element is pronounced *Hep*. It is an extremely rare and unusual glyph and it apparently only has only two meanings – the 'solstice' and 'to turn'. In fact the word therefore only has one meaning, for the 'turning' that is implied here is the turning of the Sun at the limits of its annual cycle.

At the summer solstice, the Sun will reach its northernmost rising and setting position on the horizon, and will begin to 'turn' back to the south once more; conversely, at the winter solstice, the Sun will reach its southern-most rising and setting position and will 'turn' back to the north. The direct implication is that the Sun is again important in the meaning of this glyph, but in what pictorial manner can this glyph symbolize the solstice? Indeed, how can something like the solstice be symbolized and written on any papyrus?

The answer is obvious, but only from the 'alternative history' point of view. From the alternative perspective, the pyramids of Giza have nothing to do with tombs and everything to do with solar and stellar pointers. The prime astronomical pointers on the plateau are the vast pyramid causeways, which thrust out from the eastern bases of the pyramids at a specific angles in relation to the rising Sun. In fact, these causeways are not set to point at the rising Sun at the solstice, but instead at the cross-quarter points; the points midway between the equinox and the solstice (see the book *Thoth* for details).

Here, then, is the way in which the solstice can be imagined and written as a glyph; the Sun rising over the end of one of these pyramid causeways may be just such an image. As it happens, the original depiction of this *Hep* glyph proves this assumption to be correct, the glyph can also be drawn like this ⊤. Here we can clearly see the perfect symbolism of the

1. *Origins*

morning Sun rising over the long line of the pyramid causeway. But there are two glaring problems with this new symbolism for the word and glyph that mean 'west': unfortunately, the pyramid causeways do not point at the solstice and they do not point westwards; in fact, they point the other way entirely, towards the east. These may seem like insurmountable problems, but there are perfect answers to each and every possible objection that simply serve to reinforce this novel interpretation.

Firstly, the 'solstice' glyph in its final form does not have a single line beneath the Sun, but two. This is not indicating that there should be two causeways for the Sun to shine over; rather, it is indicating that this is not the full solstice we are really looking at here. The long and short lines were derived from the 'fractions' glyph, which looks like this ⊤. This indicates that we are probably looking at a 'fraction' of the solstice cycle, rather than the solstice itself; in other words, instead of the causeway pointing towards the very northern or southern extent of the Sun's annual track along the horizon, it may be pointing at an intermediate position.

A confirmation of this 'fraction' interpretation can be seen in another word for west and east. This is listed in the Budge dictionary as *ges*, but the primary glyph in this word is obviously difficult to interpret, as the usual pronunciation of this glyph is 'm' or 'am', which would make a great deal more sense in relation to the word *amentet* (meaning west). The pronunciation is not important here, but what is important is that the other meaning of *ges* or *am* is 'half'. Here, we can see that the symbolism of *amen* is not only of a fractional part of the solstice, but quite possibly exactly a half of it. It so happens, of course, that the causeways attached to the Great and Second pyramids of Giza point to the cross-quarter sunrise, the 'half-solstice'.

Fig 5. Ges-eabt (Eabtet) – east, or Ges-amen (Amentet) – west

The second objection to this theory, however, is perhaps the most devastating. The causeways on the Giza plateau all point towards the east – towards the morning sunrise – so how, in this case, can the meaning of *amen* refer to the west? The answer to this is as neat and as lateral as one could possibly find and it lies in the last element of the *amen* glyph to be looked at – the feather ꟼ . This flag or feather, which resides on the top of the Sun symbol, can be pronounced on its own as *shu*. One of its prime

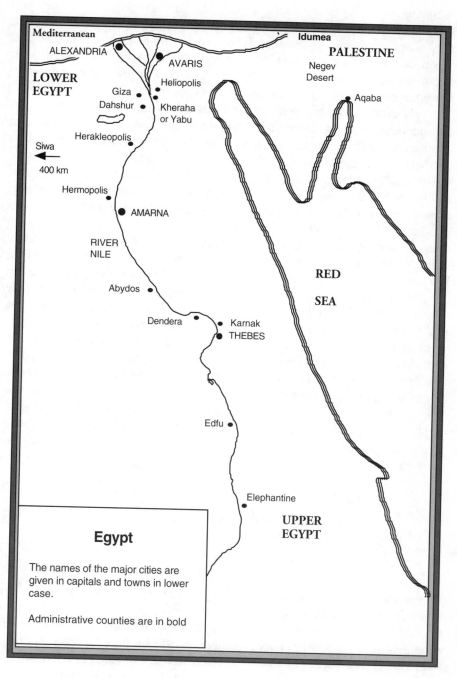

Fig 6. Map of Ancient Egypt.

1. *Origins*

meanings is the air or atmosphere god, *Shu,* and all things connected with the wind and air. While interesting, this terrestrial explanation for *shu* is not very enlightening and so the search continued. The next meaning for ᨈ that stood out was 'shadow', and the fact that this meaning may have been important was further confirmed by the ᚛ glyph also having a secondary determinative function as 'shadow'.

　　The reason for the shadow symbolism was immediately apparent to me, because I had just been translating a difficult passage in the Koran that seemed to be talking about shadows from the pyramids, but more of that later. The fact is, however, that it is perfectly possible that the celestial event that the priests were looking for was not simply the Sun rising over the horizon along the line of the causeway, but instead they were also observing the shadow of the pyramid along the causeway; and there was a good reason for this. While the morning sunrise can easily be seen in the eastern sector along the pyramid causeways, there is no equivalent causeway, temple or ceremonial center towards the west of the pyramids. We know that both the rising and setting of the Sun were very important in Egyptian theology, but while the rising Sun was easy to observe, the only way to record the setting of the Sun would have been to watch the shadows of the pyramids lengthen down the pyramid causeways.

　　If the Sun rose in the summer along the Great Pyramid's north-eastern causeway, as it would have done on the equivalent of our May 21ˢᵗ and August 22ⁿᵈ, then in that very same evening the dying shadow of the Second Pyramid would be seen to come to a halt exactly on the line of the Second Pyramid's south-eastern causeway. This, then, is why this solstice glyph *amen* actually refers to the west rather than the east. In fact, the glyph can be broken down into separate elements that spell out the meaning of the whole glyph:

> ᨈ The shadow
> 　 Of the Sun down the causeway
> 　　 At the half-solstice
> 　　　 Amen

Do we also see here the origins of the Christian intonement 'Amen'? It has often been said that the word Amen was derived from the Sun-god Amen-Ra, but, on second thoughts, this may be a little unlikely to be directly so. Amen-Ra was primarily a Theban deity but I will be arguing for the Judaic traditions to have been derived exclusively from the Hyksos and Heliopolis, who would have preferred the use of gods like Atum or Djeheuti (Thoth).

1. *Origins*

With this sunset symbology, however, one could perhaps imagine a much older tradition, from which the Theban Sun-god Amen was eventually derived.

As the Sun set in the west at the summer half-solstice and the shadow of the Second Pyramid reached the line of the causeway, the final words of the priest may have been *Amen*! The priest meant 'the west' (amen), but there was also a clear reference to the dying Sun over the horizon, and hence the compass point and the Sun-god both became known as Amen.

Not only was the day finished but so, too, was the season of the year and so the cry of the priest also inferred 'so be it!' or 'it is done!', which is the traditional Judaic, Christian and Islamic translation of Amen (אמן).

Here, then, is the most comprehensive breakdown and explanation of a single glyph that one could possibly have. But more importantly than simply giving us a reason for why the glyph for 'west' was chosen, it also infers that the 'alternative' historians were perhaps correct in some of their assumptions. The glyph clearly demonstrates that the pyramids were not simply tombs, but were also (or instead) cult centers for the priesthood; platforms and stage-props for the celebration of the movement of the stars, planets, Sol (our Sun) and Luna (our Moon).

East

This is all very intriguing, but it does not explain why the town of Yabu uses the glyph for east: how does this glyph fit into this convoluted explanation? Well, the reasoning given for the glyph for west can be used in a similar fashion to decipher, for the first time, what the glyph for east really means. Like the western glyph, the word for 'east' contains a complex determinative-like glyph that is composed of many sub-units and it is these sub-units that will explain the real reasoning behind this letter in the Egyptian alphabet.

The glyph has two forms which look like this ⚷ ⚷. The first element in this glyph is the 'flame' on the top ⚲ and the pronunciation for this particular glyph is *tcha*. The prime meaning behind *tcha* is of a 'fire-stick' being rubbed into a block of wood to create fire and, as one might expect, the term therefore has sub-meanings of fire and burning coals. This is not quite the imagery of the Sun that I had been expecting, but it still gives connotations of lighting-up or ignition.

This glyph stands on the top of a pole with a chevron underneath it, and the origins of this particular glyph took a lot of finding. The rather

1. *Origins*

surprising match that finally presented itself was a glyph which is pronounced *mer* and means 'pyramid': it has two forms, one simple and one more ornate ⌂ ⌂. This was a conundrum in itself, for why should this shape have anything to do with pyramids? The only answer that I could reasonably put forward is that the four pillars that were supposed to hold up the sky were drawn in a very similar fashion; once more there are two forms for this pillar glyph ⌂ ⌂. In Egyptian mythology, the four pillars stood at the cardinal points and held up the sky, but in later chapters I will be arguing that the four pillars were, in fact, metaphors for the four (five) pyramids of Giza and Dahshur. In reality, the sky was held aloft by the four largest of the pyramids of Egypt and it was this symbolism that was the origin of this strange 'pyramid' glyph.

The east glyph is therefore the combination of two concepts, ignition or fire and the pyramids; and I think that this is exactly the imagery that the priests would have seen on the Giza plateau when the Sun first broke over the eastern horizon. When the Sun was setting in the west, they observed the pyramid's shadow swinging around towards the massive pyramid causeways. When the Sun was rising in the east, however, they observed the pyramids light up with the first rays of blood-red light, as if the pyramids themselves were being ignited by the sacred fire from Ra himself.

Here once more, we see the importance of the imagery of the pyramids of Giza and how the theology of Egypt was probably shaped and influenced by those great monuments. Indeed, there are two curious points that tend to confirm the role of the Giza pyramids and the 'east' glyph.

Firstly, if the pyramid glyph is tuned upside-down we derive the glyph for *sen* meaning the two brothers, the twins or the two gods. The four largest pyramids in Egypt, are the Vega (Bent) and Draco (Red) Pyramids at Dahshur and the Great and Second Pyramids at Giza. These, I will be arguing in later chapters, are unique monuments in the mythology of Egypt as they were regarded as the four pillars of the sky. They also happen to stand adjacent to each other as two pairs. In this inverted pyramid glyph, we may begin to see these pyramids as divine pairs; quite possibly, the 'Two Breasts' of Egyptian mythology that were reputedly the source of the Nile, and which Herodotus described as the two conical hills of Crophi and Mophi.

Secondly, the 'fire-stick' glyph was known as *tcha*, while the similar-sounding and similarly spelt word *tchau* refers to a sacred rectangular lake in Egyptian mythology that measures 440 x 440 cubits. There is only one conspicuous monument in Egypt that has a rectangular base and measures 440 x 440 cubits – and that is the Great Pyramid itself. The only apparent confusion here is that the Great Pyramid is being referred to as a 'lake' for some reason; but perhaps this analogy is not too surprising,

1. *Origins*

bearing in mind the possible close association between this pyramid and the mythical source of the Nile. If the Great Pyramid was the mythical source of the Nile, then surely it can be regarded as being a 'lake' in some respects.

This association between the Great Pyramid, its partner the Second Pyramid, and the Twin-Breasts, is a subject that will be developed in later chapters, but note here how these pyramid celebrations were tied to the half-solstice and therefore to the seasons of the year. Of course, the Nile flood would have become associated with the pyramids, because it was the pyramids that appeared to 'regulate' the movements of the Sun. The summer/autumn half-solstice sunrise along the Great Pyramid's causeway, on August 22nd, marked the start of the *akhet* or inundation in the region of Giza; the autumn equinox in September marked the peak of the flood; while the autumn/winter half-solstice along the Second Pyramid's causeway on October 22nd indicated that the flood had ended and the planting of crops could begin. The *peret* or growing season of Egypt was in the northern hemisphere's winter season, while the Sun rose each morning to the south of the Second Pyramid's causeway.

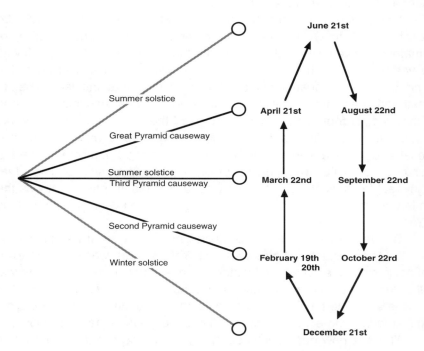

Fig 7. The Giza months and seasons

1. Origins

As can be seen, the entire cycle of Egyptian agriculture can be derived and planned using the position of the Sun in relation to the pyramids at Giza and their causeways, and I put it to you that this was one of the prime functions for these particular pyramids, and of the entire Giza site. Giza was a ritual center that was almost beyond parallel in the ancient world.

Perhaps we can also see here the reasoning behind our curious concept of the 31-day month. The Egyptian month was supposed to have comprised 30 days, and so twelve of these months left five odd days at the end of the year. This system would be fine for civil use, but the Sun does not conform to such tidy mathematics. Instead, the Sun, as it sped from the Great Pyramid's causeway to the Third Pyramid's causeway and then onto the Second Pyramid's causeway, spent exactly one month in between each of these solar pointers. But this is one celestial month, or a rather less agreeable 30.44 days.

The Sun therefore spent exactly four months of each year rising at dawn between the pyramid causeways, and exactly four months of the year to the north and south of these causeways. The diktats of the solar deity Ra himself, therefore demanded that the year was split into twelve months of alternating 30 and 31 day months, and this is more or less the same calendrical system we have to this day.

Here, at last, we can begin to see why Yabu (Eabu) should be relocated back to Giza. The Egyptian terms for 'east' and 'west' were intimately involved with and derived from the pyramids of Giza, and it was the name for 'east' that was so intimately involved in the spelling of the name for Yabu. It seems reasonable to assume that the later Theban priesthood knew that this symbology for east and west was important, and so they simply took these glyphs and used them for their temple rituals on the island of Elephantine. Likewise, the 'Two Breasts' were also relocated to Elephantine; but while it may seem more logical to have the source of the Nile in Upper Egypt, it was the pyramids of Giza that 'regulated' the seasons and therefore regulated the Nile floods. It was the two largest pyramids at Giza that were originally the mythical Twin Breasts of Yabu.

But Yabu was not known as *Yabtet*, meaning east; it was known as Yabu the town. Exactly where, then, was Yabu? There was only one town that could claim the title of the 'eastern town' – especially when the context of that 'east' revolved so closely around the pyramids of Giza – and that was Kheraha. The town of Kheraha was known as the 'Babylon of Egypt', and it stood on the east bank of the Nile, opposite the pyramids of Giza.

There is now good evidence that many of the events from Thebes were originally derived from the rituals of Lower Egypt and, more

specifically, from Heliopolis. It was at Heliopolis that the Hyksos/Israelite priests officiated and now we can also see that it was from this very location that the tale of the Nile turning to blood was derived. Now it is perhaps becoming clear why this story became included into the Israelites' history book; as a possible Theban myth it seemed to be completely out of place, but as a story from Heliopolis it is not at all surprising that it was included.

Water

It is always interesting to come across these interesting snippets of information that have been kept so quiet over the years. It must have been so glaringly obvious that this particular Egyptian story of the turning of water into blood was also an event that was included in the Bible; so why does no-one say so? Here we enter, not for the first time, the murky world of biblical censorship.

All those diligent historians and theologians do not really want to alter the status quo: it would affect their own positions within their academic institutions and it would also affect the very religious body through which they have worked their way up. Life is short, so why rock the boat; better to turn the page and find another topic. While I cannot believe this to be a worldwide conspiracy of silence, each and every one of us makes a personal decision whether or not to pursue a topic, and I think the global decision has simply been to turn the page.

This must certainly be true of the next set of quotations, because if one of these does not jump off the page and demand one's attention, nothing will. The first of these small extracts is from the *Instruction of Ankhsheshonq* (a long list of quite intuitive and eminently sensible pearls of social wisdom), again written in the New Kingdom era:

There is no Nubian who leaves his skin. [15]

The biblical version of this same adage reads:

Can the Nubian change his skin, or the leopard his spots? [B16]

The whole point of this small extract, among many others, is that it is a simple adage that would really only pertain to an Egyptian perspective. To the Egyptians, the Nubians were the dark-skinned people and it is to the Nubians that the adage refers. The Bible, however, has picked up these

1. *Origins*

Egyptian influences, and others besides. The next one is particularly interesting:

> I was true of heart, impartial trusted,
> One who walked on the water of god. [17]

The translator then remarks dryly of this sentence that, 'being on someone's water is a frequent metaphor for loyalty'. But, for some reason, the translator didn't dare make the obvious comparison with a well known biblical event:

> And Peter said, Lord ... bid me come unto thee on the water. And (Jesus) said, Come. And when Peter was come down out of the ship, he walked on the water, to go to Jesus. But when he saw the wind boisterous, he was afraid; and beginning to sink, he cried, saying, Lord, save me. And immediately Jesus stretched forth his hand, and caught him, and said unto him, O thou of little faith, wherefore didst thou doubt? [B18]

Jesus was standing on the surface of the water, and Peter wanted to emulate him. This passage is often used as one of the kingpins of the Christian faith; here was direct 'evidence' for both a miracle and the divine nature of Jesus. Yet quite obviously, the whole paragraph is simply an ancient Egyptian metaphor. Walking on water was a metaphor for a test of loyalty and, in the clearest of terms, that is *exactly* what Jesus was doing to Peter – testing his loyalty to believe. No miracles, just parables and metaphor.

Since we are looking at the New Testament, another good example of this reworking of much older Egyptian traditions into the biblical narrative can be seen in a text known as the *Maxims of Ani*. This is a twenty-second dynasty text that appears to have been based on earlier eighteenth dynasty work, which places it in the fourteenth to sixteenth centuries BC. The text discusses the concept of god and his worship, but there is one section that is familiar:

> The sanctuary of god, its abomination is much speaking. Make you your prayers with a heart of love, all the petitions of which are in secret. He will perform your affairs, he will hear what you say ... [19]

The paragraph contains two pieces of valuable advice for the pious reader, to guide them in their relations with the great deity. Firstly, the endless

repetition of a phrase like 'Holy Mary, Mother of God' is not a recommended method of prayer; indeed, this 'much speaking' is regarded as an abomination. Secondly, one should not shout out ones prayers on the street corner for all to hear; they should be made in secret and yet the great deity will still hear them. This may sound like good advice from a wise sage; in fact, it is such good advice that it should, perhaps, be repeated for the benefit of every generation, in every era, and in every land ...

> But when ye pray, use not vain repetitions, as the heathen do: for they think that they shall be heard for their much speaking ... your Father knoweth what things ye have need of, before ye ask him.

> And when thou prayest, thou shalt not be as the hypocrites are: for they love to pray standing in the synagogues and in the corners of the streets, that they may be seen of men ... But thou, when thou prayest, enter into thy closet, and when thou hast shut thy door, pray to thy Father which is in secret. [B20]

The second quotation is from Jesus' *Sermon on the Mount* and, as can be seen, the text is identical to the ancient sentiments of the scribe, Ani. It is often said that 'there is nothing new under the Sun' and clearly these same pearls of wisdom have been doing the rounds of the great temples for millennia. The same Egyptian text continues to mimic Jesus' *Sermon on the Mount* and in this similarity, perhaps the distant origins of what became known as the *Lord's Prayer* can be seen:

Our Father which art in heaven.	The god of this Earth is the ruler of the horizon.
Hallowed be thy name.	The god is for making great his name. Devote yourself to the adoration of his name.
Thy kingdom come.	Give your god existence.
Thy will be done,	He will do thy business.
In earth, as it is in heaven.	His likenesses are upon the Earth.
Give us this day our daily bread.	(God) is given incense and food offerings daily.
And forgive us our debts, as we forgive our debtors.	The god will judge the true and honest.
And lead us not into temptation.	Guard against the things that god abominates.

1. *Origins*

But deliver us from evil:
For thine is the kingdom ,
(you are the king),
the power, and the glory,
For ever and ever.
Amen. [B21]

Preserve me from decay.

(God) is the king of the horizon.
He magnifies whoever magnifies him.
Let tomorrow be as today. [22]

Another intriguing similarity is to be found in the ancient Egyptian perception of how heaven could be reached. Budge makes some interesting observations in this regard:

> The idea of the means to be employed for reaching the heaven of the Egyptians was as primitive as that of the heaven itself, for the Egyptians thought that they could climb onto the iron floor of heaven by going to the mountains, the tops of which it touched in some places. At a later period it was thought that a ladder was necessary ... and in many tombs models of ladders were placed so that the deceased might make use of them at the proper time. [23]

The concept of climbing to heaven may appear to be a little primitive to the modern perception, but clearly it was not to the early Israelites:

> And (Jacob) dreamed, and behold a ladder set up on the earth, and the top of it reached to heaven: and behold the angels of God ascending and descending on it. [B24]

The tale of Jacob's ladder is so famous that I cannot believe that Budge had not heard of it when he wrote the extract above; but if he *was* aware of the direct similarities between Jacob's ladder and Egyptian theology, it would seem to be unusual for a such pillar of the Victorian establishment to be calling Christianity and Judaism 'primitive' in such strident terms. Indeed, the Jewish concept of heaven will also be shown to be based on these very Egyptian concepts later in this book. All in all, it would appear that many of the biblical events from both the Old and New Testaments are based on ancient Egyptian antecedents, and that this similarity applies to theological concepts, moral adages and even miracles.

If this is so, then perhaps there is another set of biblical miracles that deserve further investigation, so that their true origins can be exposed. Of all the events of the Old Testament, one of the most momentous, and perhaps mysterious, are the plagues on Egypt. They are presented in the Bible as miracles from the hand of a vengeful god, but they are interpreted

1. *Origins*

by the modern liberal clergy as being natural catastrophes, as the concept of an emotional and vengeful god is no longer deemed appropriate to our 'civilized' sentimentalities. So did these plagues really occur? And if so, how do we account for them?

As has already been mentioned, the Nile flowing with blood appears to have been reported by the Egyptians, even if the circumstances by which it occurred still appear to be a little odd; but what of the other plagues? Was there a period of famine and plague in Egypt that can be identified with the biblical accounts? Did great storms cover the Two Lands of Egypt during the period between the Middle and New Kingdoms? An in-depth study of the relevant texts has revealed some very surprising and highly contentious results ...

Chapter II

Plagues

The historical evidence for the biblical plagues has always appeared to be rather scanty, but perhaps that really depends on what we are looking for. We are unlikely, in the extreme, to find an inscription in a temple outlining the supposed seven or ten plagues that hit the people of Egypt, exactly as the Bible narrates them. But a quick look at the type of plagues that are reputed to have been divinely inflicted upon Egypt may give us a clue as to what kinds of events to look for in the historical record.

	Bible	**Josephus**
1.	River to blood	River red
2.	Frogs	Frogs
3.	Lice	Lice
4.	Flies	Pestilential creatures
5.	Cattle died	Boils
6.	Ash	Darkness
7.	Storms, hail, fire, boils	Hail
8.	First-born died	First-born died

Now, apart from the River Nile turning red with blood, a plague that has already been adequately explained, the other disasters appear to be similar to the perennial natural events that strike nations across the globe, calamities that often involve either climate change or human conflict. So are there any ancient historical records that speak of a national calamity hitting Egypt at any time? In fact, there are quite a few; this topic appears to have been a national obsession. Taken at face value, however, some of these texts appear to be just general reports of calamities and they are not

related to the plagues in any way or form; but later on we shall see other events that look suspiciously biblical. A typical example is the catalogue of disasters that is contained in the *Prophesies of Nerferti*. This is a New Kingdom script about Middle Kingdom issues – the 'invasion' of Egypt by Asiatics – but the story is told as if it were a historical prophesy of these events, written back in the Old Kingdom era. It is a long story, so I shall only use selected extracts: [1]

> Lo, the great no longer rule the land.
> What has been made has been unmade.
> The land is quite perished, no remnant is left.
> The land suffers, none care for it.
> The Sun-disk is covered, it shines not for people to see.
> One cannot live when clouds conceal.
> All are numb from a lack of it.

Now this passage could refer to the biblical plague of darkness, with clouds covering the Sun. But it is more likely to have been a metaphor for the suppression of the native Egyptian religion by the Asiatics, who are presumed to have been invading the Nile Delta, and perhaps it is Ra the Sun-god who is being obscured by their new pagan deities. But while the religion of Egypt may have been suppressed under the yoke of these 'invaders', did the Sun really dim as well? Was this obscuring of the real Sun seen as a sign of god's wrath and a divine reason for the 'invasion' by the Asiatic hoards?

> Ra separated himself from mankind.
> If he shines forth then the hour exists.
> No-one knows when midday falls,
> for his shadow cannot be distinguished.
> There is no-one (who is) bright of face when seeing him.
> The eyes are not moist with water,
> when he is in the sky like the Moon.

Here we see that the sundials are obscured and no-one can tell the time. Although this could be another metaphorical lament for the religion of Egypt, the reference to a more mundane activity of not being able to tell the time tends to suggest that the Sun was really obscured. Indeed, the description of seeing a ghostly Sun that looked like the Moon is just what one might expect from the fallout of volcanic eruption, which is the most likely physical cause for the biblical plagues. An eruption of the magnitude

of that which occurred at Thera in the Aegean could easily place dust in the high stratosphere – a ghostly veil which could obscure the Sun for weeks. Perhaps in this case these biblical and Egyptian records are based upon a real event and at some point in time before the New Kingdom, the Sun really did hide from the people of Egypt:

> And the Lord said unto Moses; Stretch out thine hand toward heaven, that there may be darkness over the land of Egypt, even darkness which may be felt. And Moses stretched forth his hand toward heaven; and there was a thick darkness in all the land of Egypt three days.

If the two accounts are talking of the same event then the Egyptian lament for Ra, their lord and provider, may have been based upon a natural calamity. In the eyes of the scribe, the reason for, or perhaps the consequence of, Ra being dimmed in this fashion is as follows:

> A strange bird will breed in the Delta marsh.
> Having made its nest beside the people (Egyptians).
> The people (Egyptians) having let it approach by default.
> Then perish those delightful things,
> The fishpond full of fish eaters.
> Teeming with fish and fowl.
> All happiness is vanished.
> The land is bowed in distress.
> Owing to those feeders.
> Asiatics who roam the land.
> Foes have risen in the east.
> Asiatics have come down to Egypt.

The 'strange bird' breeding in the Delta was, of course, the 'invading' Asiatics. The modern translators of this text have gone along with the text's introduction, which says that these events occurred in the time of the pharaoh Snorferu, who is reputed to have reigned way back in the fourth dynasty. But the text was written in the New Kingdom and the much more recent 'invasion' of Asiatics in the minds of the scribes would have been the 'invasion' of the Hyksos people. As far as we know, up until the New Kingdom era, the Hyksos were the only 'Asiatic immigrants' to become so powerful as to take the kingship from the native Egyptians.

This confusion of the era being reported is possibly explained in terms of the Judaic philosophy of Aggadic Midrash, or the divination of

current events by reading the ancient scripts. It is readings and observations such as these that form the bulk of the Talmud and they are primarily written as contemporary events, based on the ancient scriptures. In the same manner, the Egyptian scribe may well be explaining a current situation in terms of the events that were to be found in their historical annals. Hence, the scribe writes of Snorferu, when the texts actually describe a more recent calamity that occurred in the Hyksos era. The scribe's lament continues:

> I show you the land in turmoil.
> Men will seize weapons of warfare.
> The land will live in uproar.
> Men will make arrows of copper.
> Will crave blood for bread.
> Will laugh aloud at distress.
> None will weep over death.
> I show you the son as an enemy, the brother as a foe.
> A man slaying his father.

Not only have the Asiatics invaded, but now the land is riven with strife and civil war; both sons and brothers are fighting each other. But the question has to be asked: if this were a simple invasion by Asiatics, why are sons and brothers fighting each other? Invasions tend to bind populations together in the common cause, whereas inter-family strife is more likely to be based upon political or religious differences.

The best known and the greatest of all the episodes of civil strife in Egypt has to be the end of the Hyksos period, when there were some fifty-odd years of internal strife and civil war. Despite the subtle kind of evidence above, however, the orthodox texts still tend to blame the Hyksos war on an Asiatic invasion of Egypt.

> The land is shrunk, its rulers many.
> It is bare, the taxes are great.
> The grain is low, the measure is large.
> The weak-armed is strong-armed.
> One salutes him who saluted.
> I show you the undermost uppermost.
> The beggar will gain riches, the great will rob to live.
> Gone from the Earth is the Nome of On (Heliopolis).
> The birthplace of every god.

2. Plagues

Once more, the correlations with the Hyksos period are stark and obvious. Although Egypt was probably divided during the seventh to tenth dynasties, the much later fifteenth to sixteenth dynasties of the Hyksos period mark the most infamous era when the Two Lands of Egypt were split between two pharaohs – one Hyksos and one Theban. The text talks of taxes, and the fact that the northern Hyksos pharaohs demanded tributes or taxes from cities that would have liked to have been loyal to Thebes is well known.

Then there is the reference to the turning of social tables and classes, which is a common result of a military or political coup. It is well known that the British Raj in India was largely run by people who had attained a rank well beyond their social station or abilities; likewise, much of the dirty work of the German Third Reich was performed by petty lower-class thugs who were given the chance to get their own back on their perceived symbols of upper-class authority, the Jews.

Lastly, the central location of all this strife in Egypt is given to us, the city of On, the biblical name for Heliopolis. Significantly, the text says that On has 'gone from the earth'. This was not a literal event, of course; instead, it probably means that Heliopolis has been taken over by the Hyksos and that the people of Thebes can no longer travel there. Once more, all these events seem to radiate out from Heliopolis, the central temple of both the Israelites and the Hyksos people.

> Then a king will come from the south.
> Ameny, the justified, my name.
> Son of a woman of Ta-Seti, child of Upper Egypt.
> He will take the white crown.
> He will wear the red crown.
> He will join the Two Mighty Ones.
> He will please the Two Lords with what they wish.
> The field circler in his fist, oar in his grasp.
> Rejoice O people of his time.

The orthodox interpretation of the pharaoh Ameny, who united the Two Lands of Egypt after the chaos and turmoil of the Asiatic invasion, is that this was Amenemhet I. It is true that Amenemhet I did indeed achieve some consolidation of the Two Lands at the conclusion of the troubles during the First Intermediate Period, but the most famous of all the uniting monarchs in Egypt has to be Ahmose I, who overthrew the Hyksos rulers in Lower Egypt and ejected them from the country in the great exodus. So to which era was this passage referring, Amenemhet I and the twelfth dynasty, or Ahmose I and the eighteenth? Perhaps another scribe can assist us.

2. Plagues

The next Egyptian text to chronicle a period of chaos in Egypt is the *Admonitions of Ipuwer*. It is a long story that closely parallels the *Prophesies of Nerferti* that we have just looked at. Once more, the tale is a lament on the fate of Egypt and this is such a common theme in these texts that one begins to sense the depth of the social scars that this turmoil caused. This event was for ancient Egypt as the civil wars were for England or America. The campaigns of Cromwell have largely subsided into history in recent years, but the effects of the American Civil War are celebrated and rumble on to this day.

Should an American state still be allowed to fly the Confederate flag? Viewed from afar, such arguments appear to be trivia, but the depth of feeling and the passion that surround such issues underline the dreadful reality of civil wars. The question of the Confederate flag is still a topic of national debate in America, despite the passing of the centuries. The Egyptian civil war against the Hyksos must have aroused similar passions and the *Admonitions of Ipuwer* once more laments the 'Asiatics' that now control the Delta lands and the social disruption that this has caused. Dated from the Middle Kingdom, the text has been described as a 'literary inspiration'; in other words, it has been dismissed as nothing more than a fable. I find this curious, for the text once more echoes the whole Hyksos/ Israelite occupation of Lower Egypt during the fifteenth to sixteenth dynasties. Again, the text is long and repetitive, so selected texts are taken for illustration: [3]

> The birds ... are lined up for battle.
> The Delta dwellers carry shields.
> A man regards his son as an enemy.
> Foreigners have become people (Egyptians) everywhere.
> Lo, the face is pale.
> A man goes to plough with his shield.
> Crime is everywhere, the robber is everywhere.
> Hapy (the Nile) floods and none plough for him.
> Poor men have become men of wealth.
> He who could not afford sandals are men of wealth.
> There's blood everywhere, no shortage of dead.
> Lo, the dead are buried in the river.
> The stream is the grave, the grave a stream (of blood?).

The lament is quite obviously another version of the *Prophesies of Nerferti* and once more it is obviously being written from the Theban point of view. The birds being mentioned are the Asiatics who have taken over the Delta

region; the pale face is that of the god Ra who no longer shines favourably upon the people; and it would seem that the lower castes have become rulers once more.

Clearly, this was a famous piece of literature in ancient Egypt and it must have been copied and re-copied throughout their long history; but should it be dismissed so lightly as being a 'literary inspiration' with little or no historical content? Much of the text may be fictional, but equally, many of the great fictional literary works from the modern era use similar momentous events in history as a dramatic backdrop for their unfolding drama. Titles like *Gone with the Wind* or *Doctor Zhivago* may be great fictional works, but in many respects they are great historical documentaries of troubled times too. The fictional-cum-historical drama is a tried and trusted formula throughout history.

So perhaps, if we look a little deeper into the text, might we find evidence of a biblical/Hyksos exodus?

> Lo, ... storms sweep the land,
> Lo, the river is blood,
> As one drinks of it, one shrinks from people, And thirsts for water,
> Gold is lacking, exhausted are materials for every craft,
> What belongs to the palace has been stripped,
> Lo, Yabu, towns are not taxed because of strife,
> Lo, trees are felled, branches stripped,
> See how fire has leaped high,

Now we can see some more interesting details, great storms, fire, trees felled and rivers of blood are all beginning to sound distinctly biblical. Here, in a few short sentences, are four of the events described in the biblical plagues. The lack of gold and materials is a biblical topic too and this same event is also mentioned on the *Tempest Stele* of Ahmose I; but this is a long topic that will be discussed in the next chapter. Then, we have the mention of Yabu once more, a city that has already been identified with the presence of the Hyksos/Israelites in the Delta region and specifically with the city of Heliopolis.

> Lo, the Private Chamber, its books are stolen,
> The secrets are laid bare,
> Lo, magic spells are divulged,
> Spells are made worthless through their being repeated by people.

Stories of the 'Private Chamber' – the Holy of Holies in the temple – being

2. Plagues

ransacked and the secrets of the priesthood being laid bare are also rather familiar topics. The Egyptian historian Manetho says, of a very similar event, that:

> ... they forced the priests and prophets to slaughter the (sacred) animals and then they turned them out naked ... (they) set villages and cities on fire, not only did they pillage the temples and mutilate the images of the gods, but not content with that, they habitually used the very sanctuaries as kitchens for roasting the venerated sacred animals. J4

Although this is a later Egyptian document, Manetho says that this act was perpetrated by both the Hyksos and the biblical Moses. Clearly Manetho is equating the Hyksos with Moses, who he says was both their priest and leader, and Manetho is also linking the Hyksos with the desecration of Egyptian temples. More and more, this whole episode of chaos in the lands of Egypt appears to resemble a real event; one that is not so much a natural calamity but is, instead, a man-made catastrophe caused by an episode of civil strife that happens to be intimately connected with the Hyksos 'invasion'. So, were these events connected to the biblical plagues?

The deciding factor for me in this matter, was a third lament that was written in a slightly different style, for while it started with a lament, the mood became quite upbeat by the end. More importantly, however, it also included some new elements that could be considered distinctly biblical. This extract is from the *Famine Stele*, and once more it is a much later work that is reported to be of events in the Old Kingdom, and once more it is presumed to be fictional: 5

> In a period of seven years.
> Grain was scant, kernels were dried up.
> Scarce was every kind of food.
> Temples were shut, shrines covered in dust.
> Everyone was in distress.

In a similar fashion, the Bible says that:

> And the seven years of dearth began to come, according as Joseph had said: and the dearth was in all lands ... And when all the land of Egypt was famished, the people cried to Pharaoh for bread. B6

2. Plagues

But the period of seven years of famine is purely symbolic, we know this to be so because there is a similar tale specifying the same span of seven years of famine that can be found in the ancient texts of Sumer. As any number of famines could have effected Egypt during its long history, this in itself is not much use as evidence. But the text continues:

> There is a town in the midst of the deep.
> Surrounded by Hapy (Nile), Yabu by name.
> It is the <u>first of the first</u>.
> First Nome to Wawat.
> Earthly <u>elevation</u>, <u>celestial hill</u>.
> Its temple's name is 'Joy of Life'.
> 'Twin Caverns' is the water's name.
> They are the Yabus that nourish all.

So where is this town of Yabu and is this important? The true identification of Yabu is actually central to deciphering all of these events and I have already identified Yabu as being as Kheraha near Giza, but the orthodox translation of the text above once more places it at Elephantine!

Quite obviously, however, the rest of the description in the text should have settled the matter a long time ago; with or without the new translations for the glyphs of 'east' and 'west' in chapter I. The reference to the '<u>first</u> of the first' and the 'earthly <u>elevation</u>' just has to be a reference to the '<u>first elevation</u>', the 'primeval mound'; or the first beginnings of the cosmos in the creation myth of Atum.

The whole of this myth and the worship of Atum revolves around the primeval mound and the Benben stone. The primeval mound was supposed to have been located at Heliopolis; indeed, the Benben stone was supposedly a replica of this primeval mound and this stone was again located in the temple of Heliopolis. This whole myth is intimately linked with Heliopolis, and Atum himself was known as the 'Lord of Heliopolis'. How the translators of this passage can then proceed to say that Yabu refers to Elephantine, I really do not know – or perhaps I do know.

This identification of Yabu with Kheraha, near Heliopolis, may eventually give the ranks in the theological department a few palpitations, because the text of this extract continues into yet choppier theological waters. Firstly, it once more identifies the 'Twin Caverns' – the 'Twin Breasts' that were the source of the Nile – with either Giza or the temple of Heliopolis. Secondly, the declaration in this text is being made by someone with the title:

2. Plagues

The Count, Prince, Governor of the Domains of the South, Chief of the Nubians in Yabu – Mesir.

The translator again dryly annotates the fact that 'the name Mesir (or Mosir) is not Egyptian in origin' and for good measure she adds, 'he may have been a Nubian chief ruling Elephantine'. The image of a Nubian chief ruling some Nubians in Elephantine may sound reasonable, and this is probably another reason for the various translators suspecting that Yabu was in the south of Egypt. Alternatively, this may just be a very simplistic and highly convenient answer to this thorny issue, for it may or may not have escaped the attention of all the translators in the last century that the Hebrew name for Moses was *Moshe* (מֹשֶׁה). But it is not simply a similarity between these names that makes this observation interesting; the evidence is much more compelling than that, for there are some remarkable coincidences to be found here.

The governor in question who has made this declaration, Mosir, was supposed to have been the chief of the Nubians in Yabu. This mention of Nubians just might have been the reason for the translators and compilers being taken completely off track and presuming that Mosir lived in Elephantine and governed the Nubians there: for who on Earth would think that there was a group of Nubians being governed by their own ruler in Heliopolis? But, perhaps due to an over-specialization in their narrow subject or perhaps instead due to a fear of the repercussions, what the Egyptologists have failed to notice is that the biblical Moses was an important Egyptian army commander who was sent to quell the Nubians. More importantly, however, on the condition that the Nubian capital was spared, Moses apparently became betrothed to and married a Nubian princess!

> Tharbis, was the daughter of the king of the Nubians, she happened to see Moses as he led the army near the walls ... she fell deeply in love with (Moses) ... and talked with him about their marriage ... He accepted the offer on condition that she would deliver up the city ... (Moses) gave thanks to god and consummated the marriage. [J7]

Moses was, of course, a prince of the royal court of Egypt himself and, according to Josephus, he was a claimant for the royal throne of Egypt. So, in effect, this marriage seems to have been a typical dynastic alliance between Egypt and Nubia, consummated by the biblical Moses. In this case, it is axiomatic that Moses' new bride, a Nubian princess, would have brought a complete retinue of Nubians with her to Heliopolis, which is

where the biblical texts say that Moses lived. Thus, there was not only a large group of Nubians living in Heliopolis, but the new governor and prince of Nubia, Moses (Mosir), was resident there too!

The Egyptian text refers to the 'Count, Prince, Governor of the Domains of the South, Chief of the Nubians in Yabu – Mosir'. But now it can be seen that Moses was also a royal prince of Egypt; he was a governor of the domains of the south in Nubia; he was chief of the Nubians, who had accompanied his wife back to Egypt; he was married to a Nubian princess; he lived in Yabu [near Heliopolis]; and, lastly, he was called Mosir (Moshe). There is complete agreement on every point between this Egyptian title and that of the biblical Moses, and so quite plainly the text of the *Famine Stele* refers to none other than the biblical Moses!

Having made this amazing connection, perhaps we should investigate this piece of text in more detail. What else was Moses supposed to be doing, according to the Egyptian perspective? The first thing to note, perhaps, is that the author was writing as if he were living in the era of an Old Kingdom king, Djoser; but this is the usual literary device of the historical prophesy – once more, the text itself is certainly much younger than this.

The prince was based in Heliopolis and must therefore have been a Hyksos prince. At the end of the text, the king is seen to be granting property and tax rights to Moses. The translator, Barguet, places these properties in Hermopolis, while Lichtheim says they were in Heliopolis. The Bible says that the pharaoh who Joseph acted as vizier for, got a 20% tax on his properties across all of Egypt; while the pharaoh who Moses served, according to this Egyptian text, only took a 10% tax on Moses' estates. But nevertheless, the properties listed must have made Moses an extravagantly wealthy Egyptian. In addition, he had several native groups as workers, including the 'kiry-workers', smiths, craftsmen, Nubians and the *Apiru*. The text does not exactly say what the Apiru were doing for Moses, but the possible mention of 'Hebrews' in connection with Moses has to be significant.

Conclusion

While these Egyptian laments do seem to be descriptions of real events – namely the occupation of Lower Egypt by the Hyksos peoples – they do not seem to fully support the concept of an invasion of Asiatics from the east, and they do not exactly support the descriptions of the biblical plagues. The bottom line with this enquiry, so far, is that the biblical plagues, far from being a natural event, seem to be wholly due to social conflict.

2. *Plagues*

However, while the Bible is certainly describing a social conflict between the Israelites and the [Theban] Egyptians, it also seems to be hinting at natural disasters, even if this was only something simple like the Sun being dimmed by high stratus clouds. Somewhere out there, there must be an Egyptian reference to a natural catastrophe that was somehow linked to the social upheavals of the Hyksos period. The answer to this thorny problem lies in a little-known text from ancient Egypt – the *Tempest Stele* of Ahmose I.

Chapter III

Tempest

The *Tempest Stele* was erected by the pharaoh Ahmose I at the beginning of the eighteenth dynasty of Egypt, or about 1570 BC. The stele derives its dramatic title from the great storms that it details, which apparently struck Egypt during this pharaoh's reign.

Ahmose I was a Theban pharaoh and, climatically speaking, southern or Upper Egypt can be thought of as being in the midst of the Sahara desert. Although the occasional desert thunderstorm may create a flash flood in this region every few decades or so, the area is otherwise bone dry. Ahmose's account of a raging nationwide tempest of rain, continuing without cessation and being louder than a waterfall at Aswan, can therefore be considered highly unusual in this region.

What is even more unusual about the events detailed on this particular Egyptian stele is that, inserted into the text is not just a paragraph that has biblical connotations, but instead it contains a large biblical quotation! This would not be unduly astonishing if the quote were something trivial or mundane, but it is not. The quote in question actually details the events that led up to the biblical exodus, and also the events that led to the construction of the temple known as the Tabernacle (mishkan משכן), and the Ark of the Covenant (arown bariyth ארון ברית).

The text of the *Tempest Stele* does not appear to be necessarily a quote as such, but rather more likely it seems to be a record of the same events, written from an Egyptian perspective. This alternative view of these events contains some profound implications for both history and theology, as it explains not only why the exodus occurred, but it also confirms, once more, exactly who the Israelites were. The quotation will be discussed in detail later, but for now the question to be answered is:

47

3. Tempest

why did this natural calamity, that is detailed on the *Tempest Stele,* occur?

The scientific paper that I had been sent, and which precipitated this dramatic discovery of the biblical quotes, was by Foster and Ritner of Yale University. [1] They were looking into the similarity between the statements on the *Tempest Stele* and the effects of the volcanic eruption of the island of Thera (Santorini) in the Aegean. Superficially, there do seem to be some great similarities between the two events. The *Tempest Stele* says of this storm:

> ... now then ... the gods declared their discontent. The gods (caused) the sky to come in a tempest of r(ain), with darkness in the western region and the sky being unleashed without [cessation, louder than] the cries of the masses, more powerful than [...], [while the rain raged] on the mountains louder than the noise of the cataract which is at Elephantine. Every house, every quarter that they reached [...] floating on the water like skiffs of papyrus opposite the royal residence for a period of [...] days, while a torch could not be lit in the Two Lands [of Egypt]. Then his Majesty said: 'How much greater this is than the wrath of the great god, than the plans of the gods!' [2]

Heavy rain for days on end, darkness, loud noises and all the lamps extinguished in Egypt; such events could well be associated with the ash fallout from a massive eruption, and we know that the island of Thera did explode violently at around this time.

It has to be borne in mind that the Thera eruption was truly massive. It has been estimated to have been of the same magnitude as the eruptions at Tambora in 1815 and Krakatau in 1883. The Krakatau eruption was located off the coast of Java and yet the atmospheric shock-waves (not the seismic tremors) registered on equipment at Potsdam in Germany. [3] If the Krakatau explosion could be detected at such an enormous range, the Thera eruption must have boomed and reverberated its way across all of Egypt, perhaps even stunning the inhabitants for a few minutes.

Various attempts have been made to date the Thera eruption and they have produced the usual scatter of projected dates, but there is an emerging consensus within the scientific community. Some of the archaeological sites at Akrotiri, on the island of Thera itself, have been carbon dated and these have produced results in the band of 1630-1530 BC. [4] This is quite a wide scatter, but not exceptional for the carbon-14 dating technique (C_{14}). A method that is claimed to have more accuracy is the simple technique of counting tree rings. Dendrochronology, as it is

known, depends on the fact that a poor growing season will produce narrow growth rings. So, a worldwide climatic event like a large volcanic eruption – throwing up millions of tonnes of ash and dust, and thus cooling the atmosphere – will show up in the size of the growth rings. Although the technique cannot prove exactly which event caused each climatic change, it is evident that there *was* a dramatic climatic cooling in the years 1628-1626 BC. Note the claimed accuracy of this technique!

Another method of trying to date the era of the Thera eruption, is the study of ice cores from Greenland. The annual cycle of snowfall in the northern latitudes will produce layers and layers of ice. Eventually, these layers will compact and end up looking rather similar to the tree rings. But, each layer of ice will trap inside it some of the dust and gases from the atmosphere and, from these traces, evidence of climate change can be gleaned. The Dye 3 ice core from Greenland recorded an atmospheric 'event' in 1665-1625 BC. [5] This date is remarkably close to the dendrochronology event, and so one might be legitimately tempted to declare that they were caused by the same climatic episode.

Finally, a study of tsunami deposits in south-western Turkey produced some more C_{14} results. These deposits were linked to the Thera eruption by a layer containing shards of pumice, shown to be of Theran origins, which were overlaying the tsunami deposits. The C_{14} dating of the tsunami deposits, however, yielded dates in the range of 1706-1990 BC. [6]

So, how do we explain these discrepancies? Well, the most accurate dating system, if it can be positively linked to outside events, is dendrochronology. Even when the first radiocarbon dates are included, there still seems to be a reasonable cluster of dates around the 1620s BC. The tsunami deposits have registered earlier dates, and the scientists involved indicate that there could have been contamination of the samples with older material from lower levels in the excavation.

But one thing is absolutely certain: the Thera eruption *did* occur at some point in time. It was also the biggest volcanic eruption in Europe in recorded history; its effects must have been felt around the Mediterranean and recorded somewhere within the tree-ring and ice-core records. Indeed, the Thera eruption was so great that evidence of pumice from it *has* been found in Lower Egypt, which confirms that the Egyptians would have experienced some kind of climatic event at this point in time. [7] Although the date of the Thera eruption has not been precisely established as yet, the favourite date has to be around 1625 BC. If we are to equate this eruption to the stele of Ahmose I, however, there is a small discrepancy in dates of some 70 or 100 years that needs to be explained.

3. Tempest

Looking through the classical Egyptology texts, the chronology of Egypt initially appears to be well known and understood, with the reigns of the pharaohs being given, to the nearest year, all the way back into the Old Kingdom. But, what is not so well known is how rickety this whole chronology sequence really is. The current sequence was built up on the foundations of a few ancient Egyptian king-lists, and these have been added to and deleted from over the years in order to arrive at the sequence of monarchs with which we are now familiar. But this is hardly a precise science.

The following is a list of the numbers of kings in each dynasty, as recorded by two respected authorities:

Dynasty	Oxford History	Wallis Budge
15th and 16th	4	38
17th	9	37
18th	14	18
19th and 20th	19	19 (plus another 8)
21st	7	13 (plus another 6)
22nd	10	13

It may be said that Budge's list is a hundred years out of date, but since no definitive king list has been discovered in Egypt since his time, are we really any the wiser? While there are some areas of good agreement between the two lists, some of the dynasties are extremely different and the situation continues to deteriorate when we proceed back into the Middle Kingdom. Yet, the reign of Ahmose I lies at the very start of the eighteenth dynasty and the exact date of his reign could therefore be greatly affected by the apparent confusion in the chronology below this level in the list.

What has happened, of course, is that during eras of weak rule in Egypt, various principalities decided to have their own ruler and a classic example of this is the Hyksos period itself. Thus, Budge has dutifully recorded every princeling that ruled in the land and many of these would have had concurrent reigns. So, two or more pharaohs may have been recorded in any one era, perhaps doubling the number of monarchs over a particular century. Modern historians will simply say that Budge was inaccurate in his chronicle, but can we be so sure?

The other problem is that while the exact order of the pharaonic reign is highly uncertain, so are their reign lengths. The various historical king lists have attempted to give the reign lengths of each pharaoh but, as may be expected, they in no way agree with each other. Another thorny issue is

the problem of co-regency. It was not unknown, even in times of relative stability, for a son to reign alongside his father, the pharaoh; so, unless the length of co-regency is known, the reign lengths of the monarchs concerned will be completely useless. With Budge recording some 80-odd pharaohs between Ahmose I and the relatively well known Persian era, it doesn't take more than a year or two error in each reign length before an error of centuries can begin to develop.

All in all, it can be said that the precise chronology of Egypt is not fully understood and this is why radiocarbon dating and dendrochronology have become such important archaeological tools. But radiocarbon dating is not *that* accurate either. There are so many variables involved in the technique that the brandishing of a +/- 20-year C_{14} date, as sometimes occurs, is laughable. But as a tool, radiocarbon dating is a valuable addition to our dating systems and it can greatly assist in our understanding. Nevertheless, the chronology of Egypt is still relatively uncertain and, while the reign of Ahmose I is traditionally given as being in the middle 1500s BC, there is still some scatter. For instance, the *Oxford History of Egypt* gives reignal dates for Ahmose I of 1550-1525 BC, while the *Chronicle of the Pharaohs* gives 1570-1546 BC; so here in the standard texts, both recently published, we can already see a twenty-year discrepancy.

So, can we decide on a firm date for the reign of Ahmose I? Bearing in mind the possible inaccuracies of the historical king lists, this may be possible. Note that the C_{14} dating for the Thera eruption, as just mentioned, gave results that are in line with the orthodox reign of Ahmose I; in fact, the C_{14} date range effectively straddles the reign given in the *Chronicle of the Pharaohs*. But, in its turn, this orthodox date for Ahmose I will have been influenced by the very same process; the radiocarbon dating of Egyptian artifacts. Each of these dating methods may well have been influenced by the other.

So is there a positive date here? Did the Thera eruption occur during the classical reign given for Ahmose I? Perhaps, but the most accurate method for dating a volcanic eruption has to be through dendrochronology and ice-core data, and this stubbornly gives a slightly earlier date for the Thera eruption. This evidence seems to take the eruption event away from the reign of Ahmose I, unless of course the radiocarbon dating method is consistently in error and those results are, in turn, affecting both the classical Egyptian chronology dates.

The way to prove that this is happening is to confirm a positive link between the Thera eruption and the reign of Ahmose I, and that is the next task.

3. Tempest

Calamity

If the text of the *Tempest Stele* can be taken at face value, then the storm during the reign of Ahmose I must have been quite dramatic; it was not only worthy of a stele being cut to record these events but, from the meteorological perspective, the description of the storm affecting the whole of Egypt (the Two Lands) is highly unusual. Only something very rare, such as the eruption of Thera, might explain such a widespread storm across all of Egypt. But even so, there still have to be doubts that this could have occurred, for the island of Thera lies some 900 km from Giza and the possibility that the storms generated by the eruption could reach out that far has to be questioned. Although it has to be noted that the modern name for the Egyptian capital, Al Qahira (Cairo), still gives echoes of the Egyptian word *quera,* meaning 'Tempest'.

So, was the inscription on the *Tempest Stele* really a description of the Thera eruption? This is still a distinct possibility and, seemingly as confirmation of this hypothesis, there appear to be other similar, contemporary accounts of this eruption and its effects on Egypt. For these, we have to come back to the now familiar subject of the biblical accounts of the plagues upon Egypt.

These biblical plagues have often been dismissed as being far too late, chronologically speaking, to be the result of the eruption of Thera; but as has already been explained, I believe that the biblical exodus was much earlier than currently thought. In essence, I agree with the first century historian Josephus when he says that the Israelite exodus was, in fact, the exodus of the Hyksos people from Egypt. The Hyksos exodus has been determined as being in the reign of Ahmose I, and the identification of the Hyksos as the Israelites would therefore place the biblical exodus, and its plagues, in exactly the same era as Ahmose I.

We now seem to have a satisfying agreement between these accounts. The Israelites experienced plagues and an exodus; in a similar fashion, the Hyksos certainly had an exodus, but now, according to the *Tempest Stele*, the Hyksos seem to have suffered some plagues too. In addition, the island of Thera is likely to have blown its top at around the same era. The agreement between these three separate pieces of history looks good so far, but it requires more evidence to confirm these assumptions.

The confirmation was not long in coming, for the description given in the biblical-type accounts makes it clear that they can only have been reporting the fallout from a volcanic eruption. Take a look at the following descriptions of the biblical plagues:

3. Tempest

... and the Lord sent thunder and hail, and the fire ran along the ground and the Lord rained hail upon the land of Egypt (such as has not been in Egypt since the foundation thereof until now) ... Take you handfuls of ashes of the furnace, and let Moses sprinkle it toward the heaven ... And it shall become small dust in all the land of Egypt and shall be a boil breaking forth with blains upon man and upon beast throughout all the lands of Egypt. [B8]

... a thick darkness, without the least light, spread itself over the Egyptians; whereby their sight being obstructed, and their breathing hindered by the thickness of the air ... under a terror least they be swallowed up by the dark cloud ... Hail was sent down from heaven, and such hail it was, as the climate of Egypt had never suffered before ... the hail broke down their boughs laden with fruit. [J9]

Thereupon the earthquake felled them, and when morning came they crouched lifeless in their dwellings... [K10]

Breathing hindered by a thick cloud, which caused boils on the skin and fire on the ground – what else are these texts talking about? Significantly, the boils on the skin were caused by Moses *taking ash from a furnace* and *throwing it into the air,* where it *settled as dust across the land* – the implications of how the boils were caused are perfectly obvious, hot ash fallout from a volcanic eruption.* Not only are these biblical accounts very good descriptions of the effects of a volcanic eruption, but readers will have to admit that they also agree quite well with the accounts of great storms inscribed upon the *Tempest Stele.* There is a very satisfying unanimity in these descriptions that deserves further research.

In addition to this, the Bible records that the sea went out in an unusual manner to let the Israelites across, and then rushed back in to consume the Egyptians. It matters not as to whether the Egyptians were really caught out in exactly this fashion; the event may well have simply been used as a propaganda tool. What is important is the description of the unusual movement of the sea. Today, we know that these tidal events are related to an eruption because we now understand the principles of geology very well, but how did the ancient scribes know about these effects some 1,500 years BC? How did they know that (rather counter-intuitively)

* The skin 'burns' or rashes could have been caused by heat, acidity or even shards of silica in the ash fallout; any of these is likely to have been interpreted as 'hot' ash by the scribes.

the sea retreats during a tsunami before advancing once more? It all looks suspiciously like an eyewitness account of these events.

If the additional information from the *Tempest Stele* is included, there are now some new similarities between the texts of the biblical exodus and the parallel history of the Hyksos exodus.

In the following list:
 a. = Items from the various religious texts about the Israelites.
 b. = Items from historical accounts about the Hyksos.

 a. There was a darkness across the land.
 b. There was a darkness across the land.

 a. The darkness lasted for three days.
 b. The darkness lasted for an unknown number of days. (The text was unreadable at this point.)

 a. The people's sight and breathing was obstructed by the 'thick' air.
 b. This account accords well with a volcanic eruption.

 a. Only the Israelites lamps could be lit.
 b. Egyptian lamps could not be lit.

Note the amazing symmetry between the two texts here. The *Tempest Stele* says that the Egyptian's lamps could *not* be lit and in a similar fashion the Bible says that *only* the Israelite's lamps could be lit. It is a small detail, but so peculiar in its nature that it just could not have been invented by chance in two completely different accounts. The two texts have either to be copying each other, or speaking about the same event.

 a. There was a heavy fall of hail and great floods.
 b. There was a heavy storm and great floods.

 a. There were skin burns to the Egyptians.
 b. An ash cloud can be either hot, acidic or full of silica shards; any of these volcanic products are capable of causing skin rashes.

 a. The rashes were caused by Moses throwing hot ash from a furnace into the air.
 b. This account accords rather well with the results to be expected from a volcanic eruption.

3. Tempest

a. The gods were angry.
b. The gods were angry.

a. The people near the king's palace persuaded the pharaoh to get rid of the Israelites.
b. The [bodies?] of the people near the king's palace were floating like papyrus boats on the water.

Plagiarism

More and more, these texts are beginning to look suspiciously alike and this brings us back to the rather interesting translation of the *Tempest Stele*, a few paragraphs of which actually appear to be a direct quotation from the Bible. A section of the text from the stele reads as follows:

> Then his majesty descended to his boat with his council following him, while the crowds on the East and West had hidden faces, for they were naked (without clothes) after the manifestation of god's wrath.

> Then his majesty reached the interior of Thebes, with gold confronting (?) gold for his statue (of god) so that he (Amon-Ra?) received what he desired.

> Then his Majesty began ... to provide them with silver, with gold, with copper, with oil, and of every bolt (of cloth) that could be desired. Then his majesty made himself comfortable inside the palace. [11]

This account consists of five items or incidents in as many sentences:

1. Naked people.
2. Wrath of the gods.
3. Offerings of gold to a statue.
4. Precious materials of gold, silver, copper, oil and cloth provided.
5. Entering a palace.

In the Bible, an exact equivalent of the description above is to be found. During the exodus, the Bible says:

3. Tempest

And when Moses saw that the people were <u>naked</u>; for Aaron had made them naked unto their shame among their enemies.

And Aaron said, Let not the <u>anger of my Lord</u> wax hot: thou knowest the people are set on mischief.

And I said unto them, whosoever hath any <u>gold</u>, let them break it off. So they gave it to me; then I cast it into the fire, and there came out this golden calf (<u>statue</u> of the gods). [B12]

This is the offering which ye shall take of them; <u>gold, silver, and brass</u> (<u>copper</u>). And <u>cloth</u> of blue, and purple, and scarlet, and fine linen ... <u>oil</u> for the light, spices for anointing <u>oil</u> and for sweet incense ... and let them make a [<u>palace</u>] sanctuary that I may dwell among them. [B13]

This account consists of three items or incidents in as many sentences, plus another two in another related chapter on the same topic:

1. Naked people.
2. Wrath of the gods.
3. Offerings of gold to make a statue.
4. Precious materials of gold, silver, brass, oil and cloth provided.
5. Making and entering a palace.

In fact, what we appear to have here is a section of the Bible written upon an Egyptian stele (or vice versa). Even the extract from the *Tempest Stele* describing the pharaoh on a boat and the crowds being to the east and west [banks of the Nile?] is a biblical quote, but this small section will be dealt with later in this chapter. This similarity between these texts would not be so peculiar if they were speaking of something that was common in Egyptian life, but here the text seems to be somewhat obscure – just why were the people naked? Why was the pharaoh relaxing, when his country was supposedly in chaos?

In pure historical terms, one might postulate that the nakedness was a result of poverty, perhaps caused by the people having lost all their possessions in the storm; but when looking at the biblical version of these events, a very different story will shortly emerge. As to the pharaoh relaxing during the chaos, well perhaps there was an unspecified period of time inferred in the text and the pharaoh is relaxing after the chaos had all ended. Again, the biblical texts will indicate that this idea is also false.

The great beauty of this direct correlation between the Bible,

Fig 8. The Tempest Stele. Reproduction with kind permission from; Department d'archeologie, Universite catholique de Louvain, Belgium.

3. Tempest

Egyptian history and the *Tempest Stele*, is that we now have other sources to refer to if the original texts are unintelligible. There are new ways of turning the ancient Egyptian ramblings into meaningful statements – if nothing else, the biblical texts are far more voluminous than their Egyptian equivalents, even if their historical veracity is sometimes doubted by historians.

It may seem odd to say that the context of the stele's text needs to be known in advance, but it is surprising how easily one can be led astray by misplaced perceptions. Ritner and Foster make this very point in their study of the original French translation of these texts. The direct translation of the text indicated that the storm affected the 'Two Lands' of Egypt; but, knowing that desert storms are only ever local events, this nationwide aspect was re-translated as being something more ambiguous – it either occurred 'anywhere' or even just on the 'two banks' of the Nile.

These misplaced perceptions, based on 'common sense', decreed that an Egypt-wide storm was impossible and so the translated text was amended to reflect this. Having corrected this error, however, Ritner then goes on to insert his own mistranslation at a later point in the text. This little, and quite understandable error, nearly covered up the full import of the text completely.

Naked

So why were the people in the *Tempest Stele* text naked? Unfortunately, the Bible is not much help in this regard. It does not explain exactly why the people were naked; it just seems to be a reference to some kind of shame or embarrassment caused by the wrath of the gods. But the Bible is not our only resource in this line of enquiry; so if we now refer to the same events, which were written by the first century historian, Josephus (who quotes from an older source than our current Old Testament), the reason for the people's nakedness becomes readily apparent. It would appear that they were not 'naked' as the Bible says, but 'without clothes', much as the literal translation of the *Tempest Stele* translation implies, and there is a subtle difference between the two explanations.

The missing clothes were not normal garments, but priestly clothes – a priest's stole. These were sacred garments; they were very expensive, richly ornamented and obviously of great importance, as they are described in the minutest of detail in both the Bible and Josephus' *Antiquities*. In fact, the robes were richly ornamented with cosmological imagery, representing the planets, the Earth, the heavens, the stars and the twelve constellations

– a rich tapestry that appears to be much more Egyptian than Israelite in nature. But of course this Egyptian imagery is to be expected; even if the Hyksos/Israelites were immigrants, they had already spent some 200 years in Egypt at the very least and had adopted many of the Egyptian customs. In addition, and contrary to common perceptions, the Israelites were noted for their 'knowledge of celestial science', which was supposed to have originated with Abraham and their Chaldean ancestors.

It would appear that, in priestly terms, the lack of this all-important ceremonial dress was considered being 'naked', and it is *this* image that both of these texts were alluding to. The historian Manetho hinted at exactly this same conclusion. He also said that the [Theban] priests were 'naked' and, in this case, their nakedness was probably caused by their maltreatment at the hands of the Hyksos/Israelites, which rather implies that their robes had actually been stolen:

> ... they forced the priests and prophets to slaughter the (sacred) animals and then they turned them out <u>naked</u> ... It is said that the priest that gave (the Hyksos) a constitution and a code of laws was a native of Heliopolis, named Osarseph after the Heliopolian god Osiris, and that when he went over to this people he changed his name and was called Moses. ᴶ14

This last sentence is not from the Bible: it is an ancient Egyptian record of the Hyksos people and their great exodus. It clearly demonstrates, once more, that the Israelites and the Hyksos were probably one and the same people, and it also confirms that the events recorded on the *Tempest Stele* are inextricably linked to the Hyksos/Israelite exodus.

In all three of these texts, the priests were described as being either naked or without their robes. This is not a question of cherry-picking similar sentences from these copious texts; this is three separate accounts of the same biblical event. In each case, the reference to nakedness appears after the plagues and during an altercation of some kind that took place during the exodus. It is Josephus, however, who clarifies the description by explaining that the priests had taken off their sacred robes.

But why were the priests in the *Tempest Stele*'s account appearing without their ceremonial robes? Was this also due to an altercation of some kind? In the biblical and Josephan texts, the event took place at the foot of Mt Sinai during the exodus, after a great storm that had resulted in the population returning in a state of terror to the old tradition of worshipping a golden calf; which in turn resulted in the anger of the gods. The texts indicate that Moses, who was a priest, also did not wear his ornate priestly

stole – perhaps because he had taken up arms and slaughtered all the bull worshippers. (Moses had been a high-ranking Egyptian army commander.)

Was this the same event that was mentioned on the *Tempest Stele* and in the account of Manetho? Certainly, the Bible and Manetho agree on there being an altercation just before the exodus and evidence will be shown shortly, indicating that this was the same skirmish as the Mt Sinai event; but the fact that the *Tempest Stele* was probably referring to priests without their robes and not to the common people being poor and naked is, in itself, quite illuminating.

When the biblical texts mention the second storm and the golden calf, as just discussed, it looks suspiciously like this is another version of the *Tempest Stele* account and its record of the storms that descended upon Egypt. In its current location in the Bible, therefore, this section appears to be both out of place and also a duplication of material that has already been covered; the plagues had already finished and the Israelites had already left Egypt by this time. But chronological misplacements are by no means rare in the Bible.

The unrelated story of Abraham going to Egypt and meeting the pharaoh, for instance, displays the same problems. The original compilers of the Bible obviously received texts from many different sources, but they had no set order in which to place them – the order they chose for each 'scene' in the 'play' was obviously dictated by maintaining a coherent story-line. Thus, when assembling Genesis and exodus, a few of the scenes can be seen to be out of place and the Abraham scene just mentioned gets no less than three insertions in three completely different places!

The Koran is also a good example of this problem. It would appear that the compilers who put the Koran together did not bother to sort the various texts out at all; so the Koran not only displays exact duplications of material, there is also no chronological order to the chapters whatsoever! It should therefore be borne in mind, as this investigation continues, that this mention in the Bible of 'naked' priests may have actually occurred back in Egypt. Such a scenario would concur with the *Tempest Stele* report of these events.

Tributes

The second reference, in the *Tempest Stele*, to tributes of gold, silver, oil and cloth, also made little sense: were these precious materials supposed to be offerings to the gods? But a gold offering already seems to have been given to the gods, so what was this second offering for? The biblical version

of this text gives us the vital clue to the text's true meaning – the biblical version is not describing an offering to the gods, but the expensive materials that were brought to Moses for the building of the mobile temple known as the Tabernacle, and its accompanying repository, the Ark of the Covenant.

This stupendously extravagant construction was a mobile copy of the standard Egyptian temple, with outer courts, an outer altar, rows of pillars, and an inner Holy of Holies containing the Ark. Once more, the Bible describes this lavishly decorated and very expensive construction in the minutest of detail: it was certainly the centerpiece of Israelite culture, perhaps more so than even the Ark of the Covenant, which eventually resided inside it. Once the Tabernacle had been constructed by the people, Moses made himself comfortable inside the palace [Tabernacle], exactly as the pharaoh does in the *Tempest Stele*.

So, was this a description of exactly the same events in both the Egyptian and the Israelite accounts? Was Ahmose I making a Tabernacle? If this was a description of the same events, however, it might initially seem that Ahmose I would then have to be a pseudonym for Moses! It is highly unlikely that Ahmose I is being confused with Moses, although the name is undeniably similar – Ahmose I was not Hyksos and he did not flee Egypt, thus it is unlikely in the extreme that Ahmose I would have required a mobile temple (as the fleeing Hyksos would have done). As a possible explanation for the similarity between these texts, this has too many problems attached to it and a more plausible explanation is required.

If Ahmose I was not Moses, what other scenarios are there that would make more sense of the two texts? One obvious solution might be that one of the two scribes had simply copied the text from the other; but it is difficult to see why this would have been done if the events being described did not apply to that particular political grouping.

A much more likely scenario is, perhaps, to be glimpsed from the different context of the two texts. If the texts can be understood to be accurate in some detail, it is significant that Ahmose was <u>giving</u> the precious materials of gold, silver, copper, oil and cloth, but Moses was <u>receiving</u> them. Does this small observation make more sense of the two texts? I think it does. The alternative scenario is that there were two sides to everything that was being discussed – two pharaohs, two sets of priests, two parties of advisors and two different perspectives from which the account of these events was eventually written.

What I am saying here is that Ahmose I had actually met his counterpart, the northern Hyksos pharaoh, and the tributes of precious

materials were being passed from the Theban pharaoh to the Hyksos pharaoh. Both sides at this meeting would then have written their own, obviously very similar, account of the proceedings. This does rather infer, of course, that Moses was either the Hyksos pharaoh himself, or more probably, an official high-ranking enough in the Hyksos royal court to accept these extremely valuable tributes. As Moses was, by the admission of the various biblical type texts, brought up in the court of the pharaoh; an Egyptian army commander; a prince of the realm; and also a high priest of Heliopolis, perhaps this elevated rank is not too surprising.

Exodus

A summary of the events leading up to the exodus is perhaps required at this point. We know, from both the historical and biblical records, that the people of Egypt thought that the gods were angry during this period, Both the *Tempest Stele* and the Bible appear to talk of great storms deluging the otherwise arid lands of Egypt.

We also know that there were tensions between the Theban pharaohs and the Hyksos pharaohs, and likewise between the Egyptian pharaoh and the Israelites: both records speak again and again of political or religious tensions between the two parties involved. Furthermore, we know that both the Hyksos and the Israelites were thrown out of Egypt and that both these events involved a battle with the Egyptian army. Finally, both the entire Hyksos and the entire Israelite populations embarked on an exodus towards Palestine – the Egyptian historian Manetho even indicating that the destination of the Hyksos refugees was Jerusalem.

The similarity between these two historical events is perfectly obvious and so it should not be surprising that someone should propose that they are, in reality, one and the same event. But even if they were the same event, what is not quite so certain is whether this exodus was initiated by a simple pitched battle followed by a hasty retreat, or whether there was some kind of treaty signed and a more orderly withdrawal initiated.

The constant biblical dialogue between the Israelites and the Egyptians would tend to infer that there was some form of discussion and possible agreement between the parties, and not just outright conflict. According to the Bible, the Israelites wanted to leave Egypt, but the [Theban] pharaoh [Ahmose I] would not let them go. I think that the Bible is nearly correct in this, except that the true situation was not that the [Theban] pharaoh would not let them go, but that he *would not agree to*

their terms. Thus, the Israelites (Moses) go back to the pharaoh time and time again, asking if pharaoh will agree; he accedes at last, but only after there were a number of national calamities in Egypt, including some deaths among the [Theban] Egyptians.

So was there a negotiation between the parties and an orderly withdrawal? Was there an agreement that allowed the Israelites/Hyksos to leave Egypt on *their* terms, with heads held high and their pockets brimming with gold? The *Tempest Stele* could, just possibly, be recording this when it mentions the bounty of gold, silver, copper, oil and cloth that was being given to some unknown party. The Theban pharaoh, Ahmose I, was clearly *giving* a king's ransom to someone, and in a similar fashion the biblical Moses was clearly *receiving exactly the same items of tribute* from someone. So were these two independent reports of the same event? The third century BC Egyptian historian, Manetho, is often derided as being an unreliable reporter; however, he clearly asserts that the above scenario was historically correct for the Hyksos people and their exodus from Egypt:

> The (Theban) pharaoh attacked the walls (of Avaris) with an army of 480,000 men, and endeavoured to reduce (the Hyksos) to submission by siege. Despairing of achieving his object, he concluded a <u>treaty</u> under which they were all to evacuate Egypt and go whither they would unmolested. Upon these terms no fewer than 240,000 families with their possessions, left Egypt and traversed the deserts to Syria (later explained as being Jerusalem). J15

Clearly, there was an ancient tradition that indicated that the Hyksos concluded a treaty and were possibly bought off by the Theban Egyptians with a large tribute of precious metals and materials, just before their exodus from Egypt. But what of the Israelite traditions? If the Israelites were the Hyksos peoples, as the historian Josephus says, then surely their traditions should say something similar? This is not only sound reasoning, but it also seems to be remarkably accurate. The biblical texts say of this same event:

> Speak now in the ears of the (Israelites), and let every man borrow of his neighbour (the Egyptians) ... jewels of silver and jewels of gold. And the Lord gave the (Israelites) favour in the sight of the Egyptians, so that they 'lent' them such things as they required. And they spoiled the Egyptians. B16

They [the Egyptians] also honoured the Hebrews with gifts; some in

order to get them to depart quickly, and others on account of their neighbourhood and the friendship they had with them. [J17]

Even the Koran, the third of the books to be derived from the Israelite manuscripts, holds a record of the Israelites receiving the wealth of the Egyptians. At precisely this same period in time, just before the biblical exodus, the Koran quotes the Egyptians as saying:

> 'These', they said, 'are but a puny band, who have provoked us much. But we are a numerous army, well prepared.' Thus did We (god) make them (the Egyptians) leave their gardens and their fountains, their treasures and their sumptuous dwellings. Even thus; and to the Israelites We (god) gave those. [K18]

The Israelites, like their alter egos the Hyksos, were apparently given a financial inducement to leave Egypt; and, like the Hyksos, the Israelites also set off on a great exodus across hostile territory towards the city of Jerusalem. How many coincidences do we need before it is recognized that the Hyksos were the Israelites?

If the tributes mentioned in the Bible were really those mentioned on the *Tempest Stele*, then the reparations also seem to have included the expensive materials that were specifically required for the construction of the mobile Egyptian temple – known to Israelite history as the Tabernacle – and also for the construction of the Ark of the Covenant. It seems highly likely, therefore, that the gold, silver, copper, oil and cloth mentioned on the *Tempest Stele*, was being donated to the Hyksos/Israelites by Ahmose I as an inducement for them to leave the country. Any nation as deeply religious as the Hyksos/Israelites would have needed a mobile temple before even contemplating their long journey across the Sinai peninsular.

As the tributes given and received in these two accounts are identical, it would seem likely that these are two descriptions of the same event. But if that is so, then the events described in the Bible as being at the foot of Mt Sinai must have actually occurred on the banks of the Nile, in Egypt. Sound reasoning that will serve to reinforce this notion will be discussed later.

What we seem to have in the *Tempest Stele* is not only an account of the biblical plagues, but also an account of the beginning of the Hyksos/Israelite exodus, and how it was organized and implemented by the two parties involved in the dispute. Although the biblical and the historical accounts of the exodus both hint darkly about a great deal of looting, pillaging and murder of the [Theban] Egyptians by the Israelites/Hyksos, it

can now be seen that these apparently independent Israelite and Egyptian records both strongly allude to a diplomatic agreement between the parties involved; with substantial financial reparations being given to the impending Israelite/Hyksos refugees.

Devastation

Continuing with the text of the *Tempest Stele*, it would appear that there was still a great deal of devastation across the country that had to be cleared up by Ahmose I. But was this clearing up required simply because of the devastation wrought by the savage storms, or was there another reason? The text reads:

> Then his majesty was informed that the tombs had been entered [by water], with the tomb chambers collapsed, the funerary mansions undermined and the pyramids fallen, having been made into rubble. Then his Majesty commanded to restore the temples which had fallen into ruin in this entire land: to refurbish objects in the noble chamber, to mask the secret places, to introduce into their shrines the cult statues which were cast to the ground, to set up the braziers, to erect the offering tables, to establish their bread offerings, to double the income of the personnel, to put the land into its former state. [19]

The text seems to be obvious in its meaning: the damage caused by the great storm had to be repaired. But nevertheless, on reading the passage a second time, not all of it makes sense. All the texts that mention the storm speak of heavy rain and darkness, but perhaps significantly, none of them mention wind of any kind. So how did heavy rain on its own collapse a mighty pyramid? How did heavy rain ruin the temples? How did heavy rain open up the secret places? (The secret place is most probably a reference to the Holy of Holies, deep inside the temple.) How did heavy rain cast the cult statues and offering tables to the ground, or end the custom of bread offerings?

A number of these effects are not exactly the damage one might initially expect from a heavy rainstorm lasting three days. In fact, the entire concept of a 'storm' will be shown to be entirely false in later chapters; the 'storms' were actually a part of the literary subterfuge of the scribes, due in part to the Egyptian preoccupation with the pun. This over-reliance on the literal claims in the *Tempest Stele* is where the logic of Ritner's translation

of the stele may have deceived him. The mid sections of the stele's account appear to detail the effects of a great storm on all of Egypt, possibly caused by the fallout from the eruption of Thera, so it might be reasonable to assume that the end paragraph on the same stele also refers to the same storm and to the damage it had caused.

But what if the subsequent damage to the temples were caused not by the 'storm', but by the political and religious instability that the sudden 'storm' [or dispute] had generated? We have already seen the extent of the confrontation that was simmering in the Two Lands of Egypt, between the Hyksos people and the Theban pharaoh, Ahmose I. We have also seen convincing evidence for a political agreement and an exodus, but was there also a battle between the factions that caused the devastation documented on the stele?

Although it is a radical reappraisal of these texts, this alternative scenario is highly likely to be true. In the paragraph on the previous page the reference to 'water', in brackets, is an addition by Ritner to aid the understanding of the text. But, as has been mentioned earlier in this article, when the exact nature of an ancient text is not known, it is very easy to fall into the trap of interpreting the text according to the little information that is understood. Ritner, therefore, placed the word 'water' right at the top of the text and the effect of this is to colour one's perception of the whole paragraph from then onwards. But if we were to insert the word 'Hyksos' or 'Israelites' into the text in the same position, this totally changes the character of the whole of the paragraph. Read the paragraph again, replacing the word 'water' with 'the Hyksos'.

If the latter interpretation of this passage is true, then the whole paragraph begins to make sense. The Hyksos can enter tombs just as easily as water can; but whilst the Hyksos can also strip the pyramid casings, overturn the cult statues, open up secret places to the public and end the bread offerings with ease, water would find this increasingly difficult. The *Tempest Stele* text is actually alluding to the desecration of the sacred temples throughout [Middle] Egypt by the Hyksos/Israelites.

As already discussed, there were fundamental differences between the theology of the Egyptians and the Hyksos/Israelites and these lay at the root of their animosity towards each other. In the Koran, it was Abraham who was accused of these very same acts of desecration. The Koran says of Abraham that:

He broke them all (their idols) in pieces, except their supreme god, so that they might return to him. 'Who has done this to our deities?' asked some. 'He must surely be a wicked man.' [K20]

3. Tempest

There are clear parallels between this quote and the *Tempest Stele's* account. Given these kind of religious tensions that evidently existed between the two sides in this dispute, could not the sudden 'anger' of the gods, manifesting itself in the Theran ashfall, have pushed one or other of the two sides into violence? The *Tempest Stele*, in its new improved format, certainly seems to indicate that the Egyptian temples were desecrated by the Hyksos/Israelites, but is there any further corroboration to this new understanding? In fact there is, and the *Tempest Stele* shows us that the ancient historian Manetho was correct yet again, when he records that the fleeing Hyksos people:

> ... set villages and cities on fire, not only did they pillage the temples and mutilate the images of the gods, but not content with that, they habitually used the very sanctuaries as kitchens for roasting the venerated sacred animals. [J21]

The testimony of Manetho exactly matches that of the *Tempest Stele*; yet the *Tempest Stele* was not even visible in Manetho's time, as it had been reused as hardcore during the construction of another temple. Thus although these two accounts were written quite independently of each other, they agree remarkably well. As both of these records show, the temples of the Egyptians had been desecrated, the statues mutilated and the sacred sanctuaries (the secret places) had been violated and thrown open for use as kitchens! The similarity between the accounts is uncanny!

Clearly, Manetho knew of all the calamities that befell the temples at the time of the exodus and they were *not* caused by seepage of water; Manetho's increasingly reliable account specifically says that the destruction of the temples was wrought by the Hyksos/Israelites. Manetho's text is a historical record, but if the Hyksos *were* the Israelites, then surely a parallel record of such a dramatic orgy of destruction should occur in the biblical records too. The Bible and Josephus do indeed mention the looting and pillaging by the Israelites/Hyksos, and the accounts infer once more that the events that are said to have occurred at the foot of Mt Sinai really happened in Egypt.

Josephus says of this slaughter of the Egyptians *before* the exodus:

> ... for the destruction of the first-born came upon the Egyptians that night, so that many of the Egyptians who lived near the palace, persuaded pharaoh to let the Hebrews go. [J22]

The description here is rather similar to the *Tempest Stele's* account, where

3. Tempest

[bodies] are seen to be floating opposite the royal residence. The Bible backs this up with an identical and more detailed description of the conflict in Egypt, that goes on to say:

> ... and there was a great cry in Egypt; for there was not an (Egyptian) house where there was not one dead. [B23]

The accounts are recording how the Israelites (god) went from house to house at midnight, killing all the Egyptians. The explanation for this slaughter, as given in the Koran and also inferred in the other texts, being that the Egyptians had reneged on the 'agreement' that they had just made – no doubt this was something to do with payment of the tribute and the presumed agreement to leave peaceably. The misplaced biblical paragraph, that seems to record the same murders, says:

> And (Moses) said to them ... put every man his sword by his side and go out from gate to gate throughout the camp, and slay every man his brother, and every man his companion ... and there fell that day about three thousand men. [B24]

Was that going from gate to gate, or door to door? This looks to be another version of the murders that took place in Egypt, especially as it follows the paragraph with the 'naked' people [priests]. Significantly, the Israelites identified themselves during the conflict in Egypt with the symbol of a lamb and, in a similar fashion, those who died in the second encounter were bull worshippers.

This second biblical report, of a slaughter during the early stages of the exodus, occurred at the time the Tabernacle and Ark of the Covenant were being constructed. But it has to be observed that the enormous amount of precious metals and materials required for these projects, and the complexity of the manufacturing required to fabricate them, could not have been achieved in the wastes of the Sinai desert. By necessity, the construction of the Tabernacle and thus, also, the giving and receiving of the tribute, the destruction of the temples, the battles and the looting, must all have occurred in Egypt – just as the *Tempest Stele* seems to indicate.

This theory will be shown to be true in later chapters, but in a rather radical fashion. Instead of just these events occurring in Egypt, I will instead be proposing that the entire location be brought back into Egypt too. The whole of the Mt Sinai and Mt Horeb environs were actually located in Egypt and I will endeavour to convincingly show this to be the case.

3. *Tempest*

Looting

Whilst the biblical texts describe the destruction and looting in some detail, unfortunately they do not mention the desecration of the Egyptian temples to corroborate the *Tempest Stele's* account. Yet there must have been something of this nature in the original manuscripts from which these books were derived, because the Koran – the youngest of the branches to divide from the Jewish stem – has somehow managed to pick up a small sliver of this information and preserved it for posterity:

> Thus was your Lord's gracious word fulfilled for the Israelites, because they had endured with fortitude; and We (god) destroyed the <u>edifices</u> and the <u>towers</u> of the pharaoh and his people. [K25]

It can be seen, once more, that this quotation is an exact copy of the events that were described in the *Tempest Stele.* As both the Koran and the stele say, the Egyptian's <u>edifices</u> (their cult statues) were destroyed (thrown to the ground). But there is another, less obvious, similarity between these texts. The description in the *Tempest Stele*, of the destruction wreaked upon Egypt by the Hyksos, includes the observation that the 'pyramids were fallen'. As I have already indicated, even if there were a thunderstorm, it would be highly unlikely that it could affect the mighty solid stone structure of a pyramid; but here in the Koran we have a much more believable account of what happened to the pyramids.

The Koran says that 'We destroyed the towers of the pharaoh', a sentence which probably needs a little interpretation. The term 'tower' is often used in the biblical texts to describe a pyramid, like the more famous 'Tower of Babel', which was a reference to the brick ziggurats (pyramids) of Babylon. Thus, we have a reference to pyramids being destroyed, but who was responsible for this? The Koran says 'We', meaning 'god', but as will be shown later, both the royal 'We' and the term 'Lord' were often used to describe the presence of a pharaoh. If this is the case, then the text in the Koran is implicitly saying that an Israelite or Hyksos pharaoh was responsible for the 'pyramids falling' or being destroyed.

Here we have yet another confirmation that the destruction of the pyramids and temples, as detailed in the *Tempest Stele*, was caused not by the storms, but by the Israelite/Hyksos people – who were most probably reusing the fine limestone casing blocks on the pyramids for other building projects. Considering the Hyksos' undoubted veneration of the great pyramids of Giza and Dahshur, which will be discussed later, I would propose that if the Hyksos were dismantling any pyramids, then these were

the later, poorly built structures of the pharaohs. As I mention in the book *Thoth*, the Old Kingdom pyramids of Giza and Dahshur were quite different from the later, shoddy constructions.

Stele

The true significance of the *Tempest Stele* is thus much more profound than a simple record of a storm and a few mopping-up operations. The stele, in reality, appears to be an eyewitness account of the fallout of ash from the eruption of Thera, which in turn caused a major political and religious crisis in the land of Egypt. The gods were angry and the people were looking for scapegoats; but the situation did not descend into anarchy straight away. The two pharaohs of Upper and Lower Egypt (the Hyksos pharaoh and the Theban pharaoh) organized a conference to discuss the deteriorating position of the people in the eyes of the gods, who had just rained ash on them for days.

At the conference the two pharaohs met. The *Tempest Stele* records that the crowds [of priests] line up 'to the east and west', having removed their robes. But if there was such a priestly and royal conference between the Hyksos and the Theban Egyptians, and if the biblical account reflects the historical account with such precision, then surely some evidence of it should also appear in the Bible: can the parallel accounts of the Bible and Koran confirm this meeting that was held all that time ago? Indeed they can; but in addition to this, because of the assiduous record keeping of the Israelites/Jews, we also still have the precise minutes of that meeting and, what is more, these records agree precisely with the *Tempest Stele's* account:

> And Moses was 40 years old when he spoke to pharaoh ... and Aaron (brother of Moses) threw down his rod [of authority] before pharaoh ... and it became a serpent. Then the pharaoh called the wise men and sorcerers: now the magicians of Egypt (the priests) and they also did in like manner with their enchantments. [B26]

The texts are difficult to follow here as, once more, it is difficult to place ourselves in the minds of the ancient chroniclers, especially when we lack a full understanding of the events that they were trying to describe. But when looking at the same texts in the Koran, we clearly see that there was a great conference, or competition, between the assembled priests from the two sides in this dispute.

3. Tempest

The sorcerers (Egyptian priests) were gathered on the appointed day, and the people were asked if they had all assembled ... And when the sorcerers came to pharaoh, they said: 'shall we be rewarded if we win?' 'Yes', he replied, 'and you shall become my favoured friends.' K27

Once assembled, the two opposing conclaves then tried to establish which side were the more authoritative in terms of theology (described as magic). Moses says to the Theban pharaoh:

O king, I do not myself despise the wisdom of the Egyptians, but I say that what I do is much superior to what these (priests) do by magic arts and tricks. J28

Of course the quote is not going to be verbatim, but the nature of the dispute between the Israelites/Hyksos and the [Theban] Egyptians is being made perfectly clear. As is often the case in such political disputes, even to this day, 'god' was definitely on 'our' side, and both sides of the dispute would have said exactly the same thing.

The contest was a bizarre affair, which, it has to be admitted, the *Tempest Stele* sheds little new light upon. The Egyptian priests had rods or staffs that became snakes, but Moses also had a rod that became a snake and it swallowed up the Egyptian snakes. Moses then drew out his hand from under his robes and it was inexplicably white in colour. This latter event may be related to Moses trying to prove that it was *he* who had put his hand into a furnace and thrown the hot ash into the air that had fallen on Egypt. This explanation is supported by the Koran, which says that although his hand was white, it was nonetheless unharmed.

Whatever this description of 'magic' was trying to convey, the biblical accounts were unanimous in saying that it impressed the Theban priests – but not the Theban pharaoh. The biblical texts go on to indicate that Moses' magic won the day, a fact which greatly angered the Theban pharaoh. This description has to be treated with some caution, of course, as the biblical propaganda machine would have demanded that they stated this whatever the outcome.

So the three texts – the Bible, Koran and Josephus' *Antiquities* – all say that there was an ancient conference between the priests of the Israelites and the priests of the [Theban] Egyptians. The *Tempest Stele* also indicates that there was a meeting of the priests, who were said to be 'naked', or without their robes. The two groups of priests were standing on the 'East' and 'West' [banks of the Nile], but the stele does not indicate who

the other party was. So how can we be sure that the second group was the Hyksos priests, and even if it was the Hyksos priests, how can we be sure that the historical and biblical accounts are talking about the same meeting? As before, the evidence can be clearly seen in the uncanny similarity between the different texts. The *Tempest Stele* says of this meeting:

> Then his Majesty descended to his boat, with his council following him, while the crowds on the East and the West [banks] had hidden (averted their?) faces, having no clothing on them [no priestly robes] ... [29]

In a remarkably similar vein, the Bible says of this meeting:

> And the Lord said to Moses ... get thee unto pharaoh in the morning; lo, he goes out into the water; and you shall stand by the river's bank for when he comes; ... [B30]

For yet another view of the same event, the Koran says:

> 'Who is the Lord of the Universe?' asked (the Egyptian) Pharaoh. 'He is your Lord', (said) Moses, 'and the Lord of your forefathers.' ... 'The Lord of the East and the West [banks],' said Moses, 'and all that lies between them. If only you could understand!' [K31]

The *Tempest Stele* is describing two groups of priests on the east and west [banks of the Nile], with the Theban pharaoh in a boat on the river. Here, at last, we have three almost identical descriptions of the conference between the two sides in this dispute, 'gathered on the appointed day', as the Koran so succinctly phrases it. They faced each other across the wide grey-green snake of the Nile, like a pair of opposing armies. (And one can imagine that their respective armies were not too far behind, just in case.) In between the two groups, the Theban pharaoh Ahmose I was rowed cautiously to the center of the river for his momentous appointment with his opposite number, the Hyksos pharaoh.

It was the perfect setting for a conference between two bickering leaders and their respective priests and armies. Their representatives probably said to each other, 'You keep your forces to the west bank and I shall keep mine to the east bank. We shall rendezvous at such and such a place and our leaders will meet in the middle of the river.' It was the perfect stand-off, the perfect location for two powerful factions to meet without the threat of immediate combat. As the Koran says of this meeting:

3. Tempest

[Pharaoh said] 'Have you come to drive us from our land with your sorcery, Moses? Know that we will confront you with sorcery as powerful as yours. Appoint a day when both of us can meet, a tryst which neither we nor you shall fail to keep, and a place at an equal distance from both of us.' K32

It is apparent that Moses was not being summoned like a poor slave to meet the Theban pharaoh, as the biblical texts would like us to believe; this was definitely a meeting of equals at a place convenient to both parties. The only detail missing from the story so far is the name of the Hyksos pharaoh who met Ahmose I. In the book *Jesus*, I propose that this was actually the Hyksos Pharaoh Jacobaam – to be equated, perhaps, to the biblical patriarch Jacob.

In the second quote on the previous page, the Bible dramatically confirms, once more, both the setting and the details of the *Tempest Stele*'s account. Moses is detailed by 'god' to wait on the banks of the Nile for the pharaoh to approach in his boat. The details could not be more precise and in agreement with the stele's historical account if they tried.

Here also, is an allusion to the presence of the Hyksos pharaoh. The Bible often confuses the word 'Lord' with an important individual, like a pharaoh; the pharaohs *were* gods themselves, so the confusion is quite understandable. The same is true of the Koran, which uses the pronoun of 'We' for the title of god – indeed, much of the text is written in the first person of 'We'; thus the Koran often reads as if the Israelite/Hyksos pharaoh (We) has written the text himself using the royal 'We'. In the biblical version, it would seem as if the Hyksos pharaoh [the Lord] is telling Moses to stand on the river bank, while perhaps the pharaoh himself takes to the water.

Looking at the third quote, the Koran simply serves to confirm once more, if confirmation were really needed, that all these texts are based on the same events. But the Koran tends to be superbly succinct, if not a little confusing at times, so perhaps an explanation of the sentence is required. The Theban pharaoh was asking Moses who his 'Lord' is, to which Moses replies 'He is your Lord'.

Unfortunately, we are not privileged to know who exactly Moses is referring to by 'He'. The obvious and simplistic theological explanation would be that Moses was referring to 'god' as his 'Lord', but the rest of the text seems to indicate that it was another pharaoh that was being referred to – most probably Moses' Hyksos pharaoh. If so, the rest of the text becomes much more logical and understandable. The dispute between the Hyksos and the Theban Egyptians has already been discussed in some detail, but here is an almost verbatim record of the very nub of the dispute.

3. Tempest

The question asked by the Theban pharaoh was something like, 'Which of these two pharaohs is to be Lord over the Two Lands, Lord over all of Egypt?' Moses replies that his unnamed pharaoh (He) is 'Lord of the east and west, and all that lies in between them'. This was a provocative and treasonous statement to deliver to the Theban pharaoh, if ever there was one. Moses was saying that this unnamed pharaoh was Lord over all the priests that had lined up on the east and west banks of the Nile, and Lord over all that was in between. Quite obviously, the Theban pharaoh was standing in a boat in between the two banks of the Nile, so Moses was saying that his pharaoh was superior not only to the Theban pharaoh's priests but also superior to the Theban pharaoh himself!

The Theban pharaoh then goes on to confirm the supposition that the title 'Lord' refers, in reality, not to a 'god' but to a pharaoh by saying that Moses must be possessed, for *he* as a Theban pharaoh was the only Lord on the Earth. He then goes on to say that if Moses serves any other 'god' but him, he will throw Moses into prison. The Theban pharaoh is clearly calling himself both 'Lord' and 'god', which was quite understandable as all Egyptian pharaohs were seen to be gods.

The sequence of events in both the *Tempest Stele* and the various biblical accounts, including the Koran, is thus identical in just about every respect. In all these accounts, we have a series of natural calamities descending on Egypt, a high-powered conference between the two leaders, an agreement for tribute to be paid, a short conflict, some looting and then eventually an exodus. In addition, the biblical version can also shed some light on some of the other more impenetrable areas of the *Tempest Stele*'s account.

a. In the *Tempest Stele*'s version, it was reported that the Theban pharaoh had 'gold confronting gold', because it was 'desired' for the statue of the gods. The American translators of the stele have placed a question-mark after 'confronting' because the translation makes little sense in its current form and it also leaves out a preposition; it should read as 'the confronting', which makes even less sense. The Egyptian word in question is *hes* or *hesi*, which can mean 'to confront' but it also means 'the enemy showing themselves'.

There are other dubious translations here. For instance, the word for 'desire' is *yabu* and yet this word is actually formed from the same glyphs as the word *Yabu*, the town that has already been discussed at length. Yabu has been, and will again be, firmly linked not only to the town of that name, but also with the Hyksos people themselves, so the precise identity of those who were 'desiring' the gold is being made quite

plain. The Hyksos were probably branded by the Thebans as being unreasonably demanding, and so the town of Yabu became synonymous with 'demands' in much the same manner as the town of 'Avaris' was later turned into a word for 'greedy'.

Another change to this sentence is the beneficiary of this gold. The American translators have presumed that this was a gold offering to the gods and have guessed at Amon-Ra being the recipient, while the French said it was for a male relative. The beneficiary is not explicitly given, but I think myself that the beneficiaries were really the Hyksos. The French translation could still be correct, however, as it is quite possible that Ahmose I was actually related to his Hyksos counterpart. Just like all the squabbling European monarchs of the last millennia or so, who were all close relatives, there could have been any number of strategic marriage alliances between Upper and Lower Egypt.

The original sentence from the *Tempest Stele* read as:

'with gold confronting (?) gold for his statue so that he (Amon-Ra?) received what he desired'.

Taking into account these changes, an alternative translation might well be:

'gold for the enemy, gold [from] the statue so that he [the Hyksos pharaoh] received what he desired'.

One final change that I have made to the text above is that the gold is no longer destined *for* the statue, but *from* it instead. Since this final modification turns the whole meaning of the sentence around, is this justifiable? The preposition 'm' has many meanings in Egyptian, including 'from'; in fact, one of the few terms that is not listed is actually the translator's choice of 'for'. Considering the linguistic ambiguities here, it is impossible to say whether the gold was <u>for</u> or <u>from</u> the statue, but if a tribute was being paid by the Thebans to the Hyksos, then it is safe to conclude that the gold was being stripped <u>from</u> the statue.

This interpretation is confirmed by the *Prophesies of Nerferti* that we looked at in chapter II. This ancient Egyptian text said that:

Lo, ... storms sweep the land.
Lo, the river is blood.
As one drinks of it, one shrinks from people, And thirsts for water.
Gold is lacking, exhausted are materials for every craft.

3. Tempest

What belongs to the palace has been stripped.
Lo, Yabu, towns are not taxed because of strife.
Lo, trees are felled, branches stripped.
See how fire has leaped high.

As already covered, this extract mentions almost all the biblical plagues in just eight short sentences. There is the large storm, the river of blood, the trees felled and branches stripped (by the storm according to the Bible), and finally the fire (running along the ground according to the Bible, but leaping high here). This great similarity between these two texts places this extract as being in the same era as the biblical exodus and talking of the same events.

But there are two other sentences of interest here. The first of these talks of gold being lacking. As stated in the previous chapter, it is quite obvious that this text was written from the Theban perspective, and now we see that the Thebans lacked gold and 'materials for every craft'. The reason for this is now dramatically obvious, for all the precious metals, cloths and oils had just been given in tribute to the Hyksos. The second sentence describes exactly where these materials had come from, they had been 'stripped <u>from</u> the palace'. Here, then, is independent written evidence that my alternative translation of the *Tempest Stele* is based on very secure foundations. The gold was being stripped from the statues in the palace and used to pay the huge tribute demanded by the Hyksos, and this had left Thebes destitute of all her precious materials.

A full translation of the *Tempest Stele* is given in Appendix I, and it contains all the re-translations and new meanings that this novel research has highlighted.

b. The *Tempest Stele* also says that the Egyptians' lamps could not be lit throughout the Two Lands: why was this? Is it possible that the ashfall was *that* heavy that no lamps could be lit inside any houses or palaces? Was every tinderbox in all of Egypt ruined by the dust? While this is possible, there is another, more logical, reason that explains *all* the aspects of this peculiar report. The Bible states that whilst the Egyptians could not light their lamps, the Israelites could!

And Moses stretched forth his hand toward heaven; and there was a thick darkness in all the land of Egypt three days. They saw not one another, neither rose any from his place for three days: but all the children of Israel had light in their dwellings. [B33]

3. Tempest

Is this biblical alternative an accurate account of these events or just the result of biased reporting? I think it is likely that the report *is* accurate, and that the whole of this episode is fully explained by the tributes that were given by the Theban Egyptians to the Israelites/Hyksos. Both the Bible and the *Tempest Stele* report that oil was given in tribute by the Egyptians; but the biblical report, as usual, goes into far more detail. The Bible says that there were two kinds of oil given to them, one was incense and the other was 'oil for the lamps'. Once more it would appear that the Bible holds a very precise record of the events that occurred over 3,500 years ago – the Egyptians could not light a lamp across the whole of the Two Lands because all of their lamp-oil had been given to the Israelites/Hyksos!

This account also infers that the conference and resulting tributes given by the Theban Egyptians was held *before* the arrival of the ash-cloud; by the time that the ash-cloud had arrived, their oil had already been given away and they were left in darkness! But surely the conference was only held because of the calamities that were falling on Egypt, so how could this report be correct?

The Koran is the only account that preserves the real reason for this seeming anomaly. The Koran reports that a large earthquake occurred before the plagues, which were probably caused by the final eruption of Thera. Such an account not only accords well with the physical reality of an eruption, it also accords with the known sequence of the Thera eruption. It is a known fact that there was a large earthquake that destroyed much of the ancient Theran city of Akrotiri *before* the volcanic eruption and subsequent ashfall.

> ... broken staircases, ruined houses and heaps of debris in the excavation of Akrotiri show that earthquakes struck the settlement before it was covered by the masses of ash from the (Thera) eruption. [34]

Once more, the biblical-type texts are surprisingly accurate in their testimony. It would seem that the Egyptian conference was probably held because of the earthquake – as the sequence of this chapter in the Koran directly implies – and the darkness of the ash-cloud only arrived *after* the Egyptian's oil had been given away, but *before* the conference had dispersed. This would also explain why the white hand of Moses was so important; he was probably claiming responsibility for the new calamity that had just arrived over Egypt during the conference.

3. Tempest

Conclusion

The testimony of the *Tempest Stele* and the biblical texts, to there being a conference and treaty between the Hyksos and the Theban Egyptians, fundamentally changes our perspective of both history and religion. All of this new information just serves to confirm that my (and Josephus') original premise is fundamentally on solid ground – that the Israelite kings, who were shepherds in Egypt, were the Hyksos Shepherd Kings *of* Egypt. Everywhere one turns, more and more evidence comes to light that supports this notion – that the Israelites were a substantial nation who ruled the whole of northern Egypt during the fifteenth to seventeenth dynasties of Egypt. The Israelites *were* the Hyksos peoples, a substantially Egyptianized nation who had their own dynasty of pharaohs based in Avaris on the Nile Delta, and worshipped many of the Egyptian gods.

Despite this, there were many fundamental theological differences between the Hyksos and the Theban pharaohs and their people. As I speculated in the book *Jesus*, the Hyksos were probably more cosmological in their beliefs and also worshipped a 'great god' above all the others – much as the historian Josephus describes. The disagreements between the two nations that these differences engendered had festered for decades and it was for this reason that Abraham went down to Egyptian Thebes, to:

> know what they said concerning the gods ... designing to convert them if his own notions proved the truest. [J35]

But the situation came to a climax a few generations later, when it appeared to both sides in this dispute that the gods were very angry with them. The volcanic mount at Thera, in the Aegean, had huffed and puffed throughout history, but on this occasion there was a large earthquake that was felt all across the Mediterranean. A week or more passed; long enough for most of the occupants of Thera to flee their island. Then, with sea water percolating inside the volcano through fresh fissures, the pressures building within the central caldera became too much; there was a succession of cataclysmic blasts which blew the whole island apart and some 30 cubic kilometers of material was blasted into the atmosphere. [36]

This vast plume of ash from the volcano spread out downwind of the blast and much of it drifted across the eastern Mediterranean; mostly over Anatolia, but some also covering Palestine and the Two Lands of Lower and Upper Egypt. If the winds were light, the ash would have taken a day or so to reach Thebes and the sight of its approach, in the normally clear skies

of Upper Egypt especially, would have caused a great foreboding throughout the land.

The effect of this fallout on the god-fearing people of Egypt was traumatic in the extreme. A great darkness descended over the land and it began to 'snow'. Either the acidity or the silica shards in the ash could have caused skin rashes. Crops were spoiled, livestock and people were maimed and killed by breathing in the turbid air, while the thick darkness left the population in terror of their lives.

It must have been a terrible event for a god-fearing nation to witness, but it was by no means a total cataclysm. The Bible specifically says that although the 'storm' destroyed the flax and the barley, the wheat and rye were *not affected*, on account of them being too young. The Bible blames this devastation on the 'storm', but if the 'storm' was a literary pun, as I will show later, then this devastation would have been solely due to the ash-cloud. In fact, the effects of an ashfall on crops may actually be worse than a large hailstorm.

From these biblical reports, it would appear that although the ashfall was frightening, in reality it was not totally devastating. Crops, especially new ones, can easily survive and grow through, say, 10 cm of ashfall. In fact, the geological evidence indicates that just 1 cm or so of ash fell in this region; but this report has to be read with some caution, as the layer of ash is likely to have been greatly compressed over the millennia. Fresh pumice can be as light and as fluffy as fresh snow and it can even float on water. If the subsequent compression of the ash was similar to that of snow, then the original depth of the ashfall may have been in the region of 10-15 cm. [37]

Nevertheless, new crops would have grown vigorously on the fresh and fertile layer of ash; skin rashes would have healed, and the surviving animals would have delivered a new generation of young. Although dramatic, the plagues of Egypt delivered by the Thera eruption were eminently survivable; the problems that the population really faced were not meteorological as such, but theological.

However, the effects of this eruption were still to provoke a major rift between two political and religious groups. That conflict would eventually result in the exodus, but it is at this point that reality begins to separate itself once more from the biblical accounts. The majority of the exodus accounts were real events, but in fact they had nothing to do with the exodus of the Hyksos/Israelites to Jerusalem. As we shall see in later chapters, there was another great 'migration' of people that has become confused with the real exodus, and this event became known as the strange 'wanderings' of the Israelites in Sinai.

Chapter IV

Urim and Thummim

The histories of the Hyksos people and the Israelites now appear to be firmly bonded together; they were the same people. But if this were the case, then surely we should be able to see many more similarities between these two cultures; the Bible should be infused with Egyptian symbolism. Had it not been for the work of later scribes and redactors, I believe it would have been; but, after the trauma of the exodus, an Egyptian heritage was considered to be anathema to the Jews and the texts had to be altered accordingly.

But these manuscripts were supposed to be the written words of god – sacrosanct and inviolable. This caused a problem for the later editors, as they could not radically change the texts unchallenged; thus, the alterations had to be small and subtle, like changing Shepherd Kings into mere pastoral shepherds. For modern researchers, however, these restrictions are a great boon. It means that if one looks through the text and reads it in the light of historical facts, the original meanings can often resurface from the present confused muddle, almost unchanged.

One of these hidden details involves one of the prime symbols of Egyptian kingship – the flail and the shepherd's crook. In the funerary furniture of one of the last of the Amarna pharaohs, Tutankhamen, the crook and flail were portrayed as the central piece of iconography for the departed king; two blue-and-white or blue-and-gold striped rods crossed boldly together over the pharaoh's chest, as though they were warding off intruders and protecting the mummified body concealed within. The real symbology of these two items of royal regalia is rather uncertain, but it appears not to have been one of protection for the deceased. Instead they

are thought to have been symbols of divine power, perhaps allied to vague concepts of magic. In fact, these were probably the symbols of royal office that were used in daily ritual, rather than imagery reserved for the necropolis.

The crook and flail were not only carried by the pharaohs, but also by the gods Min and Osiris. They were used throughout dynastic Egypt but more notably during the New Kingdom era. For these items to be displayed so prominently, they must have been central to Egyptian theology and yet, presumably because the majority of the royal and priestly rituals were arcane and hidden from the population, the meaning of these primary symbols of office seems to have been lost to us. Is there any way in which we can bring back this hidden knowledge; to glance over the shoulder of the High Priest of Heliopolis and see the inscriptions on his secret scrolls?

Perhaps there is a way in which we can divine the past, and this technique centers on the way in which the flail and the crook have been portrayed by the Egyptian artisans over the millennia. Prior to the Middle Kingdom (c. 2000 BC), the imagery displayed is almost without exception of just the flail on its own, draped over the pharaoh's right shoulder. This is plainly evident in the statuette of the pharaoh Khufu, and also in the reliefs of Senusret I. During the Middle Kingdom, the imagery had definitely changed and it is quite evident that the flail and crook were now being shown together. Occasionally, they were shown being held together in one hand, but more often than not they were grasped, one in each hand, and inclined so as to cross over the pharaoh's chest. Almost without exception, the flail is resting on the pharaoh's right shoulder, while the crook lies on the left.

Finally, when we reach the middle of the New Kingdom (c. 1250 BC), the finely carved granite statue of Ramesses II, discovered by Drovetti, portrays just the crook on its own, resting on the pharaoh's right shoulder. Is there one simple explanation that can make any sense of this apparent change in these royal symbols of office? Is there anything that can show us why a flail or crook should be viewed as being a symbol of divine power?

Cattle

I think there is such an explanation, but we have to elevate our gaze to be able to see it. In addition to threshing the corn, the flail was also used in ancient Egypt to gently goad the cattle through the fields whilst ploughing. One imagines that the flail was used with a gentle swaying action against the bull's flanks, as cattle are easily spooked and using the flail like a whip is more likely to propel the startled cow over the distant horizon. This is

exactly what the imagery in the *Book of the Dead* shows, with the flail being wafted over the cow's back. The copy from the tomb of Kerquny from the Ptolemaic era is a good example of this.

Fig 9. Flail as a method of controlling cattle.

But the flail was not just a simple implement for labourers in the fields. Even right back at the very beginning of dynastic Egypt, in the Old Kingdom, the pharaoh Djoser was depicted as running with a flail in his hand during the Sed festival of royal rejuvenation. If nothing else, Egypt was a society of long-lasting traditions, so this same rite survived the passage of numerous centuries to be shown once again, in exactly the same format, with the depiction in the Red Chapel at Karnak of the pharaoh Hatshepsut performing in her Sed festival.

Like Djoser before her, the Egyptian queen was shown to be running between two sets of three markers. The Sed festival is a curious, little-understood event and the classical texts indicate that the pharaoh was symbolically running between boundary markers that may have been

4. Urim and Thummim

indicating and delineating the boundaries of the Two Lands of Egypt. While this is possible, later in this book there will be shown conclusive evidence that the prime ritual in Egypt was actually a procession between Giza and Dahshur. Personally, I think that in reality the markers were actually pyramids, and they were depicted as breasts because this term was a recognized pseudonym for a pyramid. The glyph for a boundary marker has parallel sides and a domed top, like a tombstone, whereas Djoser's markers are most definitely continuously tapered, like breasts.

One argument against this concept might be that the later texts concentrated on just two pairs of pyramids at Giza and Dahshur, imagery which does not equate with the two groups of three markers that are shown in the Sed festival of Djoser. But perhaps the imagery had simply altered over the millennia, for Giza and Dahshur could each be considered to have three main pyramids. While the Giza site can obviously be regarded as a group of three pyramids, the Dahshur site initially appears to have just two. But in fact, the Vega (Bent) Pyramid has a sizeable satellite pyramid, which is often hidden from view behind it.

Leaving aside the nature of the markers, perhaps the Hatshepsut scene can shed more light on the real meaning of this arcane ritual; because here, the queen runs not only with a flail in her hand, but also while chasing a bull. Whether it is a simple farmer in his fields or a divine pharaoh in a great temple, it is quite clear that the flail can be thought of as being a symbol of control over the movement of cattle.

The name given to the flail would tend to support this hypothesis. The Egyptian word for flail is either *ag* or *nekhekh*. The word *ag* probably refers to the threshing type of flail, as the word *agt* refers to grain and *aga* means to strike. The word *nekhekh* means to beat once more, but also to hang and swing, a motion much closer to what I imagine is required to goad a bull into taking the plough. So, does this word have anything to do with cattle? Actually is does, but only if we rather brutally split the word apart and substitute different glyphs for its spelling. These rhyming puns, however, were a common theme in all Egyptian texts, so although this adjustment is more extreme than usual, the alteration is hardly setting a precedent. If we are allowed this indulgence, then the syllable *nek* means 'bull' or 'ox', while *heq* can mean to 'rule', 'control' or 'govern'.

Fig 10. Nek-heq – flail. Control of a bull.

Is this syllable separation valid? Does *nekhekh* really mean 'control of a bull'? I think this is likely, and the reason for this is that the Egyptian word for that other important pharaonic symbol of office, the crook, is also known as *heq* or *hekh*. This word also embodies the same type of symbology as the derivation given for the flail, as it can mean either 'control', as we have just seen, or 'goat' – thus we can derive the meaning 'control of a goat'. Note how the spelling has changed, however, to include the shepherd's crook. Not surprisingly, given the possible meaning of 'control' and 'goat', the word *heq* was also the name given to the Hyksos Shepherd Kings. Although the reason for this title is complicated, as will be discussed later, this is a sure sign that control over sheep was one of the intended meanings of this word.

Fig 11. *Heq – control of a sheep.*

But the question remains as to why this trivial event, of chasing a cow with a flail, should be thought of as being important enough for a pharaoh to perform it in a sacred national festival? Why would a pharaoh wish to be shown chasing a bull? Is this really a simple analogy with agriculture, as the spellings seem to suggest, with control over livestock being equated to control over the people? Initially, this may seem likely and, taking the Sed festival scene at its face value, it would appear that the pharaoh is being depicted as the 'good shepherd', looking after his people with the same tender loving care that a farmer would afford his flock. But if this were the case, why should the symbology change over the centuries from cattle to sheep, with a transition period of both animals being symbolically cared for?

As is often the case, especially with the biblical texts, the initial and obvious link to an agricultural explanation is far too simplistic. Egyptian theology, if anything, was more concerned with astrology and astronomy than agriculture and so, for a more convincing explanation, we must look to the stars and the cosmos. If this same imagery were to be translated instead into astrological terms, then the flail can equally be thought of as being a symbol of control, not over real cattle, but over the celestial movement of the constellation of Taurus. In its turn, the crook can also be seen to be a symbol of control over the movement of the constellation of Aries. Like the crook and the flail, which are often carried together by the

pharaoh, it so happens that Taurus and Aries are also adjacent to each other in the night sky.

More importantly in this explanation, the movement known as precession makes the astrological signs move slowly through the heavens with the passing generations; each sign giving way to the next every two millennia or so. This is a crucial observation, for now we can possibly see why some of the Old Kingdom pharaohs were depicted with only the flail as a symbol of their office; for in that era (c. 3150-1800 BC), the constellation of Taurus alone was dominant in the springtime morning sky and, thus, also dominant in the astrology of Egypt with the veneration of the Apis bull.

From the Second Intermediate period through the Middle Kingdom and beyond (1800 BC onwards), however, there was a change in the night sky. The precessional wobble of the Earth meant that the constellation of Taurus was slowly fading in the east – the reign of Taurus was nearly over. A transition period had arrived, with the constellation of Aries slowly becoming dominant in the heavens and also in the theology of Egypt with the rise to prominence of the Hyksos Shepherd pharaohs.

Thus, we now have a novel and highly plausible explanation for these mysterious symbols of office for the pharaohs of Egypt. The flail and the crook were symbolic of the constellations of Taurus and Aries respectively. Just as the constellations had eventually changed from Taurus to Aries, the symbols of office had likewise changed from flail to crook – with an intermediary period of flail and crook being shown together. There are exceptions to this rule, notably with the flail and crook being displayed together long after the intermediary period had effectively ended, but nevertheless there is a noticeable trend in the iconography that fits the astronomical equivalent uncannily well.

During this intermediate astrological phase, the pharaoh, by crossing these two symbols over his or her chest, was symbolizing the crossing point or the crossover between the constellations of Taurus and Aries. When rising in the east at the vernal or spring equinox, the Sun in this era was sitting in between the two constellations of Taurus and Aries. The pharaoh himself was a manifestation of the Sun-god Ra; thus, by holding these symbols of the heavenly constellations of Taurus and Aries across his chest, the pharaoh was creating a graphic, if covert, representation of the heavens above. The Sun in this New Kingdom era lay at the crossing point between the two constellations and, in the royal imagery, the heart of the pharaoh also lay at the crossing point of the crook and flail.

4. Urim and Thummim

Orion

The iconography that has come down to us from ancient Egypt also indicates that there were special positions for these symbols: the crook is predominantly on the left shoulder of the pharaoh and the flail on the right. Although there are exceptions to the rule, more than 90% of the images seem to place the crook on the left and the flail on the right.

But surely the right-hand side of the pharaoh is likely to be the more important, so shouldn't the new constellation of Aries [the crook] be on the right-hand side of the king? Greg Taylor, the founder and editor of the influential *Daily Grail* website, may have a possible answer for us here. Greg argued that the pharaoh was not only a representation of the Sun, but – in the standard militaristic imagery of the royal warrior, with his arms and legs outstretched and club at the ready – the pharaoh was also being portrayed in the guise of the constellation of Orion.

In the book *Jesus*, I put forward an argument that indicated that the Gilgamesh epic also showed this precessional change from the constellation of Taurus to the era of Aries. In the Sumerian epic, it was Gilgamesh who was portrayed in the strikingly similar pose of Orion; it was Gilgamesh as Orion who killed the Bull of Heaven [Taurus] and so ushered in the new era of the Sumerian Shepherd Kings [Aries]. If the same kind of imagery was being used in Egypt, then one might presume that the Egyptian pharaoh was equally being shown in the guise of the constellation of Orion, and so helping to guide in the new era of Aries once more.

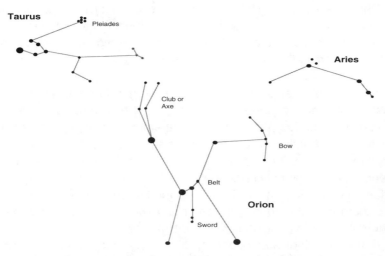

Fig 12. Orion standing between Taurus and Aries.

4. *Urim and Thummim*

Astrological convention dictates that the constellation of Orion faces towards us in the night sky. If we were to move Orion so that it stood between the two competing constellations of Taurus and Aries, like a modern referee standing between two pugilists at the end of a boxing match, then Taurus would be on the right-hand side of Orion and Aries would be on the left. The stellar imagery is now complete; the pharaoh stands with the flail [Taurus] over his right shoulder and the crook [Aries] on his left. In this manifestation, the pharaoh can now be seen to be the referee of the cosmos – supreme arbitrator of the heavens. By his wisdom and power as a celestial god, he is shown guiding the new era of Aries smoothly into place and ensuring that the stars continue in their silent millennial waltz.

Shepherd Kings

It may be surprising to some, but we can also find some strikingly similar representations to the crook and flail in the biblical accounts. As one trawls through the biblical texts, passage after passage seems to reinforce the hypothesis that the patriarchs identified themselves with the same symbology of cattle and sheep – Taurus and Aries – as the pharaohs appear to have been doing with their emphasis on the symbology of the crook and flail. The biblical Joseph calls for his brothers to join him in Egypt, but he has to caution them on one specific subject – cattle and sheep:

> Pharaoh will say to you, 'What is your occupation?' You shall say that your trade has been cattle from our youth until now, both we and also our fathers that you may live in the land of Egypt: for every shepherd is an abomination to the Egyptians. [B1]

Such a statement seems to be rather confusing in terms of the traditional simplistic explanation of agriculture: just why were shepherds an 'abomination' to the Egyptians? But the statement makes a great deal more sense in terms of politics and theology. The pharaoh was not asking about the brother's 'occupation' but rather their 'religion' and thus, their political allegiances. This event occurred in the post-exodus era, so in this case the Egyptians had just fought a civil war with the Hyksos Shepherd people and ejected them from the country in the great exodus, so it is no wonder that 'shepherds' were an abomination to the Egyptians!

If the astrological symbolism of Taurus and Aries was so well established in the biblical texts, what of the crook and flail: were they

represented too? Surprisingly enough, there are some very good candidates for the crook and flail in the biblical accounts; descriptions of some very strange, important and yet unidentified implements that gave Moses great prestige and power over his people. Both Moses and his brother Aaron appear to have been high priests and, when looking at the rather detailed description of the highly ornate and stupendously extravagant priestly vestments of Aaron, several peculiar items are described. Two of the accoutrements accompanying these ornate priestly robes are described as follows:

> And thou shalt put in the breastplate of judgement the Urim and the Thummim: and they shall be upon Aaron's heart. [B2]

The description above of two sacred emblems being placed on the heart of the high priest accords very well with the imagery that has come down to us from ancient Egypt. Aaron was not only a priest but he was also, like Moses, allied to the royal household and possibly even a pharaoh himself. In this case, was Aaron holding the flail and the crook?

Interesting as this all is, the evidence so far for a biblical description of these royal symbols of office is rather flimsy. All we have at present is a vague reference to some strange items being worn on the breast of the priestly robes. So what exactly did the *Urim* (Uwriym אוּרים) and *Thummim* (Tummiym תמים) look like? Were they anything like the crook and the flail of the pharaoh Tutankhamen?

It is clear from the spare rods that were left in Tutankhamen's tomb that not only was the crook painted with stripes, but so too was the handle of the flail. In addition, the cartouche-shaped coffer of Tutankhamen shows that the stripes were not only blue and gold but sometimes blue and white. [3] Were the biblical Urim and Thummim made from striped rods in the same fashion? There is another description in the Bible that may shed some light onto this very question:

> And Jacob took him rods of green poplar and hazel ... and cut white strakes in them, and made the white appear which was in the rods. [B4]

Jacob was the father of the Old Testament Joseph, and here he is described as making rods with white stripes. He then used these striped rods to 'change the spots' of the cattle belonging to Laban, his uncle. Jacob placed these striped rods in front of Laban's pregnant cattle and they gave birth to spotted calves. It was agreed that if any animals in Laban's herds (and flocks) became spotted, then they really belonged to Jacob. But Jacob

was selective in his 'conversion' of these 'cattle'; he only showed the striped rods to the strong 'cattle' and left the weaker ones to Laban. Thus Jacob grew rich and powerful while Laban almost lost his entire inheritance.

Again, it is one of those strange tales from the Bible that makes one wonder if the compilers and scribes of this great tome were in their right minds; quite plainly, the whole incident makes absolutely no sense whatsoever in the agricultural terms in which it has been explained. It does, however, make perfect sense once more in terms of Egyptian politics and theology. The 'cattle' were the Apis bull worshippers of Egypt while, on the other hand, Jacob was quite obviously allied to the Hyksos pharaohs and so preferred the imagery of 'sheep' for his people. The tale is actually one of Jacob making conversions amongst the citizens of Egypt from one political or theological institution to another. Jacob was showing the symbols of office – the striped rods – to the most influential of Laban's followers and so gained their support. Laban was left with the poorer and least influential citizens and so was politically weakened:

> Laban's sons (said) Jacob hath taken away all that was our father's and of that which was our father's hath he gained all this glory. B5

As the texts indicate, the victory had more to do with glory than gaining a few flocks of starving cattle or sheep. The important point, however, is that the possession of some kind of sacred rod with white stripes was deemed to be very important to the leaders of the tribes of Israel. In a similar fashion, Josephus says of these rods:

> (Moses) desired the heads of the tribes to bring their rods, with the names of their tribes inscribed upon them ... These rods Moses laid up in the Tabernacle of God. J6

The rods were being used as the divine symbols through which god would communicate with the tribes and decide which of the tribes would become the custodians of the Israelite priesthood. Apparently, since the rods were made of almond wood, the rod that started to grow almonds would signify the tribe of the priesthood. Rather predictably, knowing Moses' customary sleight of hand, the rod that grew was that of Aaron and Moses, so the Levites became the priesthood and all the other tribes had to give tribute to them. In modern political circles, this type of event is more likely to be known as either nepotism or institutional corruption.

This sacred rod of Aaron was the same rod that Moses had used during the plagues and the beginnings of the exodus. This rod held within it

4. Urim and Thummim

the authority of the Israelite god and so it had the power to become a snake and confound the Egyptian priests; it could inflict the plagues upon the Egyptians; it parted the waters of the Red Sea; it assured a victory against the Amelekites; and it also brought forth water out of the rocks of Mt Sinai. Clearly the rod was deemed to be a powerful symbol of office, and a source of political and physical power to be wielded by the Israelite priesthood.

It is clear from other texts that there was not just one type of sacred rod, but two. The following is a very famous quotation from the Bible and it shows once more the divine power of these two types of rod:

> Yea, though I walk through the valley of the shadow of death, I will fear no evil: for thou art with me; thy rod and thy staff they comfort me. [87]

Remember this sentence when the valley of Tura [Tuwa] is discussed later in the book. But does this sentence simply refer to a person being comforted by having two walking sticks, or something more esoteric? The psalm in question actually starts with 'The Lord is my Shepherd, I shall not want', so this sentence is probably better explained by visualizing a pharaoh being comforted by his two royal sceptres, one of which happens to be a shepherd's crook.

The two rods mentioned here were the *shebet* (שׁבט) and the *mishenah* (מִשְׁעֲנָה), the first meaning a sceptre and the second a staff. There are many Egyptian words meaning rod or staff, so it is just as well that some of the following translations from the Hebrew are so precise. The first of these words, *shebet*, translates rather convincingly as *shabdjet* in the Egyptian, meaning staff, rod or walking-stick. The alternative derivations of this word in the Egyptian are not very illuminating; other meanings include watermelon and perhaps a name of Alexandria. *Mishenah,* too, is not a very rewarding term, and so the search had to widen out a little.

The rods of Aaron and Moses were obviously different, as these were known as *matteh* (מטה) and *makkel* (מקל) and these terms *do* have interesting Egyptian antecedents. *Matteh* in the Hebrew means both rod and tribe, which is not too surprising as the rods of the Israelites were each engraved with the names of one of the twelve tribes. The Egyptian equivalent of this word, *mater,* means staff or stick; but the root of this word is from *met* or *metut*, meaning the seed, offspring, descendants or the generations of mankind. That the Hebrew word *matteh* was derived form the equivalent Egyptian word *mater* is therefore conclusively confirmed by this dual usage of the word as both 'stick' and 'tribe'. Furthermore, from the

4. Urim and Thummim

Egyptian perspective, the rod seems to have had definite sexual connotations. It will be shown later that the title of the biblical Joseph has similar sexual overtones and that his role as high priest at Heliopolis involved much of this sexual imagery.

Fig 13. *Mater – rod,* *Met – offspring.*

This match between the two languages is all very interesting, but unless the rod in question looked like a penis, this translation still does not give us any real clue as to what this particular rod looked like. Perhaps the second term will be more fruitful. The other rod of Aaron was called *makkel* in the Hebrew and this word was most probably derived from the Egyptian *makkes*, meaning the sceptre or staff of authority. Here, the meaning of the two rods conforms precisely; both the Israelite version and its Egyptian predecessor were known as 'rods of authority'.

But the Egyptian term *makkes* may also give us a clue as to what these rods looked like, for as well as being a sceptre, the term also inferred the color 'blue'. We know from actual Egyptian artifacts that have been discovered that both the crook and flail were striped in either blue and white or blue and gold, and this coloration is now mirrored by an equivalent word which means the color 'blue'. The fact that the Israelites must have picked up this term and used it for their sacred rods infers that the Israelite sacred rods may also have been the same color.

But we have just seen evidence that these biblical rods were also made with white stripes, so the evidence is pointing towards a blue rod with white stripes. This is a rather provocative but firm indication that the Israelite sceptres and the Egyptian sceptres may have been similar artifacts; they were probably royal symbols of office – the crooks and flails.

Fig 14. *Makkes – sceptre,* *Maker – blue.*

The important symbols of Israelite office, worn across the chest of the Israelite high priest, were known as the Urim and the Thummim. But,

4. Urim and Thummim

another important symbol of Israelite power now seems to consist of blue rods with white stripes, which may have been similar to the Egyptian crook and flail. So, were the prime pharaonic symbols of office in ancient Egypt – the crook and the flail – known as the Urim and Thummim?

Urim

The word *Urim* (Uwriym אוּרִים) in Hebrew means 'light', and the word *Thummim* (Tummiym תֻּמִּים) means perfection. But these are nebulous terms that tell us very little; somehow the real meaning of these implements has been lost to history. It seems incredible that the Bible can record so many little details, but when it comes to some of the central and most important items involved in their religious services, the meaning has been lost.

The words 'light' and 'perfection' obviously mean nothing of significance and if the covert nature of the Bible is anything to go by, then these derivations are probably just convenient puns. The eminent theologian J. B. Smith says of this dearth of data:

> On every side we meet with confessions of ignorance – *'Non constat'* (Kimchi), *'Nescimus'* (Aben-Ezra), *'Difficile est invenire'* (Augustine) – varied only by wild and conflicting conjectures. [8]

Clearly, none of the great authorities in either the Judaic or Christian hierarchy has had a clue about what the Urim and Thummim really were. I tried a few Hebrew puns without success, but, as is usual, the Egyptian dictionary proved to be more fruitful. First, it would be nice to know that the Urim and Thummim were Egyptian artifacts as well as Israelite ones. The obvious start in this exercise would be to look at the Egyptian equivalent for 'light'; a search that was to prove worthwhile. The Egyptian word for light, by some strange coincidence, turns out to be not *Urim*, but *Uin* or *Uhem*.

Fig 15. Uin – 'light', *Uhem – 'blaze'.*

The transliteration was not exactly perfect, but it would seem that, once more, we have direct evidence that the origins of many Hebrew words lie in

the Egyptian language. But does this word also describe the sacred implement that Aaron was supposed to be using? Simply finding 'light' is not much use to us, as it does not confirm either the usage or the design of the implements. The search was another of those blind alleys and this translation is most probably just a pun that has been used by the Israelite scribes as a secondary meaning. Perhaps, instead, the true derivation can be found by simply ploughing through the dictionary and finding a similar phonetic transliteration.

The result was a little surprising, for although there was nothing remotely similar beginning with 'u', there was something rather interesting that began with 'e'. The word in question was (*e*)*rim*, meaning to be 'studded with gold'. The word (*e*)*rimt* was also interesting, meaning 'shoulder' and a similar word (*e*)*remen* meaning 'to carry on the shoulders'. The biblical Urim may, of course, have been rested upon or worn on the shoulders.

Fig 16. (E)rim – studded with gold.

The link between the Egyptian word *erim* and Urim was certainly interesting, but far from conclusive. The only way to make further headway in this search was to take a look at the partner of the Urim, the Thummim.

Thummim

Going through the same sequence once more, the Egyptian word for 'perfection' proved to be a little surprising. Instead of beginning with a 'th', it was listed under 'm'. The reason soon became apparent, however, because the word in question was *men* or *min*. This search appears to have homed in on the suffix of Thummim, and found just the 'mim' syllable. But, as with the Hebrew meaning for Urim, the rather strange meaning of 'perfection' does not really describe the appearance of this artifact in any way. So, the search went back to the listings to hunt for more likely derivations under 't'. The result was, in the circumstances, an extremely suitable word.

The possible match, bearing in mind the artifact we are trying to describe and the possible Egyptian derivation for the word Thummim, is the

Egyptian word *themes* (thumis). This has a few meanings that are all fairly similar, it means to write, to paint, to be striped, the striped rump of an animal.

Fig 17. Thumis – Thummim.

The Hebrew translations for the Urim and Thummim were always likely to be quaint euphemisms, but here, instead, we find a more satisfying answer. While not being wholly conclusive, the Urim and Thummim could be translated from the Egyptian as 'striped with gold'; a phrase that rather perfectly suits the crook and flail emblems of the pharaohs.

But the classical texts on this topic would strongly beg to differ: they say that the Urim and Thummim were two stones that were fastened on the shoulders of the high priest. The reason why this may be a possibility is that the accounts of Josephus may well give us a description of the Urim and Thummim. Although Josephus does not use these terms himself, he does mention these two stones in exactly the same point in the text where the Urim and Thummim should occur. The Bible also describes these stones, but in a different point in the same text.

> And thou shalt take two onyx stones, and grave on them the names of the children of Israel. And thou shalt put the two stones upon the shoulders of the ephod for stones of memorial unto the children of Israel: and Aaron shall bear their names before the Lord upon his two shoulders for a memorial. [B9]

The Bible says the two stones were made of onyx, while Josephus describes them as being sardonyxes and shaped like large 'buttons' on the shoulders of the high priest, much as a modern military commander might wear buttons (pips) as a sign of his rank. Josephus goes on to say that:

> ... the one of (the stones) shined out when god was present ... it was in the nature of a large button on his right shoulder, bright rays darting out thence, and being seen by those that were most remote ... now (this stone) left off shining two hundred years before I composed this book. [J10]

Josephus is indicating that these stones were still extant in his day; that is,

in about AD 75. He mentions that one of the stones shone brilliantly, which could indicate that they had discovered some kind of natural luminous ore. On the other hand, Josephus says that the two stones were actually seen to be representations of the Sun and the Moon; the fact that just one of them was shining could have been an extension of this symbolism, with the bright stone representing the Sun and the duller one, the Moon. This is a topic that will be discussed in detail in later chapters.

This alternative report by Josephus would naturally reduce the likelihood of the Urim and Thummim being the names for the striped crook and flail rods of the pharaohs, but it does not invalidate the idea that these rods – or something very similar – existed within the Israelite hierarchy. This fact that sacred rods were owned by each Israelite tribe is beyond doubt, and it has already been shown that these rods were used in their religious ceremonies and were seen to represent the divine authority of god. So where does the Urim and Thummim theory stand now? There are several possibilities here, any of which could be true at this stage:

a. The Urim and Thummim and the two sardonyxes, mentioned by Josephus and the Bible, are two entirely different items of the priestly regalia.
b. The Urim and Thummim were not rods at all, but were instead the two shoulder stones, as the classical texts maintain.
c. That Josephus is slightly muddled and the two 'stones' are actually the two striped rods.

It is a shame that neither Josephus nor the Bible directly name the two shoulder stones they describe, and it is an equal and opposite shame that the Bible names the Urim and Thummim but does not describe them! Either of these options would have clarified the whole issue; but there *is* some data to go on and there are some similarities between the two texts.

The Bible calls the two shoulder stones 'onyxes', which are black and white striped stones, while Josephus calls them 'sardonyxes' instead, which are brown and white striped stones. The tentative Egyptian translations of the Urim and Thummim, as discussed above, pointed towards these artifacts being gold striped rods, so there is some common ground here; both of these artifacts are possibly striped with gold or brown colors. Could Josephus have been mistaken about the form that these 'stones' took, or were there two different items being described here? A comparison between these two very similar accounts may help decide the matter.

Both of these accounts describe the priest's ornate stole, known as

4. Urim and Thummim

the *Ephod* (Ephod אפד). The Ephod is described as a sleeved jacket with epaulettes on the shoulders, woven with fine coloured linens and embroidered with gold thread. The curious feature about this priestly stole was that the chest area had a rectangular hole in it, which measured one hand span by one hand span. Behind this 'hole' sat the *Essen* (Khoshen חשׁן) or breastplate, which was square, made of (stiffened) cloths and was joined to the stole with rings and ribbons. Nobody today knows what the Ephod and Essen really were or what they really represented, but the Egyptians obviously did because they had the same garment: it was called an *Efodj*.

Fig 18. Efodj – Ephod the garment, Ephod the box.

The *Efodj* obviously means garment in the Egyptian, but as is usual with these derivations that I am describing, this is not just a translation in the dark. In the case of the *Efodj*, this is most certainly so because the same word also mean a 'sarcophagus', a 'rectangular box' or even a 'rectangular recess'. Such a description conforms to the design of the Israelite Ephod so well, with its square recess in the chest area, that this simply has to be the same type of garment.

The biblical texts describe these garments as having lavish terrestrial and cosmological symbology – descriptions which may still be valid in some manner – but now we can also begin to see the fundamental origins of where this design was really derived from. The Ephod and Essen were a symbolic representation of either a sacred chamber or a sarcophagus, and this kind of symbology will become very important in later chapters.

The breastplate is also an Egyptian word, but perhaps it is a surprising one. The route to deriving the origins of this word was a little tortuous, as there has been a little syllable swapping – as was seen in the names of the pharaohs of Egypt in the book *Jesus*. Despite this, the evidence for this being the true translation of *Essen* is quite compelling and the route to this word also gives us further clues to the true nature of the Ephod. The Egyptian word *Efodj* is derived from the root word *fedj* (*fodj*), and this is known with some certainty because these words have similar meanings. *Efodj* has some meanings of squareness, including a 'four-poster bed', but it also means 'the sweat of god'. This may seem like an odd

4. Urim and Thummim

phrase, but it may refer to the anointing oil that was poured upon the head of the high priest Aaron.

The Egyptian words *fedj* and *fedjit* mean disgusting or nauseating and here we can see another Egyptian word that has worked its way into the English lexicon – 'fetid', which was taken from the Latin *fetidus*. Apparently, the Egyptian original does not refer to smells as such, but since *fedj* (*fodj*) also means sweat, body secretions, sweet-smelling ointment and the sweat of the gods, it is obvious that the nausea also had some kind of reference to smells.

The sudden change from the sweet-smelling 'scent of the gods' to a 'fetid nausea' was not, in my estimation, a continuation of the Israelite fascination with dualism. Rather, it is more likely to have been a post-exodus slur, devised by the victorious Theban regime and applied to everything that was Hyksos/Israelite. The simplest way to achieve this demonization and hatred of the despised Hyksos/Israelite regime was to turn all of the words and concepts that were associated with the Hyksos/Israelite occupation into terms of hatred and ridicule, and there will be many more examples of this to come.

But where does this leave the Essen (Khoshen חשֶׁן) breastplate? Well, the word *Essen* is a Greek derivation that is actually taken from the Hebrew word *Khoshen*. While *Khoshen* does not appear to exist directly in the Egyptian lexicon, if the last syllable is reversed we find a much more interesting name, that of *khonesh*. Now if one indulges in too much syllable swapping or rotation, almost any word can be found in a dictionary, but this particular change is not without good reason. The thing is that the word *khonesh* also means a putrid stink. The Theban dislike of the Hyksos/Israelite ceremonial robes was consistent in its abuse, but perhaps the scribe who turned these words into terms of disgust did not know that he would be assisting a researcher to link these words back together some 3,500 years later.

The interesting thing about *khonesh* is not the smell, but the alternative meaning of this word; for this is none other than *Khoneshu* (Khonshu), which is a title of Thoth the Moon god. Josephus confirms the cosmological symbolism of the breastplate (Khonesh – Khonshu), but he says instead that the breastplate was a representation of the Earth. As we shall see, it is more likely that the Moon was the true representation, but don't worry too much at this point in time as to how this Egyptian Moon symbology is connected to the high priest of Israel, as this will be fully explained in the next chapter. For now, it is simply interesting to note that Josephus also said that the two sardonyx shoulder stones were representations of the Sun and the Moon. It would seem that this Moon

symbolism of the shoulder stones was also connected somehow to the Egyptian Moon god Khonshu (Djeheuti or Thoth).

Fig 19. Fedj – disgusting, Khenshu (shu) – a god.

Here we have a strange box residing in the chest of the high priest's robe, which is now identified with the Moon and the Moon-god. Into this container went another twelve semi-precious stones. The Bible says that these stones represented the twelve tribes of Israel, but Josephus indicates that they actually represented the twelve signs of the Zodiac:

> And for the twelve stones, whether we understand them by the months, or whether we understand the same number of the signs of that circle which the Greeks call the Zodiac, we shall not be mistaken in their meaning. [J11]

Since the two stones on the shoulder of the high priest represented the Sun and the Moon, the most probable meaning of the twelve stones is just as Josephus reports – they represented the twelve signs of the Zodiac. The age of the reference texts that Josephus was using to write his *Antiquities* is not given, but he says that he took them from the ruins of the Temple of Jerusalem after the Romans had sacked it in AD 77. If so, his texts were older than any complete Old Testament or Torah that is extant to this day.

If this report that Moses and Aaron were keeping representations of the Zodiac back in the seventeenth century BC is in any way true, then this places the design of the Zodiac back to long before the Greek era in which it is often said to have been invented. Like most things that are supposed to be of Greek origins, the Zodiac was most probably Egyptian in origin.

Zodiac

Now we come back to the two shoulder stones. Both the Bible and the account of Josephus mention these stones, and both indicate that they

were striped onyx-type stones. Each was engraved with the names of the tribes of Israel (six names on each) and they were made in the form of buttons, much as an army commander wears shoulder pips to this day. When one also reads of the 'chains, finely wrought' that connected the shoulder pips to the breastplate, one is again reminded of the golden regalia of the military and their draped bands of filigree.

The sacred rods of the Israelites also had the names of the tribes engraved upon them, so it would appear that both these artifacts may have had very similar symbolism. Josephus has already declared that the symbolism of the stones was connected to the Zodiac, so if the symbolism was intended to be similar, it may well be that the sacred rods and the shoulder stones both have some kind of astrological symbolism.

The twelve sons of Jacob were often depicted as encamped in their tents around the Tabernacle at the base of Mt Sinai. One famous depiction of this scene was by La Fevre de la Boderie, in 1569. The scene was created without a tent for Levi, because the tribe of the Levites had the temple itself for a camp and they were therefore at the center of this Israelite Universe. When this picture was copied by Villalpando in 1605 and the signs of the Zodiac were added to it, the Levites did not get an astrological sign: the spare sign was split between Joseph's sons, Manesseh and Ephraim. The full Zodiac was distributed between the twelve tribes in the following fashion:

Joseph's sons	Gemini and Taurus
Benjamin	Sagittarius
Judah	Leo
Simeon	Pisces
Ruben	Aquarius
Zebulon	Cancer
Isachar	Scorpio
Levi	Priesthood
Dan	Capricorn
Napthali	Virgo
Gad	Aries
Asher	Libra

The importance of this symbolism will only become apparent in later chapters, but what the artists have depicted here is the Tabernacle surrounded by the twelve signs of the Zodiac. Various pieces of the Israelite regalia that were used in the ritual of the Tabernacle were intended to be representations of the Sun, Earth and Moon; in effect, what we have

4. *Urim and Thummim*

in this Israelite encampment is a symbolic Universe, with the twelve constellations 'orbiting' around the Sun, Earth and Moon.

As already explained, the pharaonic symbols of office – the crook and the flail – may have been related to the signs of the Zodiac and, in turn, the names of the tribes of Israel (the constellations of the Zodiac) were also engraved on both the Israelite stones and rods. So, both the stones and the rods were engraved with the Zodiac and both were said to be stripy in appearance. These two types of priestly decoration sound incredibly similar in their symbolism and strikingly similar in their appearance, but which of these is the Urim and Thummim?

Both of the biblical-type texts mention the shoulder stones and both mention the sacred rods. Only the Bible, however, mentions the Urim and Thummim, and it does so in a way that is quite distinct from the descriptions of the two shoulder stones.

> And thou shalt put in the breastplate of judgement the Urim and the Thummim; and they shall be upon Aaron's heart, when he goeth in before the Lord: and Aaron shall bear the judgment of the children of Israel upon his heart before the Lord continually. B12

It is unlikely that the Urim and Thummim were the two shoulder stones, as the theologians suggest. The shoulder stones are only mentioned in the context of being fastened to the shoulders and never in regard to the Khoshen or breastplate. If the Urim and Thummim were really in the breastplate, it is unlikely that they were the crook and flail; but if they were simply 'upon Aaron's heart', then they could easily have been. The final quote, which may or may not serve to clarify this point, is from Josephus:

> There were two sardonyx upon the Ephod at the shoulders, to fasten it in the <u>nature of buttons</u>, having each end running to the <u>sardonyxes of gold</u>, that they might be buttoned to them. J13

It would seem that there were actually two types of sardonyx, one pair being in the form of buttons and the other pair were 'sardonyxes of gold'. Onyx has nothing to do with gold, it is simply a striped stone, so the term 'sardonyx of gold' probably refers to 'stripes of gold'. So was this a reference to the gold filigree that hung from the shoulder stones, or was it a reference to the gold-striped Urim and Thummim, the gold-striped royal symbols of the crook and flail?

4. Urim and Thummim

Ark

The most elaborate of the sacred items to have been built by the Israelites were the Tabernacle (Mishkan מִשְׁכָּן) and the Ark of the Covenant (Arown bariyth אֲרוֹן בְּרִית). The Tabernacle had a multitude of Hebrew names, mostly meaning tent or camp, and I have given *Mishkan* as being the original version.

It may seem surprising, but even the Tabernacle and the Ark of the Covenant appear to have been based on original Egyptian designs. The Tabernacle, the mobile temple of the Israelites, was a simple copy of the Egyptian temple. It had open outer courts, complete with a large altar, an inner cloister, two large pillars and, towards one end, the Holy Place of the priests, containing the Holy of Holies. The Israelites had simply constructed a mobile version of the Egyptian temple and taken it with them on the exodus.

The other artifact that the Israelites carried with them on the exodus – the one that has caused a great deal of fuss over recent years – was the Ark of the Covenant. Note here that the name of Aaron (Aharown אַהֲרוֹן), the brother of Moses and the first priest of Israel, was virtually identical to the Ark (Arown אֲרוֹן) over which he officiated. It is highly likely that one of these two names was derived from the other, as we shall see.

A great deal of hot air has been written about the Ark but, to be honest, I cannot see what all this fuss about. Many pharaohs of Egypt had very similar Arks to the one described in the Bible. The Ark of Tutankhamen, for instance, is sitting in the Egyptian Museum. It is so similar to the description of the biblical Ark, that its image is often used as an illustration of what the Ark looked like; even the detail of the poles running in metal rings is faithfully reproduced. A classic example of this similarity is to be found in the *Hodder Bible Handbook*, which brazenly reproduces an exact image of the Ark of Tutankhamen and labels it as an 'artist's impression of the Ark of the Covenant'.[14] The tradition of the Ark is, therefore, at least as old as the New Kingdom, but in fact it goes back much further than this.

Take a look at any statue of a pharaoh, in virtually any era of Egyptian history, and you will see that he is depicted holding the ends of two poles and striding forwards. The poles are probably such a small detail within the greater composition of the statue that they are probably ignored by most people. But the poles are important, because they demonstrate that the Ark was a very old tradition in Egypt. The poles were, of course, the carrying poles for the Egyptian arks of the gods and clearly, these arks

were important enough pieces of ritual furniture for the pharaoh to be depicted carrying them.

The purpose of the Egyptian ark was twofold. Its most important function was to contain the images of the gods. The images or statuettes of the gods were placed in shrines, which were in turn placed onto boats, and it was originally the boats that had the carrying poles attached to them. This boat imagery is sometimes said to be a copy of the functional transport of the gods, from temple to temple, down the Nile. This is not so. The gods were originally thought to be beings of the starry firmament, and in these ancient beliefs, the gods and the cosmic bodies they represented – the stars and planets – were sailed around the Universe in cosmic boats. In a similar fashion, the earthly representations of the gods were ferried around this earthly representation of the cosmos in small barques.

As a part of these celebrations, the arks were taken down the Nile and also around the cities on their carrying poles, just as Christian reliquaries are transported around Mediterranean cities to this day. It is more than probable that one of the pharaoh's primary duties of office was to carry the ark for a symbolic part of this journey. Hence, all the major items of statuary from pharaonic times depict this important function of the pharaoh holding the two carrying poles.

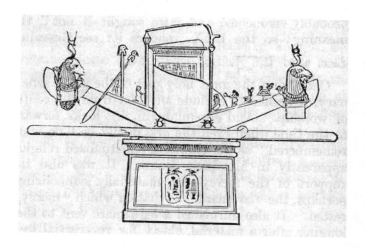

Fig 20. Egyptian Ark and barque/reliquary.

4. Urim and Thummim

The other role of the pharaoh's ark was a personal one. The evidence from the Ark of Tutankhamen indicated that very similar, but less ornate, caskets carried the regalia of the pharaoh and, perhaps, a secret document or two. This was most probably the dual purpose of the Israelite Ark. It was supposed to be the mobile sacred chamber with which to transport the Israelite's god during the exodus, as we shall see in chapter VI; but it may have also carried the wealth, regalia, crown jewels and sacred documents of the Israelites. In this case, the Ark of the Covenant was not only sacred, but also extremely valuable; so it was most probably not the vengeful god that struck the innocent bystander down, but the guardians of this ornate and valuable trunk.

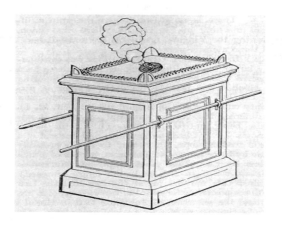

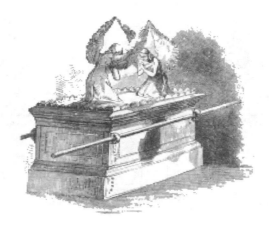

Fig 21. Israelite Arks.

4. Urim and Thummim

Note the small corner pieces on the top of the first Israelite depiction of the Ark in figure 21; these will be discussed in chapter VI. That the Israelite Ark was of Egyptian origin is also implicit by its very construction technique and materials. The following is a description of the Ark from the Bible:

> And thou shalt make staves of shittim wood, and overlay them with gold. And thou shalt put the staves into the rings by the sides of the ark, that the ark may be borne with them. [B15]

The *shittim* wood (shittiym בּׁטׁשׁ) is translated from the Hebrew as being acacia. The precise type of wood used is immaterial in some respects, but the thing to note was that it was called *shittim* and that it was covered in gold. For comparison, the following quote is from the *Tale of the Shipwrecked Sailor*, which is a part of the Westcar Papyrus. This text dates from the Middle Kingdom and it is therefore pre-exodus material.

> After the ships had been moored to the shore, he travelled overland seated in a carrying chair of ebony, the poles of which were made of *ssedjm*-wood plated with gold.

Hold on a minute! Here we have 'ss-m-something' wooden poles plated with gold: is this the same as the construction of the biblical Ark in any way? The application of gold to wood was a well-known craft and practice in ancient Egypt, so perhaps this detail is not too unusual; but what of that wood?

The Egyptian name is *ssendjm*, meaning a very costly, perhaps sweet-smelling, wood. But the thing that caught my eye was the fact that the Egyptian 'd' and the Israelite 't' are often transposed – as in the Egyptian A̱ton changing into the Hebrew A̱dhon. Had this same confusion occurred with these wooden poles, the name *ssedjem* would then be transformed into *ssetchem*. Since the vowels are not explicitly given in Egyptian, the 'e' vowels are a complete guess by the translators: the true pronunciation could just have easily been an 'i'. And that double 's'; does that really infer a long 's' or does it perhaps denote a 'sh'? With the most minor of pronunciation changes – which may well be more correct than the classical interpretation – the odd sounding word *ssedjem* has just been transformed into *ssitchim* or even *shitchim*.

Here we see that the Ark of the Covenant was not only fabricated in Egypt, it was also fabricated according to the Egyptian traditions and materials. The carrying chair of Prince Haredef was constructed using two

4. Urim and Thummim

poles made of shittim wood, covered in gold foil. When it came to the fabrication of the biblical Ark of the Covenant, exactly the same techniques and materials were used. Clearly the traditions and language of Egypt were central to the Israelite's culture.

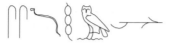

Fig 22. Shittim wood.

If small, insignificant items like the poles of the Ark of the Covenant can be shown to be firmly based in Egyptian culture, then surely the Ark itself may prove to be an even greater prize? The Hebrew name for the Ark of the Covenant (Aaron ארון) literally means 'money-box'. This word was, in turn, derived from the Hebrew root word *arah* (ארה), meaning 'to gather'. Taken at face value, therefore, the Ark was no more than a collection plate or a tax collector's treasure-chest. Indeed, these arks made similar processions around the cities of Egypt, so perhaps one of their prime roles was to collect the temple's taxes or the people's contributions. As one might expect for such an item infused with Egyptian culture, the word *arah* also appears to be Egyptian.

The root of the word for the Ark of the Covenant would seem to be derived from the Egyptian word *ahah* or *aah,* meaning boat, and possibly linked to the word *aah* (*Yah*), the Moon-god, who was in turn associated with Djeheuti or Thoth. As can be seen in the previous diagram, the Egyptian form of the Ark of the Covenant often had a boat associated with it, and the curved hull of the boat takes up the exact shape of the Egyptian hieroglyph for the Moon.

Often, the ark was placed in a real boat and the boat was physically sailed down the Nile. In the annual procession from Karnak, the ark – or the shrine containing the image of the gods – would sail between the temples of Karnak and Thebes. The carrying poles were only required when the boat and ark were brought up onto land and into the temple itself. But this arrangement of boat and shrine made the ensemble rather unwieldy for transportation around the town, so later arks consisted of just the shrine and a much smaller symbolic boat on the top of it. It was probably from this transposition of the original custom that the shrine carried between two carrying poles became to be known as the Ark (Hebrew *Arah*, Egyptian *Ahah*.) Thus, both boat and shrine had now acquired the same name.

4. Urim and Thummim

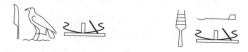

Fig 23. Ahah – boat or Ark.

This dual meaning for the word 'Ark' is still clear, even in modern English. The English word ark means a box, while the similar word barque (bark) means a boat – both of these words being derived from the Latin. In addition, the Ark of the Covenant is referred to by the same word – ark – as the Ark of Noah, which was quite obviously a boat. Thus, the box (chest) and boat terminology are exactly the same in three very different languages – English, Latin and Egyptian. Once more, we see good evidence that the Ark of the Covenant was derived from not only Egyptian customs, but also from the Egyptian language.

But this only serves to give us another interesting little conundrum, because the Ark of Noah has another name in the original Hebrew. The difference is, of course, that the vessel of Noah was not a little boat perched upon a reliquary, but an enormous ocean-going ship. Quite sensibly, the Hebrew scribes gave the Ark of Noah a different name, so it was called a *Tebahu* (תבה) in the Hebrew. Now if you are following this train of thought closely, you might have guessed what is coming next – *tebahu* is another Egyptian word. The ancient Egyptians called vessels the size of the Ark of Noah, *kebahnu* – ocean-going ships.

Fig 24. Kebahnu – ocean-going ships.

The strange thing with this similarity is that, although the Torah consistently uses a different word for the Ark of Noah, somebody still understood that the Ark of the Covenant was also a symbolic boat, and the Latin and English scripts were created or amended to reflect this. Unlike the Hebrew, where different words are used for the Ark of Noah and the Ark of the Covenant, the same name is used in the English whatever the size of the boat. If the Egyptian scribes had used the same custom and called a sacred barque an *Ahah,* no matter what its size, then a sacred vessel like Noah's would also have been an *Ahah.*

4. Urim and Thummim

The funny thing is that this may well be true, and the clue for this came from the eventual resting place of the Ark of Noah – Mt Ararat. The Hebrew name for Ararat is exactly the same as the English – *Ararat* (אררט). But the problem here is that the name for this mountain is presumed to be a 'foreign' word and so nobody really knows either what it means, or where it is located. Because of this lack of information, pilgrims repeatedly trek off towards the mountainous regions of eastern Armenia looking for Mt Ararat.

Again, a lot of hot air has been expended on this topic when the real solution is fairly simple in comparison. The Ark of Noah was probably not called *Kebahnu* in the Egyptian, but *Ahah* instead. *Ahah* means 'boat' and this conveniently appears to be the first syllable in the word *Ararat* [Ahah-att] – the syllables are the same in the Hebrew, too. The next problem was finding out what the second syllable in Ararat means – the 'att'. But the search was certainly worth the time and trouble, for the answer is not just fundamental to the origins of Judaism, but perhaps a little humorous too. In fact, the *Aatt* syllable in *Arar-att* was simply the Giza necropolis!

Fig 25. Aahtt – the Giza necropolis.

It appears that the symbology of the sacred boat of Noah was uniquely linked to the Giza plateau, and with very good reason. The name Ararat was likely to have been derived from the Egyptian words *Ahah* and *Aatt*, which together mean the 'Ship of the Giza necropolis'. Perhaps, now, the reader can begin to see the ironic humour of this translation, for the biblical Ark of Noah was nothing more than a representation of the Egyptian 'Solar-boat', the spiritual ship that sailed the sea of the cosmos; or outer space in modern terminology.

Fig 26. Ahah-aahtt – the Ark on the Giza plateau.

The gods sailed the Universe on great Solar-boats just like Noah's grand vessel and so, like so many things in this particular quest, our modern

terminology has not changed much at all. We do not launch into space riding in a space-plane, as one might expect, but instead we rise up to the stars and planets on a mighty space<u>ship</u>. The Egyptian Solar-boat was just such a fantastic spaceship; it rode the cosmos, carrying the Sun in its perceived 'orbit' around the Earth. But this great task required not one, but two great ships; one was known as *Mandet,* the day barque that travelled the hours of daylight; the other was known as *Mesektet,* the ghostly barque that travelled the underworld and brought the precious Sun back to the eastern horizon each morning. A similar scene was originally carved into the front portico of the Parthenon in Athens, but in this version, divine horses pulled the Sun around its daily orbit.

Amazing as all this may seem, the final result of this long scenario was to be even more devastating for the orthodox creed. It transpires that the Ark of Noah was not some mythical vessel from the unreliable early part of the Bible and Torah; the idle gossip of children and fools. In fact, the Ark of Noah was, and is, a real physical boat! Of course, the voyage of Noah was, in many respects, symbolic; but a real vessel *was* constructed by someone, who may or may not have been called Noah. Indeed, it can also be shown that there was not just one Ark of Noah, but instead two of these great vessels were constructed to re-enact this great death-defying voyage that was recorded in the annals of the Israelites.

If one looks at the account of the flood, the whole symbology of the myth was of dualism, and so there were two of every animal to enter the Ark. In the book *Jesus,* the reason for this symbolism is shown to be based not on simple male and female dualism, but instead, the precessional signs of the Zodiac. The story of the Ark of Noah was based on the precessional era of the constellation of Gemini – the twins – and this was the prime reason for the 'two-by-two' dualism. Following this astrological symbology to its ultimate conclusion, however, if there had to be (symbolically) two of every creature on board, should there not have been two biblical Arks too?

In fact, that is very likely, because it was quite possibly from this very symbolic astrological dualism that the Egyptians claimed there were actually two Solar-boats, not one; and thus, two of these massive cedarwood boats were constructed for ritual entombment on the Giza plateau. The Egyptian word for this kind of ocean-going vessel is *kebahnu,* from which the Hebrew word *Tebahu* was derived. The interesting thing here is that the word I have chosen, *kebahnu,* is the plural form of *keban.* Thus, the form in which the Israelites have copied this word from the Egyptian, and have derived their version of *Tebahu,* is implicitly indicating that there must have been more than one Ark of Noah.

These stories of *Mandet* and *Mesektet* ,and the biblical Ark of Noah,

just have to be a part of the same ancient rituals and myths. As was stated before, the name of Mt Ararat was likely to have been derived from the Egyptian words *Ahah* and *Aatt*, which together mean the 'Ship of the Giza necropolis'. The rather astounding conclusion to this investigation is that these two great Arks of Noah, the two Solar-boats of *Mandet* and *Mesektet*, still lie on the Giza plateau. One of these great vessels still lies inside its limestone tomb, while the other has been reassembled and resides inside a modern concrete structure to the south of the Great Pyramid. These two ancient vessels are, like the biblical narrative says, large enough to be ocean-going ships; they are the *Tebahu* and *Kebahnu,* in the Hebrew and Egyptian languages respectively.

If the reader cares to take a quick flight out to Cairo, they can be rewarded by not only seeing the biblical Mt Ararat [the Giza plateau], but also the actual Arks of Noah that have remained such a biblical conundrum for so long. These ships are not only still extant, but they have also been perfectly preserved in the arid, semi-desert conditions, and in their expertly sealed chambers, they look almost as if they were new. These two great Egyptian vessels are the 'Ships of the Giza necropolis', or in biblical/ Egyptian terms, they are the Ahah-Aatt.

Chest

The words for both of these arks, both the chest and the ship, were derived from the Hebrew word *arah,* which was in turn derived from the Egyptian word *ahah*. But could there have been an alternative Egyptian name that influenced the Latin name for the Ark, the *Arca.* There is such a term and, while it could be considered to be a box or chest, in actual fact it looks quite different. The 'box' in question contained the sacred books of Thoth:

> And (Djedi) knows the number of the secret chambers of the Sanctuary of Thoth. Now the majesty of King Khufu had been spending time searching for the secret chambers of the Sanctuary of Thoth in order to copy them for his (pyramid) ... Said Djedi; Please, I do not know their number, O king. But I know the place where it is ... there is a chest of flint in the building called 'inventory' in Heliopolis. It is in that chest. [16]

The 'Sanctuary of Thoth' is a coded reference to the Great Pyramid at Giza. This odd text may have been indicating that there was a secret chest in Heliopolis that held within it the secrets of the Great Pyramid's upper

chambers – which were still hidden at that time within the massive bulk of this pyramid. The symbolism here is of secrets chests and secret chambers, and all of this has something to do with the Great Pyramid.

There is a distinct possibility, therefore, that the Latin word *Arca* – meaning Ark – could have been derived from this very symbolism. The original name for the Great Pyramid was actually *Aakhut* or *Arkhut,* and the hieroglyphs for this name used the ibis glyph of Djeheuti or Thoth; hence the term 'Sanctuary of Thoth'.

Fig 27. Arkhut – Great Pyramid.

It is through this original name for the Great Pyramid and its secret chambers, that not only was the Latin name for the Ark of the Covenant derived, but also, I believe, much of the central liturgy of the Judaic and Christian Churches. We shall see convincing evidence for this in chapter VI.

Chapter V

Yahweh

It would appear that the long-lost secret code has at last been broken and these most ancient of messages, which have been transmitted across both time and space, can at last be translated into meaningful text. The technique is relatively simple; if a difficulty emerges in a text, look into the original Egyptian pronunciation and meanings, and see what the biblical patriarchs would have seen. The name of Yahweh would prove to be no exception to this.

One of the great unsolved mysteries of Judaism is the tetragrammaton YHWH (יהוה), the sacred and unspeakable name of god. The reason why the name of god was deemed to be so unmentionable is uncertain, but the tradition has been persistent and so we find that Cicero calls the Judaic god the *illud inexprimible*, or 'that inexpressible being'. In a similar fashion, the Greek Hermes is reputed to have called god ανεκλαλητος. αρρητος, σιωπη φωνουμενος: or 'the ineffable, the unspeak-able, and that which is to be pronounced in silence'. The respected theologian Adam Clarke, notes the custom and says of this conundrum, that the Jews:

> ... to a man, the (Jews) all declare that no man can pronounce it; and that the true pronunciation has been lost, at least since the Babylonian captivity; and that God alone knows its true interpretation and pronunciation. This, therefore, is the name which no man knew but (god). [1]

The tetragrammaton consists of the four consonants of the name of the great Judaic deity, but, as is common with many Eastern languages, the vowels in the name are never written and so the exact pronunciation of the

name was, and is, uncertain. This uncertainty was further compounded by the peculiar Judaic insistence on pronouncing the four consonants as *Adhonai* (יאדני), a rendering that is nothing like the spelling of the tetragrammaton. So why was this strange custom adopted?

I would tend to support the assertion of the renowned theological author Ahmed Osman, who proposed that the peculiar pronunciation of *Adhonai* was a compromise between two religious factions in the original Israeli tribes. [2] The rather astute suggestion is that one tribe managed to keep the spelling of their name for god, while another faction kept the pronunciation. Thus, we find the rather odd current situation, where the spelling and pronunciation of the same word are completely different.

Ahmed Osman further asserted that the pronunciation of Adhonai was derived from the Egyptian deity that was promoted by the rebel pharaoh Akhenaton, which was called Aton. This was just one small element in the evidence that Ahmed put together to demonstrate that the pharaoh Akhenaton was, in fact, the biblical Moses. See the book *Jesus* for further details.

The tetragrammaton was originally translated into English as the four-letter name JHVH, giving the King James Bible's version of the name of the Judaic god – Jehovah. In the absence of any other biblical clues to the correct pronunciation, theologians based their research upon a Greek interpretation of the texts, which, in turn, suggested this pronunciation. This translation was later challenged and the current view is that the four letters should instead be YHWH. But what vowels should go with these consonants? Again, there have been many suggestions, but the current consensus is for an 'a' followed by an 'e'; this gives the modern interpretation of the sacred name of god – Yahweh. But this convention is still in dispute and many scholars simply write the four consonants as YHWH; and, seemingly abiding by the long-held Israelite tradition, they will not offer either a pronunciation or a meaning to the name.

So, will we ever know what the name of god really means or how it should be pronounced? I think there is a way to discover the truth, and the solution is to look at the modern form of worship, as it has come down to us through the new offshoots of Judaism – Christianity and Islam.

The first thing to note is that, rather than the name of god being unknowable, this god actually seems to have many known names. Amongst many others, the general terms for god in the Old and New Testaments tend to be written as *Adhonai, El Elyon, Ehyeh, Elohim, Eloi* or *Eli*. Adhon (the singular form of Adhonai), as already stated, was most probably derived from the Egyptian Sun-god Aton. El, or Eli, is likely to have been a derivation of an Ugaritic god of Syria, and must have had Sun-god

Plate 1. The Ark of Tutankhamen; an exact replica of the Ark of the Covenant?

Plate 2. One of Noah's Arks. The Ark of Noah is reputed to have held two of every animal; in keeping with this astrological dualism there were actually two of these Arks constructed, *Mandet* and *Mesektet*. Both of these biblical Arks are still preserved on the Giza plateau.

Plate 3. Aya Sofia, Istanbul. The four pillars that held up the Egyptian concept of the heavens — faithfully copied in early Christian architecture.

Plate 4. Taj Mahal, India. The four pillars that held up the Egyptian concept of the heavens — faithfully copied in later Islamic architecture.

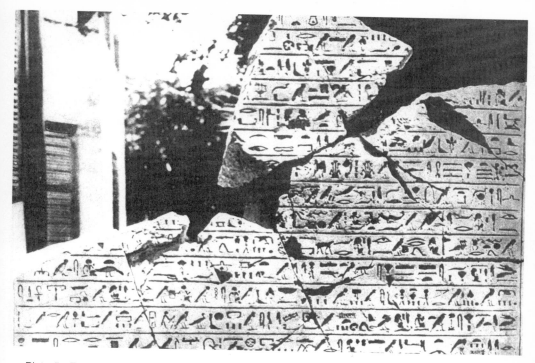

Plate 5. The Tempest Stele of Ahmose I. It was discovered at the Temple of Karnak, having been reused as fill during the construction of the third pylon.

Plate 6. The symbol of the Moon at Holy Communion.

Plate 7. The image of the crescent-shaped boat goes back to pre-dynastic Egypt .

Plate 8. Small stone altar from Megiddo, Israel. Like the minarets of the Aya Sofia, the four horns of the traditional Israelite altar are representative of the four pyramids that held up the heavens.

Plate 9. Minoan altars and the god-axe. The horns are a copy of the Egyptian and Israelite concept of heaven.

Plate 10. An Israelite altar on the steeple of a small village church near Windermere, Cumbria. A copy of the Egyptian concept of the four pillars of heaven.

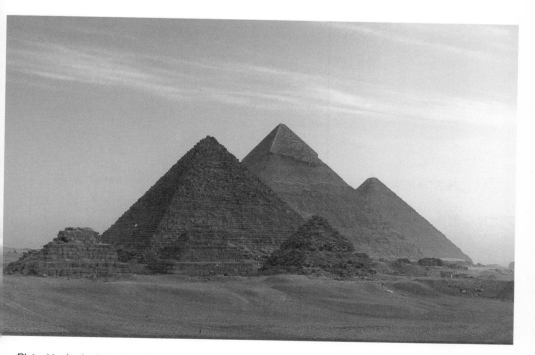

Plate 11. In the background are the Second and Great Pyramids of Giza. These were two of the four pillars that held up the Egyptian heavens; they were known as the Twin Peaks, the Two Breasts, the Two Brothers. It is from the four peaks of Giza and Dahshur that the form of the Egyptian altar was conceived.

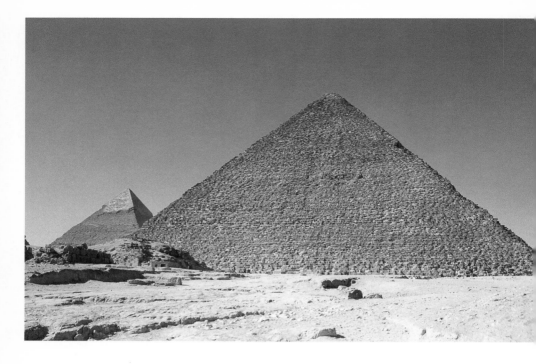

Plate 12. Looking along the (much ruined) causeway of the 'high and sharp' biblical Mt Sinai, which is more commonly known as the Great Pyramid of Giza. The observation of the Sun's shadow along the line of this causeway was a central part of the Israelite rituals at Giza. For scale, note the almost invisible people at the foot of the pyramid.

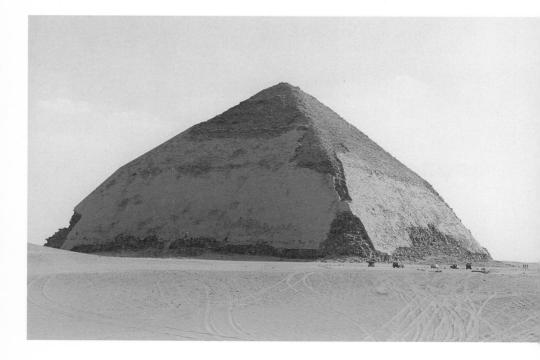

Plate 13. The Vega Pyramid at Dahshur. Was this the biblical Mt. Hor?

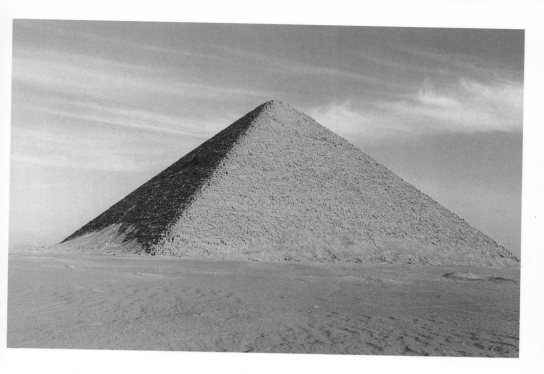

Plate 14. The Draco Pyramid at Dahshur. Was this the biblical Mt. Seir?

Plate 15. The faithful circling the Ka'ba at Mecca during the Hajj. The symbolism is of the daily and annual movement of the constellations, as they 'circle' around the Earth.

Plate 16. The nested caldera of Kilimanjaro, the natural model for the island of Atlantis. (D. K. Jones, Images of Africa.)

Plate 17. The Finding of Moses, by Nicolas Poussin (1594-1665). The background owes more to the architecture of Greece than anything to be found in Egypt.

connotations, as it eventually became known as Helios in the Greek. The additional 'H' in the Greek is most probably derived from the Hebrew adjective 'H' meaning 'the', giving '*the* Sun'.

The derivation of the Greek *Heli* (Ηλι) from the Hebrew *Eli* (עלי) is given in Strong's footnotes to the Bible. It transpires that both Heli and Eli mean 'ascension', but what is not explained in these notes is what, or who, is ascending, and why? The real answer is likely to be explained by the movements of the Sun itself.

As previously explained, one of the prime principles of the Egyptian religion was the marking of the sunrise against the background of the stellar constellations. It was this astronomical observation that marked their solar calendar and the passing of each era, from Taurus to Aries to Pisces. The prime 'ascension' of the Egyptian priesthood, therefore, just has to be the rising of the Sun; and, as explained in chapter I, this was most probably achieved by observing the sunrise down the length of the pyramid causeways. This very succinctly explains the fusion of the concepts for both 'Sun' and 'ascension'.

In addition to this, a further derivation of the Hebrew word *Eli* (עלי) is also *Alah* (עלה). The different-looking spelling in the Roman script belies the fact that the spelling in Hebrew is almost identical and that their meaning is also equivalent; they both mean 'ascension' once more. Alah is, of course, the root of the Arabic name for the Judaic god, and once, more it would seem that Alah was derived from the same Hebrew root meaning 'ascension' or to 'climb up'. Thus, the name of the Judaic and Islamic god may well have some reference to the rising Sun.

In this case, we have the rather surprising possibility that two of the possible names of the Judaic god could well have been derived from an Egyptian solar ritual. Since, however, the history of the Israelites is so intimately entwined with that of Egyptian history, perhaps that should not be so surprising. Both Joseph and Moses were high priests of Heliopolis and they could not have attained that exalted position had they not practised the vast majority of the Egyptian beliefs.

So, the Judaic god may have had both Egyptian and solar influences, and this information may assist us to fully explain the peculiar and secretive tetragrammaton of YHWH. In the Bible, the tetragrammaton tends to be used when the god is referenced specifically to the Israelites themselves, and alternative names are often used in conjunction with general comments about god: it would appear that YHWH is the personal, rather than general, name of the Israelite deity. It is also clearly stated that this name of god was not known to Abraham's people, a situation which again is probably not too surprising.

5. Yahweh

> And I appeared unto Abraham, unto Isaac, and unto Jacob, by the name of God Almighty, but by my name Yahweh was I <u>not</u> known to them. [B3]

The Bible asserts that Abraham came from another land, from Ur of the Chaldee or Babylon of Mesopotamia, and this is sometimes the reason given for this lack of understanding. I am less sure of Abraham's origins and it will be shown in the next chapter that Abraham had always been settled in Lower Egypt; in fact, he was a prince of Lower Egypt and eventually became a Hyksos pharaoh.

If this was the case, then why was the name of god not known to his people? In the last chapter, it was suggested that the name of god was a state secret, known only to the guardians of Heliopolis. If this were so, it is possible that the name YHWH was actually Egyptian in origin and therefore it is to Egypt that we must look for further evidence of its meaning. What, then, does this name really mean? The only real clue in the Bible is to be found in the famous verse in Exodus, where Moses converses with god and says:

> But ... the children of Israel ... shall say unto me, 'What is his name?', what shall I say unto them? And god said to Moses, I AM THAT I AM ... thou shalt say unto the children of Israel, I AM hath sent me unto you. [B4]

The reply by the deity has been variously translated as 'I am who I am ', or 'I am he who exists', or 'I will be what I will be'. The reply was typically and predictably enigmatic, most probably because later scribes and authorities found this tactic beneficial and therefore deemed this to be so. The more cryptic the answer, the less the plebeians would know about the true origins of the religion, and the more secure the authorities would feel in their positions of power. Later in the chapter, however, we shall see that this phrase was probably correct, but that a very poor rendition of the original Egyptian phrase was deliberately used when translating into the Hebrew.

Bread

After that long but essential introduction to the question of the name of god, what was the tetragrammaton's real meaning? The answer is to be found in a surprising location – a modern-day Christian service and the priest holding up a circular wafer of bread above his head. In performing this act,

the priest is giving out a coded message. Most priests will, of course, be totally unaware of the symbolism of the act and the message they are spreading, but the inference is clear enough.

The wafer used in the church service is a symbolic piece of bread, as we all know; a symbolic piece of the bread that Jesus broke at the Last Supper. In turn, the 'bread' is supposed to be a symbolic piece of Jesus' flesh – the body of Christ. But that is the surface symbolism for the laity, while the initiate into the Church could understand an even deeper layer of truth. As I explained at length in the discussion in the book *Jesus,* regarding the parable of Jesus and the Greek woman, the symbolism of this rite goes much deeper and it transpires that the mention of 'bread' is purely symbolic of a deeper truth – 'bread' is really a metaphor for 'knowledge'. More specifically, it infers the deep spiritual knowledge that was only conferred upon the highest of initiates into the Church.

The Last Supper was less of a meal and more of an initiation rite; when Jesus was 'breaking the bread', he was actually 'divulging the secrets'. A similar interpretation can be made of the biblical miracle of 'feeding the 5,000'. The food that was being given to the congregation was specifically said to be 'loaves and fishes'. The reference to 'bread' once more infers that this was an induction ceremony, and that sacred secrets were being divulged; while the 'fish' was a reference to the constellation of Pisces. When reading between the lines and translating this event into plain language, it transpires that Jesus was explaining to his followers that the constellation of Aries had ended and the constellation of Pisces was now dominant. The fact that a great deal of 'food' was left over at the end of the sermon probably indicates that much of this sacred enlightenment fell onto deaf ears. See the book *Jesus* for further details.

But the Christian wafer has a dual (or should that be triple) symbolism and the next mystery concerns not the fabric of the artifact, nor its metaphoric meaning, but its physical shape. The wafer is circular and formed from a piece of white bread; its symbolism is therefore, quite possibly, rather similar to another symbolic piece of bakery – the French croissant. The croissant, so the story goes, was actually devised by the bakers of Budapest in Hungary, to celebrate the discovery by the city's bakers of a surprise dawn attack by the Muslims. The bakers, by profession amongst the world's early birds, spotted the Muslim hordes and saved the city; so, in celebration, they devised a new type of morning bread in the shape of the Islamic crescent Moon. What they had created, of course, was the croissant, and the French name means just what one might expect – crescent.

The croissant is, unlike the Christian wafer, rather brown in colour; so

is this colour symbolic of the real Moon or just a practical result of the baking process? A quick look at the Islamic Moon symbology might perhaps answer this question. The Islamic Moon is portrayed as a recumbent crescent, lying on its back with its two horns pointing vertically upwards. The presentation may seem unimportant, but in fact, these two simple aspects of this portrayal can resolve for us the location, season, time of day and colour of the Moon that this symbolism represents:

a. The Moon being presented in a recumbent position, like a hammock strung up at either end, shows us that the time of observation is either dawn or dusk. This is the only time of day in which this position can occur and obviously, at dawn or dusk, the Moon will be sitting close to or on the horizon. The recumbent position also indicates that the observation was made in an equatorial or tropical latitude, which makes sense for astronomical observations made by Muslims in Mecca.

b. The fact that the Moon is a crescent again shows that this is either a dawn or a dusk event. A crescent Moon, because of orbital mechanics, has to be in the same quadrant of the sky as the Sun. Thus, the Moon can only be seen as a crescent either shortly before sunrise or shortly after sunset.

c. The recumbent Moon can tell us one more thing about this particular astronomical observation. If the Moon was being observed at dawn, the date of that observation has to be October, and conversely, if the observation were being made at dusk, the date would have to be March. The angle of the Moon to the horizon changes throughout the year and only on these dates (October and March) do we find the Moon in the fully recumbent position with the horns pointing up to the vertical.

The observation of such a ritual, if it were performed at Giza, would have been performed at dawn along the line of the Second Pyramid's causeway; for it is this causeway that marks the October sunrise (and moonrise). The vertical horns of the Moon would therefore have coincided with the end of the Nile floods, and the beginning of the *peret*, or growing season. This is a tentative indication that the Second Pyramid was linked more closely with the Moon and, following the usual Egyptian and Israelite dualism, perhaps the Great Pyramid was therefore linked more with the Sun.

Despite the seeming lack of data, we can now see that the Islamic crescent and the Hungarian croissant are both likely to portray a dawn or dusk

scene. That the bakers foiled a dawn attack indicates that the Hungarian symbolism, at least, is one of a dawn Moon just a couple of hours before the sunrise. In this case, the colour of the steaming, freshly baked croissant is likely to have been influenced by the actual astronomical event as much as the baking process itself. The croissant is a ruddy-brown colour, and the Moon as it peeps over the morning horizon is also – due to atmospheric scattering of the light – a ruddy-brown hue.

We drifted off onto this seemingly bizarre tour of the morning bakery because it is quite possible that something as simple as a bun or loaf can apparently hold many interesting secrets and celestial symbology; just as the twelve loaves that lay on the Table of the Shewbread, in the Temple of Jerusalem, signified the twelve signs of the Zodiac.

> Now the seven lamps (of the Judaic candlestick) signified the seven planets ... Now the twelve loaves that were upon the table signified the twelve signs of the Zodiac. J5

These religions are infused with forgotten symbolism and the role of the humble Christian wafer is no different; it is definitely symbolic in some manner, but how?

The Anglican priest will offer the wafer to the congregation as a symbolic piece of Jesus' flesh. The Catholic priest will go one step further and say that this is a real piece of flesh that just looks like a wafer; indeed, it is a conveniently forgotten truth that one of the principal ideologies of the Catholic Church is nothing short of cannibalism. So, the simple wafer is largely seen as being symbolic, but I would contend that it is not symbolic of Jesus, for that is simply a recent Christian adaptation of a much older rite.

As is often the case, there are various layers of symbolism overlying other older or deeper layers of symbolism. Like the layers of an onion, we can peel off layer after layer and finally arrive at the core truths buried deep within. In reality, the pale white circle of bread being offered to the congregation and held up high above the head of the priest, as if hanging in the sky, is, like its Islamic equivalent, a representation of the Moon.

Fig 28. Ta-en-aah – bread of the Moon.

5. Yahweh

Surprising as it may seem, the Egyptians had the same symbology and their version of the Christian wafer was called *ta-en-aah* – the sacrificial bread of the Moon. This sacrificial bread has to be linked with the Egyptian Moon-god Thoth in some respect, as one of the alternative names for Thoth was also *Ta*. [6]

The Islamic Moon is a dawn event – a thin recumbent crescent with a ruddy hue. The Christian Moon, on the other hand, lies opposite the Sun, perhaps at midnight; it is a full circle, high in the sky, and a gleaming silvery-white. The fact that this white Christian Moon is made from a similar circle of white *bread*, however, means we can take the symbology one step further, for we know that 'bread' infers 'knowledge' or perhaps the 'secrets' of the Moon. Now this is more interesting, for what secrets would the Moon hold for Jews, Christians or Muslims?

Well, the answer goes back further than Judaism; it goes right back to the Hyksos/Israelite rule of Lower Egypt. It would seem that the Hyksos/Israelites practiced – maybe even devised – many of the Egyptian customs and beliefs, and this ritual was probably one of them. In reality, the Christian priest is not making a blessing to Jesus, nor to 'god, god the son, and god the holy ghost', but instead to the Moon-god of Egypt.

In ancient Egypt, the Moon was considered to be the Sun shining at night; perhaps a reflection of the Sun as it dipped below the western horizon and then coursed its way through the bowels of the Earth to arrive at the eastern dawn. In another of its aspects, the Moon was an eye of Horus, the counterpart of the Sun, which was also pictured in the same manner. Indeed, a part of the myth of Horus losing his eye may well be bound up in the waxing and waning of the Moon, with the blackness of the New Moon representing the lost eye.

Interestingly, the Egyptian Moon was often pictured as a disk sitting within a crescent, so in effect, the imagery of the Islamic Moon-crescent is being combined with that of the Christian Moon-disk; perhaps here lies the origins of both these icons. But the Moon was not just considered to be the eye of Horus; the prime Moon-god of ancient Egypt was none other than Djeheuti, or Thoth as he eventually became known. Thoth was often represented by the image of a baboon wearing a Moon headdress, and also as the sacred ibis, whose long, curved beak, we are told, is perhaps representational of the crescent Moon.

While Thoth could have been seen to be a baboon watching the Moon, the connection with the ibis' beak is more tenuous. I tend to support the assertion of Robert Graves that this latter imagery was actually due to an association between the ibis and Thoth's role as the inventor of writing. The ibis is a member of the crane family and Thoth is associated with the

crane, as well as the ibis, through the spelling of another of his appellations, *Ba-aa*, as we shall see in a later chapter. The crane family have a habit of flying high in the sky and in formation, and the ever-changing shape of their formations appears to produce the shapes of glyphs in the sky, especially the shape of the cuneiform-type scripts. The name of the ibis in Egyptian was the *hibu* or *hibui* – a name that has a clear descent through the Greek and Latin to the modern name of 'ibis'.

In the twenty-seventh dynasty, that defined the Late Period and which was precipitated by the Persian invasion of Egypt, Thoth – in the image of the Moon – also became known as the 'Silver Aton'. Since the Aton is an image of the Sun, here, once more, we see that same combination of the Sun and the Moon as equivalent celestial bodies. In reality, of course, the Sun and the Moon have exactly the same diameter in the sky and sometimes they are superimposed, exactly one upon the other; they only appear to differ in their electromagnetic intensity (giving both their heat and light). To an Egyptian astronomer, this equivalence could not possibly be a mere coincidence: it would have to have been designed that way by the great creator-god. Given the knowledge available, perhaps the confusion of these two celestial bodies is easily understandable, and so the Sun was perceived to have a ghostly night-time partner or apparition.

Trinity

In the modern religious service, however, the Moon is somehow being confused with a trinity of gods; god, the son of god and the holy ghost. How did this come about? The peculiar nature of the Christian Trinity has always been one of the most perplexing parts of this religion, especially as Christianity is supposed to be a monotheistic religion that professes a belief in just one supreme god. Ask a priest to explain the exact nature and origins of the Trinity and the answer is likely to be vague in the extreme: how can Jesus also be a god if there is only one Christian god? Just who or what is the Holy Ghost? But the origins of this perplexing Christian trinity of gods is quite possibly explained once more by the symbolism of the simple bread wafer.

Thoth, the Egyptian Moon-god, was later known in the Ptolemaic period – by the Greek Neo-Platonists – as Hermes Trismegistos, or Thoth the 'Three Times Great'. The priest's blessing to the Christian Trinity appears to be nothing more than a relic of an Egyptian ritual, where offerings were being made to the Egyptian god Thoth, who, the Neo-Platonists insisted, had three manifestations or elements of being. If this is so then it would seem that, as with many of the Egyptian beliefs, the

worship of Thoth was well established in the liturgy of the Hyksos/Israelite people.

This line of reasoning may seem to be speculative at present, but there will be more evidence to support this notion shortly. One small strand of this evidence lies in the reasons for the Judaic calendar being lunar, with all the major Judaic festivals being locked into the lunar cycle and largely ignoring the solar seasons. The origin of the Jewish calendar is traditionally thought to be unknown, but it has to be ancient. The Hebrew name *hodesh* for month means 'renewal' and it directly infers the 'renewal' that is manifest in the waxing and waning of the Moon.

The lunar aspects of the calendar are a constant problem for the Judaic priesthood. Many of the Jewish festivals still have to align themselves with the solar seasons of the year because they celebrate seasonal events; but the lunar calendar drifts noticeably against the seasons, losing whole weeks every year. The solution devised was to add seven extra lunar months every nineteen years, which keeps things roughly in time with the seasons but, needless to say, the system is rather cumbersome.

It is surprising that such an awkward calendar was ever thought of and, more peculiar still, that its precise origins have been lost to history. Once more, however, I think that the Judaic historian's and scribe's selective memories are probably the cause of this convenient amnesia. It was obviously going to be embarrassing for the authorities to admit to the truth, but it is becoming ever clearer by the minute that the origin of the Judaic calendar was Egypt, and more specifically their god Djeheuti, or Thoth.

This deep-rooted association between the Judaic religion and the Moon-god Thoth is perhaps further confirmed by the informal Jewish greeting of *mazal tov*, which is still used to this day. The phrase is meant to confer 'best wishes', but it literally translates as 'good planet'. Which planet this is referring to is not known, but the Moon is, of course, the largest of all the 'planets' in the night sky. These are some of the astrological/Egyptian elements of early Judaism that the apostle Saul sought to quash when he set up his new 'Christian' religion, and he seems to have been remarkably successful in his endeavours.

Moon-gods

While an Egyptian calendar may have been a little embarrassing to the Judaic authorities, the major concern that they had to struggle with was the

true origin of the Israelite deity itself. What I am proposing is that the fundamentals of the Israelite worship involved the Moon. This veneration is the reason for the lunar Jewish calendar, the Islamic lunar crescent symbology and the Christian lunar wafer symbology.

Nearly 4,000 years ago, when the Israelite people ruled Lower Egypt, the Moon-god was central to the people's faith. But Egyptian theology was seen to be drifting away from its roots; a plethora of new gods were being invented and the prime tenets of the religion were being ignored. Ra and Djeheuti were being sidelined in a rush for personal icons and idols, especially in the despised south of the country.

It was the likes of the biblical Abraham and the later pharaoh Akhenaton, who instigated many of the reforms that attempted to return Egyptian theology to its fundamental beliefs. Both of these rulers waged a civil war upon idolatry and both appear to have precipitated a theological crisis in the Two Lands.

Akhenaton and Abraham each brushed aside several thousand years of acquired Egyptian traditions and declared a return to the one true god, the Aton (Ra). The Aton was a solar deity, primarily based in Heliopolis; but during the New Kingdom civil war, the deity was exiled to Amarna, along with Akhenaton and his followers. The Aton was the foundation stone upon which the Israelite deity of Adhon was laid; a single solar deity who invoked not simply the physical Sun, but the power and energy that lies behind that physical burning mass.

The Aton was the sole god of both Akhenaton's and Abraham's followers and this strong political will amongst the leaders of the Israelites, to standardize upon a single god, was surely going to squeeze out any lunar worship. Even though the Moon was only seen as the dualistic counterpart of the Sun, overt worship of Thoth and the Moon probably ended at this point; but while the role of Thoth was lost from the faith, it was never entirely forgotten.

As an illustration of these theological squabbles, the Bible freely admits that Moses had continual problems with his followers reverting to the old gods of Egypt and, at one point, he had to slaughter 3,000 Apis-bull worshippers at the foot of Mt Sinai. But the faction supporting the lunar worship must have been strong and influential within the Israelite leadership, so it was for this reason that the authorities were persuaded to adopt the lunar calendar and the (latent) symbolism of the Moon.

Since the rituals that lay at the heart of Judaism were performed in secret in the Holy of Holies in the Temple, the population would have been completely unaware of any possible lunar symbolism held by the priesthood. It would seem that these rites did happen, but that they only

resurfaced in the public arena with the founding of the new offshoots of Judaism – Christianity and Islam.

It would also seem likely that there was one other compromise that was settled at this early era of Israelite history – the very name of god. As already explained, Ahmed Osman has proposed that a bargain was struck within the early leadership, whereby Adhon [Aton-Ra, the Sun-god] would become the spoken word, while YHWH [the Moon-god?] would become the written text. If that was so, what was the original spelling of Adhon [Aton] and, more importantly, what was the original pronunciation and meaning of YHWH?

The original spelling of Adhon is quite easy to solve, as it can be seen written in many parts of Akhenaton's [Aaron's] city of Amarna in middle Egypt. The name is spelled out in the following glyphs:

Fig 29. Cartouche of Aton [Adhon].

The reed (feather) gives the 'i' or 'a' sound, the bun or half-moon the 't', and the wavy line of water sounds like 'n'. The circular *Ra* or Sun-god glyph at the end of the word is a determinative and just confirms that we are talking about a solar deity, rather than any other word sounding like 'Aton'; although some still prefer to pronounce the name Eton, a name sounding similar to the name of the English private school. The plural form, Atonai, would simply involve the addition of two or three plural strokes at the end of the word.

As can be seen from the glyphs – despite the passage of several thousand years – the original pronunciation of the name of this deity, Aton, has been faithfully recorded in the Hyksos pharaohs' annals, known to us nowadays as the Torah or Bible. This is especially so when one realizes that the 'd' and the 't' are often interchangeable in the original Hebrew of the Torah. But if the Bible can be relied upon to preserve such details over such an expanse of time, could we possibly find a reference to the Torah's tetragrammaton of YHWH in the Egyptian texts? Could the ineffable, the unspeakable, name of the Israelite god be etched into the walls of the great Temple of Karnak perhaps?

It may seem incredible, but I think that this is precisely the case. The first two letters of the tetragrammaton are YH and the presumed vowel in

5. Yahweh

the middle is an 'a', giving the syllable of 'yah'. Turning to the *Egyptian Hieroglyphic Dictionary* of Wallis Budge, it can be seen that the name *Yah* can be translated as 'the Moon'. Here, at last, is confirmation that the presumptions I have made thus far are standing on secure foundations. If the word *Yahweh* was derived from Egypt, it is highly likely to have had some form of lunar connotation.

The name *Yah* is spelt in the original glyphs with a single reed, giving the 'y' or 'e' vocalization, and a coil of rope giving the 'h'. The first letter could be read as a weak 'i', giving the sound 'iah', and pronounced something like the end of the word 'liar'. But of all the possible pronunciations, 'eeah' or 'yah' are the more likely. The glyph at the end of the word is another determinative glyph that is not pronounced, and it merely confirms that we are talking about the Moon and no other 'yah' type word. [7]

Fig 30. The Moon.

But the translation of this word goes much further than this. By the simple addition of a determinative for a god at the end, the same word *Yah* not only means Moon but can also mean Moon-god. This new arrangement looks very similar to the word for 'Moon', the main difference being that the determinative has changed to the 'god' symbol to show that gods are being mentioned. At the same time, this new interpretation can also accurately determine the vowel that accompanies this word, which was only guestimated through biblical deductions until now. The 'a' vowel in the middle of the word is confirmed by the 'arm' glyph in the middle of the version on the right.

Fig 31. The Moon-god.

Djeheuti

Was this the secret embarrassment that the Judaic scribes wished to suppress? That their deity had the name of an Egyptian Moon-god? Was

5. Yahweh

Yah, the Egyptian Moon-god, really a part of the title for Yahweh? An initial confirmation of this comes from the history of Mohammed, whose deity, Allah, is the same as the Judaic Yahweh. An angel of Allah appeared to Mohammed in a dream and said to him:

> 'Read this.' I (Mohammed) replied 'I cannot read' ... 'Read' the angel repeated ... Nervously I replied 'What am I to read?' The angel said 'Read in the name of your lord ... <u>he who instructed man by the pen,</u> he (who) taught him what he did not know.' [8]

At the admission of Mohammed, the Islamic god, Allah, was specifically responsible for teaching mankind to read and write, just as the Egyptian god, Djeheuti, was. So was the Israelite god Djeheuti? The complete answer to this question has to lie in the full decipherment of the name Yahweh. We have deciphered the *Yah,* but what does that last syllable of the tetragrammaton, the 'weh', mean? Can this word be found in the Egyptian lexicon too? Unfortunately, after an exhaustive search, none of the words listed appeared to be either remotely similar or relevant to the question. But then my eye was taken by yet another extension to the word *Yah.*

An obvious new line of research had to be the original name of Thoth. Thoth, like many of the Egyptian deities, had multiple appellations. He was known as *Aanu, Asten, Khenti, Khonsu,* or *Tem* when in his image of a baboon. But he was also known as Djeheuti the ibis, or even Aah-Djeheuti as a combination of the two images. While none of these alternative names seemed to match either 'Yah' or 'Weh', an alternative form of Thoth's name did appear under the listings for 'Moon'.

It would appear that Thoth was not simply known as *Aanu* or Djeheuti, but also as *Yahew,* and this name seemed to be far too close to Yahweh for coincidence. So can this line of reasoning be expanded at all? The glyphs for this alternative name for Thoth are as follows: [9]

Fig 32. Yahew – the alternative name for Thoth.

Quite obviously, this is simply a plural extension of the *Yah* word for the Moon-god that has already been illustrated. Thoth was a Moon deity, so the

5. Yahweh

clarification of this particular Moon-god being an alternate name for Thoth is quite understandable. The new pronunciation, including the chick glyph, definitely appears to be *Yahew*, just as Budge claims. But is he correct in this, or can we, with a greater understanding of the meaning of this word, jump one step in front of the classical interpretation? I think that this is possible, but only because there appear to be three ways of achieving the same objective.

The author, David Rohl, came to a similar conclusion to the one that follows, in his influential book *Legend*. Based on the similar understanding that the patriarch Abraham, or his people, did not know of the name of god, he looked into the Sumerian possibilities for the name *Yahweh*. He noted that the cryptic answer from god of 'I am that I am' was formed from the Hebrew *eahyeh asher eahyeh* (אהיה אשר אהיה). Rohl maintains that the derivation of the second *eahyeh* could well be from *Eya*, the Akkadian version of the Sumerian Earth-deity *Enki*. Thus, Rohl's provocative translation of the cryptic answer 'I am that I am', is another biblical play on words. In this case, the real answer to Moses from god was *eahyeh asher Eaya* (אהיה אשר יה), meaning 'I am called *Eya*' or 'I am called the Earth-god *Enki*'. [10]

Note that the Sumerian Earth-god *Eya* (יה) appears to have the same Hebrew spelling as the Egyptian Moon-god *Yah* (יה), which can also be spelt and pronounced as *Eah*. As *Yah* and *Eya* are so similar, it is quite possible that there may have been an ancient confusion over the true name of god, and this may have been caused by the Hyksos priests trying to match their Moon-god, Thoth, to Sumerian equivalents. Perhaps the people were not familiar with this new Akkadian name for the Mood-god and so the biblical texts have 'god' saying to Moses, 'I am called Yah', a name which may well be a reference to Djeheuti/Thoth. [B11]

Djeheuti appears, at this point, to have gained yet another appellation; he was now called by the Sumerian derived name of Yah and this new name eventually found its way into the Egyptian lexicon. The alternative name for Thoth, however, is clearly in the plural; it is not Yah but Yahew. The 'u' or 'ew' glyph of the chick indicates a plural and this is further confirmed by the three vertical strokes, which also indicate plurality. The peculiar question of why the singular god Thoth should be written as a plural has to lie in the Trinity once more. Thoth was written in the plural because he was Hermes Trismegistos, the 'Three Times Great'. In a similar fashion, the Israelite god Adhon [Aton] should be singular (especially as the Israelites believe in the one god) yet the name is often written in the plural – Adhonai.

The plural nature of Thoth gives the 'ew' at the end of the word

Yahew, but is there an alternative pronunciation to this? Quite possibly. When talking of a double or a dual plural (two items, like two arms), the vocalization is subtly changed. The standard 'ew' plural has an 'y' or 'eh' attached to it, so a double plural becomes 'ewy' or 'eweh'. To signify a double, just two plural strokes are used at the end of the word instead of three. But Thoth has three forms not two, so how can this alternative help the situation?

Just possibly, perhaps even through an ancient error in translation some 3,500 years ago by a Hyksos/Israelite scribe, the three strokes of a plural (three or more items) came to be pronounced in the same fashion as the double plural (two items). This same plurality question must have taxed even Wallis Budge when he drew up his Egyptian dictionary, because he says of Djeheuti that he is 'twice great'. He does so because the word Djeheuti sometimes contains a double plural; it has the two strokes of the double plural, giving the 'ewy' suffix to the name. But this explanation comes despite the fact that Djeheuti is known to have been the 'thrice great'.

Fig 33. *Three forms of the name Djeheuti.*

Axe

Note that Djeheuti can be spelt with the god-flag determinative. Actually, this is rather a misnomer, for the flag is not a flag at all – it is an axe. It can be seen from some of the better representations of this glyph that the axe-head has string or a thong wound around the shaft, to bind the head of the axe to the shaft. This identification is still under some dispute, however, and some authorities like to call the symbol a roll of cloth, with a flap of material hanging free.

But there should not really be much doubt as to the axe's true identification, because the symbol can be found in another civilization that had close links to Egypt – the Minoans. The axe was a popular and enduring symbol of Minoan life, although in this new land, the axe was now double-headed and also took on the rounded shaped blade that was more

popular in this region. Examples and illustrations of the Minoan axe leave no trace of doubt that this artifact was, in fact, closely linked to their theology.

Ceremonial axes have been found close to the altars in the 'shrine of the double axe' at Knossos, while the *Larnax* from Palaikastro (a terracotta ossuary or coffin) and the temple wall paintings from Knossos clearly show that these axes were mounted upon the altar. But what does this Minoan symbology mean? Did their axe have the same meaning as that of the Egyptians?

One piece of evidence could be the discovery of nine axe heads in the Central Court of Phaestus, a find which mirrors the nine gods of the Egyptian *pestch-t neteru*. Then there is the fact that the axe was often prominently placed in the center of the Minoan altar; although the axe was sometimes replaced by the depiction of a god figure, or even a tree (of knowledge?). Finally, there are the offerings being made to the very interesting four-headed axes, as was depicted on the sarcophagus from Triada. All of these observations seem to link the double axe as a symbol of the deity in Minoan culture, but does not exactly explain the reason for this strange choice of symbolism. [12]

Inspired guesses have been made, of course, and one of the most popular is that the axe is a symbol for the weapon of the thunder-god, who was called astropeleci (αστροπελεχι). But the axe is always seen to be held by a goddess in other depictions, indicating a female deity was intended, and which the thunder-god was not. Perhaps a more likely answer lies in the form of the axe itself and the position in which it was depicted – on an altar. Mark Nilsson argues that the axe could easily have been linked to the deity through the act of ritual sacrifice. Although most of the axes discovered were ritual items and were not capable of performing their usual function, it is obvious that a similar type of implement must have been available to the priesthood to perform the sacrifice, and the constant usage of this type of implement in this manner must have influenced its eventual divine status.

Interesting as this is, there is another method of deriving the original and true symbolism of the axe through the study of the Egyptian language. The name of a god-axe in Egyptian is *neter* and the name of a functional axe is also *neter*. The list of synonyms to *neter* does help much with the origins of the word, as they all appear to be related to its divine status, but perhaps another look at Minoan culture will help in this matter. There is one other place that the axe was routinely illustrated by the Minoans and that is in the halls of pillars. The halls of pillars in the palace of Knossos are plain rooms, each bearing one or more rectangular pillars. These pillars clearly

have some ritual function and yet these, too, are inscribed with double-headed axes, one pillar alone bearing seventeen axe images.

These pillars are most probably, like the axe and many other aspects of Minoan theology, based upon Egyptian rites and rituals. The function of the pillars, in my eyes, is somewhat akin to the pyramids themselves. While classical history still tries to assure us that the largest of the pyramids are simply tombs of the pharaohs – as the smaller pyramids may well have been – that claim is looking more and more untenable. The largest pyramids, at Giza and Dahshur, bear no inscriptions whatsoever and their prime function, in my opinion, was more mathematical and perhaps astronomical. Thoth (Djeheuti) was the god of writing, maths and metrology, and the design of these larger pyramids makes them appear to be more like monuments to geometry than tombs of the pharaohs.

In a similar fashion, the pillars of Knossos are also demonstrably mathematical. The majority of these pillars are measured in Egyptian Short cubits – which is an obvious link to Egypt – and their dimensions resolve into whole number heights and fractional widths. The fractional widths were a little troubling, until it is realized that all these measurements multiply up into whole-number ratios, as demonstrated in the following table:

Metric (cm)	Cubits and hands	Ratio
180 x 80	4 x 1 c $4^2/_3$ h	16 : 7
135 x 60	3 x 1 c 2 h	9 : 4
136 x 70	3 x 1 c $3^1/_3$ h	21 : 14
Royals		
182 x 52	3.5 x 1	7 : 2
210	4	

The last two measurements were not made in the common Short cubit, but were made instead using the Royal or Thoth cubit; the cubit measurement that was used in the very pyramids themselves. What we appear to have here at Knossos is not a ritual hall of pillars, as such, but instead a room of sacred measurement standards. Since Thoth was the patron deity of metrology, many of the measurement systems in the ancient world were deemed to be sacred – including the cubit length that was used in the biblical accounts for the construction of the Ark of the Covenant.

The book of Ezekiel says that the unit being used was a 'cubit plus a hand', and this, therefore, identifies the biblical sacred cubit as being the Royal or Thoth cubit of Egypt. Here in Knossos, it would seem that the

same sacred measurement system was being stored away, in a small ritual hall, for veneration by the priesthood.

There were many halls of pillars at Knossos and they may have held all of the different measurement systems that the Minoans knew of – including two pillars that seem to be constructed with an odd cubit measuring 32.4 cm in length. But the essence of all these units of measurement, and their apparent veneration, is the concept that the construction of an artifact in precise units of measure was deemed to be both special and sacred in countries as seemingly diverse as Crete, Egypt and Israel. In the case of the Minoan culture, these pillars were also inscribed with the double-headed axe, and it is from this usage of the symbol that the origins of the divine god-axe may be glimpsed.

The Egyptian word for axe is *neter*, as we have seen. But looking through the small number of secular meanings to this word, the very similar term *neter-kherti* can be found, which means quarryman or stonemason. The term 'mason' was important in Egyptian theology, as can be seen from the way in which this tradition has filtered down into modern Masonry, where building metaphors and symbols proliferate and the term 'architect' is perceived to be sacred. The Masonic deity is known as the Architect of the Universe, in much the same way as Thoth (Djeheuti) was also known as an architect; hence, the numerous Masonic stoneworking symbols can directly be equated with the Great Architect deity that is presumably supposed to wield them. In effect, the axe symbology of the Minoan and Egyptian gods was most probably derived from the concept of the divine-being, cutting the perfectly proportioned stone block from a rough ashlar; which is, in itself, yet another Masonic metaphor.

Children

As we saw earlier, the name Djeheuti contained a double plural at the end (as can be seen in the glyphs). But the plural here is rather odd, because it combines both the masculine and feminine endings. The chick and double strokes suffix is masculine and it is pronounced 'wy' or 'ooee'. Conversely, the half-moon 'bun' and double strokes is feminine and is pronounced 'ti' or 'tee'. Djeheuti, like many of the Egyptian deities, seems to have androganous tendencies and has gained the suffix of 'uti' or 'ootee', denoting both sexes.

Whatever the gender, though, it would appear that Thoth was known as either a dual personality, or – as later Platonic tradition would have us believe – a triple personality. But this triple personality, the Trinity, seems to

use the linguistic rules for a double and it is this grammatical oddity that gives us the 'ootee' vocalization at the end of the name Djeheuti.

There seems to be mounting and inescapable evidence that the name of the triple god, Thoth, should not just have the normal plural suffix of 'ew' to the name, but instead have one that mimics the double vocalization 'eweh'. If we add this double suffix to the name 'Yah', we no longer derive Budge's 'Yahew' – instead the name of Hermes Trismegistos, or 'Thoth the Three Times Great', would have to be pronounced as 'Yaheweh'.

Here also, most probably, lies the real linguistic root of the tribal name for the Israelites. The simplistic concept of the word 'Jew' being derived from the tribe of Judah belies the fact that the Aramaic pronunciation of this new title for the Israelites is spelt *Yahewdaiy* (יהודאי). On the other hand, the true pronunciation of the tetragrammaton for the Judaic god would now appear to be *Yaheweh*. It rather seems as if the name of the Jewish people simply had a 'd' or perhaps 'da' inserted into the god-name of Thoth.

Interestingly enough, the word 'da' in Egyptian means the 'seed' or 'offspring', so the new appellation for the Israelites of *Yahewdaiy* appears to mean the 'sons' or 'children' of Thoth. The spelling of this word is not quite standard in the original Egyptian, but since the word was only coined after the Israelite exodus, it could well have been derived using other linguistic rules.

Fig 34. Yahewdaiy – children of Thoth.

The name of Joseph can be explained in much the same manner. The full name for Joseph, as taken from the Torah, is *Yahowceph* (יהוסף) and here again we can see an 'o' or 'u' vowel being admitted into the center of the word, just like the newly proposed pronunciation for Yaheweh. Joseph was named after his god Yahew, as everyone knows, but what does the 'seph' suffix mean? The biblical dictionary gives 'Yahweh has added'; a translation that is suspiciously bland.

The Egyptian dictionary, however, gives a more believable meaning – 'sef' can mean to slay, to kill. But I would imagine that this was just a ritual killing, so *Yahowceph* could well mean 'Sacrifices to Yahweh', or – bearing

in mind the conclusions just reached in this chapter – '(He who) Sacrifices to Djeheuti/Thoth'. There is no alternative confirmation of this translation; but since Joseph was most probably a high priest of Heliopolis, such a conclusion is not without some justification. Chapter VI contains an additional and very interesting translation of Joseph's Egyptian name, which may clarify his role and duties in the temple of Heliopolis.

Fig 35. Joseph – 'Sacrifices to Thoth'.

These new insights perhaps give us a more believable translation for that enigmatic reply, by the Israelite god, of *eahyeh asher eahyeh* (אהיה אשר אהיה), supposedly meaning 'I am that I am'. David Rohl, as we saw earlier, translated half of this phrase into a Sumerian derivative, giving something like *eahyeh asher Eaya* (אהיה אשר יה), meaning 'I am called Eya' or 'I am called Thoth'.

Whilst this is possible, I think a more plausible interpretation can be derived by keeping the translation entirely in the Egyptian language. Both *eahyeh* (אהיה), meaning 'I am', and *YHWH* (יהוה), the name of the Israelite god, are derived from the same Hebrew root word of *hayah* (היה), meaning 'to exist' or 'become'. So, even in the Hebrew, it is quite justifiable to replace the dubious translation of 'I am' with 'Yahweh', giving the phrase 'Yahweh that Yahweh', a rendition which still does not mean very much.

But if we were to replace the Hebrew Yahweh with Egyptian Yaheweh (Thoth), and Egyptianize the whole phrase, this gives us *Eaheweh asher Eaheweh*. The *asher* is an Egyptian ritual offering of roast meat – the traditional burnt offering – so the complete phrase could well translate as 'Thoth, sacrifice to Thoth'. (The sacrifice may be related to the *Aser-t* tree, as discussed later.) The full biblical quote then appears to make much more sense than it ever did using the original Hebrew translation. Moses asks god for his name and the now slightly less cryptic reply from the deity was:

> And God said unto Moses, 'Thoth. Sacrifice to Thoth. Thus you shall say unto the children of Israel, Thoth hath sent me unto you.' [B13]

All in all, it would seem that here we have one of the secrets of the

millennium – the mysterious and arcane name of the Judaic, Christian and Islamic god has been uncovered at last. Here is the unmentionable truth that the Judaic scribes and authorities wanted to hide from the world – the god of the Israelites and Jews was called either Adhonai [Atoneh], the Sun-god Ra; or Yaheweh, the Moon-god Thoth.

That this fusion of Sun and Moon should occur is self-evident in the Egyptian Late Period's reference to Thoth as the 'Silver Aton'. The Aton is the Sun, while its 'silver' shadow is the Moon. Quite obviously, the Israelites had the same fusion of gods and symbols as the Egyptians had under Persian rule. But since the Israelite religion had been strictly monotheistic since the time of the pharaoh Mam-aybre [Abraham], if the identity of Djeheuti were to be preserved, then there had to be a way of combining the two icons. The peculiar, but self-evidently successful ploy, was to make the Sun-god Aton [Adhon] the spoken word, while Yaheweh (Yahweh) became the standard spelling.

It is from this union of Sun and Moon that much of the liturgy of the Christian Church was derived. The disciples and prophets endlessly and cryptically talked of light and darkness, but I do sometimes wonder if they had a clue what the symbolism of these terms really was. In my estimation, the 'light' was derived from *Aakhut*; the name of the Great Pyramid of Giza and the term that had connotations of the sacred light of the Sun-god Ra. *Aakhut* or *Aakhen* was the light of the Sun; brilliance, splendour, the sacred flames, the spirit of man. But *Aakhu* was also intimately linked to the god Djeheuti (Thoth) – a fact that is implicit in the spelling of the prefix *Aak*, which invariably uses the glyph for Djeheuti. Thus *Aakhut* can now also be seen to be synonymous with *Yahewey*, the Moon-god.

The Great Pyramid was seen to be the sacred light of the Sun-god Ra; and also the ghostly silver light of the Moon-god Thoth and the netherworld of spirits. The Great Pyramid represented the key duality of the Gnostics: it was both light and darkness, and it was both life and death.

Wrath

It was never the wrath of god that prevented YHWH (יהוה) from being spoken out loud to the world; instead, it was the wrath of the Judaic priesthood, who feared that its religion, its nation and its whole way of life might unravel if the truth were known.

Now, however, the genie is well and truly out of the bottle and, while the truth may often be feared from afar, its ramifications are never quite so dire as the expectations. 'Oh what a tangled web we weave ...' is the motto

which many a disgraced politician should have borne in mind before embarking on a strategy of deceit. In truth, had the politician owned up in the first instance, he or she is likely to have been forgiven – but the public rarely appreciate or forgive a congenital liar. As to the deceits of Judaism; after three-and-a-half millennia, and several exiles and holocausts, will the people not forgive a religion that has been a little economical with the truth? Are we surprised that the Jewish religion has had to flex and bend a little to adapt to the changing sociopolitical climate of each era?

From an orthodox Judaic, Christian or Islamic perspective, the Egyptian heritage of Judaism being uncovered in this chapter may still be a truth that is too hard to swallow. From a more distant standpoint, however, the vista appears a lot more rosy. If the Judaic god Yahweh is really based upon the Moon-god Yaheweh, then the history of Judaism has just been launched into the distant past. Here is a religion that has remained steadfast in many of its core beliefs, and in much of its symbolism, throughout not just the 4,000 years of Judaic history, but perhaps the 6,000 or 8,000 years of Egyptian history that may well precede this. Here is an organization that has admirably coped with the enormous transition from Bronze Age to Space Age over a time span of six or more millennia, and with what may be considered to be very little change to its basic tenets and principles.

Judaism may not look like the orthodox perception of Egyptian religion, with their great pantheon of gods, but in reality these multifarious gods were simply a distraction from the prime god Aton-Ra. Aton was not simply a Sun-god; it was more a belief in the cosmos, the great celestial power that drove the Universe through its daily and millennial cycles. It was the rebel pharaoh Mam-aybre [Abraham] who initially purged the northern territories of Egypt of these heresies and instituted the reforms that would spawn Judaism as we know it. It was Abraham who was the first pharaoh specifically known for not being an idolater, as the Koran makes perfectly clear. After the first exodus of the Hyksos/Israelites, the responsibility then rested on the shoulders of Akhenaton to continue these reforms, and he did so with great fortitude and to stunning effect.

But Akhenaton was to prove a victim of his own single-minded piety and undoubted success, and after his eviction from Egypt on the second exodus, the core of the Egyptian religion removed itself from its ancestral lands and implanted itself around the world as the seed-corn to many new nations and beliefs. Not least among these new nations was the Jews of Israel, where many of the traditional symbols and customs of the original temple at Heliopolis may have survived, even into the Roman era.

With the sacking of Jerusalem, however – first by the Persians and

then by the Romans – the secret rites that were performed in the Temple of Jerusalem were weakened and then largely lost to Judaism. Accordingly, many of these customs have had to find other conduits to survive into the modern era. Nevertheless, would we really be surprised to enter one of the great temples of ancient Egypt four thousand years ago and to discover there a large, seven-branched candelabra on the altar and a shaven-headed priest with long curly side-locks, nodding his head before it?

Chapter VI

Sinai

As we have already seen in chapter III, the early events of the exodus all appear to have occurred in Egypt. There was the possible evidence for a climatic disruption, of whatever severity, that was most probably caused by the eruption of the volcano at Thera. There was firm evidence of a conference between the Israelites/Hyksos and the Theban pharaoh, which led to tributes being given to the Israelites/Hyksos. In short, the Theban pharaoh Ahmose I wanted the Hyksos/Israelites to leave the country *en masse,* but he did not have the capability to defeat them militarily and so this dispute had simmered on for years, if not decades. The other option open to Ahmose I, which was frequently used in these times, was to buy off one's enemies with a large tribute. This technique was, more often than not, used to dissuade an enemy from attacking a city, but its use to induce an enemy of 'occupation' to leave the country is not too dissimilar.

Thebes was a very wealthy city and province, and it could afford the tribute, although it does rather sound as if all the coffers and temples had to be stripped to finance the deal. The entire wealth of the south, in terms of gold, copper, fabric and even oils – both industrial and fragrant – was handed over to the Israelites/Hyksos. The exodus then began and the massed tribes of the Hyksos/Israelites, numbering up to half a million according to both the Bible and Manetho, began their long and arduous journey towards the north-east and Jerusalem.

But as they left, a few of the departing Hyksos/Israelite soldiers thought that they may as well take a few extra 'tributes' from the people who had decided to stay behind in the Delta region. These people were, in their eyes, only the laggards who had secretly supported the Theban regime all along, and so they were probably despised as traitors. Thus

began an orgy of looting and violence as the departing Hyksos/Israelites stripped the land bare. It was destruction on an unprecedented scale and it prompted the Theban pharaoh, when he saw the ruins of Avaris, to declare that this was not just greed, but Avarice! Suitably shocked and angered, the Theban pharaoh then decided to follow the Hyksos/Israelites and punish them:

> And it was told the king of Egypt that the people fled: and the heart of Pharaoh and of his servants was turned against the people, and they said, 'Why have we done this, that we have let Israel go from serving us?' [B1]

The biblical reasoning for the pharaoh's change of heart is weak in the extreme. We are being led to believe that the mighty pharaoh of Egypt had already vacillated seven or more times, during the plagues saga, as to whether or not he should allow the Israelites to depart from Egypt. Now, having said that they could go, he changes his mind once more. Do the scribes and clergy take us for fools? The reason for the pharaoh's change of heart is eminently understandable – effectively, the treaty had been broken by the Hyksos/Israelites and their looting, and it was for *this* reason that the Theban army now moved to chase and punish the fleeing refugees.

But the military action was ineffective. The Hyksos/Israelite army was still amongst the most powerful in the region and they could quite effectively defend themselves during the retreat, with or without god's trick with the tides. These are the true events of what happened at this time, as gleaned from the evidence in the Bible, Manetho, Josephus, Egyptian texts and also the *Tempest Stele*.

Cover-up

But within this new account of these events lies a small problem; the Bible gives a slightly reversed order in which these events occurred. Specifically, it says that the tributes were only given to Moses *after* the exodus had already started. In fact, they were given to Moses at the foot of Mt Sinai.

I initially thought that the compiler must have been confused about the chronology of these events and placed the receipt of the tributes in the wrong section. But then I thought more about what the scribes were doing, and what they hoped to achieve on the completion of their great work. The most obvious prerequisite of all their efforts, was that the role of Egypt had to be reduced to an absolute minimum in their scroll. Here was the greatest

nation on the Earth at the time and, in many respects, they are portrayed within the biblical texts as being on a par with a minor city state in Palestine.

Whilst every town and village in Judaea and Sinai appears to have been recorded in the Bible, not even the great temples of Karnak or Heliopolis get a biblical mention. Joseph was the royal vizier to the pharaoh, Moses was a royal prince, both were high priests of Heliopolis; so why does this great and magnificent temple not get even the slightest mention? The only time On (Heliopolis) is mentioned in the Bible is when Joseph marries the high priest's daughter; but since the inheritance of Egypt was matrilineal, Joseph was marrying into the family of the high priest and he became high priest himself. Why, in this case, did this magnificent temple not get a proper mention in these texts?

The answer is simple: the scribes didn't want you to hear anything of Egypt, let alone anything that made it sound grand or mighty. Indeed, there probably *were* some extracts that originally mentioned Heliopolis, but they have been subtly changed to obscure the facts, as we shall see shortly.

Direct evidence for this process has already been shown with the deliberately ambiguous name of Mt Ararat. The location of Ararat was on the Giza plateau, just a few kilometers from Heliopolis. So, did the scribes not know the name for Giza or Heliopolis? Is this the reason for their lapse? Hardly likely; Heliopolis was still a functioning temple at the time these accounts were first written and still would be for another fifteen hundred years or so. In fact, Simon Onias, the Jewish high priest of Jerusalem, reopened and refurbished the Temple of Heliopolis during the Roman period: did he not know of the temple's original names or its history?

Of course he did, and so did the original scribes; but they were not going to tell the world that, not only were the biblical patriarchs pharaohs and high priests, but that much of the Israelite liturgy was based upon Egyptian practices. By necessity, the details of the land of Egypt, and its intimate relationship with the Israelite peoples, had to be suppressed.

The problem with the order of the events of the exodus, as given in the Bible, is not the chronology so much as the geography. Because the scribes did not want the details of the receipt of the tributes by the Israelites, from the Theban pharaoh, to have occurred in Egypt, the location of this event had to be moved a little further away. But if we were to be very bold and take all of those events that happened at the foot of Mt Sinai and place them back into Egypt, the text would actually make a great deal more sense.

Firstly, as already pointed out, the fabrication of the Tabernacle and

the Ark of the Covenant would make much more sense in Egypt. The tributes that were given to make these priceless artifacts came from Thebes and they were given in order to induce the Hyksos/Israelites to leave. There would have been no point in giving the tribute if the Hyksos/Israelites had already departed and were now sitting at the base of Mt Sinai. Also, the fabrication of these artifacts needed proper industrial resources; goldsmiths and coppersmiths, carpenters, tailors, embroiderers, and more besides. Even if the Israelites had these artisans amongst their number, they also needed the workshops, tools and the food and energy supplies to carry out the work. The evidence all points towards these events occurring in Egypt, where all the required infrastructure resided.

But there are other peculiar details to be explained about this period at Mt Sinai. One of the big events that occurred at this time was a great storm:

> A cloud spread itself over the camp of the Israelites, such as none had before seen, and encompassed the place where they had pitched their tents ... there came up strong winds, that raised upon the large showers of rain, which became a mighty tempest. There was lightning as was terrible to those that saw it; and thunder with its thunder bolts ... [J2]

But we have already just had the storm that 'none had before seen'; it was one of the biblical plagues and it happened in Egypt. This later storm appears to be a duplication of this account. Then there is another curiosity, the slaughter of the bull worshippers:

> And (Moses) said to them ... put every man his sword by his side and go out from gate to gate throughout the camp, and slay every man his brother, and every man his companion ... and there fell that day about three thousand men. [B3]

It had always struck me as a bit odd that not only had Moses allowed bull worshippers on his exodus, but also that they should have wanted to go in the first place. The whole point about the exodus is that the Theban people still worshipped the Apis bull [Taurus], while Moses and his followers had converted to the symbolic veneration of sheep [Aries] and were known as Hyksos (shepherds).

On their departure from Avaris and the Delta regions, the Israelites/Hyksos sacked the entire land and looted the people, and no doubt the bull worshippers would have been on the receiving end of that destruction and

persecution. There seems to be no logical reason why any self-respecting Apis bull worshipper would want to join the exodus, and this is confirmed by the actions of Moses when he found out about them – he killed them all.

The answer, as you may have guessed, is that all these events actually took place in Egypt, and the slaying of the 3,000 Apis bull worshippers was probably a part of the general looting and devastation that took part in Lower Egypt before the exodus started. All that has happened, is that there has been a bit of deliberate sleight of hand here, for the scribes did not want anyone to know the true location for these events.

The Mount

The task is to discover the true location for these events; that is, the true location of Mt Sinai. The process begins, once more, with an analysis of the texts and terminology involved. The actual location of Mt Sinai is completely unknown – either within the Bible or later traditions – which is a sure sign of a cover-up. Here is the most important mountain that appears in the Bible, the very mountain that god descended upon and where he/it conversed with Moses, and mankind in general. Here is the most sacred mountain on the planet, and then someone goes and forgets where it was. Again, we are being taken for fools.

Sinai is pronounced *Ciynay* (סיני) in the original Hebrew and it can be translated as 'thorny' according to the *Bible Dictionary*. But perhaps even this description is just yet another layer of deceit, for the derivation of Sinai given in the King James concordance is 'sharp' or 'pointed'. Such a small alteration and yet such a dramatic change in perception; out go the images of a mountain covered in thorn bushes and in comes an image of a sharp and craggy peak. Josephus appears to confirm this new image of Mt Sinai when he says of it:

> When Moses had said this, he ascended up to Mt Sinai, which is the highest of all the mountains that are in that country, and is not only difficult to climb, on account of its vast altitude, but because of the sharpness of its precipices also, indeed, it cannot be looked at without pain of the eyes. ᴶ4

Josephus clearly associated the adjective 'sharp' with Sinai, just as the concordance does. The biblical reports that we have, which indicate the location of Sinai, are all obscure; but a few facts can be gleaned from the

texts. But, let us start with a blank sheet here, and not be influenced by the Sinai peninsular, for the clergy are always trying to divert our attention into that region for some reason.

Firstly, it is worth noting that Moses had already visited Mt Sinai during his encounter with the burning bush. Moses also kept some of his 'sheep' there, although bear in mind that 'sheep' refers to Moses' followers:

> Now Moses kept the flock of Jethro his father-in-law, the priest of Midian: and he led the flock to the backside of the desert, and came to the mountain of God, even to Horeb. [B5]

This quote is doubly useful, as it gives us another name for Mt Sinai – Horeb. Horeb (Choreb חרב) is said to mean desert, but it is later confirmed in the Bible that Horeb is not only a mountain, but is actually another name for Mt Sinai. So Mt Horeb is Mt Sinai: one name meaning desert and the other meaning 'sharp', or perhaps 'peak'. A 'desert peak' is a rather apt name for Mt Sinai, one might think. But then, into this debate, comes another mountain – Mt Hor, the mountain that Aaron was buried in. Now because of the chronology of the biblical exodus, this mountain has moved over to the eastern side of the Sinai peninsular, somewhere towards Jordan. Is this true, or is Hor simply another name for Horeb?

> And Moses did as the Lord commanded: and they went up <u>into</u> mount Hor in the sight of all the congregation. [B6]

Certainly the talk of ascending Mt Hor is very similar to that of Mt Sinai and Mt Horeb. Whatever the case, the name 'Hor' may assist us with the translation of Mt Horeb because the word *Hor* seems to be another Egyptian word, where it was pronounced *Har* and means mountain, just as one might expect. Remember that the Hebrew language does not use vowels, so their Hor and Horeb may equally be Har and Hareb.

Fig 36. Har – mountain.

A tentative link is being made at this stage between these two peaks, which will be confirmed later. But what of the shape and size of Mt Sinai? What, if anything, is said of this? The records here are rather scanty and the

descriptions poor. We have already seen Josephus' description of it being sharp and difficult to climb, and the only real reference to be found in the Bible adds that:

> And thou shalt set bounds unto the people round about, saying, 'take heed to yourselves, that ye go not up into the mount, or touch the border of it: whosoever touches the mount shall be surely put to death. There shall not an hand touch it, but he shall surely be stoned, or shot through'. [B7]

> Set bounds about the mount, and sanctify it ... but let not the priests and the people break through to come up unto the Lord, lest he break forth upon them. [B8]

Now this is a curious thing to say about a mountain; how can the base of the mountain be so sharply delineated that one can separate the people from it? Most mountains gradually keep rising and rising into a peak. To be able to separate the people from the mountain in this manner would imply that the base of the mountain has a distinct change between the valley floor and the mountain itself – something resembling a cliff perhaps. Since Josephus said that Mt Sinai was 'difficult to climb', that may well be the case.

And how was this 'setting bounds' around the mountain achieved? The texts make it appear as if the priesthood had placed a complete cordon around the base of the entire mount; but how does one cordon off an entire mountain? It makes it sound as if Sinai was not only quite steep and difficult to climb, but a rather small mountain too.

Troglodytes

The investigation desperately needed more descriptions of these mountains: exactly what did they look like? A clue came from another tribe mentioned in the Bible – the Horim or Horites (Choriy חרי). The Horim were a people who were associated in some way with Mt Hor, and perhaps also with the similar sounding Mt Horeb. But the role or lifestyle of these people in respect to Mt Hor was quite specific, for the translation of Hor in Hebrew is that of cave-dweller.

This is possibly confirmed by the Egyptian word *Haa*, meaning cave. The Horim are described as simple cave-dwellers but, for some reason, these simple folk were deemed to be a threat to the Israelites and they

were ruthlessly slaughtered by the sons of Esau, who then proceeded to take their place in the caves!

> The Horims also dwelt in Seir before time; but the children of Esau succeeded them, when they had destroyed them from before them, and dwelt in their stead. B9

The fate of the Horims is a bit of a tricky event to explain. Why would anyone want to slaughter some cave-dwellers and take their place? Esau has already been identified as being a very great and influential person within Egypt, the brother of a pharaoh no less, so why should such an influential individual want to bother with troglodytes?

The texts say that the cave-dwellers lived in *Seir* (Seiyr שֵׂעִיר), which we are later told was yet another mountain. So what were the Horim doing in the mountains and where was this mountain called Sinai/Seir? The mention of Horim in relation to Seir seems to confirm the supposition that Hor is a short form of Horeb, for we now have two pairs of mountains. Hor and Seir, Horeb and Sinai. Since Horeb and Sinai are either the same mountain or next door to each other, is the same also true of Hor and Seir? Can all these peaks be linked together?

Confirmation that Seir and Sinai were linked was quickly forthcoming, for although the clergy like to place Seir over in the east, it also appears to be intimately associated with Mt Sinai:

> And he said, The Lord came from Sinai, and rose up from Seir unto them; he shined forth from mount Paran. B10

> And the children of Israel took their journeys out of the wilderness of Sinai; and the cloud rested in the wilderness of Paran. B11

Note in the first quote how the Israelite 'Lord' is being directly equated with the Sun. The 'Lord' was rising up and shining forth, and it quite obviously must have been a manifestation of Ra. The Sun also seems to be making a grand tour over the three mountains, from Sinai, to Seir, to Paran. It is almost akin to a diurnal journey, with one mountain in the east, one in the south and one in the west; and the Sun passing over all three during the day. The parallels between this description and the ritual observation of the Sun on the Giza plateau (as explained in chapter I), are striking.

All three of these 'mountains' appear to be very close to each other and they seem to have something else in common, too. The Horim cave-dwellers lived <u>in</u> Mt Seir and Seir seems to be located somewhere near

6. Sinai

Sinai. But Mt Paran (Paran פאר‍ן) also means 'caverns' or 'caves'. In this case, two of the four mountains here seem to have a cavern inside them, so what about Mt Sinai and Mt Hor; do they have caverns too?

> And the Lord spoke unto Moses and Aaron <u>in</u> mount Hor, by the coast of the land of Edom, saying ... [B12]

> And Moses did as the Lord commanded: and they went up <u>into</u> mount Hor in the sight of all the congregation. [B13]

Moses and Aaron do not just go up the slopes of Mt Hor to converse with god: they actually go <u>inside</u> it. It would appear that Mt Hor also has a cavern. Yet I have already identified Mt Hor with Mt Horeb and Mt Horeb is, in turn, either next to or another name for Mt Sinai. In this case, what evidence is there for a cavern inside Mt Sinai?

> And the Lord said unto Moses, Come up to me <u>into</u> the mount (Sinai), and be there: and I will give thee tables of stone. [B14]

> And afterward all the children of Israel came nigh: and he gave them in commandment all that the Lord had spoken with him <u>in</u> mount Sinai. [B15]

> These are the statutes and judgements and laws, which the Lord made between him and the children of Israel <u>in</u> mount Sinai by the hand of Moses. [B16]

> These are the commandments, which the Lord commanded Moses for the children of Israel <u>in</u> mount Sinai. [B17]

It is apparent that all of these mountains were in close proximity to each other and now it is also beyond doubt that all four had caverns or chambers deep inside them. Indeed, some of these caves were 'inhabited' by tribes and others could be visited by Moses and his god. This is nearly enough data for us to now make an educated identification of the true locations of Mt Sinai and Mt Horeb. We are beginning to peep behind this confused veil of obfuscation, but there needs to be another revelation before the real truth can be seen.

* * *

6. Sinai

Secrets

The little secret goes something like this. If you take an electronic Bible and type in a search for the word 'pyramid', the machine will grind its way through the long text and it will eventually beep a solemn lament and say 'nothing found'. Isn't this a little strange? The biblical patriarchs were resident in Heliopolis, which is just an arrow's arc away from Giza. The Giza plateau, with its three great pyramids, is not just a wonder of the ancient world, but a stupendous wonder of the modern world too. Here we have, in the form of the Bible, a complete family history of the Israelite patriarchs who lived in Heliopolis and yet it would appear that none of them ever had tea at the pyramids or noticed these great 'mountains' on the near horizon.

People today not only come from all over the world to see the pyramids, but the locals do just as I have described: they go and sit and take tea under the pyramids – it is a social gathering place of national importance. I am sure that exactly the same applied in the era of the patriarchs, if not more so. While I am sure that some parts of the plateau were considered to be sacred and so certain sections of the pyramids would have been 'cordoned off', exactly as Moses did at Mt Sinai to prevent his followers from touching the 'mountain'; nevertheless, I am sure that the Giza plateau would still have drawn in some massive ancient public-holiday crowds.

Remember that the pyramids were a commercial enterprise, the same as the great temples of Upper Egypt were. They needed income to maintain the site and to pay for the priests and officials who worked there. The way this would have been achieved was by both tithes (taxes) and the time-honoured method of the common people making offerings. The most common offering in Egypt was a bread offering in a conical form; a shape probably representing either the pyramids or the Benben stone from Heliopolis. But wealthier individuals could come and offer fish, poultry and beef to the gods, and at the same time line the pockets (or the storehouses) of the priesthood.

Indeed, the large bakery and butchery that provided for this industry was recently discovered at the foot of the Great Pyramid. It was instantly interpreted by the archaeologists on site as being the bakery for the workers who actually built the pyramid, but there is not a shred of evidence to support this assertion. Instead, it is much more likely that this large bakery and butchery provided the offerings for the rich trade in pilgrims who visited the Giza plateau.

From Abraham to Moses, each and every one of the patriarchs could have come and made an offering at the pyramids; then they would have

subsequently mentioned this in the biblical accounts. More importantly, bearing in mind the whole thrust of this book, the patriarchs from at least Abraham to Jacob were pharaohs of Egypt; while the later patriarchs from Joseph through to Moses were high priests of Heliopolis, at the very least. These important officials and rulers would have not only come to Giza to make an offering at the pyramids, they were most probably the very high priests who were officiating at the service itself!

So why, then, are there no references whatsoever to the pyramids of Egypt in the Bible? The answer is obvious: the Bible *does* mention the pyramids, and it mentions them quite often; but the names of all the pyramids have been deliberately obscured by the scribes. The Giza plateau is mentioned in the Bible, as is the Great Pyramid itself, and the biblical name of the latter is Mt Sinai.

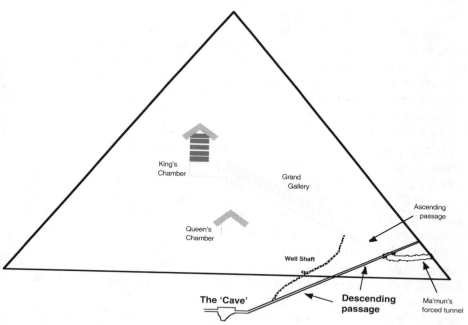

Fig 37. Mt Sinai.

Pyramids

Now, that will be a monumental upheaval for the orthodox clergy to absorb. But while this claim may at first seem wild, as it sinks in it begins to make

more sense. In the biblical accounts, there appear to have been about three or four sacred mountains. All of them appear to have had caverns deep inside; and at least one of those caverns, Mt Sinai's, once harboured the Israelite deity. While the biblical account was difficult to equate to a natural mountain, it makes every sense in terms of the layout of the Great Pyramid. Mt Sinai itself is described as being sharp, pointed, difficult to climb, small enough to be cordoned-off, and yet the highest peak in this area.

The Great Pyramid conforms to each and every one of those descriptions: it would have been very difficult for Moses to climb; it can easily be 'cordoned off'; it is sharp and pointed; and it contains a cavern deep inside its interior. Bear in mind that all the upper chambers of the Great Pyramid would have been sealed and concealed by limestone and granite plugs. The upper chambers were not discovered until the ninth century AD; prior to that time, only the rough cave deep under the pyramid would have been accessible. The conclusion is becoming inescapable – Mt Sinai is the Great Pyramid of Giza.

A great number of events occurred in the Bible at Mt Sinai, and the most important of those was the meeting between Moses and god. The majority of these events also took place in front of a large congregation. But the Giza plateau is primarily a necropolis – a place of the dead – and many Westerners would not consider a graveyard to be a great meeting place for a religious ceremony. That, however, is a matter of custom. It was not so long ago that many of the population of Ireland would pack a picnic box and go to the graveyard of a Sunday afternoon, along with thousands of their compatriots. It wasn't a religious service as such, but the parents met, the children played and the people stayed in touch with their ancestors.

The pyramids, too, must have been a place of worship. We have seen the ritual of the observation of the Sun along the pyramid causeways; likewise, there are the great Arks of Noah – the Solar-boats of Ra – that sat in their massive tombs at the foot of the Great Pyramid. Now surely these hugely expensive boats did not just get a sending-off after their initial construction and burial – only to be forgotten about ever after. The myths of the Solar-barques, and the presence of that myth within the Bible, all indicates that this was a regular celebration for the people. Perhaps once a year, or once a season, the population would assemble at Giza and hear the liturgy of the Sun's journey in these sacred boats, 'which are buried at your very feet, ladies and gentlemen!' ('And pass the collecting plate a bit quicker too.')

At a similar biblical event, Moses invited 70 of the Israelite high officials to go up to the temple that lay at the foot of Mt Sinai, to converse

with god. The description of this event is interesting, for the officials were amazed at the temple's construction:

> And they saw the God of Israel: and there was under his feet as it were a paved work of a sapphire stone, and as it were the body of heaven in his clearness. B18

The 'clearness' means lustre and so the comment was probably made purely in regard to the superb finish of the pavement. That the officials were so amazed at the gemlike lustre of this pavement, indicates how sacred and secret this place was; it would seem that even the high officials had not been there before. The paved work of sapphire, which looked like the night sky, is likely to have been the great basalt pavement that lay at the foot of the Great Pyramid. It was not blue (sapphire) but black; it would have been as smooth as polished ice and studded with small silica inclusions that, at first glance, would have resembled the stars. If this interpretation of these events is true, it is interesting to have confirmation that the basalt pavement was still intact at this time.

But the officials were likely to have been there for a reason: to observe, as independent witnesses, Moses' ascent up to the entrance of the Great Pyramid, which is some way above the pavement surface, on the northern side of the pyramid. But these would not have been the only people there on the plateau. It is now apparent that the Horim troglodytes had been guarding the Giza plateau, but they had been defeated and replaced by the sons of Esau. The Koran gives some other descriptions of these guardians and the treasures that they watched over, as we shall see shortly.

Sleepers

As the investigation continued, I found that some of the best information on the shape and form of Mt Sinai is actually to be found in the Koran. Firstly, it has to be noted that the lower chamber of the Great Pyramid was always open for the priesthood, even in this era, as I narrate in the book *K2*. It was only the upper chambers within this pyramid that were completely sealed and concealed.

So, when reading the following tracts from the Koran, try to imagine yourself as a young, god-fearing initiate who is being taken through the first steps towards enlightenment. Place yourself halfway down the descending passage leading into the heart of the Great Pyramid, a flickering candle

your only illumination in the world; perhaps precariously hanging onto a rope to prevent yourself from plunging into the gloomy depths. Think of your state of mind if, on top of all this, you also understood that 'god' lived in the cavern deep below you:

> When (god) suspended the Mountain (Mt Sinai) over them as though it were a shadow, for they feared that it was falling down on them, (god) said 'Hold fast to that which he has given you and bear in mind what it contains ...' K19

> When you depart from them and their idols, go to the Cave for shelter. God will extend to you his mercy and prepare for you a means of safety. K20

While the first quote from the Koran is definitely talking of Mt Sinai, the second is not so certain; but the mention of 'departing from their idols' just has to be a reference to the making of the golden calf at the foot of Mt Sinai.

Despite these quotes being references to Mt Sinai, both of them have a distinct ring of hanging onto a rope while plumbing the depths of the Great Pyramid. 'Hold fast to that which he has given you and bear in mind what it contains' translates as 'hold fast onto the rope, and bear in mind what the cavern below you contains'. Likewise in the second quote, a rope has been provided for the initiate's safety.

But if the 'Cave' is a reference to the cavern inside the Great Pyramid, then there are some other interesting things to note about this event. The next reference to the Cave in the Koran is more enigmatic:

> Did you think the sleepers of the Cave and Al-Raqim were a wonder among Our signs? When the youths sought refuge in the Cave they said, 'Lord have mercy on us and guide us out of our ordeal'. We (god) made them sleep in the cave for many years and then awakened them to find out who could best tell the length of their stay. K21

> You might have thought them awake, though they were sleeping. We turned them about to right and left, while their dog lay at the cave's entrance with legs outstretched. Had you looked upon them, you would have surely have turned your back and fled in terror. K22

This is a curious event in the life of Mt Sinai, but much more understandable in terms of the sacred nature of the Great Pyramid. Firstly the identity of Al-Raqim is unknown. In Egyptian, however, *Ra-Qim* would

translate as 'Ra of Egypt' or the 'Sun-god of Egypt'. Secondly, since the lower chamber of the Great Pyramid was always open, it is highly probable that this chamber was used. The strange passage in the Bible about the Horim people who 'lived' in Mt Seir and Mt Hor is perhaps testimony to that. Their 'cave' or chamber was certainly important enough for them to be killed and for the sons of Esau to take over the location. I am not imagining here a Bedouin family actually living inside the pyramid; instead this reference has to be in regard to the *guardians*, the high officials that governed the pyramid plateau.

If the Giza pyramid's chambers were being used in some manner, then the second puzzling thing about this extract concerning the 'sleepers' is also easy to explain. No doubt the Hyksos/Israelite pharaohs wished to be buried in an imposing edifice and what better monument for that than the Great Pyramid itself? The lower chamber of the pyramid had always been accessible and, as long as there were officials at the entrance to guard the tomb, what better place to rest the royal cadaver? The Hyksos had simply usurped either the Great or even the Second Pyramid for their own use, as either a tomb or cathedral.

The seven sleepers were simply the seven (the exact number is uncertain) mummies of the Hyksos kings. This is why the initiate thought they were sleeping; they were not, of course, but a finely decorated anthropomorphic sarcophagus can look very real in the flicker of a candle. The amount of time the sleepers had been there was about right, too; again, the time span is uncertain, but they were guessing at from three to nine hundred years. Had they been Hyksos pharaoh mummies, they could have been there for as long as 300 years. This is probably why the patriarchs, like Joseph, demanded that their 'bones' be taken with them on the exodus: they knew that the location of their tomb would not be secure without political and military control over the plateau. Their mummies were obviously not secretly hidden in a remote rock-face tomb; they were probably placed in the chambers of one of the Giza pyramids.

That dog in the Koran's account; is that familiar, too? The outstretched legs, poised at the entrance to a cave? In Egyptian terms, this has to be a reference to Anubis (*Anpu*), the jackal god of the dead. Like the sons of Esau, Anubis was the guardian of the necropolis and known as the *Tepy-dju-ef*, or 'he who is upon the mountain'.

To the great god in Rutisut;
(To) Anubis upon his mountain,
To the embalmer who presides over the shrine,
(And to) all the gods in Rostau. [23]

6. Sinai

The dog of the seven sleepers is performing exactly the same duties; he is guarding the secret chamber of the dead and he sits at the entrance to the Great or Second Pyramid, the former of which is perched some distance up the north face of this particular 'mountain'.

Fig 38. Anubis (Anpu) – Tepy-dju-ef.

But the word *Tepi* has other meanings, and this perhaps gives us the clue as to what Anubis was really doing there, at the entrance to the Great Pyramid. He was not simply looking out and watching over the necropolis, as the Egyptologists would have us believe; for a start, there is not much of the Giza necropolis that can be seen from the north face of the pyramid. The secondary meanings of the word *Tepi* are, 'something pointed', 'first day of the year', 'first day of the month', 'first rays of the dawn'. Basically, *Tepi* is something calendrical. The method by which Anubis was related to both the calendar and time is given to us by the Koran.

> You might have seen the <u>rising Sun decline</u> to the right of their cavern, and, as it set, *go past* them <u>on the left</u>, while they stayed within. That was one of god's signs. [K24]

That is a typically confusing Koranic sentence but, with a little insight, it *can* be explained. The only way to have the Sun rising on your right and setting on your left is to stand facing north, with the Sun behind you at midday. This is just the position Anubis would have been in, sitting at the entrance of the Great Pyramid. But there again, how does the rising Sun decline? As is often the case, the Koran is far too succinct and the meaning of the text is often lost to us. But Anubis and *Tepi*, the rising Sun, shows us the way forward.

Tepi refers to something calendrical or diurnal: it pertains to time. The best way to follow the course of time, especially in somewhere as sunny as Egypt, is to set up a sundial. A sundial is simply something pointed, resting on a grid of some nature; a gnomon and dial. The time of day is simply ascertained by watching the course of the shadow that the gnomon produces. As it happens, the Great Pyramid is about the largest gnomon in the world, even by modern construction standards. As we saw in chapter I, one of the major functions of the Giza pyramids was to throw a shadow down the causeway, and one of the major rituals of the plateau involved watching the course of that shadow. So, the passage from the

Koran most probably has nothing to do with the motion of the Sun, as such, but instead it describes the passage of the Great Pyramid's shadow across the ground.

The situation being described was actually like this. The observer stands to the north of the pyramid, facing south and looking at the pyramid itself. The Sun is rising on the left of the pyramid, but *its shadow* is on your right and it is getting shorter; ie, it is 'declining to the right'. Likewise, as the Sun is setting to the west of the pyramid, *its shadow* is 'passing to the left' of the observer. *That* is what was considered to be one of god's signs.

The Egyptian religion was obsessed by timing, whether it be daily, monthly, yearly, centennial or millennial. Time was one of the secret forces of the cosmos, one of the great powers of the Universe. The Sun was the standard by which time was both metered and monitored and thus, Ra became the supreme god of the cosmos.

That the Israelites/Hyksos were following this age-old tradition means that they had absorbed all of the fundamental tenets of the Egyptian religion; the only point of contention between them and the Theban Egyptians, however, was that the Israelites/Hyksos wanted to get 'back to basics'. The Hyksos/Israelites wanted to do away with the distracting plethora of demigods and concentrate on the 'great deity'. The 'great architect' was manifest in the Sun as Ra, Atum, Aton, Adhon, Eli; and, in his ghostly night-time form, he was the Moon, the Silver-Sun, Khonsu, Djeheuti and even Yaheweh,

Quails

The origin of this tale of the seven sleepers is obviously quite old, at least prior to the sixth century AD and the Koran. Another copy of it surfaces in the *Decline of the Roman Empire* by Edward Gibbon, and the text here is taken from Gregory of Tours.

The story is of the same 'seven sleepers', who were sealed in a cavern and secured with a 'huge pile of stones'. In this version the, number of years for the sleepers' interment is given as exactly 187 years – well in line with the projected history of the Hyksos in Egypt. The text then goes on to say that the 'inheritance of the mountain' has gone to Adolius, an account that dovetails nicely with the biblical account indicating that the sons of Esau had inherited Mt Seir [Mt Sinai] from the Horim tribe. The 'slaves of Adolius' was probably a reference to the 'followers of Adhonai', or the 'followers of Yaheweh'; Adolius just has a typically Greek suffix added to the god-name Adhon.

But, why does the Bible describe Esau apparently taking over control of Mt Sinai from the Horites at this late period in Hyksos history? Well, if the Hyksos had started to take control of Lower Egypt at the time of Abraham, if not before, they may not have been able to secure control of the all-important Giza plateau at that stage. By the time of Jacob (brother of Esau), they had become powerful enough, but the original guardians on the plateau were not going to give up without a fight, and so the entire tribe of the Horim was wiped out in the ensuing battle. The Hyksos exodus appears to have occurred at the time of this same biblical Jacob [Hyksos pharaoh Jacoba]; so perhaps this taking control of the sacred plateau from the Horim was one of the last straws in the bitter dispute with Thebes that precipitated the first exodus.

Gibbon, in his epic work, goes on to mention other details of the sleepers' story. The sleepers grew hungry and one of them went out secretly from the cave and bought bread; but the subterfuge was rumbled when the archaic language and coinage of the sleeper was discovered by the baker, and the sleeper ran back to the cave. A high official hastens to the cave to find that the sleeper is indeed awake: the sleeper bestows his benediction upon the official and then returns to his slumbers. Details such as this return to 'sleep' just serve to confirm that we are really dealing with a tale of embalmed mummies and the officials who guarded them. The Koran, however, confirms but also confuses this strange issue of the purchase of bread:

> Let one of you go to the city with this silver coin and bring you back whatever he finds most wholesome there. Let him conduct himself with caution and not disclose your whereabouts to anyone. For if they find out they will stone you to death, or force you back into their faith. [K25]

The strange tale of buying bread and other foods in secret is, I think, explained in terms of a biblical miracle. The episode of quails and manna occurred in the location known as Sin (Ciyn סִין), which in Hebrew is yet another place of 'uncertain origins'; but it seems to have the same derivation as Sinai. From Sin, the people then 'journeyed' to Rephidim where they found no water. Moses strikes a rock, which was at or on Horeb, and discovered water. But Horeb (Choreb חֹרֵב) was, as explained previously, simply another name for Mt Sinai. So in fact, the tribes had gone absolutely nowhere; they were still at Mt Sinai – on the Giza plateau.

Then comes a quick interlude in the Bible, with a battle against the Amalekites; an event that sounds rather like the battle against the Horim for control of the Giza plateau. The battle only goes well if Moses keeps his

arms up, but Moses grows tired and so his arms are kept propped up by Aaron (his brother) and Hur. This new character, Hur, is said to be a 'chief assistant' of Moses, but it is odd that he is never mentioned in the Bible before this time; he just appears as if from nowhere to take this important role in the battle.

The obvious solution to this nonsense is that Hur is not a person but an artifact. Hur means cave in Hebrew and may be related to Hor, which is the Hebrew name for mountain and the root of the name Horeb. The Egyptian equivalent of the Hebrew word *Hor* is *Har*, meaning a mountain, or *Haa* meaning cave. Thus, Hor [Har] and Haa [Hur] have the same meanings in both languages. The inference is clear; Aaron held up one arm of Moses, while the other was supported by the Great Pyramid itself [Har, Hur]. Thus, the Israelites were still at Mt Sinai and so the event with the bread and quails was also at Mt Sinai; in this case, the miracle of the quails occurred on the Giza plateau and it can therefore be explained in much more logical terms.

Moses was a master of subterfuge and propaganda. The people were unhappy with their position regarding this dispute with the Theban army, and they needed a sign from god(s) that all was well. The answer was a gift from god. The Israelite 'god', in his more physical form, was deemed to live inside Mt Sinai [the Great Pyramid], so Moses *secretly* sent the guardians of the 'sleepers' [the sons of Esau] from the chamber of the pyramid off to the town to buy food. Later, this food was then thrown out of the entrance of the pyramid and this largesse was perceived by the Israelites as a gift from the god that lived inside the pyramid. As the texts say of this event:

> ... the (quails) fell down upon the Israelites, who satisfied their hunger with them. [B26]

> ... this (bread) comes down in rain, according to what Moses obtained from god, who sent it to the people for their sustenance ... So the Israelites were very joyful at what was sent to them from heaven. [J27]

Moses, the master strategist, had pulled off another marvellous stunt. For the price of a few loaves and quails, he had assured himself of the unquestioning loyalty of his people. It may have been a slight corruption of the Egyptian beliefs, to have 'god' sitting inside the pyramids and hurling bread and quails out of the entrance, but for now that was unimportant; there was a civil war to be won and civil wars are not won on the battlefield, but in the hearts and minds of the people.

6. Sinai

Anubis

The explanations above infer that the Koran's description of the sleepers and their dog is nothing less than a reference to Anubis and some of the arcane rituals that were played out upon the Giza plateau. While this may initially appear to be a long shot in this identification of the true meaning of the biblical-type texts, there is further evidence to be found that supports this idea.

Going back to chapter I, it will be remembered that the explanation for the terms of east and west involved the original rituals that were performed on the Giza plateau. The glyph for west, for instance, was formed from sub-units that spelt out the act of watching for the shadows of the Great or Second Pyramids aligning themselves with their great causeways. That, too, may have seemed to be a shot in the dark, but remember the Koran's odd description, which was interpreted as the movements of the shadow of the pyramids.

The Egyptian descriptions of the role of *Anpu* (Anubis) simply serve to reinforce this interpretation; they describe *Anpu* as the 'personification of the summer solstice' and his alter ego, in the form of *Ap-uat*, as the winter solstice. [28] The links continue when we find that Anubis was also described as the 'four quarters of heaven and Earth and the four seasons of the year'; and he was perhaps also linked with the points of the compass. Finally, *Anpu* (Anubis) was also linked with concepts of time, as already described. In fact, all of the attributes of *Anpu* are also the attributes already described for the hieroglyphic symbols of east and west, and attributed to the rituals on the Giza plateau. The shadows of the Sun were observed at the half-solstices and they regulated the seasons, and thus the flooding of the Nile.

Classical Egyptology might say that *Anpu* and *Ap-uat* were separate gods, although both were jackal gods and they were often confused in the literature. But this separation of these two gods is based on an ignorance of the original roles of the twin jackals. The prime roles of both jackals was as the 'opener of the roads' for the dead to enter the Kingdom of Osiris, or heaven. This could, of course, be a metaphorical description, but it could also be a physical reality. If the jackals were sitting at the entrance passages to the greatest of the Egyptian pyramids, then they would indeed be the 'openers of the passageways', ready for the dead to pass through for their ritual burials. Since there were at least two great pyramids on the Giza plateau, the guardians would have required at least two manifestations of Anubis to watch over the entrances and open the passageways.

In addition to this role, the jackals were also related to the seasons of the year. *Anpu* was a personification of the summer solstice, while his twin *Ap-uat* represented the winter solstice. The solstices (the half-solstices) are marked by two separate pyramids, each having its own chamber, passageways and guardian jackal. If the jackal-gods were observing the pyramids' shadows down the pyramid causeways, as seems likely, then *Anpu* (the summer solstice) would be the guardian of the Second Pyramid, while *Ap-uat* (the winter solstice) would be the guardian of the Great Pyramid. Yes, there were two jackal-gods, but they were simply identical twins that performed exactly the same function in the two greatest pyramids on the Giza plateau.

This line of reasoning now brings us to the *Book of the Dead* and an extract from the *Text of Unas*.

Keep watch, O messengers of Qa, keep watch,
O you who have lain down, wake up,
O you who are in Kenset,
O you aged ones, thou Great Terror,
Sedjaa-ur, who comes forth from Hep (Hapi), thou Ap-uat,
Who comes forth from the Asert Tree,
The mouth of Unas is pure. [29]

This short quote, from a text that was written back in the Old Kingdom era, appears to embody all the components of the Giza rituals that I have been trying to explain. Line by line, the extract begins to meld together the Koran, Bible and Egyptian history into a solid billet of real history:

Keep watch, O messengers of Qa, keep watch:
The translation of *Qa* is reasonably secure, because while *Qa* has many meanings, they all tend to describe the same type of imagery. *Qa-pet*, the height of heaven; *Qa-qait*, a high place on which the god of creation stood; *Qaa*, a high hill; *Qa-t*, height; and finally *Qa-qa*, two very high mountains. The determinative for *Qa* is often the ibis of Thoth, so the clear inference is that the text is talking about the Sanctuary of Thoth, or the Great Pyramid.

But it is not just the word Qa that is crying out to be called 'pyramid'; so, too, is the text that surrounds it. The call to 'keep watch' has to be a reference to the great watcher, Anubis, or perhaps even to the guardians of the plateau themselves – the tribe of Esau, who had defeated the Troglodytes (Horim).

6. Sinai

O you who have lain down, wake up:
This, coming as it does immediately after a reference to the watchers in the pyramids, can only be a direct confirmation of the story of the *Seven Sleepers*. Here are the sleepers of the pyramids from Roman and Islamic history, but in a reference that is much older.

O you who are in Kenset:
Kenset is described as being Elephantine once more, but of course, the name uses the 'three-hills' glyph as a determinative. The usage of this glyph almost certainly places the original location of this area as being close to Giza, as we shall see shortly.

O you aged ones, thou Great Terror:
The 'Great Terror' is *Sedjaa-ur*, the god of thunder and earthquakes. This quote now starts to blend in some biblical content, for the patriarchs were all accredited extra longevity and the mention of thunder and tremors is a favourite biblical phrase, when made in conjunction with Mt Sinai [the Great Pyramid].

Sedjaa-ur, who comes forth from Hep (Hapi), thou Ap-uat:
In the context of classical Egyptian mythology, it is difficult to understand how the storm god relates to Hapi, the god of the Nile (storms were not the source of the Nile floods), and how, in turn, Hapi relates to Ap-uat (the twin of Anpu).

The Giza pyramid rituals, however, explain each and every aspect of this sentence. Hapi was related to the pyramids because the pyramids regulated the season of its inundation, and were therefore regarded as the source of the Nile; indeed, the Great Pyramid was called the *Tchau* or Great Lake, that measured 440 x 440 cubits. The storm-god was also constantly linked to the pyramids in the biblical-type texts and the Egyptian puns, as already explained. Likewise, Anubis is related to the Great Pyramid because he was the watcher over the necropolis; 'laying at the entrance with his feet outstretched', as the Koran puts it.

Who comes forth from the Asert Tree:
This final sentence is also interesting because the Aser-t tree is a strange feature of the traditional Giza ritual, as there are no trees growing on the plateau. The Aser-t tree is described as the tree that Ap-uat (Anubis) 'came out of', although it is not said what Ap-uat was doing in the bush in the first place, so the intended ritual is a little obscure here. There is, however, another description of this event in the Bible; one that confirms this ancient tradition of a Giza 'tree':

158

6. Sinai

> And the angel of the Lord appeared unto him in a flame of fire out of the midst of a bush: and (Moses) looked, and behold, the bush burned with fire, and the bush was not consumed ... God called unto him out of the midst of the bush, and said, 'Moses, Moses'. And he said, 'Here am I'. [B30]

Moses had been standing at the bottom of Mt Horeb or Mt Sinai (depending on the account) at the time of this vision of god. Since we now know that Mt Sinai and Mt Horeb are the massive pyramids on the Giza plateau, the name of the god that Moses saw is plain to see. The unnamed god of Moses in the biblical account, and the god Ap-uat in the *Text of Unas*: both came out of a bush at the foot of the Great Pyramid. The Koran not only agrees with the biblical description of this burning bush, it adds some new elements that confirm its location:

> When (Moses) saw a fire, he said to the people: 'Stay here, for I can see a fire (on the mountainside). Perhaps I can bring you a lighted torch or find a guard nearby.' When he came near, a voice called out to him 'Moses, I am your Lord (blessed be god who is in the fire). Take off your <u>sandals</u>, for you are now in the sacred valley of *Tuwa*'. [K31]

While the Koran is traditionally succinct, it also lets out little details of interest. That mention of *Tuwa*, for instance; it is an unknown location that is not mentioned in the biblical account, but it happens to translate well into Egyptian. As confirmation that this coming translation is based on secure foundations, the first word to match with *Tuwa* is *Tuwi*, meaning <u>sandals</u>. This mention of sandals is not only a physical command to go barefoot, it is also a scribal pun to show those in later generations, who were 'in the know', what the real translation of *Tuwa* was likely to be. This secretive method of writing is very similar to the pattern of hints and puns that are to be found in the cockney rhyming slang dialect that has developed in the East End of London.

In cockney rhyming slang, a dog and bone means a telephone: the phrase not only rhymes well with phone, but the image of a 1920s two-piece phone is quite exquisite. Similar rhymes and imagery are to be found in the husband's 'trouble and strife' and the pilot's 'joystick'.

In Egypt, the technique was more of a straightforward pun than a rhyme and so *Tuwi* (the sandals) also becomes; *Tuwa* the pillar, *Tjua* the mountain, and *Tjui* the two mountains of sunrise and sunset, which have already been identified with the pyramids of the Giza plateau. The custom

was obviously to take off one's sandals when stepping onto the mirror-smooth black basalt pavement around the Great Pyramid, as both the Bible and Koran imply, and so the sandals became synonymous with the sacred site itself. The Giza pyramids were also symbolically associated with many other, more mundane, items that came in pairs, so perhaps there was a strong link in this sandal pun directly to these pyramids.

It is probably from this tradition that the Masonic 'slipshod' pose, that of wearing only one sandal during an initiation, arose. This tradition was wonderfully portrayed in the film *Life of Brian*, where the reluctant hero Brian loses a sandal and instantly becomes a famous prophet. But this obscure detail of a cult film must have a distinguished and quite ancient tradition, for Jason does exactly the same thing at the start of his quest for the Golden Fleece; in fact, Jason was only recognised by Pelias because he had lost a sandal. Like Brian, Jason's fame, quest and destiny was forged by the loss of a humble sandal.

It should also be pointed out that the Giza pyramids were encased in *Tura* limestone, from the *Tura* quarries across the Nile. This does not appear to be an ancient Egyptian name for this type of stone, but there again, it only needs to be as old as the Koran, which dates from the sixth century AD. If *Tura* was the original Arabic name for the quarry and, in turn, for the limestone casings blocks on the Great and Second Pyramid, as seems highly likely, then the 'sacred valley of *Tuwa*' (as the Koran calls it) would be a perfect description for the small gap in between these two great monuments. This once more confirms, from a completely independent perspective and source, that the biblical 'burning bush' episode happened on the Giza plateau.

But there is a problem with this interpretation of Anubis and the bush. The Koranical account describes a lighted torch, while the biblical (and Josephusan) account describes a complete tree that was burning. The accounts of the Koran are the least embellished of the biblical texts, so it can be assumed that this ritual only involved a small tree, perhaps about two meters high. While this drastic reduction in size would accord more with the arid and barren reality of the Giza plateau, it still does not explain the burning. The Egyptian texts do not indicate that the *Aser-t* tree was burning in any way, so this surely undermines this whole thesis?

It would, if it were not for the inventive scribes. As one might expect, a pun or two has been employed here and the first of these alternative interpretations of the *Aser-t* tree gives a secure confirmation that this pun is not being made up. *Ash-t* means a jackal, the very animal that lends its image to Ap-uat (Anubis). This pun also confirms that the swap from an 's' to an 'sh' is perfectly acceptable (numerous Egyptian words involving an 's'

have exact equivalents using 'sh'). Looking at further synonyms, however, we find that *asher* means to roast, *asher-t* is a roasted sacrifice, while *asher* is the evening and also a fire or flame.

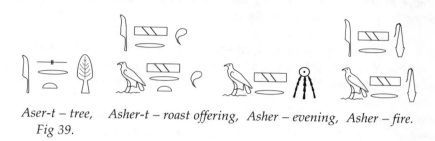

Aser-t – tree, Asher-t – roast offering, Asher – evening, Asher – fire.
Fig 39.

Not only does this scribal wordplay explain the burning of this bush, but it also shows why the Koran chose to set the scene in the evening. There is no evidence that the original ritual, on which this story was based, involved the sacred bush of *Aser-t* actually burning, or it being performed in the evening; so it has to be assumed that this was another piece of cockney rhyming slang. The London East Enders are reputed to have evolved the slang dialect so that they could talk in code without the police or informers being able to understand the location of the next robbery; the biblical slang was derived so that only the priesthood would understand that the 'burning bush' meant the sacred *Aser-t* tree of Ap-uat (Anubis). Both the laity and the police remained intentionally in the dark.

This wordplay also explains the reason for the biblical burning bush not 'being consumed' by the fire. The scribe is simply labouring the pun a little; the tree was not 'consumed' because it was not really on fire. Yes, thank you scribe, we got that one the first time! So here was Anubis' sacred tree of *Aser-t* and the strange ritual of Anubis talking through its branches.

This ritual, if not its real meaning, was certainly known about in a very late era of Egyptian history, and I confidently assert this because the same ritual has been inherited by that dumping ground for leftover arcane rites – Christianity. The modern version of the *Aser-t* tree is known as a Christmas tree and originally this, too, was 'burning' but not (hopefully) consumed. In the interests of safety, however, the candles have now been replaced by small lights. To finish this esoteric symbolism, a star is then placed upon the top – but is this the 'Star of David' or is it Sirius, the Dog Star? While Sirius is not explicitly related to Anubis, it is true that the words *Sepdj-t* and *Shedj-t* refer to Sirius and Anubis respectively. If the star of the Christmas tree were a representation of Anubis, then the re-enactment of the ritual would be complete.

6. Sinai

According to the Bible, this ritual of the burning bush was performed at the base of Mt Sinai [the Great Pyramid], a location that was confirmed by the Koran's *Tuwa* mountains. But there remains one final piece of biblical evidence that confirms again the true location for this ritual: it comes from a short extract in Genesis:

> And it came to pass, that, when the sun went down, and it was dark, behold a smoking furnace, and a burning lamp that passed between those pieces. [B32]

Now this extract concerns Abraham rather than Moses, but both these events involve the participants making a covenant with god, so presumably this 'divine agreement' was a part of what this original ritual entailed. Note that in this extract it was evening and dark, and a fire was seen; all of which is exactly as the Koran tells the story. But instead of the fire being on a mountain, it is now between two 'pieces'. Just what are these strange 'pieces'? I would suggest that another Egyptian word has found its way into Hebrew and the Torah, because the Hebrew word for 'pieces' is pronounced as *Gezer* (גזר).

And don't be tempted to suggest that Giza (Gizeh) is a modern name for the plateau. As we saw in chapter I, *Ges* was the prefix used for 'east' and 'west', which have, in turn, been translated as being pseudonyms for the pyramids themselves. In fact, the glyphs for these words use the glyph for 'side' or 'platform', indicating that the intended terminology was something like *Ges-abtet* – 'platform of the east' and *Ges-ament* – 'platform of the west'. It is not hard to see 'platform' being yet another pseudonym for pyramid.

Likewise, if the glyph for 'side' were the more important notation in *Ges*, then the biblical type texts display a very similar reverence for particular sides of these pyramids:

> We (god) delivered you from your enemies and made a covenant with you on the <u>right side</u> of the Mountain. [K33]

> You were not present on the <u>western side</u> of the Mountain when We (god) charged Moses with his commission. [K34]

Undoubtedly, each side of the pyramids had its own specific role to play in the liturgy and ritual of Giza, and this is why the term *Ges* – meaning the side – was so important. So, in both the eastern and western form of *Ges*, the word <u>*Geza*</u> (<u>*Geza-btet*</u>, <u>*Geza-ment*</u>) can be clearly seen. The Giza of

the west would refer to the Second Pyramid, while Giza of the east would refer to the Great Pyramid. In this case, it is quite understandable that the 'burning lamp', or the 'burning bush' was seen to be in between these two 'pieces'; and in turn, 'Giza' is most probably a very ancient name for the plateau. Note that in the examples in figure 40, the 'm' plinth glyph can be replaced with the 'g' throne glyph, giving the pronunciation 'ges' rather than 'mes'.

Geza-btet – platform/side east, Geza-ment – platform/side west.
Fig 40.

Trio

There is mounting evidence (pun intended) in the Egyptian record and lexicon that Mt Sinai was actually the Great Pyramid of Giza. But there seemed to be a great confusion of the names of these mountains [pyramids] earlier on in this chapter: Sinai, Horeb, Hor, Paran and Seir. It hardly seems likely that they can all really be different names for the same pyramid, so am I making too many assumptions here? Not necessarily; remember, there is more than one pyramid at Giza and there is still Dahshur to consider. The names of the biblical mountains and their Hebrew translations that we have seen so far are:

Sinai	=	Sharp
Horeb	=	Desert
Hor	=	Mountain
Seir	=	Hairy
Paran	=	Caverns

Many of these names can be seen to be equivalents of each other or neighbours of each other, as previously explained. These assumptions can be further confirmed because many of these places also have a common denominator – the town of Kadesh:

... the wilderness of Sin, which is between Elim and Sinai. [B35]
... unto the wilderness of Paran, to Kadesh.
... journeyed from Kadesh, and came unto mount Hor.

... that is the water of <u>Meribah</u> in <u>Kadesh</u> in the wilderness of <u>Zin</u>.
... they removed from Kadesh, and pitched in mount Hor.
... and pitched in the wilderness of <u>Zin</u>, which is <u>Kadesh</u>. [B36]
... the waters of <u>Meribah-Kadesh</u>, in the wilderness of <u>Zin</u>. [B37]

Now Zin = Sin = Kadash and since Sin = Sinai, then Kadesh must also be near to Mt Sinai. But a crafty scribe must have noticed this little possibility and went around changing most of the names of *Sin* to *Zin*, so that it could be read as being a different place. The giveaway to this deceit is the linking name of Meribah. Meribah was the water-hole that Moses found when he struck a rock, and he did so while standing on Mt Horeb (Mt Sinai). Therefore, while Meribah is in Zin, Meribah is also in Sinai, so Zin must be the same location as Sinai. Equally, Sin is next-door to Sinai, so Zin must also equate to Sin. Finally, the text clearly states that Kadesh was in Meribah, so Kadesh must be near to Mt Sinai (Giza).

> Behold, I will stand before thee there upon the rock in Horeb; and thou shalt smite the rock, and there shall come water out of it ... And he called the name of the place Massah, and <u>Meribah</u>. [B38]

Both *Meribah* and *Massah* echo the image of Mt Sinai itself. The Hebrew translations of these words, 'strife' and 'temptation', do not sound very convincing. But although they seem to bear no relation to the Hebrew, the Egyptian versions of 'pyramid-flood' and 'foundry' seem to be more reasonable. Moses caused a flood at the pyramids and Mt Sinai was perceived to be a furnace. These are very speculative translations, but interesting nevertheless.

So, Kadesh is close to Mt Sinai, and Zin (Tseen צִין) *does* equate to Sin (Ceen סִין), and not surprisingly, both of these words were derived from the Hebrew word for 'thorn' or 'prickle'; which is the same meaning as is given for Mt Sinai itself. But Zin (Sin) is also near to Hor and Paran.

The next link that is required is between Hor and Horeb. Again, the scribe saw us coming and placed an 'eleven-day journey' in the text, but this bracketed sentence is quite obviously a later insertion to try and separate Hor from Horeb. Without it, the situation would be clear, Mt Hor is Mt Horeb, which is Mt Sinai.

> And when we departed from Horeb, we ... came to Kadesh. (There are eleven days' journey from Horeb by the way of mount Seir unto Kadesh.) [B39] (Bible's brackets)

6. Sinai

Doppelganger

So how, you might be wondering, did such a confusion arise? Why are so many Egyptian locations apparently explained in the Bible as being in Syria/Palestine? The problem that the translators were faced with was the obvious duplication of locations in Egypt and Palestine, and there are two possibilities as to how this occurred.

Either the scribes have replaced many of the Egyptian names in the texts with Judaic alternatives, which seems unlikely; or, after the exodus of the Hyksos/Israelites to Palestine, the people named many towns in their new land with the names that they had been used to in Egypt. This is not only highly likely, it can be demonstrated as fact. A typical example of this transposition is the biblical land of Goshen. Now in the Bible, Joseph brought his family to live in Goshen:

> And thou shalt dwell in the land of Goshen, and thou shalt be near unto me, thou, and thy children, and thy children's children, and thy flocks, and thy herds, and all that thou hast. B40

We know that Joseph was in Egypt at the time and that his family came to live in Heliopolis, so, in this case, Goshen was a province near Heliopolis. However, later on in the Bible, Goshen also turns out to be a province in Palestine:

> So Joshua took all that land, the hills, and all the south country, and all the land of Goshen, and the valley, and the plain, and the mountain of Israel, and the valley of the same. B41

The land of Goshen can mean two things, depending on the era. Prior to the exodus, Goshen was near Heliopolis, but afterwards it became a province in Israel. Clearly this duplication in terminology is both confusing for us and possibly useful to the biblical scribes. An honest reporter may be genuinely perplexed, but a scribe who wants to distance Israel from Egypt may jump with glee.

Furnace

The 'travels' of the Israelites in the 'wilderness of the Sinai' seem to confirm that all of these 'mountains' [pyramids] were either the same or in close proximity to each other. The place to look for confirmation of this is in the

original annals and place names of Egypt. This was to prove to be fertile ground once more.

The first name I looked at was Hor. As we have already seen, this Hebrew word may be derived from the Egyptian *Har,* meaning mountain. But the root word *Haa* has a few other forms and, because of the Egyptians' love of the odd pun, I took the time to look at these explanations too. The result was that *Haa* can also mean 'descend', 'cavern', 'burn', 'furnace', 'afraid'. Then I remembered that the Koran spoke of people <u>descending</u> inside a mountain. Likewise, both Josephus and the Bible talk of the Israelites being <u>afraid</u> when they were at Mt Sinai:

> This sight, and the amazing sound ... disturbed the Israelites to a prodigious degree, for these (sensations) were not such as they were accustomed to and ... they contained themselves within their tents ... and expecting like destruction for themselves. [J42]

> And Moses hid his face; for he was <u>afraid</u> to look upon God. [B43]

But the description that convinced me that the Bible was speaking in puns once more, was that of Mt Sinai itself.

> And Mount Sinai was altogether on a smoke, because the Lord descended upon it in fire: and the smoke thereof ascended as the smoke of a <u>furnace</u>, and the whole mount quaked greatly. [B44]

The description of smoke billowing everywhere when god appeared on the mountain has always seemed a little odd; just why should god appear in the form of fire and clouds? In truth, the Great Pyramid was not really on fire; this was simply a pun on the Egyptian word *Har*, which means both 'furnace' and 'mountain'. Likewise, the mount 'quaking' is no more than a reference to *Sedjaa-ur* the Great Terror, or the god of tempests and earthquakes, from the *Text of Unas,* as already explained.

Was this word *Har* (Mt Hor) in the Bible a description of a real mountain, as they would have us believe, or was it instead one of the pyramids on the Giza plateau? At last, we can see the biblical deceit, for it so happens that Har has one more meaning in Egyptian: it is the original name for the Third Pyramid on the Giza plateau, the pyramid often ascribed to the pharaoh Menkaure.

* * *

6. Sinai

Fig 41. Har - Third Pyramid of Giza.

If the pyramids (mountains) of Hor and Horeb, Seir, Sinai and Paran are all on the Giza plateau, then what was all this long journey about that the Bible describes? According to the Bible, the Israelites seem to be continually on the move from one mountain to another for a symbolic period of 40 years: what was it all for? The following diagram may either assist or further confuse this issue:

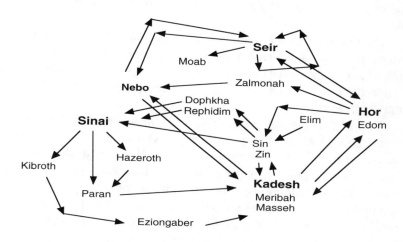

Fig 42. The wanderings in Sinai.

Firstly, note that the Bible specifically says that Sin *is* in Kadesh; that Nebo *is* in Moab; that Hor *is* next to Edom; that Meribah *is* Kadesh; that Edom *is* in Hor; and that Seir *is* in Edom. Thus, several of these places are either identical or next door to each other. Likewise, the Book of Numbers provides another comprehensive list of the various Israelite encampments; these start in Sin, pass through Sinai ten encampments later and terminate in Zin. After no less than 31 stopping points, the Israelites were back where they started.

Secondly, note that the majority of these places are known as 'mountains'; so if the text is taken literally, it would appear that the Israelites

were just hopping from mountain top to mountain top and going around in circles, with half a million people and all their baggage. It is an unlikely scenario in the extreme. The Sinai peninsular is one of the most barren places on the face of the Earth; it has no cities; no permanent rivers; and little in the way of vegetation. It would be folly in the extreme to lead half a million people into this region, and it is inconceivable that such a vast population could last there for more than four weeks, let alone 40 years. The text is just not credible. But the reality of the situation is more believable; this mountain trek was *not* part of the real exodus!

There *was* such an event as the great exodus, but it did not take the 40 years that the Bible describes and, therefore, not all of this great long journey is quite as it is written – some of it is much more local, if not metaphorical. The truth is that the majority of these places were actually pyramids, and so this part of the exodus story (the wanderings in Sinai) actually describes a religious procession that went from pyramid to pyramid.

Confirmation of this explanation lies, in all places, at Mecca. The Muslims hold a great festival in Mecca every year, called the Hajj, after the month of that name. Muslims stream into the region from all over the world to join in the celebrations, which become one of the largest gatherings of humanity on Earth.

Part of this festival involves running seven times between the two hills of Safa and Marwah, and throwing seven stones at the three stone pillars called Jamarahs. The throwing of small stones at a pillar has another obvious parallel to the Minoan religion, where the altar – with its central axe or pillar – was surrounded by a bed of small stones. Whether these small stones in the Minoan temples simply lay there or whether they were ritually thrown is not known. Another part of the Islamic rites involves circling the sacred Ka'ba seven times and kissing the sacred black stone, the Hajar al Aswad. In the light of the rites that are performed at this religious festival, especially the circling of the Ka'ba, the wanderings of the Israelites in Sinai have a familiar ring to them:

> So ye abode in Kadesh many days, according unto the days that ye abode there. Then we turned, and took our journey into the wilderness ... and we <u>compassed</u> mount Seir many days. And the Lord spake unto me, saying, Ye have <u>compassed</u> this mountain long enough: turn you northward. [B45]

Some of the events in the Bible have always appeared to be rather peculiar and incomprehensible, but now the veil is slowly being lifted. At this point in

the exodus, the Israelites were not on a great long journey through the wilderness of the Sinai peninsular; they were actually marching seven times between two groups of pyramids, and then going round and round one particular pyramid [mountain]. It is extraordinary to understand that this exact same ceremony is still being performed today at Mecca, where thousands and thousands of the faithful continuously circle the Ka'ba, the central cube that was supposedly built by Abraham and which contains the sacred black stone.

The Ka'ba itself, being cubic, is most probably a copy of the Holy of Holies from the Temple of Jerusalem and, in a very similar fashion to the Judaic version, it is covered in a rich brocade called the Kiswah. A new veil is made in Egypt each year, while the old one is cut up and sold as souvenirs. This aping of the Judaic shrine is not so surprising as it may at first seem; the two shrines were originally quite similar to each other, with the Holy of Holies in the Jerusalem Temple originally being a cube exactly like that of the Ka'ba. Muslims initially prayed towards this sacred cube in the Temple of Jerusalem and only changed the direction of worship, or the *Qibla* as it is known, to Mecca after a schism with the Jews. Despite this, the Dome on the Rock at Jerusalem is still revered as the location where Mohammed rose into heaven and is the third holiest site in Islam.

The symbolism of the modern rites at the Hajj in Mecca are all taken from the Koran, via the Torah, but the true symbolism of the ritual can only be seen from above. The Ka'ba is regarded as the navel of the Universe, about which everything in the Universe rotates and, looking from above, the analogy with the planets circling the Sun or the stars and the constellations revolving around the Celestial and Ecliptic poles, is quite striking.

In the equivalent Egyptian festival at Giza, the tribes of the Hyksos/ Israelites were performing exactly the same rite, and the texts confirm that they were 'compassing' or circling one of the great pyramids at Giza. The Great Pyramid, being a representation of the Sun, should have the planets going around it. But, if this ritual was derived from a geocentric model of the Universe, then the pyramid can be seen to have the seven rings of the planets, stars and the constellations circling around it.

Either way, the Hajj-type festival contains the obvious symbolism of the celestial bodies 'compassing' the Ka'ba or, indeed, 'compassing' pyramids themselves. That the Hajj may have been derived from this very ritual is further reinforced by the contents of the Ka'ba. The Ka'ba may be famous for containing the black stone, but standing in mute testimony inside the building are three pillars which support the roof. These pillars may well be structural, but they also may be representations of the three pyramids standing on the Giza plateau: this would indicate that the faithful

at Mecca were indeed following the ancient rite of circling the Giza pyramids.

But there is a problem with this scenario. The structures that surround the pyramids on the Giza plateau are not conducive to having thousands of pilgrims walking around them; the pyramids being surrounded by mastabas, causeways, quarries and steep inclines. Furthermore, both the Bible and Koran infer that the pavement at the base of the Great Pyramid was sacred, out of bounds and, indeed, cordoned off. Faced with so many obstacles, it is quite unlikely that such a festival could ever have taken place at Giza. So does this invalidate the whole concept? Not a bit. The Great Pyramid may not have been the prime focus of the circling in the original festival – because both the symbology and the physical terrain are not right – but there is another pair of ancient megalithic pyramids that do fit all the requirements for this festival.

I made an argument in the book *Thoth* that, while the Giza pyramids may have been representations of the belt of the constellation of Orion, the pyramids at Dahshur could equally have been representations of the Celestial and Ecliptic Poles. The symbology of the Hajj rite is of the stars circling the poles and here we have two pyramids that I have previously, and quite independently, argued were representations of these poles. If this were the case, then the full ceremony is likely to have involved the long trek between Giza and Dahshur, and the circling of the two pyramids at Dahshur – which I named Draco and Vega after their stellar counterparts in the northern sky.

It has always mystified Egyptologists why the Vega Pyramid, in particular, defied the usual conventions of pyramid building and apparently had no substantial causeway, valley temple, necropolis or even mortuary temple close to the pyramid itself. Now, however, there are some answers to this riddle. If the Dahshur pyramids were indeed representative of the Celestial and Ecliptic Poles, it would make a great deal more symbolic sense for the circling aspect of the festival to occur at Dahshur. When looking at the night sky, the stars, constellations and the planets appear to circle the Celestial Pole at a rate of once per day. The Celestial Pole is represented at Dahshur by the Vega (Bent) Pyramid.

The Celestial Pole, at present, points towards the star Polaris, but from the layout of the Giza and Dahshur pyramids, the Bent Pyramid appears to be in the position of the star Vega. This would have been the stellar position for the pole that was present many thousands of years ago, as I discuss fully in the book *Thoth*. If the hordes of the faithful were symbolic of the celestial bodies, then they would have been circling the Celestial Pole, which is represented by its Earthly companion of the Vega

Pyramid. The flat and open ground around the Vega Pyramid would have been much more amenable to such a rite than the obstacle course at Giza: in fact, it is almost as if this site was designed for this very purpose.

Bearing in mind the content of the Ka'ba at Mecca, it is worth noting that both of the Dahshur pyramids contain three tall chambers. Although it is not known for certain if the Dahshur chambers were open during dynastic times, I think myself that this was likely. It is clear that the primary role of these pyramids was not as sepulchres, as such. While the odd pharaoh may have been temporarily interred there, their primary task was to be a temple to the gods: a pillar that held up the heavens and skies. In essence, the pyramids can be considered to be the ancient equivalent of cathedrals – the fact that kings are buried at Westminster Abbey does not make the prime function of this splendid structure a tomb. This was the prime rationale for the Giza and Dahshur pyramids' construction; they were ritual centers for the great festivals of the people.

The Ka'ba is therefore akin to the Israelite Tabernacle; a substitute pyramid around which these ancient rituals can be replayed annually, even if the pyramids themselves are hundreds of kilometers away. However, the faithful originally worshipped at the Giza plateau. They threw seven stones at the three pillars (pyramids) at Giza; they then made the ten-kilometer journey south to the pyramids at Dahshur and began circling the Vega pyramid seven times. When the compassing was completed, the procession then turned to the north and began the long journey back to Giza, the ritual complete. As god said to Moses in the previous quote: 'Ye have <u>compassed</u> this mountain long enough: turn you northward.'

The name of the Ka'ba itself can perhaps support this notion of a direct link between the Hajj and these rituals in ancient Egypt. The two syllables of the Ka'ba are well known from Egyptian theology; they are two parts of the five attributes of mankind. The five forms of each person were considered to be the Name and the Shadow, plus the *Akh, Ka* and *Ba*. The *Akh* is sometimes considered to be the physical body, sometimes the union of the *Ka* and *Ba*. The *Ka* is the life-force of the body, the attribute that distinguished us from the dead; while the *Ba* could be considered to be the 'personality' or 'soul', the identifying force that makes us unique. The *Ka* and the *Ba* are the two recognized forms that make up a person – the <u>life-force</u> and the <u>soul-force</u>.

We might look upon these terms as being quite alien and incomprehensible to us and our lives in the modern world: what on Earth did the ancients understand by the *Ba* and *Ka*? And then, in the same breath, we might add that "Sandra was the 'life and soul' of the party last night". In reality, not much changes over the millennia.

6. Sinai

The *Ka* was represented hieroglyphically by the two arms being held outwards and upwards, in much the same fashion as a Muslim may hold his hands while at prayer; while the Ka and the Ba together form themselves precisely into the word Ka'ba. And in a final piece of holisticism, the town of Mecca – the site of the Ka'ba itself – is known in the Koran as *Baakkah*. Thus, the town at which this festival of the orbiting celestial bodies is held is known as the *Ba-Akh-Ka* – the three main forms of the body of mankind.

Shini

If so many new thoughts can arise because of the original simple pun on the name for Mt Hor [Har] at the beginning of this chapter, then what can be learned from the names of Mt Sinai or Mt Paran? Having seen so many translations of various biblical locations, what does the name of the prime mountain [pyramid] of the Israelites really mean? For a multitude of reasons, the Egyptian equivalent for Mt Sinai just has to be *Shini-t* or *Shin-ti*. The word *Shini-t* not only sounds very similar to Sinai, it also produces the following familiar puns: *Shini-t*, meaning a chamber in a temple (a reference to the chambers inside the pyramids); *Shini-t*, meaning a hailstorm or tempest (a reference to the great storm that was supposed to have hit Mt Sinai and the clouds that engulfed its peak).

Sheni-t is not the name of the storm given in the *Tempest Stele's* account, however, rather this was called *Tcha*. Nevertheless, there is a comparison to be made between the two because *Tcha* was the 'firestick' and the lake that measured 440 x 440 cubits that was discussed in chapter I; both of these were possibly references to the Great Pyramid. Perhaps more importantly, *Tcha-t* is also a term for a type of goose, and chapter VII will show some surprising alternative meanings for the humble goose. There are, therefore, some tentative links between the *Shini-t* storm, the *Tcha* tempest inscribed on the *Tempest Stele,* and the Great Pyramid itself.

Then we come to a rather surprising term for *Shini-t*. Having written the bulk of this chapter, including all the references to the ceremonies at the Hajj, I find that the prime meaning of the term *Shini-t* is to 'circle' or 'orbit'. The Israelites spent a long time compassing these mountains, and now we can see exactly where the name for this particular mountain [pyramid] came from. *Shini-t* means to 'circle' and this name for this mountain was therefore derived from the ceremony that took place at the very foot of this pyramid.

6. Sinai

Another pun that has biblical connotations is the Egyptian word *Shin*, which refers to a storm that covered the right eye of Ra. Remember that Josephus' description of Mt Sinai included the following peculiar description: *it cannot be looked at without pain of the eyes.* This may have sounded as if there was a pain in the eyes of the observer as they looked at the sharpness of the mountain, but now we see that, like everything in Egypt, this was actually a reference to the gods. Josephus was relating that it was Ra who suffered the 'pain in the eye', and this injury was caused by the storm that is in some way associated with Mt Sinai.

The last pun on Sinai, however, is perhaps even more interesting. The biblical mountain that had the most peculiar of all the Hebrew definitions was that of Mt Seir, which has already been identified with Mt Sinai. For some reason, Mt Seir apparently means 'hairy' in the Hebrew. But why should a mountain be called hairy? This label may make some kind of sense in terms of a mountain covered in trees, but one has to travel up as far as the Lebanon to see such luxurious growth on a mountain. The Egyptian pun alternative on Mt Sinai is, however, much more compelling; *Shini-t* also means hairy.

Fig 43. Shini-t – hairy, hail, chamber.

But, puns aside, there may be a logical explanation for Mt Sinai [Mt Shini-t] being called hairy. The Bible says that Seir is the same as Edom and also that Edom, is the same as Esau. So Mt Seir is the same as a place called Edom and the name Edom means to be red, so Mt Seir is not only hairy but red as well. In its turn, the location of Edom means the same as the name of the patriarch, Esau. This actually makes a peculiar kind of sense. Just like the mountain of Seir, which was said to be both red and hairy, Esau, the brother of Jacob, was also known for being both red and hairy for some strange reason:

And the first came out red, all over like an hairy garment; and they called his name Esau.

And Esau said to Jacob, Feed me, I pray thee, with that same red pottage; for I am faint: therefore was his name called Edom. [B47]
Now Isaac loved the elder, who was called Esau, a name agreeable

to his roughness, for the Hebrews call such a hairy roughness Esau or Seir ... J48

The red mountain of Seir is linked physically as well as nominally to Esau because, according to the Bible, it was Esau who had killed the Horim (who had lived there previously) and taken over this red mountain for his tribe. In effect, and reading between the lines, Esau and his tribe were now the guardians of the Giza plateau.

Esau's redness and roughness was not necessarily physical, of course, because the hairy 'garment' (addereth אדרת) that Esau looked like can also mean an aura or radiance. An obvious alternative interpretation is not that Esau looked like a hairy red garment, which sounds too silly to even contemplate as an explanation, but instead that something about Esau was considered to give him an aura of being 'red'. This may also sound like a daft explanation, until the history of Egypt is used once more to explain this biblical confusion.

Previously, in the book *Jesus*, I have tried to show the links between the biblical patriarchs and the pharaohs of Egypt, and it is this connection that gives us the most logical answer. Since Esau was the first-born of Isaac, the redness of Esau could easily be explained in terms of the royal inheritance of Egypt. The king of northern Egypt was identified by the Red Crown of Lower Egypt and, if Isaac were a Hyksos pharaoh, then his son Esau would have been in line to inherit this Red Crown. If this were the case, then of course Esau would have been associated with all things red and would have an 'aura' of being red. But it was Esau's brother Jacob who was to eventually usurp Esau and take the inheritance from him by promising to give Esau, who was feeling faint, some red soup in exchange for his birthright. But how does one steal a birthright with a bowl of tomato soup? Once more, the passage makes absolutely no sense; until the original Egyptian text is understood, that is.

The name for the Red Crown of Lower Egypt was *Djesher-t*, but the name had several other meanings that could be used as puns by the inventive scribes. *Djeser-t* was also a red drink (red soup) and it could even mean to become drunk. This may simply be a play on words, or perhaps the passage is using the pun to imply that Esau had forfeited his birthright though being a drunkard. Whatever the case, the explanation for the peculiar red soup in the biblical texts is now fully explained. Jacob was not simply taking the family birthright from his brother Esau; he was taking the Red Crown of Lower Egypt. It almost sounds like a witty 'fair exchange' was being organized by the scribes – a *Djesher-t* for a *Djeser-t* – except that, in reality, this was the royal crown of Lower Egypt being exchanged for a bowl

of red soup! Jacob got the better in this literary deal, and was to be the next pharaoh of Lower Egypt.

This same Egyptian word, *Djesher-t,* also gives us the real reason for Esau being 'hairy', for *Djesher* also means red hair. Thus, all of Esau's supposed attributes are easily explained though simple puns upon the name of the Red Crown of Egypt and, once more, the validity of this technique for explaining these peculiar biblical events and stories can be clearly seen. Here we have three or four different biblical attributes and events that make absolutely no sense whatsoever, neither in the English nor in the original Hebrew. Take one step further back into the past, however, and the situation becomes absolutely clear in the original Egyptian language.

Fig 44. Djesher-t – Red Crown, red hair.

The link between this redness and the mountains is the word *Djutesher,* which also means a red mountain somewhere near Heliopolis. This 'mountain' may well be one of the pyramids and it may be from this symbolism that the importance of the Red Crown – the symbol of royal authority in Lower Egypt – may have first been derived. There are two pyramids that could deserve the adjective of 'red'. The first of these is the Third Pyramid at Giza, which has a sizeable amount of red granite at its base. The second is the Red Pyramid at Dahshur, which I have called the Draco Pyramid because of the position in the night sky that this pyramid is supposed to represent.

Now the Third Pyramid at Giza may be the more likely, because I say in the book *K2* that the granite layer on the bottom of this pyramid is supposed to be representative of trees on a mountain, with the white Tura limestone casing blocks above representing the upper snowcapped peak. The join between the two colours could be thought of as being a tree line and therefore, the granite below might be considered to be 'hairy', or covered in trees. Alternatively, at Dahshur, we can see the red-coloured Draco Pyramid standing next to the (originally) brilliant white of the Vega Pyramid. The symbolism here may be of the northern Red Crown of Lower Egypt against the southern White Crown of Upper Egypt. Indeed, the red Draco Pyramid *is* the northern pyramid of Dahshur, while the (originally) brilliant white Vega Pyramid is the southernmost of the two.

This symbolism, for either Giza or Dahshur, is compelling and either or both of these explanations could be true. But perhaps the important point is that the Dahshur pyramids could be as important in this symbolism as those standing at Giza. Both the Dahshur and Giza pyramids are 'original' constructions, from before pharaonic times, so the use of both these sites would be rather fitting. Incidentally, it is through the Egyptian word *Djesher-t* (meaning the red land or desert), that the modern name for desert is derived, and the survival of this word just goes to show how important it was.

Paran

The last biblical mountain in the vast biblical range of peaks, that of Mt Paran, was, perhaps, the easiest to translate. A similar word, *Per-aa,* was the Great House – the mansion of the pharaoh – and the name can also refer to the Giza necropolis. The suffix of Paran is also well known: *An* is the Temple of Heliopolis in Lower Egypt, just opposite the pyramids at Giza. The *Per* prefix is well known from many palaces too, and perhaps the most well known is the *Per-aa-ten*, the palace of the Sun at Akhenaton's city of Amarna. Budge lists Heliopolis as having the same kind of name, *Per-Ra*, which also means the 'temple of the Sun'. But an equivalent name is just as likely to have been *Per-An*; the 'Mansion of Heliopolis' or 'Temple of Heliopolis'.

Now a proper reference to Heliopolis in the biblical texts has been a long time in coming, Heliopolis was perhaps the greatest of the Egyptian temples and must have been a spectacle to all who saw it; the absence of this name from the Bible was always the problem, not its possible inclusion. Heliopolis' absence proved that there had been a cover-up. But here it is at last, *Per-An* (Mt Paran) – the great temple – which is also being called a 'mountain' for some reason. But if this is the right translation of this word, how does the Bible manage to confuse a pyramid and the Temple of Heliopolis?

The Temple of Heliopolis was relatively unusual in Egypt, for it was a Sun temple, a *Per-Ra*. The Sun temples all contained, within their courts, a large obelisk, which was simply a massive gnomon or a sacred sundial. The Temple of Heliopolis was no different and so it contained, with its courts, not only a large obelisk, but also one of the most important artifacts in Egypt – the Benben stone. The Benben was another gnomon-type obelisk, but it was surmounted by a strange, sacred conical stone that may have been meteoric in origin. Thus, the Benben in the Temple of Heliopolis

could easily be equated linguistically with a pyramid. Not only were the pyramids themselves considered to be gnomons, but the most important aspect of the whole pyramid was the pyramidion on the top, which could be considered to be a similar artifact to the Benben stone itself.

Ur

From this long list of biblical pyramids, we have seen good evidence that Mt Sinai was most likely to have been the Great Pyramid, because Josephus said it was the tallest. We have also seen evidence that Mt Hor was the Third Pyramid, for that is what *Har* means in Egyptian; while Mt Seir could have been the red and 'hairy' Draco Pyramid. Now, there is evidence that Mt Paran was the great Temple of Heliopolis. But what of the other pyramid on the Giza plateau: what of the Second Pyramid?

The original name for the Second Pyramid does not exactly match any of the biblical mountains, but the results of this little investigation were interesting enough, because the original name for the Second Pyramid gives distinct echoes of the meanings that were derived from the name of Mt Hor. The Egyptian name for the Second Pyramid was *Ur* and *Ur* can also mean a violent storm, a cavern, fire or a mountain – puns that are all very familiar. Perhaps it is easiest if all these puns are listed, as below:

Meaning	Great Aakhut (Shini-t)	Second Ur	Third Hor
Furnace			Δ
Tempest	Δ	Δ	
Horizon	Δ		
Burn	Δ	Δ	Δ
Descend			Δ
Cavern	Δ	Δ	Δ
Afraid			Δ
Mountain		Δ	Δ
Hairy	Δ	Δ	
To circle	Δ		

The Egyptian name of Ur for the Second Pyramid was derived from its function as a sacred repository; Ur also means both a funerary mountain and a funerary chest, or Ark. The title of the Great Pyramid was *Aakhu* or *Aakhut,* meaning 'light' – a reference to the divine light of the god Ra. There appears to have been a confusion of terms here so that the Second

Pyramid, the funerary chest, became synonymous with the *Aakhut* of the Great Pyramid; hence the Latin term 'Ark' for a funerary chest. Like Mt Sinai, the Ark of the Covenant was also described as being on fire, or covered by clouds.

In fact, all of these pyramids were equated with the imagery of fires or furnaces, and it is probably from these origins that the English term for 'pyramid' was derived. Whether through pun or ritual, the pyramids were considered to be 'on fire' for some reason, and so Mt Sinai was described as resembling a furnace in the Bible, with clouds of smoke billowing from the top.

Because of this fire symbology for the triple pyramids of *Aakhut, Hor* and *Ur,* the word *Ur,* especially, became synonymous with both fires and furnaces. Eventually, after borrowing some of the 'light' imagery from the great Pyramid, the word *Ur* was translated into the Greek as *Pur* meaning 'light' and 'fire'. It is from these origins that the Greek *Puramis,* the Latin *Pyramis* and the English 'Pyramid' were eventually derived.

The suffix of 'mid' in the word 'pyramid' may also be of Egyptian origins. The Greek suffix of 'mis' is the typically incorrect Greek suffix of adding an 's' instead of a 't', which made me suspect that the modern pronunciation of 'pyramit' is substantially the more correct. If so, the Egyptian derivation of *met* could mean fertility, but I think that the meaning was even more specific that this. *Mett* means the 'emissions' of the 'Nile god', the source of the Nile. Thus, we derive *Ur* (pyramid) and *Mett* (source of Nile), giving *Uramett* or *Puramet,* which translates as 'the pyramid as the source of the Nile'. This, in effect, was one of the roles for the pyramids; they were the Twin Peaks that were the mythical source of the Nile.

I also proposed in the book *Thoth,* that the word, meaning, and the additional Greek letter of Pi (the mathematical formula) were also all derived from these same Egyptian roots. In this case the influence was not taken from the symbology of the pyramids, but their dimensions instead; those of the Great Pyramid are demonstrably based upon Pi.

Yabu

Coming back to a related topic, copious evidence was shown earlier on that demonstrated that the location of Yabu (and therefore the mythical source of the Nile) had been confused by Egyptologists as being at Elephantine. The confusion arose for three main reasons:

a. The Nubians and their leader were resident at Yabu, which tends to suggest that Yabu was in the far south of Egypt. But in actual fact, this

situation had arisen because the biblical Moses married a Nubian princess. Moses was therefore a leader of the Nubians and he was actually based in Heliopolis.

b. The Twin Peaks of Crophi and Mophi were described by Herodotus as being at Elephantine, but this was just a tradition that was hijacked by the Theban priests at a later date, and so the myth of the Twin Peaks eventually moved up-country.

c. Elephantine was called Abu, which is a similar name to Yabu. But this name was again most probably taken by the Theban priesthood when it borrowed the liturgy of Heliopolis, and so the name was used in Upper Egypt at a later date.

Budge confirms this situation when he comments on the role of *Amen* in Egyptian theology. As explained in chapter I, *Amen* originally meant 'the shadow of the pyramid at sunset at the half-solstice', but this meaning had been changed by the Theban priests:

> In the early empire; ie, during the first eleven dynasties, this god (Amen) ranked only as a local god, although his name is as old as the time of Unas; and it is not until the so-called Hyksos had been expelled from Egypt by the Theban kings of the seventeenth dynasty that Amen ... was acknowledged as the national god of southern Egypt.

Budge adds to this that:

> The Thebans had chosen (Amen) as their great god, and whose worship they had declined to renounce at the bidding of the Hyksos king Apepi. [49]

The inference from both of these statements is that the Theban priesthood had taken the Hyksos liturgy and changed it to suit its own position and location in Thebes. They had also, much to the obvious annoyance of the Hyksos priests, corrupted these rites to such a degree that *Amen* had been elevated into being *the* major god of Upper Egypt. It would seem that the Theban priests respected the liturgy of Heliopolis but they were not about to use exactly the same terminology as the despised Hyksos people, so the rituals involving Atum and Djeheuti were now performed by Amen.

This elevation of Amen into a state god occurred *after* the Hyksos/ Israelite exodus, so it would seem likely that at the same time as borrowing the rituals of Heliopolis, the Thebans also borrowed the locations that went

with it. Yabu, therefore, was relocated at Elephantine. The same process can be seen in the role of the god Khnemu, who was supposed to be resident in Heliopolis ant yet was also called 'Lord of Elephantine'. Khnemu probably made the same journey as did Amen.

The site of Yabu has now been firmly linked to the pre-exodus Hyksos/Israelite occupation of Kheraha and Heliopolis and, likewise, the Twin Peaks have been linked to the two massive pyramids on the Giza plateau. The evidence for this is compelling but there is more evidence that can forge an even stronger link between Yabu and Giza:

> An offering was made to Atum in Kheraha, the Ennead in Perpesdjet, and the cavern of the gods in it ... His majesty proceeded to Heliopolis over that <u>mountain</u> of Kheraha on the road from Sep to Kheraha.

The translator then notes that:

> The cavern means a source of the Nile; in addition to the 'twin sources' of the Nile at Elephantine, Kheraha claimed possession of a source. [50]

The real and original mythological source of the Nile, and its associated Twin Peaks, was most definitely at Kheraha, which is known to have been just south of Heliopolis on the east bank of the Nile, opposite the Giza pyramids. But the associations continue, for Kheraha, like the Second Pyramid at Giza, was also called *Uar* and it was most famous for being known as the 'Babylon of Egypt'. Further evidence for the location of Yabu comes from the *Book of the Dead*, where it is said that:

> I am the Phoenix (Bennu), that which is in Heliopolis. I am the keeper of the book of that which is, and of that which will be. Give (Osiris) splendour in heaven, might on Earth, triumph in the Netherworld ... sailing up to Abydos (*Yabtu*) as Phoenix (Bennu), going in and coming out without being repulsed ... [51]

The name for Abydos (*Yabtu*) has been derived from Yabu once more, but linked to the two-hills glyph (*tu*), a glyph that has already been tentatively linked to the two pyramids of Dahshur. The Phoenix was the symbol of Heliopolis, so if the Phoenix was going to be flying anywhere, it should have been towards Heliopolis, not Abydos. Like Elephantine (Yabu), it would seem like the name for Abydos (*Yabtu*) has been borrowed from the

Giza rituals. This seems likely because the whole essence of the *Book of the Dead*, especially in its original form from the pyramid of Unas, is that this was the liturgy of Heliopolis. The texts in this pyramid say of *Annu*, or Heliopolis:

> O god, thy Annu is Unas, O god thy Annu is Unas, O Ra thy Annu is Unas, O Ra. The mother of Unas is Annu, the father of Unas is Annu, Unas himself is Annu and was born in Annu ... (Unas) cometh to the great bull which cometh forth from Annu ... (and he) utters words of magical importance from Annu.

The central theme in the *Book of the Dead* is *Annu*, or Heliopolis; so why then does the Phoenix, the sacred bird of *Annu,* fly off to Abydos in Upper Egypt! The translation makes no sense in its current form, but it makes every sense in terms of the liturgy of Heliopolis. The Phoenix, or Bennu, was imagined to be in the form of an eagle with golden plumage that came back to nest at Heliopolis every 500 or 1,400 years. Although the Phoenix was sometimes linked to Venus, it also had some strong solar connotations and was considered to be the 'Soul of Ra' and the 'Heart of Osiris'. In addition the spelling can also link the Bennu to the Twin Peaks – the twin sources of the Nile. The Twin Peaks have been identified with the Giza pyramids and this is confirmed by the use of two geese as determinative glyphs, a subject to be discussed in the next chapter.

Clearly, the story of an image of the Sun dying and being reborn in Heliopolis, after a vast time span, has to have something to do with precession. In the precession of the constellations of the Zodiac, the Sun is 'reborn' into a new constellation every 2,100 years or so, and the myth of the Phoenix has to pertain in some manner to this astrological event.

Tempest

Thus far, we have seen good evidence to indicate that the Phoenix was involved in the rituals of Heliopolis; that the stories of the Yabu and the Twin Peaks were originally based at Giza; and that the biblical wanderings of the Israelites were also a part of a Giza ritual. But in some manner, as yet unexplained, these rituals, mountains and pyramids were all linked to fire, storms and tempests.

It is becoming more and more likely that the 'storm' mentioned in the *Tempest Stele* was not a real tempest at all. In fact, the 'great storm' was probably a reference to some of the rituals on the Giza plateau. In my

estimation, there has been a gross mistranslation of the text, which has been caused by a lack of insight into what the stele was trying to say. This mistranslation has not only affected the type of 'storm' involved, but also its location. The orthodox version reinforces the opinion that Yabu is Elephantine, when nothing could be further from the truth. The classical translation of the *Tempest Stele,* maintains that the storm was '*louder than the noise of the cataract which is at Elephantine*'. This, however, is bunkum:

a. For a start the location is wrong; the reference to Yabu, as already explained, refers not to Elephantine but to the Giza plateau.

b. The mention of a 'cataract' is wrong too. This may sound like a reasonable translation, in the light of the 'Elephantine' location, but the word here is *qerti* – which actually refers to the, by now familiar, Twin Peaks at Giza.

c. The 'louder than' (*Aau*) is also wrong, as the determinative is of a person speaking. The true translation here does not refer to the noise of the rain (for there was none), but the noise of a person's voice. In fact, *Aau* actually means 'to blaspheme'.

Again, it can be seen that knowing the context of the text can completely transform the import of the *Tempest Stele's* proclamation. The 'great tempest' was not a tempest at all, but a part of the rituals on the Giza plateau. The original translation suggested that the:

... '*tempest*' was '*louder than the noise of the cataract which is at Elephantine*'.

Taking into account all the objections above, the sentence should actually infer that the:

... '*Giza ritual*' was '*(the) blasphemy of the Twin Peaks at Giza*'.

As is usual in Egyptian literature, the scribes were not so much interested in the weather as in the theology of Egypt. While the eruption of Thera may have dusted the land with ash, the major dispute between Upper and Lower Egypt lay in their different theological interpretations of the world. The fact that the gods of Ahmose I were 'discontented' (*Temp.* line 7) was not demonstrated by the 'rain they unleashed' upon Egypt (*Temp.* line 9); rather, the gods were plainly unhappy with the 'blasphemy of the rituals' that were being performed on the Giza plateau by the Hyksos/Israelites.

Likewise, the location of the pharaoh also appears to have been changed. The *Tempest Stele* says that Ahmose I was at *Sedjefra-tawy*, which lay to the south of *'Ant'*, while Amon-Ra dwelt at *'Anu'*. These locations have been translated as being 'south of Dendera'. While it is true that the name *Ant-enut* does mean the town of Dendera, it is also a fact that both *Ant* and *Anu* are well-known variations of the name *An*, for Heliopolis. The 'pillar with a cross on the top' glyph that was used for both *Ant* and *Anu* bears out this latter interpretation.

It is likely that the translators have used the 'Dendera' interpretation because it would seem illogical for Ahmose I to have been near to Heliopolis; after all, Ahmose was supposed to be at war with the Hyksos. However, knowing that there was actually a conference between Ahmose and the Hyksos pharaoh clarifies the situation greatly. Like any news report, the *Tempest Stele* was not describing the mundane events at the local royal court; it was describing the exciting, unusual and newsworthy account of the great pharaoh of Upper Egypt travelling northwards into enemy territory. Ahmose I was just south of Heliopolis and in conference with the Hyksos.

Two Breasts

The source of the Nile being located at Giza may initially seem a little illogical, but remember that it was the pyramids that 'controlled' the Sun and its associated seasons, through the sacred alignments of their causeways and the all-important rituals that preserved this cosmic order. It was the pyramids that controlled the seasons and, therefore, it was the pyramids that also controlled the flooding of the Nile. This is confirmed by the name of the Nile-god itself – *Happy*. The original name for the Nile god was *Hap, Hapi* or even *Hep*. But as we saw in chapter I, the Egyptian name for the solstice – the very seasonal events that were being observed at Giza – was also *Hep*. So, the Nile floods and the Nile god were named after the solstice and the symbolism of the Giza rituals; a sure sign that the original location of the Twin Peaks was at Giza.

Fig 45. Hep – Nile god, Hep – the (half) solstice.

6. Sinai

This link between the Giza pyramids and the legend of the Twin Peaks – the two mythical breasts that the Nile flowed out of and nourished the land of Egypt – betrays the presence of yet more biblical pyramid references:

> ... the Almighty, who shall bless thee with blessings of heaven above, blessings of the deep that lies under, blessings of the <u>breasts</u>, and of the womb. The blessings of thy father have prevailed above the blessings of my progenitors unto the utmost bound of the everlasting hills. [B52]

This may seem like a normal, naturalistic sentence, typical of the quaint naturalism of the Bible, but why should the priesthood be making a specific blessing to breasts? The alternative scenario is that the original sentence was deemed to be too revealing and, although blessing breasts may seem odd, it was better to write of 'breasts and wombs' than of 'pyramids and caverns'. But there again, perhaps the original Egyptian texts also spoke of breasts. The *Famine Stele* says of these Twin Peaks:

> There is a town in the midst of the deep.
> Surrounded by Hapy (Nile).
> Yabu by name.
> It is the first of the first.
> First Nome to Wawat.
> Earthly elevation, celestial hill.
> Its temple's name is 'Joy of Life'.
> 'Twin Caverns' is the waters name.
> They are the breasts that nourish all.

The Twin Peaks, now identified as the Great and Second Pyramids of Giza, were known as breasts. This is not too surprising; the very rituals performed at Giza were supposed to nourish the land of Egypt, and the massive pyramids on the plateau did look rather breast-like. But they also had pyramidal features and so Herodotus says of them that they were 'two hills, sharp, with conical tops'. The biblical Mt Sinai, remember, also means sharp or pointed. So it is quite possible that the Bible has used this breast terminology as a deliberate subterfuge, to make the true meaning of the ritual unclear. Another example of this obfuscation is demonstrated by the offerings by Aaron (brother of Moses) at the Tabernacle, sited at the foot of Mt Sinai:

> And they put the fat upon the breasts, and he burnt the fat upon the

6. Sinai

altar. And the breasts and the right shoulder Aaron waved for a wave offering before the Lord; as Moses commanded. B53

Why Aaron should be placing fat upon breasts is not made clear: just whose breasts were they? The spelling seems to infer an animal's breast (chazeh חזה), but I am not so sure that this is correct. The Hebrew word *chazeh* is derived from 'see', 'to divine the future' or 'seer'. But for divination of the future, a seer in the ancient world would normally use the intestines of an animal, not its chest or udder. This rummaging about in the intestines of the sacrifice was a favourite pastime of the seers of Alexander the Great, and it seemed to serve him well in his great campaign across Asia. But the intestine of an animal, being down in the abdomen, is hardly going to be confused with an animal's ribs, and *chazeh* could not mean udder either, as the sacrifices were of a bullock and a ram.

So what does this passage mean, and whose breasts were being anointed? Personally, I think that Aaron was not pouring the fat upon the 'breasts and the altar', but on the 'pyramids and the altar'; and if the ritual was performed in a Giza mortuary temple, the altar and pyramid would have been adjacent to each other. This scenario is perhaps confirmed by the actions of Jacob, who also pours fat onto a stone:

> And Jacob rose up early in the morning, and took the stone that he had put for his pillows, and set it up for a pillar, and poured oil upon the top of it.

> And Jacob set a pillar upon her grave: that is the pillar of Rachel's grave unto this day. B54

It is clear that the extract is talking about a piece of stone here and not a part of an animal. In a similar fashion to Aaron pouring oils on the 'breast', Jacob has made a small representation of a 'stone pillar' and was also anointing it with oil; but what sort of pillar was it? To me, the inference is clear: the word 'pillar' must be a reference to a pyramid. Jacob had made a small representation of a pyramid for his little ceremony, and he was anointing it with oils.

This supposition is confirmed by the second quotation, where a 'pillar' is set upon the grave of Jacob's wife, Rachel. Placing a column on a grave is not a historical custom, but the placing of a small pyramid on a tomb is very well documented. Not only did the tomb workers at Deir el Medina in the Valley of the Kings, use this device, but so too did the early Israelites, as is evident by the pyramid-topped tombs of the Kidron Valley in Jerusalem, and also at the so-called 'Tomb of the Pharaoh's Daughter'.

6. Sinai

The deciding factor, however, has to be the Hebrew word from which this term 'pillar' was derived; quite astoundingly, the word is actually *mastaba* (matstsebah מצבה) and, as any Egyptophile will know, a mastaba looks nothing like a column or pillar – in fact, it is a primitive step-pyramid. Jacob was therefore anointing a small stone pyramid and the fact that this ritual was an established custom in Egypt is confirmed by the glyphs for the 'mountain' of *Dju-uab*.

The name Dju-uab refers to the 'holy mountain' and it is spelt using the two-hills glyph, which has already been linked to the two pyramids at Dahshur. Classical texts link this 'mountain' to Elephantine once more, but it transpires that *Dju* is most definitely linked to *Dju-Manu* and *Dju-Bakha*, which were two of the four pillars of the sky and which will shortly be firmly linked to the pyramids at either Giza or Dahshur. The interesting point about the spelling of the mountain/pyramid of *Dju-uab* is that the glyphs show it being ritually anointed with oils. The presence of a biblical story about anointing pyramids with oil is therefore firmly supported by Egyptian custom.

Fig 46. Dju-uab – anointing the pyramids.

This will lead us on to an even greater discovery later in this chapter but, for now, the other attribute to this ceremony at the pyramid should be explained – the peculiar 'waving'. This oddity had me stumped for a while, but actually, it is also easily explained if the ceremony is seen from a slightly different perspective. Try this sentence to see the real meaning:

> And Moses <u>took</u> the breast, and <u>waved</u> it for a wave offering before the Lord. B55

Now, this could be considered a part of an animal being waved in the air for some reason; but remember that the scribes did not necessarily understand what they were writing here – and if they did they would have changed it anyway – so, quite obviously, the real meaning has been confused a little. But I think the truth is still visible. The breast is the pyramid once more and the wave offering is a Jewish custom that is still performed to this day. The Jews no longer have a temple at Jerusalem, but they do have what is reputed to be a remaining wall from the structure – the Wailing Wall. There they gather and talk to god, nodding continuously with their heads as the ancient custom demands.

6. Sinai

This is what the text is referring to here. The 'wave' (nuwph נוף) can also mean a 'to-and-fro' movement, or a nod. The verb 'took' (aqach לקח) can also mean 'take hold of', so, in effect, Moses was taking hold of or grasping the pyramid and nodding before it, just as is done at the Wailing Wall to this very day. Once more, we see that the pyramids were an integral part of the liturgy of the Israelites. Therefore, the Wailing Wall is nothing short of a simple substitution, not for the Temple of Jerusalem, but for the original Temple; which was the Great Pyramid of Giza, the great breast that nourished the land and its people by regulating the motions of the cosmos.

This symbolism may well have percolated down into the modern era, and to the typical television and film propaganda that is regularly placed into the public arena. The dual symbolism of the Twin Breasts was obviously not lost on the producers of the American soap opera, *Twin Peaks*. While the title credits contained the incongruous image of two large mountain peaks – which seemed to bear little relationship to the program itself – the prominent 'peaks' of the actresses were perhaps the star feature of the series. All they needed was a river gushing from between the two peaks to complete the esoteric symbolism.

Perhaps it is even from this euphemism for 'breast' that the tradition started for divination of the future through animal intestines – a practice that has always defied rational explanation. Aaron used the pyramids (breasts) as a part of the Israelite/Hyksos religious service, as well as the obligatory animal sacrifice. After the exodus, when the pyramids had been taken out of the Israelite theological perspective completely, the 'breasts' were reinterpreted as meaning a part of the animal being sacrificed. For a lack of further information, and since these were male animal sacrifices, the later seers must have presumed that the 'breasts' meant that an animal's intestines had been used in the rite.

Sacred pillar

As a by-product of investigating the rituals of Aaron and Jacob, it transpired that the term 'pillar' could also mean 'mastaba' or step-pyramid. But there are other important pillars in the biblical texts and, although these pillars are called *amood* (dwme) instead of *mastebah* (מצבה ה), I think their true symbolism will become apparent:

> And he set up the pillars in the porch of the temple: and he set up the right pillar, and called the name thereof Jachin: and he set up the left pillar, and called the name thereof Boaz. [B56]

6. Sinai

These were the two sacred pillars that stood in the Temple of Jerusalem and they were, most probably, based on the layout of the Tabernacle. According to Josephus, there were four pillars that held up the tent that covered the Ark of the Covenant, and two of these were probably represented by Jachin and Boaz in the Temple. The Bible confuses this a little by indicating that there may have been five pillars, but actually the latter agrees more with Masonic custom.

The two pillars of Jachin (Yakeen יכין) and Boaz (Boaz בעז) became important to Masonic tradition and a central part of their ritual. But rather than having just two pillars, Scottish-rite Masonry maintained that there was a third – the pillar of Mac-Benac. So why should two, or perhaps three, pillars be so central to any faith or society? The Masonic symbolism embodied in these pillars is reputed to represent an 'upright citizen' or a 'pillar of society'; an attempt to portray an image of a role model of society. Of course, the true symbolism has nothing to do with 'pillars', but 'mastabas' instead.

The two, or three, pillars of Masonry are the Twin Peaks of Egyptian history and, as explained in chapter I, these peaks are pseudonyms for the two great pyramids that lie on the Giza plateau. Herodotus called them Crophi and Mophi, the two breasts that nourished the Nile; the Bible and Masonic lore call them Jachin and Boaz. I was unable to find any significance in the physical forms of these biblical pillars, but it is worth noting that Boaz was the spirally fluted, right-hand pillar and Jachin was the vertically fluted, left-hand pillar. The relatively unknown third pillar in this possible trio was simply a representation of the Third Pyramid on the Giza plateau, although it is often ignored because it is less spectacular, less important, and eclipsed by its massive neighbours.

While he is arguing from a completely different perspective, Robert Graves appears to agree with this identification of the biblical pillars with pyramids, when he says of them:

> ... the tradition remained that 'Boaz is to Jachin as Gerizim is to Ebal'. Gerizim and Ebal were the twin peaks covering the Ephraimite shrine of Shechem. [57]

In other words, Hebrew scholars thought that the two biblical pillars could be compared to two hills in Jerusalem, which Graves conveniently calls 'twin peaks'; but in fact, the original symbolic hills for Jachin and Boaz were to be found in Egypt. This pillar symbolism for Jachin and Boaz came from the Israelite exodus and from the pillars in the Tabernacle. In its turn, the symbolism of the Tabernacle was drawn from the major pyramids on the Giza plateau.

6. Sinai

The fact that the pyramids originally had a central role in Egyptian theology, has been discussed at some length and this notion is further supported by the ancient concept of the four pillars of heaven. One of the original creation myths of Egypt explained that heaven took the form of a square slab of iron, which was supported at each corner by one of the four pillars of heaven. The four pillars were also known as mountains and the most important of these were the two mountains of sunrise and sunset, which were known as Bakhau and Manu respectively.

The texts refer to pillars or mountains and this is shown, in figure 47, by the three-hills determinative glyph that denotes 'mountains'. But does this glyph really mean mountains? Later in the chapter, I will try to conclusively show that a part of this glyph's symbolism – the true symbolism from before the exodus – was of the three pyramids of Giza.

Fig 47. Bakhau and Manu, two of the four pillars of heaven.

But for the moment, it is worth remembering that the Egyptian words for east and west were conclusively linked, in chapter I, to the ritual of observing the Sun along the causeways of the Great and Second pyramids; and in turn these two words were also given the 'three-hills' determinative glyph. This glyph is supposed to mean 'desert hills' or 'foreign lands', but the clear inference from the glyphs for east and west were that they were not related to 'foreign' things, nor to 'mountains', but instead to the three pyramids of Giza. The 'three-hills' glyph is more likely to be the 'three pyramids' glyph.

Fig 48. East, west and the Giza glyph.

In this case, the four pillars that held up the heavens could have been represented on the Earth by the two great pyramids at Giza and the two great pyramids at Dahshur. It was shown earlier that Islam may well have held onto and perpetuated some of the original rituals that were performed on the Giza plateau, but in the light of this four or five pillar symbolism,

perhaps Islam has also held onto the physical layout for the Egyptian heaven and Earth.

Firstly, it should be noted that the entire religion of Islam is based upon the concept of the Five Pillars of Wisdom, which was the source of the tile for the famous book by T. E. Lawrence. The Five Pillars are the five requirements that a true Muslim must follow during a lifetime, but this symbolism is also mirrored by the architecture of Islam.

The role of the Islamic minaret was discussed at length in the book *Jesus*, and these sacred pillars or towers were likened to the thousands of similar towers on Sardinia, the Balearic Islands and Ireland. More importantly, in this context, these Islamic minarets were also compared to the Benben tower at Heliopolis.

Bearing in mind the form that the Egyptian heaven was supposed to have taken – with four pillars (one at each corner of a square) holding up the heavens over the Earth and a possible fifth pillar or something similar in the center – it cannot be mere coincidence that this is the exact same layout for a standard Islamic mosque. A large Islamic mosque will often be designed around a square ground plan: inside this quadrangle there will be four large minarets, one in each corner, and in the center will stand the large dome-shaped mosque. The four minarets just have to be representations of the four pillars that hold up the Egyptian heaven and, within these supporting structures, lies the large dome-shaped mosque which must be a representation of the Earth. If this is so, it is not only further evidence that the Egyptian religion has affected and influenced all the Judaic religions; it is also further evidence that the spherical form of the Earth was known in very ancient times.

The Aya Sofia (Hagia Sophia) in Istanbul and the Taj Mahal in India are perfect examples of this type of layout and these two buildings also demonstrate the cross-denominational understanding and reverence for this kind of 'four poster' imagery. Although the Aya Sophia lies in Istanbul and appears to look like a mosque, it was actually constructed as a Christian Church by the rulers of Byzantine Constantinople. Since the Aya Sofia predates the invention of Islam, this beautiful church most probably represents the original design upon which all mosques were based. This is why the Eastern Orthodox Christian Church has inherited and continued with this type of architecture, although perhaps to differentiate themselves slightly from Islam, the minarets have now become vestigial towers attached to the central church: the result being a much more stylized version of the mosque. This style is evident all across the East, especially in Russia, although it has to be said that the Cathedral of St Basil in Red Square, Moscow appears to have grown another 'minaret' or tower for some reason.

Conversely, of course, the Taj Mahal in Hindu India is actually a Muslim mausoleum built in 1631 for the wife of the Mogul ruler, Shah Jahn. The Moguls were descended from Genghis Khan and their empire covered much of the Indian subcontinent, through to the eighteenth century. Since this 'four poster' style of architecture has been adopted by two of the great Judaic faiths, it ought to have some sort of significance or meaning. In the guise of the Egyptian heaven and Earth, and the four pillars that separated the two, this style of architecture has just that.

Incidently, this same layout is often used in film portrayals that have Masonic or Templar style and content. This was most notable in the Star Wars trilogy, where the headquarters of the Jedi (Djedi) Knights was essentially a large Islamic mosque with exactly the same 'four poster' layout. Since the Djedi Knights sound rather similar to the great god Djeheuti, and the knights were bound by some kind of bloodline heritage, I get the impression that the producers of this film were trying to make some sort of veiled historical/religious point.

If the mosque has been designed in the image of the Earth and heavens, then exactly what form should this central pillar take and why was it devised? This confusion over the extra fifth pyramid (pillar) may have originally stemmed from the presence of the smaller Third Pyramid on the Giza plateau, with the priesthood trying to define its role in the rituals. This controversy over the possible presence of a fifth column is, no doubt, where the modern phrase came from; a fifth columnist being a reference to a hostile group of infiltrators. It is apparent from this that not everyone agrees with the additional pillar.

In later Egyptian theology, the extra pillar in the center of the four was known as *Heh*, possibly meaning eternity. *Heh* was sometimes envisioned as being a god with his hands supporting the pillars of the sky, presumably stopping them from falling down. The glyph for *Heh* graphically illustrates this: [58]

Fig 49. *The fifth pillar – Heh.*

Another myth indicates that these four pillars were formed from the hair of a god, and the text of Unas indicates that the four pillars were elder spirits

who lived in the 'Hair of Horus'. [59] What this describes, of course, is the biblical story of Samson:

> And Samson took hold of the two middle pillars upon which the house stood, and on which it was borne up, of the one with his right hand, and of the other with his left. And Samson ... bowed himself with all his might; and the house fell upon the lords, and upon all the people that were therein. [B60]

Samson's (Shimshown שִׁמְשׁוֹן) name in Hebrew means 'a representation of the Sun', which connects him with the duality of day and night, and with the pyramids and pillars. Here, though, he is being portrayed as the fifth pillar, *Heh,* and he is letting the sky fall down on the Philistines by pushing away the pillars that kept the heavens aloft. It has to be noted that Samson's strength lay in his long hair; and so in every respect, the story of Samson was conforming to the ancient Egyptian myths and theology.

While Samson was a representation of the Sun, it is apparent that the Moon was at least as central to Israelite liturgy and this is graphically demonstrated to us by the form of the Jewish altar. The original Israelite altar was often described as being made of unhewn rock left in its natural state, as was the great crystal altar at Karnak. But the tradition that has filtered down into Jewish custom is of a square altar with horns at the four corners. This not only sounds a little like the Tabernacle's four pillars, it has a direct comparison to the Egyptian concept of heaven. The Egyptian heaven was derived from the glyph for the sky-god, and the two words are as follows:

Pet – heaven, *Nut – sky-goddess (day),* *Nut – sky-goddess (night).*
Fig 50.

But the sky-god(dess) had two forms of the sky glyph, depending on whether it was day or night. During the day, the sky was supported upon the four pillars, but at night the situation was reversed and so the pillars pointed upwards. It happens that this latter form, with the four vestigial pillars pointing upwards upon the square slab of the sky, is the precise form that the Jewish altar takes. So, rather than being a representation of a

daytime event, the Jewish altar is indicating that night-time festivals may have been equally important in Hyksos/Israelite theology.

The papyrus of Ani betrays this fact quite well. The following extract was from the *Book of the Dead,* written by the scribe Ani in the eighteenth dynasty. This era is after the exodus, but Ani still betrays distinct Hyksos leanings and so he can be said to be a supporter of the Amarna regime (who were Hyksos re-immigrants) with some certainty:

> May he (Horus) grant a view of the Aton and a sight of Yah without ceasing every day [61]

Of the many things that Ani wants to be granted by the gods, he wishes to see Aton (the Sun-god) and Yah (the Moon-god) every day. One presumes this extract was written before Akhenaton began to clamp down on worship of all the other gods and to concentrate on the Aton, but here can be seen the importance of Yah, even in the theology of Thebes (albeit a Thebes controlled by Hyksos sympathizers).

The form of the Israelite altar has quite obviously been derived from Egypt and this symbology has to be an early tradition, rather than being some later invention in the post-exodus era, as the same image can be found in Knossos. The Minoans appear to have adopted many of the Egyptian religious practices, yet one of the items that was central to their theology was a horned altar, which is identical in layout to the Israelite altar. It is true that none of the temples of Upper Egypt display this type of altar, but the Egyptian influences upon the Minoans undoubtedly came from Lower Egypt and the Hyksos. Since the northern Egyptians lost the civil war with Thebes, it was their temples that were either destroyed or left to crumble. One can be sure that the first items to be desecrated by the victorious Thebans were the despised Hyksos temples and altars; after all, this was essentially a religious dispute.

While Egypt itself does not possess any horned altars, the history of this piece of temple furniture is quite obvious. It was used in Heliopolis and was adopted by the curious Minoans, who are known to have traded extensively with the Hyksos. After the exodus, this type of altar was also taken to Israel, where it became a central item in the Temple of Jerusalem. It is by this route that such a distinctive and unusual item came to be used in two very different cultures. [62]

The Minoan altars, being identical to the Israelite versions, may give us a vital clue as to what these horns were really supposed to represent. Some of the altars have deliberately altered horns, so that they look instead like bulls' horns. This, together with the fact that bulls are known to have

been ritually slaughtered on these altars, has led to speculation that they were simply a celebration of the sacred bull. But this alternative form of horn is likely to be a corruption that was influenced by the Minoan bull cult, which was, in itself, only an enthusiastic corruption of the Egyptian Apis bull worship. No: the majority of the Minoan horns are distinguished by their vertical backs – which are perched on the edge of the altar – and their curved inner sides. These 'horns' are quite unlike anything that a bull would sport.

A more compelling hypothesis is given by Professor Kristensen, who argues that the horns on the altar represent the Egyptian concept of the 'horns of the Earth', which, he says, indicated the four cardinal points of the compass. In effect, this is the same myth that has already been discussed, with the four pillars (mountains) holding up both the sky and the heavens. Kristensen then goes on to equate these mountains with the two- and three-hills glyphs, which also have certain similarities to the Minoan 'horns of consecration', as these altars are sometimes known. [63]

Professor Newberry goes one step further and states that the two- and three-hills glyphs derive from a 'little-known divinity in the north-west Delta region of Egypt', and that this is connected to a little known title of the 'priest of the double axe'. [64]

Kristensen's and Newberry's arguments mirror those I have already outlined, except that they do not extend the argument to its logical conclusion. Firstly, it should be noted that the Israelite altars are based on exactly the same concepts and imagery as the Minoan examples. Secondly, these horns do not just represent sacred mountains, but sacred pyramids.

The four largest, most enigmatic and most distinctive of the Egyptian pyramids are the Great and Second Pyramids at Giza and the Draco and Vega Pyramids at Dahshur. Each of these pyramids has no real identifying marks or glyphs to link them to an era, let alone a pharaoh, and each was constructed from awe-inspiring megalithic blocks. Of all the pyramids of Egypt, these four stand out as being utterly unique and could easily be considered to be the four sacred mountains holding up the sky.

Such a fusion of beliefs and symbolism between the Hyksos/ Israelites and the Minoan civilization will become important in the next chapter, but for now, the symbolism of the mountains or pyramids is the important factor. The sky and heavens were said to have four pillars holding them up, but in both Minoan art and the hieroglyphic forms of Egypt, only the two forward pillars can be seen. It is presumably through this two-dimensional symbolism that the two pillars of Jachin and Boaz became the central symbols of the Holy of Holies in the Temple of Jerusalem. See the colour plates section for illustrations of these altars.

6. Sinai

The pyramids of Giza and Dahshur had been central to the liturgy of the Israelites for centuries, if not millennia, but all that was going to have to be left behind on the great exodus. Alternative symbols and rites would therefore have to be developed to continue the Israelites' communion with god. This symbolism was now deemed to be the four (or five) pillars of the Holy of Holies inside the Tabernacle, which were representations of the pyramids; and also the Ark of the Covenant that rested inside these pillars, which was representative of the sacred chambers inside the pyramids. Thus, the Israelites were now in a position to be able to take their new symbolic pyramids with them on the exodus and still maintain their link with the deity. As Josephus says:

> Moses went no more up to Mount Sinai; but he went into the tabernacle, and brought back answers from god. [J65]

The translation of the names Jachin and Boaz into the Egyptian is rather uncertain, as there are no really convincing matches. The *Yah* of Jachin is reminiscent of Yaheweh and the god Thoth, and that is about as far as the similarities go. But, whatever the origins of these names, it seems highly likely that the pyramids were now being represented in the Bible by two or three large, expensive and sacred pillars. If this is so, then there is one other biblical report that could be cleared up by this same symbolism:

> And the Lord went before them by day in a pillar of a cloud, to lead them the way; and by night in a pillar of fire, to give them light; to go by day and night. [B66]

Now even if the Thera eruption was the cause of the ashfall and some of the biblical plagues, the actual ejecta of lava and the accompanying 'pillar' of cloud from the vent would be on the very far horizon and nearly invisible. The horizon of Thera, as seen from the distance of Giza, is some 50 kilometers *above* the island. That kind of altitude is on the boundaries of the stratosphere and the exosphere, and it is only just about attainable by the ejecta from even these most massive of eruptions. Even if it were noticed, the eruption of Thera would have only shown itself as a small hillock of cloud on the distant horizon, with the approaching high-level ash cloud eventually looking like an approaching weather front. The eruption would have looked nothing like a pillar from the distance of Egypt.

But, as we have already seen, at least one of the pyramids [Mt Sinai] was also considered to be a mountain of fire and associated with clouds, as if from a furnace:

6. Sinai

> And Mount Sinai was altogether on a smoke, because the Lord descended upon it in fire: and the smoke thereof ascended as the smoke of a furnace, and the whole mount quaked greatly. [B67]

The pillar of fire in the exodus account had nothing to do with volcanic events. It was simply a pun on the name of the pyramids at Giza and this confirms, once more, that the Israelites/Hyksos were not on the exodus at this point in time; they were involved in a massive ceremony at Giza – something akin to the Hajj. The 'pyramid of fire' was actually leading the faithful from Dahshur to Giza, or vice versa, and the Giza pyramids can indeed just about be seen from Dahshur.

This imagery of the pillar of smoke and fire 'leading the way' for the Israelites was later given to the Ark of the Covenant. The Ark had become the Israelites' model substitute for the pyramid – a mobile Mt Sinai and its secret chamber for god to inhabit during the exodus to Palestine. But the Ark may also have been used for the local celebrations and festivals at Giza, and paraded between and around the pyramids as the frontal piece of the procession. Thus, the pillar of cloud and fire 'leading the Israelites' may also have been a reference to the miniature 'furnace' of the Ark of the Covenant. This explanation is implicit in the next three quotes:

> And they departed from the mount of the Lord three days' journey: and the ark of the covenant of the Lord <u>went before them</u> in the three days' journey, to search out a resting place for them. [B68]

> For the <u>cloud</u> of the Lord was upon the tabernacle by day, and <u>fire</u> was on it by night, in the sight of all the house of Israel, throughout all their journeys. [B69]

> And the Lord said unto Moses, 'Speak unto Aaron ... for I will appear in the cloud upon the mercy seat (of the Ark of the Covenant)'. [B70]

As it says in the first quote, the Ark of the Covenant travelled in front of the Israelites, as did the pillar of fire and smoke. But the next quotes are more unequivocal in their meaning. The 'cloud' always rested on the Tent of the Congregation in the Tabernacle, where the Ark was kept; indeed, the 'mercy seat' was the top of the Ark itself. Here, then, the Ark is being given exactly the same attributes as the pillar of fire and smoke that led the Israelites on the 'exodus'. Clearly, it was the Ark that was leading the Israelites, but it was not going before them on the journey to Palestine; it was going to and from the Giza and Dahshur pyramids.

6. Sinai

Shepherds

As I have been hinting all along, I am still rather uncertain as to the actual origins of the patriarch Abraham and the Israelite/Hyksos people. The Bible says that Abraham was from Ur (Babylon) in Chaldee and, in a similar fashion, historians indicate that the Hyksos people also came from Syria or Palestine. But the history of the Hyksos and Israelites, that I derived in the book *Jesus,* indicated that this entire reasoning was unnecessary and that these people may have been influential natives of Lower Egypt. The Hyksos/Israelites were only known as Asiatic invaders from the east because the word Hyksos (Hykau-Khasut) can be interpreted in a variety of ways.

The official line is that the term means a Foreign (Khasut) King (Hyk), and this gives the traditional image of invading Asiatics. But to be more accurate, this term literally means King (Hyk) of the Mountainous Lands (Khasut). This is a term that we shall look at shortly, but note that it does not specifically mean a foreign land. The fact that Egypt has no mountains and that all the mountainous lands around Egypt were foreign does not necessarily mean that 'mountain' equates to 'foreign', as I will demonstrate.

Manetho, however, had a different interpretation for the name 'Hyksos'. He maintained that the title can also mean Shepherd King and his interpretation took a lot of tracking down, because it is derived from another word entirely. It would appear that the original name for the people of Avaris, the capital of the Hyksos people, was the *Aamu*. A direct pun on this word was also *aamu*, meaning a 'shepherd'. So, the Hyksos (*Aamu*) were also shepherds (*aamu*). It was from *these* origins that Manetho derived the now common term of Shepherd (*Aamu*) King (Hyk).

Finally, the term has also been read by some as Captive (Hyk) Shepherd (*Aamu*). Since the Bible likes to portray the Israelites as being both shepherds and an oppressed people, this phrase seems to be quite apt, but the meaning of 'captive' is most probably a later invention, as we shall see.

So what was the true meaning of this title of Hyksos? The full answer to this is rather complicated, as is often the case; but bear in mind that the word Hyk (King) is spelt using the shepherd's crook as a glyph, and the people that this term applied to were obviously known as *aamu* or shepherds. This is a sure sign that one of the prime meanings of the title 'Hyksos' involved sheep and shepherds. More important than this, however, is the fact that the modern perception of the *Aamu* or Asiatic is in itself an enigma; perhaps the best illustration of this is a quote from the *Oxford History of Ancient Egypt*:

6. Sinai

Aamu was the contemporary term used to distinguish the people of Avaris from the Egyptians. It was used long before the Second Intermediate Period and was still in use long after (Ramesses II, for instance uses it of his opponents at Kedesh) in order to denote the inhabitants of Syria/Palestine. Egyptologists generally translate *Aamu* as 'Asiatics'. [71]

There are some interesting observations that can be made from this statement and the translation of the word Aamu.

Fig 51. Aamu – citizen of Avaris, or 'Asiatic'.

Firstly, we see that the term *Aamu* was used for the people of Avaris and later it was used for a people in Palestine. But since the Israelites/Hyksos made an exodus from Avaris to Palestine, this transfer of terminology is easily accounted for. In no way, however, does the term *Aamu* infer that the people of Avaris were definitely Asiatic *before* the exodus. And in like fashion, this does not necessarily mean that the Hyksos were originally Asiatics. The only direct inference that can be drawn is that the Hyksos *became* Asiatics *after* the exodus.

A tentative confirmation of this is perhaps to be found in the text known as *The Asiatic Campaigning of Ramesses II*. These campaigns took place long after the exodus and so the lands of Palestine are often called *Aamu* in this text; but in fact, they are also known by a variation on this name, that of *Aamuru*. The 'ru' suffix has very few forms to it in Egyptian and these include to 'run away', to 'depart', to 'flee', and to 'frighten away'. The inference of the term *Aamuru* is that these were the lands of the *Aamu*, the people of Avaris who had <u>run away</u> to Palestine on the exodus.

Secondly, the term Hyksos was only coined to denote the new rulers of the *Aamu*; the Hyksos were the leaders or kings of the people of Avaris. But the quote above indicates that the term *Aamu* was in use as a term for the people of Avaris long before the name 'Hyksos' came into use. This is direct evidence that the people who eventually became 'Hyksos' may well have been influential in Avaris long before the first Hyksos kings came to power, and we shall see more evidence of this in the next chapter.

6. Sinai

The obvious reason for the name Aamu being given to the people of Avaris, is that they were the first to realize that Aries was now the dominant constellation in the morning sky. This predictable celestial event of the rising of Aries occurred between 1900 and 1800 BC, as detailed in the book *Jesus*, and this accounts for the early occurrence of this name in Avaris. At a later period, when the leaders of Avaris decided to usurp the authority of the Theban pharaohs, this name subsequently became synonymous with the Hyksos and so they became known as shepherds. But if this is the case, then why should these people be thought to be Asiatic?

I suspect that there may be some circular arguments here that need to be unravelled. The name Aamu is closely identified with the 'three-hills' glyph as a determinative, as is the Hyksos name Khasu. The three-hills glyph is, more often than not, used to determine a foreign land, and since this glyph is used for both the Aamu and Khasu, they are presumed to be foreign. The trouble with this argument is that there are many exceptions to this rule, with towns like Yabu, Abydos and Heliopolis (*Agertt*) also picking up the same three-hills glyph.

Fig 52. Khasu(t) – foreign or mountainous land.

Just like the word Aamu itself, perhaps the 'foreign' element of the three-hills glyph simply comes from its association with the Hyksos people *after* their exodus to Palestine.

The proof of this lies in the phonetic pronunciation of the three-hills glyph. As a determinative, the three-hills glyph has no distinct vocalization; but since it is so intimately linked to the word Khasu, it is occasionally used as a phonetic syllable that sounds like *Kha*. Now this pronunciation will not be found in any book, as it is just my observation, but nevertheless this claim can be shown to be based on rather solid foundations.

Although the word *Kha* does not mean 'pyramid' as such, it just so happens that many of the pyramids are prefixed by the word *Kha*. The following are some examples: *Kha-ba*, pyramid of Sahure; *Kha-nefer*, pyramid-field of Memphis; *Kha-nefer*, pyramid of Merenra; *Kha-khakhepperra*, pyramid of Userten II; *and Kha-Snoreru*, the two pyramids of Snorferu.

The word *Kha* is definitely synonymous with pyramids and also synonymous with the three-hills glyph. To cap it all, however, the word *Kha*

6. Sinai

also has the same puns or subordinate meanings to it as do the other terms for pyramid that we have already looked at. *Kha* also means 'furnace' and it also means 'chamber'. In fact, the meaning is slightly more specific this time, for *Kha* means the 'Chamber of Records'. Quite obviously, the three-hills glyph is synonymous not simply with mountains, but also with pyramids – the three hills of Giza. In like fashion, the two-hills glyph, *Dju*, is synonymous with the mountains of sunrise and sunset, and it is highly likely that this glyph can be equated to the two pyramids of Dahshur.

A possible confirmation of this link between Giza and the three-hills glyph comes from the word that is often used to denote the Giza plateau itself – *Rosthau*. The name of *Rosthau* is linked to the Giza necropolis in many texts, and yet the name itself is spelt using the three-hills determinative. Here is the three-hills glyph once more and not only is it *not* being used to denote a foreign land, but it is being used instead for a location containing three massive pyramids.

The name of *Rosthau* is interesting in itself, for it just has to have been derived from the guardians of the plateau. The keepers of these traditions are often referred to as the 'watchers' and the root of the name *Rosthau* must be *Ros*, *Rosu* or *Rosut*, meaning to 'keep awake', to 'watch', 'watchman', 'night watch'. This was the role of the tribe of Esau; after defeating the Horim they became the guardians of the Giza plateau.

Fig 53. Rosthau – Giza necropolis, Rosu – to watch.

Suddenly, the symbolism between the three-hills glyph and the Hyksos becomes perfectly obvious. Of course the words Aamu and Khasu would have had the determinative for 'pyramid' attached to them, because, according to the biblical narrative, the Hyksos/Israelites became the guardians of the Giza plateau. The original meanings of the titles given to the Hyksos are probably as follows:

Title	Classical meaning	New meaning
Aamu	Citizens of Avaris	Shepherds, people of Aries.
Hykau	Rulers or kings	Rulers or kings.
Khasut	Hills / Foreigner	Giza necropolis.

But the meanings of these words were to radically change after the exodus.

6. Sinai

The Hyksos became a despised people in the eyes of the Theban hierarchy and so everything that referred to them, or that had been sacred to them, was now rejected and ridiculed. So, when looking at all the similes to the title *Khasut*, a surprising number of insulting terms can be found; in fact, there are so many that they simply must have been created in response to the departure of the hated Hyksos. The following are good examples: *khass* – helpless; *khasst* – cowardice; *khast* – defective body; *khasi* – wretched; *khasru* – exiles. Plus, there is also the pun on the term for a Hyksos ruler: *Hyk* – captive. It is like the Anglo Saxons forming derogatory terms out of the Barbarians, Tartars and Hooligans; but how the Thebans must have hated the Hyksos to have invented so many images of derision.

But if the three-hills glyph had some remote possibility of being foreign – enough to cause some confusion for linguists – the next glyph that is supposed to infer 'foreignness' has none. I refer here to the 'throw-stick' glyph. Now the throw-stick as a hunting weapon is as thoroughly Egyptian as the boomerang is Australian, and yet, despite it being a native tool, the throw-stick is also used as a determinative in words that denote a foreigner.

Orthodox Egyptian history cannot explain why these two apparently unrelated and innocuous items – the three-hills glyph and the throw-stick glyph – should both mean 'foreign'. But the answer is obvious: both of these items are intimately related to the Hyksos people and both only became 'foreign' after the exodus. The rather neat confirmation of this hypothesis involves that very throw-stick glyph once more.

Although the spelling of *Aamu* (for a citizen of Avaris) can be made using normal glyphs, the usual spelling definitely favours the use of a throw-stick glyph. The fact that the throw-stick is being used to spell *Aamu* seems to 'prove' that the throw-stick has connotations of foreignness. Or does it? I feel another circular argument brewing. The trouble with this assertion is that the throw-stick is just a pun on the word *Aamu*. The name for this throw-stick is also *aamu*, so it is an obvious pun for the citizens of Avaris. All of which is another good example of how convoluted and confusing the Egyptian language can be.

After the exodus, of course, the throw-stick, as a name, was exported to Palestine along with the people to whom it referred; only then was it given the connotations of being something foreign. There is nothing intrinsically foreign about a throw-stick that can substantiate this as being a pre-exodus concept. Prior to the exodus, it would have simply been a witty pun – the 'bent-stick' people of the Nile Delta.

As an additional or complementary interpretation, how do we know that this glyph really represented a throw-stick in the first place? Its most common literary usage was for it to be placed on top of the three-hills glyph,

where it is then supposed to complement and reinforce the 'foreignness' of the word it is attached to. The two glyphs together are supposed to mean something like 'foreign-foreign' or 'very foreign'. But if the three-hills glyph actually refers to the three pyramids at Giza, as now seems very likely, then the form of the throw-stick may have a completely different and rather revolutionary interpretation placed upon it.

The rituals of Giza were all about the Sun's alignment with the pyramid causeways, and it was the sunrise along the Great Pyramid's causeway that marked the season of the Nile's inundation. It so happens that the Great Pyramid's causeway actually had a kink at its end; indeed, the original causeway looked *exactly* like the throw-stick glyph. Now when the ancient scribes start attaching this same throw-stick to the central peak in the three-hills glyph, the true symbolism of this glyph becomes complete. The throw-stick was nothing of the kind; it was most probably a representation of the Great Pyramid's causeway. It was via this rather tortuous route that this glyph became closely associated with the Aamu/ Hyksos people, because they were the very people who performed the solar rituals on the Giza plateau! (See figs 51, 52.)

Fig 54. Aamu – throw-stick.

As a slightly tongue-in-cheek reference in the book *Thoth*, I speculated that the game of cricket has been used in later eras to encapsulate some of the sacred measurements that are present on the Giza plateau; this being achieved through some influential parties who were interested in these 'sacred measurements' mysteries. Bearing in mind the above, it was interesting to find out that the game of cricket is likely to have been a Flemish import, based on the game of *met de kick ketsen*, or *krikets*. The literal translation of krikets is the 'curved-stick' and the early renditions of this bat were identical in shape to the Egyptian throw-stick.

Cricket aside, if the rest of this hypothesis is anything like true – and it does seem to be a compelling argument – then many of the references to the three-hills glyph should, if they are old enough to be pre-exodus, have some sort of connotation to the Hyksos/Israelites. A typical example might be the Egyptian word for 'hill country', which uses the three-hills glyph once more. Just like the word *Khast*, this word can also mean 'hill-necropolis'; specifically, one on the west bank of the Nile, just like that of Giza. This

looks to be a word that might be able to confirm that the three-hills glyph was originally meant to represent what it actually looks like – three pyramids in a row, on top of the western plateau. So, in what way, if any, does this word relate to the Israelites? Well, the word is pronounced *Semi-te*.

The Semitic (Shemitic) people are supposed, in biblical terms, to be the descendants of Shem (Shem שׁם), who was, in turn, the eldest son of Noah. But is this truly the origin of this generic term for the Israelites? The whole point of this chapter is to put forward the hypothesis that the Hyksos/ Israelites were, in actual fact, famed for being the guardians of the pyramids at Giza and Dahshur. It can be seen that the three-hills glyph, which has been equated with the pyramids, is now conjoined to the word that best describes this racial type – *Semite*. The Egyptian word *Semite* meant 'desert', 'hill country', 'the hill of truth', 'hill of the spirits', 'hill of the east and west'; while the similar word *Shemite* meant a 'journey', a phrase with distinct connotations of the exodus.

Fig 55. Semite – desert hills or journey.

Like their absence from the Bible, the pyramids are also notable for their absence within Egyptian literature. Here is a people whose culture is famed today, and was probably famed then, for being inheritors and custodians of the world's largest and greatest ancient monuments. Yet these awe-inspiring structures – that must have truly seemed like mountains to the people of the Mediterranean at a time when the average temple was just a few meters high – merely figure as a backdrop to one or two of the ancient texts. Is this situation credible?

If, however – and it is an admittedly big if – the three-hills glyph originally referred not to mountains but to the Giza pyramids; and if the two-hills glyph refers not to mountains but to the Dahshur pyramids; then the greatest of the Egyptian pyramids would be dramatically shifted back to the center-stage of Egyptian literature, which is surely where they should lie.

The reason why classical Egyptology will neither propose, nor accept, this concept is the fact that they still consider these pyramids to be the tombs of fourth dynasty pharaohs. The three-hills glyph goes right back into the distant realms of Egyptian literature, so how can the three-hills glyph refer to pyramids that had not yet been built? This is a major

stumbling block that has prevented the whole of Egyptology from seeing the obvious truth. Being of 'alternative' persuasions, however, I am quite open to the idea of the pyramids of Giza and Dahshur being pre-dynastic structures; in whatever manner one likes to envisage that argument. The point is that the simple expediency of making these pyramids into much older temples, rather than dynastic tombs, alters the whole perception of Egyptian literature and religion. Suddenly, the pyramids can be seen to be the central and ancient core, around which much of the subsequent ancient Egyptian literature revolves. The question that remains, however, is why the relatively well-documented New Kingdom literature seems to contradict this theory?

The explanation is surely that, like much of the terminology extant at that time, the liturgy and rituals that the guardians of the Giza plateau once maintained were all exported to Jerusalem on the great exodus. The Hyksos/Israelites maintained the original festivals in Jerusalem for a while but, for whatever reason, they became unpopular and finally ceased. Perhaps this occurred when the Ark of the Covenant was lost from Jerusalem and, not wanting to admit the loss, the clergy simply stopped the processional (and precessional!) rituals. But knowledge of these festivals was preserved and the ritual was revived by the populrist evangelist Saul, who could see the commercial implications of a great festival carrying a money-box! Thus, the ritual of the Ark, borne by the clergy, being paraded around the city was revived in the Catholic nations that fringe the Mediterranean. The same festival also relocated itself to Arabia and to Mecca, where the original custom of circling of the pyramids was also restored.

Back in Egypt, however, the tradition and the importance of the pyramids in the original liturgy was lost, and perhaps deliberately so, for if the exodus of the Hyksos/Israelites left an open wound in the psyche of the Judaic world, this traumatic event quite obviously did the same for the Theban Egyptians. It is known that the Ramesside pharaohs tried to wipe the Amarna pharaohs from the historical record and, from the lack of Hyksos remains in Lower Egypt, it seems likely that the post-exodus era involved a similar orgy of destruction.

In return, the Israelites tried to expunge the great civilization of Egypt from history and they nearly succeeded too; were it not for the great temples and pyramids that litter that country, who would know or care about Egypt today?

In this orgy of mutual destruction, the Egyptians tried to excise all memory of the Hyksos/Israelites. If that meant reducing the Great Pyramid's fantastic festivals to a footnote in history and transferring the

remnants of these rituals to Thebes, then why not? In much the same fashion, the great Temple of Heliopolis – probably the greatest of all the temples of Egypt – did not survive into the modern era. While the great temples of Thebes were being repaired and re-fashioned throughout the Ptolemaic and Roman period, the Temple of Heliopolis was closed and in ruins. It was left to a Jewish high priest of Jerusalem, Simon Onias, to try and rebuild and reopen the Temple of Heliopolis, but that, too, was dismantled after the Temple of Jerusalem was destroyed by the Romans in AD 70.

All in all, there is quite a persuasive argument to be made that the two- and three-hills glyphs refer not to mountains and foreign lands, but to pyramids; and we shall see more evidence of this in the last chapter. But this change to these glyphs also gives an equivalent change in terminology for the Hyksos. The name that was given to the Hyksos leaders was 'Hykau Khasut' and, therefore, this title no longer means the 'Rulers of the Hill Country' or 'Foreign Kings'; instead, it refers to the 'Kings of the pyramids' or the 'Guardians of the Giza plateau'.

Migration

If all this is so, then the whole case for a large-scale invasion of Asiatic people *into* Lower Egypt during the nineteenth century BC – the Hyksos invasion – may just fall flat on its face. One of the main reasons for the choice of the term 'foreign ruler' for Hyksos has always been the fact that there was a civil war between the Hyksos and the Theban Egyptians, which 'proves' that they were a foreign Asiatic people who had invaded Egypt. But again, this may not be the case.

The whole thrust of the books *Jesus* and *Tempest* is that the dispute between these two peoples was religious, and so this civil war could easily have been precipitated between almost identical native Egyptian peoples of a different religious persuasion. That there was a religious dispute at this time is irrefutable, but were Abraham and the Hyksos Asiatic or not? Well, the Bible says of the ancestry of Abraham that:

> And Terah took Abram (Abraham) his son, and Lot the son of Haran his son's son, and Sarai his daughter in law, his son Abram's wife; and they went forth with them from <u>Ur</u> of the Chaldees, to go into the land of Canaan; and they came unto Haran, and dwelt there. B72

Haran (Haw-rawn חָרָן) was the brother of Abraham; it would seem from

this account that the family of Abraham came from Ur (Babylon), on the Euphrates, and they made the long and arduous journey to a town in Canaan called Haran. Abraham arrives in this new land and finds a town to live in that has the same name as his brother. Now was the town called Haran before or after Terah and Abraham moved there? (The Bible concordance confirms that the second Haran was a town rather than the person.) In many respects, the whole event sounds rather less like a long migration from Mesopotamia and more like a trip to see a relative (Haran) in a neighbouring town that he governed.

So did Abraham come from <u>Ur</u>, the Babylon of Mesopotamia, as the Bible maintains, and migrate all the way down to Canaan? Or was he instead from <u>Uar</u>, the town of Kheraha and the 'Babylon of Egypt'. This relocation of Abraham's new homeland from Palestine to Giza may seem to be convenient, but a similar account in Josephus' *Antiquities* seems to confirm this assumption. His account of the battle of Esau against the Horim and the settling of the Israelites in 'Palestine' is much more brief than the Bible's version, but it does contain some rather interesting details:

> Abraham contrived to settle (his sons) in colonies; and they took possession of Troglodytis, and the country of Arabia the Happy, as far as it reaches to the Red Sea. [J73]

Note how the Horim have been translated, in Josephus' Greek version, into the Troglodytes; a term that positively confirms the cave-dwelling image of this nation. Now this quote from Josephus may appear at first glance to confirm the Biblical account; that this battle had nothing to do with Egypt and, in reality, the sons of Abraham (including Esau) were actually taking control of the 'Arabian' lands of Palestine as far south and west as the Red Sea. But hold on a minute! The translation stands out as being very peculiar: why on Earth should Arabia be 'Happy', especially as a proper name? In the Loeb Library version of Josephus, this term is translated as 'felix', which is the Latin for 'happy', a derivation which just adds to the confusion. The text makes no sense, so why was Arabia called Felix, or Happy?

A deeper analysis of the text may shed some light on the matter. The term being used is the Greek ευδαιμονς (eudaimonv) which is derived from ευοδοω (euodoo); the first of these means 'to be happy', but both words also mean 'to prosper'. The correct translation for this text, I believe, should really be 'Arabia the Prosperous', but unfortunately this explanation sounds even less likely than 'Arabia the Happy'! The western side of Arabia, where it borders the Red Sea – which is the portion of Arabia in

question according to H. J. Thackeray, the translator of Josephus – is anything but prosperous; in fact, it is better described as being an extension eastwards of the Sahara desert. A less prosperous area in the world is hard to imagine and this is presumably why this particular translation was rejected. But the alternative of 'happy' is not much better, so how can the situation be resolved?

The answer lies in the traditionally misplaced location for most of the events that occurred in the biblical-type accounts. The term being used *was* 'prosperous', and it makes perfect sense if the location was not Arabia but Egypt. The proof for this lies once more in the original Egyptian version of this text. While it may be becoming obvious that much of the Hebrew language was derived from the Egyptian, not surprisingly the Greek language had similar influences. The word ευοδοω (euodoo) is no exception.

Ευοδοω (euodoo) not only means prosperous, it also means a prosperous journey or literally 'prosperous road'. The Egyptian equivalents of this word are *euodj,* meaning 'road' and *euotch,* meaning 'prosperous'. But this is not any old kind of prosperity; it is a specific reference to greenery, vegetation and the fertility of the land – a notion that is reinforced by the use of the papyrus plant as a glyph in all these words. Such a description is quite unlike anything to be found in western Arabia.

But the meaning of this prosperity becomes clearer when we find that the linked term *Euotchit* means the Delta Lands of Egypt, and *Euotch-Ur* means the Delta Lands adjacent to the Mediterranean. As the city of Ur has equivalents in both Sumer and Egypt, this provides an easy confusion between Egypt and the land of Arabia. Since the classical interpretation of this passage is so nonsensical, I would confidently propose that 'Arabia the Happy' really refers to the 'Arabia of the Nile Delta', or the 'Ur of the Nile Delta' – the Nile Delta adjacent to the Mediterranean.

Euodj – road, Euotch – prosperous, Euotch-Ur – Nile Delta
Fig 56.

In fact, the original translations of Josephus, by both Whiston and Thackeray, may actually have been remarkably accurate, but perhaps not in the manner in which the translators intended. Whether by design or coincidence, a reasonable translation of the land in which Abraham was

supposed to have settled, would be 'Arabia (Ur) nourished and made prosperous by Hapi'. Hapi was, of course, the god of the Nile who caused the fertility of the land and was therefore the source of the prosperity of the Nile Delta. The linking of the Nile Delta, prosperity, happiness and the god Hapi in this fashion is fortuitous to say the least.

The prime source of this confusion between Arabia and Egypt lay in the name of the city of *Uar* (Kheraha), which was known in antiquity as the 'Babylon of Egypt'. This town was sited just across the Nile from the Giza plateau; it has already been identified with the pivotal town of Yabu that is so common in these Egyptian texts, and it is likely to have been known in the Bible as Kadesh.

Kadesh was the pivotal town about which much of the account of the exodus revolves. Wallis Budge actually includes a town called Kadesh (*Qadjeshu*) in his Egyptian dictionary, although its location is not known. I am not sure if he intends this to be the biblical Kadesh or not, but it is interesting that the root of this name is from *Qadj* (Kad), which means to 'orbit' or 'circle'. This just has to be another reference to the festivals of the pyramids and the circling of the faithful around them.

By way of confirmation of this 'Kheraha equals Kadesh' theory, the town where Abraham lived was known as Haran. The term most probably means, in the Egyptian, much the same as Paran. Per-An was the great mansion of Heliopolis, whereas Har-An would simply mean the pyramid or Benben stone of Heliopolis. If Haran were at Heliopolis, then the biblical account of this migration by Abraham would be radically altered.

As has been hinted at many times now, the fact is that instead of there being a great migration of these proto-Israelites from Babylon in Sumer to Palestine, it would seem far more likely that Abraham and his family had simply moved from Kheraha (Egyptian Babylon) to Heliopolis – a distance of just a few kilometers.

This is all very interesting, for it also directly inferred that Lot, the son of Haran, was also resident somewhere in Lower Egypt along with the rest of this important family. Lot is more famous for a well-known biblical event, the destruction of Sodom and Gomorrah. Perhaps, then, these two infamous towns were actually in Egypt; but is there any evidence for this?

Chapter VII

Thera

A tremor shook the land and, just for a few minutes, the constant, solid and unchanging world of the people of Egypt seemed to rock with great uncertainty. The calm that followed was reassuring but, after a few days, there was loud clap of thunder that was not only heard through the ears but through the chest as well; it was a sudden shock to the whole body and it felt as though the gods themselves had punched each person in turn. Clearly something out of the ordinary was happening to the people and the small, white cloud that suddenly appeared on the very far horizon to the north-west just had to be connected with these events.

A few wispy bits of this cloud arrived high over Egypt in just a few hours, dimming the light of the great god Ra, but the looming bulk of billowing cloud far below advanced much more slowly. After a day and a half, the cloud looked like an approaching sandstorm, with billowing heaps of cloud rising up to the heavens themselves and dark brooding 'mama' formations hanging on below. The population of Egypt, being familiar with these events, would have returned home early from their work and closed their windows and doors. (Not in Thebes, as the houses have no roofs!) But the people must still have been perplexed, because sandstorms came out of the south-west, not the north-west. Suddenly, the storm was upon them, but this was going to be no ordinary sandstorm.

The 'sand' was almost white in colour, and it was not hard and grainy but light and fluffy and would not settle easily; indeed, it looked for all the world like the ash from yesterday's hearth. Some of the more impulsive rushed out to play in the strange storm, but the fluffy ash stuck to everything and made the air thick and choking. Retreating back to their homes was no escape from the storm, as the ash invaded the rooms

through every crack and crevice and whirled around the room incessantly; eyes stung, throats rasped and bare skin itched:

> Their bodies had terrible boils, breaking with blains, while they were already inwardly consumed; and a great part of the Egyptians perished in this manner. [J1]

The biblical texts assert with some authority that the ash was obviously a skin irritant in some manner. These boils could have been caused either through heat, acidity or even small shards of silica, acting like the minute needles from a cactus or the shards from working with glass-fiber. Added to this was the thick, choking nature of the air, 'breathing hindered by its thickness' as Josephus says with a graphic realism that betrays a verbatim report.

As the day wore on, the cloud grew thicker and thicker until the Sun disappeared completely and a foreboding darkness fell over the land at midday. The intensity of the storm grew worse and now small pellets like hail also rained down, clattering off roofs and breaking the ripening crops. The people choked and coughed in the midst of this great cloud for three full days, unable to so much as leave their homes or speak to their fellow man. Each household was an isolated outpost of frightened humanity; huddled masses desperately praying to their gods for a reprieve.

Finally, the storm abated and a milky-white Sun was seen in the sky once more; Ra was not dead after all. After the cloud finally cleared, Ra returned in all his glory, but the land was now white with ash and, as Ra set over the western horizon, he became an unusually intense fiery blaze of red, like none had ever seen before. Although the impact of the eruption of Thera upon Egypt may not have been as traumatic as was first suspected back in chapter I, it was still clear to the people of Egypt that the gods were angry with them. People had died, many had sores, animals and crops had perished. Even if the biblical stories of fire and tempests were purely symbolic, this would still have been a momentous event, worthy of a stele being cut and a tradition of these events being passed down to future generations.

Earlier in the book, I placed great emphasis on the fact that many of the biblical plagues were, in fact, just literary puns devised by the scribes that described, instead, the great festivals that were held around the pyramids. Many of the Egyptian names for the pyramids can also mean storms, clouds and fire. So much of the storms, fire and clouds that occurred around Mt Sinai [the Great Pyramid] may have simply been scribal wordplay. But the question remains as to how this wordplay originated. Did the word for mountain [pyramid] equate with 'furnace' and

7. Thera

'storm' before the Thera eruption, or were these euphemisms added later as an explanation of these events? Clearly, the gods were angry with the people of Egypt and if the gods lived in the pyramids, as the Bible says, then surely the traumatic events of the Thera eruption were also connected to the pyramids.

There is also the possibility that the pyramids were equated to the island of Thera before the final eruption. Thera was sometimes known as the island with a 'pillar', a reference to the frequent gentle puffs of cloud that eminated from the central vent. If this vent were conical, then this steaming Theran 'pyramid' may have been linked to the Giza pyramids for some considerable time. Any of these explanation are possible.

Some things, however, are much more certain. We know that the Island of Thera did explode with unimaginable violence at some point in time, and it is known that this eruption occurred after the Hyksos had settled in Egypt. The evidence for this comes from the cartouche of the Hyksos pharaoh Khyan, who I have identified with the biblical Cain, which was excavated from *under* the Theran ash at Knossos by Sir Arthur Evans.

It is also known that Egypt did receive a light ashfall from this eruption and it is beyond doubt that the first wave of seafarers coming in off the Mediterranean would have told lurid stories of what they had seen towards the north-west of Egypt. The tsunami associated with this eruption would not have worried ships at sea, for the wave height of the tsunami is minimal in deep water. What the skippers would have had to contend with, in addition to the effects felt in Egypt itself, was lava-bombs of varying dimensions and vast amounts of ash-pellets. This pumice is often so light that it can float on water, so tales would also have circulated about the sea turning to stone.

Sodom

Tales of these fearful events must have circulated widely and it has to be asked if these tales can be found in the historical record. The mention of stones raining down on a city and causing massive destruction by fire, brings us to another biblical event that has been variously linked to both the eruption of Thera and also to the story of Atlantis – the biblical destruction of the cities of Sodom and Gomorrah. The principal characters in these events were Abraham and his nephew, Lot. This rather places these events at too early a period to be associated with either Thera or the biblical plagues, for these events occurred at least a generation later. Nevertheless, since so many of these tales have produced such interesting alternative explanations, this famous biblical story is worth a second glance.

7. *Thera*

One of the key aspects of this reinterpretation of the story of Lot is that it may have actually occurred in Egypt. As we saw at the end of the last chapter, Abraham and Lot may have actually been moving from Kheraha (Egyptian Babylon) to Haran (the Pyramid of Heliopolis). Thus, the events of this story may have occurred in Lower Egypt and not in Palestine. The biblical account seems to confirm this:

> And they returned, and came to Enmishpat, which is <u>Kadesh</u>, and smote all the country of the Amalekites, and also the Amorites, that dwelt in Hazezontamar. And there went out the king of Sodom, and the king of Gomorrah ... and they joined battle with them in the vale of Siddim. B2

If Kadesh was Uar-tesh (Khe-desh, the Egyptian Babylon), as I have shown, then Sodom and Gomorrah would appear to have been cities that lay close to Heliopolis. The actual names of Sodom (Cadom סדם) and Gomorrah (Amorah עמרה) are unlikely to give us any clues as to their true location, as they mean 'burning' and 'submersion' respectively. This may not even be a later reinterpretation of these names by the scribes; instead, it may be an indication of how the Hebrew language has been evolved from these very biblical events. I could not find Gomorrah (Amorah) in the original Egyptian, but Sodom was more fruitful, if the pun can be excused.

The translation of Sodom is the Egyptian *Sotham*, which means to fornicate. Bearing in mind the supposed goings-on in Sodom, this translation just *has* to be significant:

> And they called unto Lot, and said unto him, Where are the men which came in to thee this night? Bring them out unto us, that we may (bugger) them. And Lot went out at the door unto them, and shut the door after him, And said, I pray you, brethren, do not so wickedly. Behold now, I have two daughters which have not known man; let me, I pray you, bring them out unto you, and (you can fornicate with them): only unto these men do nothing. B3

Clearly, the events of that night in this city were infamous and the town, whatever its real name, became synonymous with fornication – and the act of fornication in Egyptian is *Sotham*. The Hebrew scribes picked up this word Sotham and, perhaps being uncertain of is meaning, or perhaps by design, they linked it with the destruction of the town rather than its reputation. Sotham, to fornicate, became Sodom, to burn. Notice once more how the Egyptian 't' has turned into a Hebrew 'd'. Since the

7. *Thera*

Egyptologists are only guessing, the Hebrew pronunciation may well be the more correct and the original Egyptian pronunciation may have been more like *Sodham*. Like the translation of the word *Ark* in chapter IV, notice once more how the Hebrew has altered the meaning of the original Egyptian, while the Latin has preserved it. The English 'sodomy' is from the Latin *sodoma*, which has somehow preserved something very akin to the original meaning of the Egyptian *sodham*.

The reason for the Sodomites' descent into debauchery is puzzling. They are initially described as being the friends and allies of Abraham and Lot in their fight against the Assyrians. After their defeat, Abraham freed all the captured Sodomites and allowed them to return home. A possibility for their sudden decline in popularity may be that the Sodomites allowed the normal sexual imagery and rituals of the Egyptian gods to be performed by the wider population. It is not known if the sexual rituals of the Egyptian gods were acted out physically by the priesthood, but at the very least, these rituals were supposed to be reserved for the temple. That the Egyptian priesthood was somehow involved in these rituals, however, is implicit in the biblical name for Joseph.

Josephus gives the Egyptian name for Joseph as being (p)Sothom Phanech and this name has a surprisingly accurate translation. Sothom translates rather precisely as *sotham* in the Egyptian, as has just been explained, and this means to fornicate. On the other hand, the equivalent of Phanech is none other than *fanuch*, which means to create or propagate. Joseph's Egyptian title was therefore *Sotham Fanuch*, or 'Creation through Fornication'. Notice how, after all these years, the pronunciation of Joseph's title has been so accurately preserved.

While this title might initially sound bizarre, it has to be remembered that Joseph was a high priest of Heliopolis and this sacred ritual of fornication was more concerned with the creation of the cosmos than the creation of a child. Thus, the title of the biblical Joseph at the temple of Heliopolis was none other than the 'Creator of the Universe through the Sexual Union of the Gods'. In this case, Joseph was in charge of the ritual sexual union of the gods who, in turn, created the world as we know it and ensured the fertility of the land and its people. This was a very high rank indeed and so Joseph probably held the highest office possible within the priesthood.

It is uncertain if this post involved any physical re-enactment of these sacred rituals, but if the re-enactment *were* physical, then this may go some way towards explaining why the later Christian Church was so paranoid about sex. The New Testament Saul would have been keen to demonize any arcane Israelite rituals that may have survived into the first

7. Thera

century AD, and if there were any sexual imagery or ritual still employed in the Holy of Holies in Jerusalem, Saul would have moved swiftly to suppress it.

Fig 57. Sothom Fanuch, the biblical Joseph.

Atlantis

The tentative link that some people make between Sodom and the Atlantis tale comes from the description of how the Sodomites fell from grace in the eyes of Abraham and the gods:

> ... the Sodomites grew proud, on account of their riches and great wealth: they became unjust towards men and impious towards god, insomuch as they did not call to mind the advantages they received from him. They hated strangers and abused themselves with sodomy ... [J4]

This may appear to be an everyday account of a wealthy city that has become too liberal in its social structure, but it does have strong echoes of the iniquities of the Atlanteans.

> But when the divine element in them weakened ... they ceased to be able to carry their prosperity with moderation ... they seemed in their pursuit of unbridled ambition and power, to be at the height of their fame and fortune ... And Zeus ... when he perceived the wretched state of this admirable stock decided to punish them ... [5]

The fire and destruction of Sodom and Gomorrah also seems to be familiar in comparison with the Atlantean tale:

> Then the Lord rained upon Sodom and upon Gomorrah brimstone and fire from the Lord out of heaven. And he overthrew those cities, and all the plain, and all the inhabitants of the cities, and that which grew upon the ground. [B6]

7. Thera

At a later time there were earthquakes and floods of extraordinary violence, and in a single dreadful day and night ... the island of Atlantis was swallowed up by the sea and vanished ...[7]

So, are these biblical accounts of the destruction of Sodom and Gomorrah in any way similar to the Atlantean story, or indeed, the effects of the Thera eruption? While this is possible, on balance I think not.

The problem with this raining of fire and brimstone on Sodom is that there is another account of this event that paints it in a more humanistic fashion. The destruction may not have been the dramatic natural calamity that many would assume; it may have been a well planned military attack on Sodom that the Bible appears to be describing.

According to the Bible, the 'Lord' – which is a term than can apply to kings as much as gods – was with a band of men and he wanted to destroy Sodom. But Abraham wanted to save the city because his nephew, Lot, lived there. The 'Lord' was persuaded that Lot should be saved and two 'angels' were despatched to warn Lot to get out before the attack started.

And the Lord went his way, as soon as he had left communing with Abraham ... And there came two angels to Sodom at even; and Lot sat in the gate of Sodom: and Lot seeing them rose up to meet them; and he bowed himself with his face toward the ground. [B8]

As angels go, this pair are rather too humanistic to even contemplate them being spiritual entities. The whole event has an air of a well-planned military assault on the town, and so a pair of spies is being sent in first to get the friendly forces out prior to the assault with 'brimstones'. The Hebrew translation of the brimstones (gophriyth נפרית) is another enigma because their meaning of 'Jehovah's judgement' is obviously another of these convenient scribal alterations that were implemented after the event. So what were brimstones? The parallel account in the Koran seems to clear up the matter of what exactly fell on the town of Sodom and it also confirms the military nature of the destruction:

We (god) are sent forth to a wicked nation, so that we may bring down on them a shower of clay stones <u>marked by our Lord</u> for the destruction of the sinful. [K9]

We (god) turned their city upside down and let loose upon it a shower of clay stones <u>bearing the tokens of your Lord</u>. The punishment of the unjust was not far off. [K10]

215

7. Thera

This is a much more plausible explanation for the shower of stones. The stones that were fired against Sodom and Gomorrah were actually clay stones. More than that, since these stones had 'tokens of the Lord' inscribed upon them, it rather sounds as if they were incised clay tablets made for this very purpose. But what exactly were these clay tablets for? The Bible may have the answer to this:

> Thou also, son of man, <u>take thee a tile</u>, and lay it before thee, and <u>portray upon it the city</u>, even Jerusalem. And lay siege against it, and build a fort against it, and cast a mount against it; set the camp also against it, and set battering rams against it round about. [B11]

This is from Ezekiel's vision of the destruction of Jerusalem. Clearly, the method for laying siege to a town was through the making of clay tablets that were incised with some message or other. This description gives us a couple of possibilities that may fully explain this event.

The making and baking of clay tablets for correspondence is well attested to in Egypt and the storeroom at Amarna contained copious amounts of these letters to foreign princes. One possibility, bearing in mind the apparent cunning of the Israelites, is that this was an early form of propaganda. Messages describing the power of Abraham's army could have been thrown into the town of Sodom to induce their surrender.

Alternatively, the biblical passage seems to describe an image of the city of Jerusalem being drawn on the tablet, in which case the intent is probably akin to what we would might term as voodoo: the control of people and events through the manipulation of clay models. In a similar fashion, it was common in both Greece and Egypt to inscribe the names of one's enemies on small clay pots and then to ritually smash them on the ground; an act which would hopefully break the power of that enemy as well as the pot. The Berlin Museum has acquired quite a collection of these pot fragments which attests to the widespread use of this custom.

The result of this practice in Greece was a glut of potsherds, or <u>ostra</u>, throughout the country. These sherds were rather sensibly recycled as voting forms when voting against politicians and, thus, the unlucky candidate was '<u>ostra</u>cized'.

It could well be that the army of Abraham and his 'Lord' were making images of the city of Sodom, breaking them and then throwing the clay shards over the city walls. This would have the dual benefit of making the wish come true and also of demoralizing the inhabitants of the city, who could see thousands of broken images of their city lying all around. With the inhabitants suitably despondent, the city was subsequently sacked and

7. Thera

burned; which resulted in the biblical description of fire as well as brimstones.

A re-enactment of such an event may be another of the events at Mecca during the Hajj, where the faithful gather stones to throw against a stone pillar in the town of Mina. This action is supposed to recall the time when Abraham was about to 'sacrifice' his son Isaac, but the link here is tenuous in the extreme. The more famous Koranical account of the throwing of stones was at Sodom, but both the Bible and Koran portray this as being a divine action by god, so it can hardly be re-enacted at Mecca by mere mortals − not unless the reasoning behind the ritual is changed, of course.

Santorini

It would appear that the destruction of Sodom and Gomorrah had nothing to do with the eruption of Thera (Santorini). In this case, what effects *did* Thera have upon Egypt? The actual eruption of Thera was some 900 kilometers away from Giza, so, as can be imagined, the effects were going to be drastically reduced by the time the ash and pumice reached Egypt. The majority of the ash is supposed to have fallen towards the north-east, over Anatolia. But obviously, the wind must have shifted at some point in time and the cloud approached Egypt from the north-west. [12]

The effects on Egypt, as I have previously indicated, were probably frightening but eminently survivable; but the effects closer to Thera itself and the island of Crete were near-catastrophic. It is inconceivable that such a traumatic event went unrecorded in the literate eastern end of the Mediterranean, in this kind of era. The question of whether it *was* recorded has been debated many times and there are two obvious candidates for this.

The first of these comes from the tale of Jason and the Argonauts. Jason was sailing across the Aegean in search of the Golden Fleece − which just has to be a reference to the constellation of Aries, once more − and encountering all kinds of mythical beasts en route. One of these monsters was the bronze-clad Talos:

> Use gentle oar strokes to keep out of range of the rocks, until he yields to the destruction of my hands. They removed the ship from the danger of the missiles and held it with the oars ... [13]

The ship was between Crete and Thera at the time, so this description

could well be a first-hand description of a frightened crew trying to reach their island of Thera, but having to hold their position to avoid the lava-bombs that the eruption was hurling out. But the story continues, and the subject matter here seems to confirm these suspicions:

> And then straightaway, as they moved swiftly over the Cretan deep, they were terrified by the night they called 'a pall of darkness'. Neither the stars nor moonlight pierced the obscurity. The black chaos was coming down from the sky, or some other form of darkness was rising from the innermost recesses of the Earth. They had no way of knowing whether they were voyaging on water or through Hades. Helpless, they could only entrust their safe return to the sea, that was carrying them whearever it was bearing them. In this extremity Jason prayed to Apollo, and the god guided them with the glint of his bow to Anaphe, east of Thera, where they landed and sacrificed in sunshine once more. [14]

This description of a 'pall of darkness' and a 'hail of rocks' just has to be a description of the eruption of Thera. To cap it all, this is exactly where Jason landed, on the island right next door to Thera (20 km distance). So, the mythological record not only holds the seeds of historical events within its occasionally baffling texts, but those seeds also contain a kernel giving a good description of the Thera eruption.

But since one Greek myth can hold details of the eruption of Thera, what of the stories of Atlantis? The problem with this comparison are well known, however. The destruction of Atlantis was too early and the Atlantean island was too large to have been Thera; besides, the location of this mythical island was not correct either. However, there are solutions to these problems and for these I am indebted to the author J. V. Luce. [15]

Luce put forward an eminently sensible argument in favour of Atlantis being Thera. The first problem was the shape of the island of Thera; it did not seem like Atlantis at all. Atlantis seemed to be almost mythical or man-made in its layout, with rings of land being surrounded by rings of water, forming a series of concentric circles.

> (Poseidon) fortified the hill by enclosing it with concentric rings of sea and land. There were two rings of land and three of sea, like cartwheels, with the island at their center and equidistant from each other ... [16]

It seemed impossible that a natural island could ever take on that kind of

symmetrical form. But apparently it can and, like Atlantis, the type of island concerned is also intimately linked to areas of volcanic activity.

This concentric, ring-like formation is formed when the vent of a volcano is plugged. The pressures build up inside the vent as magma forces it way upwards from deep underground, and the ground at surface level swells noticeably, forming a large dome – known as a shield. If the volcano then manages to dissipate some of this pressure in a non-violent manner, then the shield can collapse and sink into itself, forming a caldera. On a few occasions, however, the shield will not subside uniformly; instead, it breaks up into a series of concentric rings and the resulting formation is then known as a nested caldera. Should this nested caldera be in the sea and subsequently manage to flood, then what is produced is a series of concentric island rings with circles of water in between. This is an exact copy of the description of Atlantis and it even has a geological name – a flooded-nested caldera.

The other problems with Plato's story were the date, size and location of Atlantis. For the very succinct and neat answer to the problems with the size and location of Atlantis, I will quote from W. Friedrich:

> J. V. Luce offers a good answer to the question of where Atlantis was located. Plato interpreted the notes of Solon incorrectly: instead of 'greater than Libya and Asia' as in Plato's text, one should read 'between Libya and Asia'. Since the Greek words in question, <u>meson</u> and <u>mezon</u>, differ in only one character. [17]

Change one letter in a word and the whole perception of Atlantis changes. At one stroke, both the size and location of Atlantis have been diverted from the Atlantic and, instead, focused back towards the island of Thera. Thera *is* in between Libya and Asia, and since the size is no longer implicit in this sentence, Atlantis could have been of any size.

The date is equally easy to adjust as the glyphs for thousands can easily be mistaken for hundreds. A date for Atlantis of 900 years before Solon would be around the 1500 BC era, which is just about right for the destruction of Thera. The descriptions of bull fighting within the Atlantis text are also pure Minoan and must have been influenced by this civilization. In the book *Thoth,* I argued for an Atlantic location for Atlantis, based on a possible location for the mythical 'Hall of Records'. As a physical reality, the new interpretation above appears to be more logical and reasonable. However, the long-standing myth of an Atlantic repository of the gods, as described in the book *Thoth*, may well have influenced the narrative and caused much of the confusion that exists to this day.

7. Thera

Here, then, is the parallel narrative to the biblical plagues. Atlantis told of the destruction of Thera in the great eruption of the seventeenth century BC; the Bible told of the effects of that eruption upon the people of Egypt.

Hyksos

It would appear that the eruption of Thera was the source and the inspiration that lay behind the writing of the biblical account of the plagues in Exodus. But, as we have already seen earlier in this book, the exodus of the Israelites was not exactly as advertised. The plagues event was indeed followed by a massive procession of the population; but they were not perambulating around the Sinai peninsular. Instead, they were involved in a massive procession between the pyramids: it was a Hajj-type festival.

What are we to make of all this? Did the exodus really occur, or was it all in the minds of the scribes, as so many of the historical and theological scholars have previously argued? Personally, I think that the historical evidence for a real Hyksos/Israelite exodus is overwhelming. The Hyksos people are a historical fact and this sizeable segment of the Egyptian population are mentioned in many of the original Egyptian texts. These historical references include the mention of the Hyksos exodus, but there are one or two interesting facts about these references.

The first point is whether or not the Hyksos were just an Asiatic people and were called 'foreign rulers'. I have already dealt with this point in some detail and explained that the term was actually derived from the term 'guardians of the Giza plateau'. So, what do the secular texts from Egypt have to say about this subject? Were these Hyksos people Asiatics or simply the people of Avaris (Aamu) who had different beliefs from other Egyptians? Well, when reading the ancient texts that contained references to the Hyksos, the first quote I found pointed towards the latter:

> When the Asiatics conspired to attack the Rulers of the Hill-Countries (Hekaw-Khasut or Hyksos), I opposed their movements. For this ruler of Retenu made me carry out numerous missions as commander of his troops. Every hill tribe against which I marched I vanquished ... [18]

This is from the *Story of Sinuhe*. The composer of this ancient text, Sinuhe, was a Theban prince who feared for his life during a royal succession and defected to the Hyksos. No doubt, on ascending to the Egyptian throne,

7. Thera

many a pharaoh imprisoned or exterminated any pretenders to the throne, so Sinuhe made a quick exit. But there are two peculiar aspects to this story.

Firstly, the Hyksos were fighting against the Asiatics, and while it is not unheard of for related tribes to squabble amongst each other, this account does still point towards the Aamu – the people of Avaris – not being Asiatic.

Secondly, and more importantly, this text was written at the end of the Middle Kingdom, and Sinuhe had been working in the court of the late Senusret I, who died in about 1910 BC. Sinuhe was then absent from 'Egypt' during the reign of Amenemhet II and returned on the accession of Senusret II in the 1870s BC. But the first of the Hyksos were not supposed to have been resident in Egypt until the reign of the Hyksos pharaoh, Saltis, of the Second Intermediate Period, or about 1650 BC. Here, we appear to have a 250-year discrepancy to explain away between the account of Sinuhe – who was working for the Hyksos – and the orthodox dating of the Hyksos 'invasion' (revolution) of Egypt, in the seventeenth century BC.

The way the Egyptologists evade this discrepancy is to say that the adventures of Sinuhe actually occurred in Palestine, not Egypt; thus, the Hyksos were not in Egypt at the time. But the text does not support this interpretation. Sinuhe had been fighting in Libya. He then returned to the Isle of Snoferu, which the translator Goedicke has ascribed to Giza; he then crosses the river Nile and proceeds north. He reaches the borders of Egypt but *returns* to *Qedem* and *Retenu*. Sinuhe finds himself at home in his new adopted land and says that his position there is very agreeable:

As if a Delta-man saw himself in Yabu, a marsh man in Nubia.

This is another good indication that Yabu should be associated with the Nile Delta rather than Elephantine; otherwise, why should a Delta-man feel so comfortable there? Yabu was obviously a part of the Delta. But the question remains as to where *Qedem* and *Retenu* were really located? The orthodox interpretation would have them in Palestine/Syria, but was this really so?

Qedem is more often than not written as *Qedjem*, a town that, in the texts, is variously located in either the Nile Delta or in Syria/Palestine. The reason for the two possible locations is, once more, that the name was taken from the Nile Delta and reused by the Hyksos/Israelites for a town in Palestine, after the exodus. *Qedj* means to circle or orbit, a phrase that was linked to the 'compassing' of the Israelites/Hyksos around the pyramids. This name is also rather similar to *Qedjeshu* (Kadjeshu), the name I identified with the biblical Kadesh in the last chapter; it is even comprised of the same glyphs. So *Qedjem* has not only the same spelling but also the

same type of meaning as *Qedjeshu*. Neither *Qedjem* or *Qedjeshu* have known locations.

Qedjem can be linked to the biblical Kadesh in the following manner. The prefix of *Qe* (Qa) can be likened to the prefix of *Kha*. In the last chapter, it was pointed out that the three-hills glyph could be pronounced as *Kha*, and this syllable was closely associated with words that referred to pyramids. The same reasoning applies to the *Qa* (Kha) prefix. There are a great number of these words that are associated with the three-hills determinative, and there are also a number of these words that are names for pyramids, such as *Qanefer* – pyramid of Amenemhet I; *Qabh* – pyramid of Shepseskaf. So, Qedjem (Khadjem) is likely to have been the same as the biblical Kadesh, which lay somewhere close to the Giza plateau.

This initially tentative translation for the town of Qedjem appears to be confirmed by some rather familiar actions by Sinuhe:

> You <u>circled</u> the 'foreign countries', going from Qedjem to Retenu, land giving land was the counsel of your own heart.

Here we see the 'circling' of the mountains once more. But this is not a biblical reference, it is a historical text that seems to confirm the biblical record and appears to suggest that Sinuhe was taking part in the annual festival of circling the pyramids that, in the biblical account, appeared to center on Kadesh (Qedjem). This should not be unexpected; *Kha* (Qa) can be a reference to the pyramids of Giza and the circling was performed around the pyramids. Thus, the prefix of *Kha* (Qa) became synonymous with circling as well as pyramids.

Some confirmation of this can be seen in the name for the Twin Peaks, the mythical source of the Nile. The actual source of the Nile was known as *Qerti*, but the determinatives attached to this name are either two rectangles, meaning 'houses', or two circles, possibly indicating 'caves'. *Qerti* is derived from *Qeti* meaning circle and it is also the name for the fifth hour of the Djuat, the mythical 'nether-world' of the gods. The Djuat not only contains the ten circles of *Djes* and the hidden circle of *Seker* it is also itself pictured as being a circle, with its determinative sometimes taking the form of a star inside a circle.

The *Djuat* contains the *Ennead* – the company of the nine prime gods. The gods were often grouped into four couples of 'married' male and female gods, each set of four couples then being ruled by a supreme god, forming the nine. Hermopolis' four pairs, for instance were *Nu* and *Nut*, *Hreu* and *Herut*, *Kehui* and *Kekuit*, *Kereh* and *Kerehet*, and these were led

7. Thera

by Djeheuti, forming the nine. There were several such nines, and the interesting thing about them is that they were connected with circles. The determinative for the nine was the New Moon glyph *Pestch,* and the nine were called the *Pestch-t,* but *pesher* also means a circle. Budge speculates that the *Pestch* glyph may have been confused with the *Pauti* glyph, which is similar but is actually a square within a circle.

The point of all this symbolism is, I believe, that the Djuat was not simply mythical, but was also real. The Djuat was supposed to be located between the four pillars that supported the sky or heavens, and this is presumed to be a mythical location. But, since these four pillars have already been identified with the pyramids of Giza and Dahshur, the location of the Djuat could easily have been the 19 km or so (20 Thoth miles) of plateau between Giza and Dahshur. The texts describe the Djuat as a long, mountainous, narrow valley with a river running alongside it and, although the plateau is not a valley, it does fit the mythical description of this location rather well. It is quite possible that the rituals of the Djuat were not entirely mythical; although they were based upon myth, the rituals were probably played out between the pyramids with real people and real Arks.

When Osiris made his circuit of the Djuat, his shrine was most probably physically carried around the Dahshur plateau on the shoulders of the priests. When the barque of Ra was said to be towed through each division of the Djuat, no doubt a real barque or Ark was carried by a vast procession, with each event and location in the Djuat being represented by a building or shrine along the way. In this case, the entrance to the Djuat, which was supposed to lie between the Twin Peaks, actually resided between the two largest Giza or Dahshur pyramids. This is clearly demonstrated by the form of the alternative glyph for the nether-world, which is called *Neter-khert.*

Neter-khert is translated as the nether-world or the Djuat, but it is literally derived from the word for the necropolis, and it can also mean a stonemason. The image being portrayed is not just of the nether-world, but also the real world of monumental masonry. The glyph being used gives the game away though, because it consists of a truncated pyramid with the axe of the gods on the top and a flag or feather at the side. The god-axe indicates that this is one of the four pyramids that held up the heavens, and the flag or feather symbolizes a shadow. Recalling chapter I, it was explained that the pyramids of Giza acted as giant gnomons, marking out the seasons of the year by observation of their shadows, which were projected to one side along the causeways. The Khert glyph consists of a truncated pyramid and a shadow to one side, thus Neter-khert was either the Great or the Second Pyramid at Giza.

7. Thera

Fig 58. Neter-khert Kher – necropolis.

There is some dispute about the form and function of the *Khert* pyramid glyph, though, and one dictionary says that it is a 'butcher's block'. But if the glyph is taken back to its basics, it can be seen that it is formed from the Sun-temple and the truncated pyramid determinative glyphs of the word *Kher*, which also means necropolis. It is also worth noting that the Minoan god-axe is often shown as being stuck in the top of a small truncated pyramid in exactly this manner, so the Minoans must have also played out these same rituals of the Djuat (Neter-khert).

It is beyond doubt that the *Khert* glyph was based upon the design of a truncated pyramid and, of course, Kheraha – the Babylon of Egypt – is spelt using the very same glyph. In fact, the name Kheraha is probably a later name for Uar (the same town), as this name has a definite meaning to it. The translation – which is graphicly illustrated by the glyphs – is 'strong battle at the boundaries of the truncated pyramid'. This name was no doubt influenced by the battles between Esau and the Troglodytes, on the Giza plateau.

As an aside, there has been much interest of late in a peculiar Masonic rite at Bohemian Grove in the USA. This ritual involves the 'sacrifice of care' which is lamely explained as being the 'sacrifice of the cares, worries and worldly affairs of the participants'. The ritual involves a curious blend of a boat on a lake, a sacrifice and much casual urinating. The Egyptian word *kher* does indeed mean the everyday affairs and businesses of man, but this is not the true basis for the ritual. It is, rather, derived from the 'sacrifice of Kher', the 'sacrifice' or the leaving behind of the truncated or Great Pyramid. (The Hyksos/Israelites left the pyramids behind when they departed on the exodus.) Not surprisingly, the (by now) traditional punning of the word *Kher* conveniently produces the words for 'boat' and 'urinate'.

If further proof were ever needed that the Giza pyramids once stood at the center stage of Egyptian theology, it is to be found in the creation myth of Geb, the brother-husband of Nut. It was Geb and Nut who laid the

cosmic egg from whence came the Sun, in the form of the Phoenix. Because of this act of oological creation, Geb became synonymous with the goose called Gebga; although it is difficult to say what name came first, the chicken (goose) or the egg. As the similar name for the goose is rather convenient, one might guess that the inventive scribes have created a goose with a suitable name to match that of Geb.

But now the scribes really get into their stride and surpass themselves with pun upon pun; what fun and games were being perpetrated in these ancient scriptorums in the name of theology. The really puzzling piece of text is from the *Papyrus of Ani*:

> I open the two doors of heaven; are opened for me the two doors of the water-floods by Thoth and by Hapi who the <u>two sons</u> are of heaven, mighty of splendours. [19]

The difficult portion is the 'two sons', which are written with two geese glyphs. Budge has pencilled in a question mark after this translation, because it does not make much sense. But this is a good example of needing to know the subject in order to be able to derive the answer, because the ancient scribe is being tiresomely devious.

The god Geb laid the cosmic egg, and so he was sometimes known as the *Gengen-ur,* or the Great Cackler, and given the goose glyph to symbolize this; all of which was probably just a witty nickname for the great god. Coming back to the quotation from the *Papyrus of Ani*, however, the 'two sons' translation above has come from a word containing two of these very geese. And in another strange twist of glyphs, this goose glyph can also be pronounced 'sa' meaning son, which gives us Budge's translation of the 'two sons'. This, however, was a linguistic cul-de-sac.

The true interpretation of this 'two goose' word is rather to be found in the word meaning 'cackle'. For some strange reason – probably due to deliberate scribal obfuscation – the word *Gengen* (meaning the Great Cackler), can be reversed and pronounced instead as *Negneg* or even *Negaga-ur;* both of which still mean the Great Cackler. The interesting thing about this version, is that the word for the pendent breasts of a woman is *negaga-t*.

The text above was talking about the opening of the doors that contained the floods of Hapi, the inundation of the Nile. The inundation came from the Twin-Peaks and now we can clearly see that the 'two brothers' were actually the 'Twin Breasts' of the great Giza pyramids. This hypothesis is further confirmed by an alternative word for the solstice. A strange rendering for the solstice uses three geese, but since I have

identified the solstice with the Giza pyramids, perhaps this association between geese, pyramids and the solstice is no longer quite so odd. The scribe's witty pun therefore links the concepts of the Twin Peaks and the cosmic egg, through a clever rhyme between the cackle of a goose and the breasts of a woman. In reality, the translation should really have read:

> I open the two doors of heaven; are opened for me the two doors of the water-floods by Thoth and by Hapi who are the *Twin Peaks* (pyramids) of heaven, mighty of splendours.

The two doors of heaven that held back the Nile floods did, indeed, reside within the Twin Peaks and they were associated with both Hapi and Thoth, so this translation makes sense. But the cosmic egg was supposed to have been laid at Heliopolis, and so this myth of the Twin Peaks had absolutely nothing to do with Thebes and Elephantine. Indeed, one of the translations of the *Book of the Dead* says that:

> I am the egg which is <u>in</u> the Great Cackler, and I watch and guard that mighty thing which hath come into being wherewith the god Geb has opened the earth. [20]

The Great Cackler has already been identified with the Great Pyramid of Giza, so the text seems to be indicating that the cosmic egg was actually inside this pyramid. But perhaps, instead, the scribe is having another small laugh at our expense. The glyph of the cackling goose is pronounced as 'sa' and the goose is known as *sabu. Sab*, on the other hand, is the name for a jackal, which can obviously be linked to the jackal gods Anpu and Ap-uat (Anubis). The egg may or may not have been inside the Great Pyramid, but the watching and guarding over the 'mighty things' on the Giza plateau was most certainly done by the twin jackal gods.

Negaga-ur – Nut/Geb,

negaga-t – breasts, *twin cackling breasts.*

Fig 59.

7. Thera

Rethenu

Another point that has led to the orthodox interpretation of the town of Qedem being in Syria was that Sinuhe wanted to return to Egypt at the end of his life, because he did not want to be 'wrapped in a skin of a ram to serve as a coffin'. This sentence has obvious agricultural and pagan connotations, which can be likened to the nomadic tribes of Syria; but as is explained more fully in the book *Jesus*, all of these references were actually astrological. What the scribe is insinuating is that Sinuhe did not want to die and be buried as a believer in the astrological sign of Aries. Like many a convert to a foreign land, a small element deep within his psyche craved for the teachings of his homelands and, despite all his assistance to the Hyksos Shepherd regime, Sinuhe wanted to be buried as an Apis bull worshipper.

The 'return' of Sinuhe to 'Egypt' could also infer that Qedem and Retenu were in a foreign country; but the fact is that 'Egypt' is often written as a reference to Upper Egypt or Thebes. In the *Protests of the Eloquent Peasant* (another ancient text), we see a description of the peasant going from the Field of Salt, which was near Faiyum in Middle Egypt, 'down' to Egypt, ending up in Greek Herakleopilis. Although the peasant started in Egypt as we know it, he travelled south towards Thebes and 'Egypt'.

Perhaps a better example of this is to be found in the *War against the Hyksos*. This is supposed to be a record of the Theban pharaoh Kamose, who says:

> Behold, it is *Aamu* (Asiatic) as far as Cusae (Hermopolis) ... we are in our Egypt. Elephantine is strong and the middle is with us as far as Cusae ... He (the Hyksos pharaoh) holds the lands of the *Aamu* (Asiatics), we hold Egypt.

Kamose is delineating the extent of the lands he holds. The land is known as 'Egypt' as far as Cusae, but from there on it is simply 'Asiatic' or the lands of the people of Avaris. In this case, 'Egypt' was only a reference to the Theban-controlled lands of Upper Egypt. In the case of Sinuhe, therefore, he returned to 'Egypt' simply because he was travelling from the Hyksos-held lands in the north to Thebes in the south.

> Then his majesty (the Theban king) sent a trusted overseer of the royal domains with whom were loaded ships, bearing royal gifts for the 'Asiatics' that had come to escort me ... I had started to set sail,

7. Thera

there was kneading and straining beside me until I reached the city of Itj-tawy (Lisht near Faiyum).

Once again, we can see that the Hyksos appear to be demanding a substantial tribute for the return of Sinuhe and, once again, it would appear that Sinuhe was travelling south along the Nile and Egypt proper was only reached at Faiyum. The Hyksos kings that Sinuhe served could easily have been in Heliopolis at this time, according the details in this travelogue.

One last point of contention is that all through the text, the scribe has Sinuhe living with the Hyksos in a large tent – which again seems to point towards the classical interpretation of him living with nomadic 'Asiatics' in Palestine. But the reason for this is easily explainable. The text was written by Theban scribes and the story ends with Sinuhe's return to Thebes. The whole point of the story is the great difference in lifestyle between Sinuhe's new luxurious home in Thebes and the humble 'tent' that was all the Hyksos could provide him with.

> Here is Sinuhe come as a Bedouin, a product of nomads ... I was put in the house of a prince. In it were the riches from the treasury; clothes of royal linen, myrrh and the choice of perfume ... I was shaved, my hair combed, thus my squalor returned to the foreign land, my dress to the sand-farers. I was clothed in fine linen, anointed with fine oil, I slept on a bed.

This juxtaposition between the wealth of Thebes and the 'poverty' of the Hyksos 'nomads' comes despite an earlier passage in the tale, which indicates that Sinuhe was also extremely well provided for by the Hyksos king. But it is obvious that the story of Sinuhe is part biography, part propaganda. The whole point of the latter half of the text was to show how superior and civilized the Theban regime was, in comparison with the Hyksos-controlled lands to the north. Despite the early date here of the 1870s BC, those Hyksos lands were not Syria/Palestine, but Heliopolis and Lower Egypt.

The final nail in the coffin for the orthodox interpretation of where Sinuhe lived, however, is in the true location of the lands of Qedem and Retenu. The possible link between Qedem and Kadesh has already been covered. If Qedem were Kedesh, then it lay just across the Nile from Giza. But what of the other town: what of Retenu?

The Egyptologists assume this town to be 'Retnu', which is said to be a place located somewhere in Palestine/Syria; but the actual location of the town is, as usual, unknown. This identification of Retnu with Palestine

probably comes directly from the orthodox interpretation of the story of Sinuhe. But not all the threads in the story really point towards a town in Palestine; indeed, many of the references seem to portray Retenu as referring to a people rather than a location.

Strangely enough, the king of Retenu's name is Ammunenshi (Amun) and the people there speak Egyptian. Such an Egyptianized religion and language might seem a little strange for nomadic 'Asiatics', but much more likely for the Aamu – the people of Avaris. But the real problem with the orthodox interpretation for the location of Retenu is to be seen in the *War against the Hyksos*, a later text from the reign of Kamose (c 1550 BC).

> I moored at Per-djedquen, my heart glad, for I had made Apepi (Apepi II?) see a miserable time, <u>the prince of Retenu</u>, weak of arms, who planned many things in his heart, (but) they have not come to pass for him. [21]

The people of Retenu are clearly being linked to the Hyksos ruler Apepi, as he is being called 'the prince of Retenu'; but the capital of Apepi and his people, the Hyksos, was at Avaris in the Nile Delta, and there is no evidence to suggest that the Hyksos had control of any lands in Palestine/Syria at this time. The translator brushes off this inconsistency by saying that '*Retenu – (is a reference to) Syria/Palestine in general, but here it is used derivatively for the Hyksos ruler in Egypt.*' In other words, the town has now become a person and the location of that person is now in Egypt.

But the true inference of this statement is more than obvious. Like Yabu, the name Retenu was inextricably linked either to the Hyksos themselves, or to where they lived – to Lower Egypt, to Heliopolis and the Delta Lands.

The classical translation of Retenu is that of *Retnu* in eastern Syria, but there is another possible identification for this name. Instead of *Retnu,* the real Anglicized spelling ought to be Rethanu. The relevance of the second spelling is that *reth* means 'people', whereas the second syllable of *Anu* means the 'Temple of Heliopolis'.

So, *Rethanu* can mean 'people of Heliopolis', and the determinatives that go with this name are the three-hills glyph and the throw-stick, once more. The three-hills and throw-stick glyphs may have prevented this interpretation in the past, but with the new association of the three-hills with Giza and the throw-stick to the Hyksos people of Avaris, this new interpretation seems highly likely to be correct.

7. Thera

Fig 60. Reth-Anu – people of Heliopolis.

Other confusions over the location of Rethanu occur once, more in the text called *The Expulsion of the Hyksos*. The story continues into the reign of Tuthmoses I and it states that:

> (Tuthmoses I) went forth to Rethanu, to assuage his heart throughout the foreign countries. His majesty reached Naharin, and his majesty ... found that enemy. Then his majesty made a great slaughter among them. [22]

Tuthmoses I only reigned for six or so years and, while his Nubian campaigns are reasonably well attested to, the supposed campaigns into Syria are not. The town of Neharin mentioned here is supposed to have been on the Euphrates river, which would mean that Tuthmoses I had attained all the accomplishments and accolades that are normally attributed to the later and far greater pharaoh, Tuthmoses III. So did Tuthmoses I reach the Euphrates? Did Tuthmoses I achieve, in six years, everything that Tuthmoses III achieved in 55? The trouble with this rather illogical assumption is that there is another interpretation to Neharin, and it is a term that is often used in conjunction with battles against the 'Asiatics'.

> Thou art sent on a mission to Djarhan at the head of the victorious army, to crush those rebels called Nearin. [23]

> The arrival of Nearin troops of the pharaohs ... from the land of Amurru. [24]

In all of these cases, the Nearin (Naharin, Neherin) are associated with troops and a battle and, in the latter two quotes, this has been translated in the notes to the text as 'young boys'. It is likely that Tuthmoses I was not reaching Naharin (the town) to engage in battle, but instead he was approaching the Neharin troops. The Neherin were actually the young elite

troops of the Hyksos/Israelites and, as one might expect, this word is therefore a Semitic word for young boys. This can be seen in the Bible, where the Israelite troops are being prepared for battle:

> And Ahab said, By whom? And he said, Thus saith the Lord, Even by the <u>young men</u> of the princes of the provinces. Then he said, Who shall order the battle? And he answered, Thou. [25]

The Hebrew word being used here for the 'young men' is the (plural), *Neherin* (nah-ar נַעַר). In the Hebrew version, the word is derived from the roaring of a lion and the shaking of its mane. A possible Egyptian derivation for this word would therefore be *Nehem* – to roar; *Ri* – a lion. If the word for lion could be inserted into the word nehem, for some reason, then the compound word would be Nehe-ri-m; but it has to be admitted that this is not a positive translation.

Quite obviously, these soldiers were the elite 'lions' of the Hyksos/Israelite army and, undoubtedly, they would have got a special mention in the texts as they were poised for battle with the Egyptian army and – if the Egyptian account can be relied on – eventually annihilated. In reality, Tuthmoses I went forth to Rethanu (the nation) to meet the elite troops of the Hyksos/Israelites and engage them in battle. Bearing in mind that this event was post-exodus, this battle could have occurred anywhere in either Egypt or Palestine; but the least likely of all the possible locations is a town on the Euphrates.

The second quote above is from a much later campaign of Ramesses II, and it can be seen that Ramesses is now using these 'Hyksos Lions' as mercenary soldiers – in this quote, they are fighting on the side of Ramesses. But note that they are still being linked to Aamu, the people of Avaris; although once more, they are being called the 'exiles of Avaris' – the *Aamu-ru*. The previous nationality of the Amurru in Rethanu, however, is made perfectly clear in the following excerpt:

> The princes of Upper Rethanu, who knew not Egypt since the time of the gods, begging for peace before his majesty. [26]

Apparently, the princes of Rethanu had not known, or more likely not lived in, the land of Egypt for a very long time. This text was from the New Kingdom and, thus, long after the Hyksos/Israelites had been exiled to Jerusalem, so of course the princes of Rethanu had not lived in Egypt for some considerable time. All of this points towards both Qedem and Rethanu originally being located in Egypt. Either these were generic names

for the people or, perhaps, they were locations near to the pyramids or Heliopolis: either way, the names seem to have travelled with the people and eventually into Palestine.

The bottom line with the tale of Sinuhe – the Theban prince who worked for the Hyksos – is that the Hyksos had part or full control of Lower Egypt as far back as Senusret II and the 1870s BC. This is not so unlikely as it may at first seem. According to Wallis Budge, there are a great number of Hyksos kings that have no firm dates attached to their reign and these shadowy pharaohs could easily stretch back this far. Most of these unconfirmed pharaonic names have been dropped from the modern text books, as nobody knows where to put them.

But the whole point of the book *Jesus* is that the Hyksos Shepherds should have come to power, or asserted their authority, in Egypt when the constellation of Aries became dominant in the heavens above. This event can be firmly dated with a computer planisphere, and the date appears to be somewhere between 1900 and 1800 BC. These dates tally very nicely indeed with the story of Sinuhe and it is therefore likely that the Hyksos leadership of Lower Egypt dated from this time; although the precise era in which they declared themselves to be pharaohs, with greater authority than the Theban royalty, is perhaps less certain.

This again indicates that the struggle of the Theban regime against the Hyksos started at a very early date. From around 1900 BC, all the way through to the 1600s BC, there must have been continual strife and border skirmishes with the Hyksos in the north. The land was obviously a hotbed of revolt, but other texts also indicate that commercial trade still continued despite the skirmishes, and that grain was grown in fields in the Delta lands that still belonged to the Theban aristocracy.

Avaris

The original Egyptian name for Avaris is Het-Uar. *Het* simply means temple and the *Uar* syllable, as we have already seen, is the name for one of the suburbs in Kheraha/Kadesh, the Babylon of Egypt. Thus, Avaris means something like the 'Temple of Babylon in Egypt'; which is not only geographically correct, but is also a rather fitting place for the Hyksos to have made their last stand against the Theban army. Furthermore, the word Het can also mean to 'circle' and this has great echoes of the circling of Sinuhe at <u>Kha</u>desh, and the circling of the Israelites, with their Ark, around the pyramids.

7. Thera

Fig 61. Het-Uar – Avaris

There is another interesting little play on words here; one that must have originated after the exodus event. Uar means Babylon, but can also mean leg. In addition, Uar can also mean to flee, to escape, to melt away. Presumably the term Uar meaning 'leg' was pre-exodus, but it looks once more as though the word Uar was then twisted into the verb to 'flee', in another fit of post-exodus jubilation by the Theban victors. It has to be significant that so many of the names that are related in some way to the Hyksos are also seen to be verbs of hatred and ridicule.

Whatever the case, we now come to the actual attack of Avaris by the Theban army. The following quotes are again from the *War against the Hyksos:*

> This is the attack! Here am I. I shall succeed ... I shall destroy your dwelling place and cut down your trees, after I have confined your women to the holds of ships. ... gold, lapis lazuli, silver, turquoise and countless battle-axes of metal ... all their valuable timber and all the good produce of Rethanu; I have seized them all. I did not leave a thing of Avaris, because it is empty, with the Asiatic vanished.

The author is attacking the Hyksos, but taking the goods from Rethanu. Again, the obvious deduction from this passage is that Rethanu was a rather wealthy province or nation, situated somewhere in Lower Egypt; but this fact is met with a stony silence by the translator, and ignored.

The text seems to indicate that the battle for Avaris was swift, but other similar texts allude to there being a long stand-off and siege. Here is another reference to the final battles of the Theban army with the Hyksos:

> When the town of Avaris was besieged, I fought bravely in his majesty's presence. There was fighting in the water of 'Pjedku' of Avaris. I made a seizure and carried off a hand ... Then they fought again in this place, I again made a seizure there and carried off a hand ... Then there was fighting to the south of this town ... Then Avaris was despoiled ... Then Sharuhen was besieged for three years ... Now when his majesty had slain the

233

nomads of Asia, he sailed south to Khent-hen-nefer to destroy the Nubian bowmen. [27]

This extract is from the *Autobiography of Ahmose, Son of Abana*. Like the previous extract from *War against the Hyksos*, this text also confirms the dual campaigns of the pharaoh Kamose with both the Hyksos and the Nubians. This confirms the story of Manetho, which indicated that the Theban pharaoh was concerned about the Nubians in the south as much as he was about the Hyksos in the north. Having dealt with the Nubians, the text indicates that Ahmose I still has the Hyksos to deal with in the north, which goes to show just how protracted this final battle really was.

> Then Aata came to the south. His fate brought on his doom. The gods of upper Egypt grasped him ... his majesty carried him off as a living captive and all his people as booty. I brought two young warriors as captives from the ship of Aata ... Then came the foe of Tetian. He had gathered the malcontents to himself. His majesty slew him, his troop was wiped out.

We know these foes were Hyksos because the text contains another humorous pun. The Theban pharaoh (god) 'grasps' his enemy, the Hyksos. The Hyksos were known as the Aamu, or shepherds, but *aamu* also means to seize or grasp, so the scribe was just having the traditional fun with his text.

Unfortunately, we shall probably never know who *Aata* and *Tetian* were, as these are probably just derogatory terms. *Aata*, for example, may simply be a pun on 'boat' because *Aata* also means boat and that is how this enemy was travelling. The text may be intended to read as, 'the boatmen came south ...'

On the other hand, the foe called *Tetian* was probably derived from the words *tet,* meaning 'image'; and *ian*, meaning 'ape'. Thus, the enemy looked like an ape, which is perhaps an apt phrase. In fact, this term may be a double pun, because *Tetian* also sounds rather like *Tatenen*, the Memphite god. Tatenen was a manifestation of Ptah and, in some respects he was the Memphite equivalent of the Heliopolian god, Atum.

Manetho also alluded to there being a long siege against the Hyksos, but in addition, he indicated that there was a treaty too:

> The kings of Thebes rose in revolt against the (Hyksos) and a great war broke out, which was of long duration. Under a king named Misphragmouthosis, the Hyksos were defeated and driven out of the

rest of Egypt and confined to a place called Avaris ... (the king) besieged the walls with 480,000 men and endeavoured to reduce (the Hyksos) to submission by siege. Despairing to achieve his object, he concluded a treaty, under which they were all to evacuate Egypt and go wherever they wanted unmolested. Upon these terms no fewer than 240,000 households left Egypt and traversed the desert to Syria. Then, terrified by the might of the Assyrians, who were at that time masters of Asia, they built a city in the country now named Judaea ... and gave it the name of Jerusalem. [J28]

The history of the Two Lands, as seen through the eyes of Manetho, indicates that the siege of Avaris was long and protracted; but that eventually, the Hyksos/Israelites did leave Egypt for Jerusalem. The question has to be, therefore: do the biblical texts confirm this in any way? We have already seen the wanderings of the Israelites being, in reality, a festival procession, but was there an exodus out of Egypt too?

In the passage from Manetho just given, the Hyksos/Israelites not only took the city of Jerusalem, but they were also 'terrified by the might of the Assyrians', as Manetho puts it. The following passage from the Bible mirrors very closely this history of the Hyksos, as narrated by Manetho.

And Jacob came to Shalem, a city of Shechem, which is in the land of Canaan ... and pitched his tent before the city. [B29]

And it came to pass ... that two of the sons of Jacob, Simeon and Levi, Dinah's brethren, took each man his sword, and came upon the city (of Shalem) boldly, and slew all the males. [B30]

And Jacob said to Simeon and Levi, 'You have troubled me to make a stink among the inhabitants of the land, among the Canaanites and the Perizzites: and I being few in number, they shall gather themselves together against me, and slay me; and I shall be destroyed, I and my house'. [B31]

That the city of Shalem (Shalem שׁלם) in Shechem was, in fact, the city of Jerusalem (Yaruwshalaim ירושׁלם) is confirmed by an extract from Josephus' *Antiquities*, where he says that:

Melchizedek, king of the city of Shalem. That name signifies 'the righteous king' ... however, they afterwards called Shalem Jerusalem. [J32]

7. Thera

Like the Hyksos, the biblical narrative says that the Israelites took Jerusalem in the time of Jacob and they, too, were afraid of possible reprisals from the nations that controlled the area. The two traditions, both secular and theological, agree with each other time after time. So, despite the confusing story of the Israelite wanderings around the pyramids, the Bible was right and there *was* a real exodus of the Hyksos/Israelites to Jerusalem.

Idols

Having slowly made our way through these deliberately misleading texts, and found the common scarlet thread that tells a consistent story throughout the disparate narratives, we are at last in a position to generate some conclusions. Here, at last, there is an entirely new interpretation for the biblical texts; one that seems to make a great deal of common, and historical, sense.

The history of the Judaic religions, including Christianity, starts way back in the third or fourth millennium BC, in Egypt. In this early era, there was a great monotheistic religion that centered on the physical Universe. The 'god', if there was one, was the physical workings of the cosmos and the motions of the planets and stars. The religion tried to understand these concepts and so to grasp at deep concepts such as gravity, precession, orbital mechanics and time. In doing so, the religion used a plethora of demigods to explain the process, so that the Sun and Moon developed 'personalities', like Ra and Djeheuti, to explain their relationships to one another and to explain their motions and functions.

But with the passage of time, the demigods began to develop a life of their own. As is to be expected, the general population of Egypt was less concerned with orbital mechanics and more interested in the soap opera of the gods; the prime preoccupation of the laity was who begat who and who was upset by whom. The religion had drifted inexorably away from its roots. But there were sustained attempts throughout the millennia to redress this balance and to restore the religion to its former monotheistic beliefs and functions.

The prime reformer was the biblical Abraham [Mam-aybre], who was reported as having originated in Uar, the Babylon of Egypt. As he and his followers gained power and influence, they moved the few kilometers up the Nile to Haran, and the great temple of Heliopolis. This was their power base, from where they were to eventually become the Hyksos Shepherd people and develop a kingship that was independent from Thebes. They

became the biblical Hyksos pharaohs and their religion was not just different, it was actually closer to the original concepts. It was for this reason that Abraham became so notorious in the biblical-type texts. He not only completely discarded the great plethora of Egyptian demigods, and smashed their idols and icons; he also travelled to Thebes and tried to convince the priests there the error of their ways:

Follow the faith of saintly Abraham: he was no idolater. [K33]

(Abraham said:) 'I will overthrow your idols as soon as you have turned your backs.' ... He broke them all into pieces, except their supreme god, so that they may return to him. [K34]

The [Theban] pharaoh gave (Abraham) leave to enter into conversation with the most learned amongst the Egyptians ... The [Theban] Egyptians were addicted to different customs and despised one another's sacred and accustomed rites and were very angry with one another on that account. Abraham conferred with each of them and, confuting the reasonings they made use of ... demonstrated that such reasonings were vain and void of truth. [J35]

Abraham was the first of the reformers who tried to put the demigods back into their true context. These reforms were so radical and unpopular, he thought that his son's future might be compromised by his actions. Abraham was not about to sacrifice his son, as the Bible claims, but to sacrifice his son's future seat on the throne of Egypt.

While Abraham was a radical, there were to be other, more zealous reformers in later eras; the pinnacle of this piety was to arrive in the form of Jacob and Akhenaton, each of whom caused enough strife in Egypt to create a civil war and force an exodus of their followers out of Egypt. It is sometimes difficult to know whether the biblical Moses was linked to the era of Jacob or that of Akhenaton; indeed, if the name was actually a title, there could well have been a 'Moses' in each of these eras. Whichever 'Moses' this particular story referred to, we know that (like Abraham, Jacob and Akhenaton) Moses' life was devoted to changing the theology of Egypt. We also know that the [Theban] pharaohs and priests were greatly afraid of this.

Pharaoh said: Let me slay Moses and then let him invoke his god! I fear that he will change your religion and spread disorder in the land. [J36]

7. *Thera*

In reality, the radical revolutionary, Moses, was the leader of a faction that was powerful enough to challenge the authority of the [Theban] pharaoh. Likewise, in the historical record, both the Hyksos and the followers of Akhenaton would have put the fear of god into the Theban pharaoh (or priests).

Sequence

Into this powder keg of continual civil and theological strife throughout the Two Lands of Egypt, came the Thera eruption, and it is most likely to have occurred in the era of Jacob [Hyksos, Jacoba].

The physical fallout upon Egypt was not as great as the Egyptian and biblical records have made out. As I have indicated previously, the great tempest was simply a part of the rituals on the Giza plateau and, while the ashfall may have been frightening, it was eminently survivable. But, for the gods to have allowed such an event to happen, this must indicate their displeasure with mankind: the gods were definitely angry and there had to be a reason for this. The obvious reason for this displeasure, in the eyes of the Theban pharaoh, was the 'heretic' northern Israelite/Hyksos people and their sacrilegious rituals upon the Giza plateau. The real fallout on Egypt from the eruption of Thera was not hail, or even ash, but an escalating theological dispute between the divided nation that lived along the Nile.

This antagonism between the two political groups eventually resulted in the eminently logical and neighbourly decision to hold a conference to discuss the problem; a meeting that was eventually recorded on the *Tempest Stele*. The precise nature of the discussions are, of course, impossible to reconstruct, but we can speculate on six possible things that eventually came out of the conference.

a. An agreement was made to cease hostilities and to allow the Hyksos/Israelites to withdraw from Egypt unmolested.

b. That a substantial tribute of precious materials was given to the Hyksos/Israelites. This tribute represented both the price of the Hyksos/Israelites departure from Egypt, and also allowed them to construct the fabulously expensive Tabernacle and the Ark of the Covenant.

c. As the Tabernacle and the Ark of the Covenant were both designed to be mobile, it is implicit that the agreement must have included the departure of the Hyksos/Israelites; there would be no point in

constructing a mobile temple and repository if they were going to stay in Egypt. The construction of these mobile artifacts has to be regarded as firm evidence for there being a physical exodus of the Hyksos/Israelite people.

d. Before the Hyksos/Israelites left Egypt, there was a great festival during which the Ark and the Tabernacle established their roles as substitutes for the great pyramids of Giza and Dahshur. This was the great spectacle that the Bible describes in so much detail, with the Israelites wandering from 'mountain' to 'mountain' and the Ark guiding the way, sporting all the fire and smoke attributes of the pyramids themselves.

e. As the Hyksos/Israelites finally left Egypt for Palestine, there was a protracted skirmish, with a great deal of looting, desecration of the temples and some deaths among the supporters of the Theban Egyptians. This destruction so angered the victorious Theban pharaoh that his army pursued the Hyksos/Israelites to the border of Egypt, but any skirmishes that occurred were probably inconclusive.

f. Under the terms of the treaty, about half a million inhabitants eventually left Egypt directly for Jerusalem, spending the absolute minimum amount of time in crossing the harsh Sinai peninsular. The actual number of refugees may have been inflated somewhat, as was often the case in these ancient texts.

It was in Jerusalem that the beliefs of the Hyksos/Israelite religion began to evolve once more. The hierarchy tried to hold onto the Egyptian beliefs and practices, but the former homeland of Egypt was now an enemy to be despised and mocked. The people had their own problems too, as life in Palestine was infinitely harder and provided less of the luxuries that they had grown used to in Egypt. But some of the Egyptian practices were kept alive and separate from the people, so the original Egyptian rites were still performed within the secret confines of the Temple of Jerusalem.

Then came the Persian and Roman empires. The Temple of Jerusalem was destroyed twice and the priesthood was either decimated or taken away into slavery; so very few of these Egyptian rites have survived within Judaism. Apart from a few isolated outposts like Q'umran, the popular Israelite religion drifted into the distinctly Judaic style that we see today; a form that had evolved around the unique environment of the

Levant, and the continual struggle that this location presented for their physical and theological survival.

These are the reasons why the evidence for the biblical exodus appears to be so lacking in the historical record. Firstly, the exodus event was not so protracted as the Bible would have us believe; the Hyksos refugees actually traversed from Egypt to Palestine in a matter of a few weeks. Secondly, it is not Judaic artifacts and influences that archaeologists should be looking for along this short route march to Jerusalem, but distinctly Hyksos-Egyptian ones.

Chronology

Having rewritten much of our current history and theology, there are only one or two final components in this whole story that need further mention.

The ice-core and dendrochronology evidence firmly indicates that the eruption of Thera occurred in about 1625 BC. Since this was the pivotal event that started off this whole train of events, it is obvious that both the radiocarbon and historical dates from this period must be slightly in error. Having demonstrated that the main Israelite exodus was the Hyksos exodus, and that this event was precipitated by the eruption of Thera, we now have another of those solid pegs upon which all other pieces of history and theology in this region can be based.

The great biblical/Hyksos exodus actually occurred in, or shortly after, 1625 BC. In this case, the start of the reign of Ahmose I, and his biblical/Hyksos counterpart Jacob/Jacoba, should both be amended to about 1635 BC. I feel quietly confident that if a detailed search and reappraisal were made of Hyksos artefacts that correspond to this particular era, verifiable historical evidence for the biblical exodus would be forthcoming.

What we have here is a new and radical, but nevertheless coherent and verifiable, history of Egypt and most of Western theology. The most radical aspect of this new history, for ancient Egypt, is the role and age of the Giza and Dahshur pyramids. The seemingly trivial alteration of the function of these pyramids, from tombs to ceremonial centers, has an intriguing and radical consequence. The solar celebrations that took place at Giza appear to have been intimately linked to the literature, language, lexicon and even the individual letters (glyphs) created by the Egyptian people. But these very same linguistic creations go back to the very dawn of Egyptian civilisation, and so the foundations of another classic catch-22 are being laid. The uncomfortable, for some people, and yet inescapable

result of this close association between language and megalithic pyramids, is that for the pyramids of Giza (and maybe also those of Dahshur) to be included in early Egyptian literature – they *must* have been pre-dynastic structures.

The consequence of a simple translation – without any preconceptions – of a single glyph in the Egyptian language, is that the entire chronology of Egypt has to be overturned. The Giza and Dahshur Pyramids were not the tombs of the pharaohs Snorferu, Khufu, Khafre or Menkaure – they were, instead, standing on the western plateau long before the first recorded kings of Egypt came to power.

The implications of these same Giza rituals are no less far-reaching for much of modern theology. Firstly, they demonstrate that the Israelites were originally native Egyptians, from Lower Egypt. Secondly, they also infer that the original religion of this nation involved the veneration of many of the standard pantheon of Egyptian deities. The most subtle and intriguing evidence for this, being the title of the biblical Joseph. His role as 'Chief Fornicator for Procreation', at the Temple of Heliopolis, shows that he officiated at a ritual involving the sexual union of the gods. We are more than familiar with the story that this ritual must have narrated, and so the fundamental beliefs of the Israelites must have involved the nine prime gods of Egypt. While Abraham was to rail against the evils of idolatry, it was Akhenaton who led the campaign against polytheism – in the process, the nine highly visible deities of Hyksos Egypt became the one (or two) carefully concealed god(s) of Israel.

While the original theology of the Israelites was, therefore, not quite as has been assumed; neither was their original mother-country. Dare one also make the obvious deduction – bearing in mind the maelstrom of political unrest that still surrounds the descendants of the Israelites – that the true homeland for the Jewish nation and the Diaspora, is not Israel, but Lower Egypt.

Appendix I

The Tempest Stele of Ahmose I

Fig 62. The Tempest Stele. Reproduction with kind permission from; Department d'archeologie, Universite catholique de Louvain, Belgium.

Appendix I

The Tempest Stele of Ahmose I

Robert Ritner

(1) Long live the Horus 'Great Manifestations', He of the Two Ladies 'Pleasing of Birth', the Golden Horus 'Who Binds the Two Lands', King of Upper and Lower Egypt, Neb-pehty-ra, son of Ra, Ahmose, living forever. Now then, His majesty came (...)

(2) Ra himself had appointed him to be King of Upper Egypt. Then his majesty dwelt at the town of Sedjefra-tawy.

Original translation:

(3) (in the district just to) the south of Dendera, while A(mon-Ra, Lord of the thrones of the two lands was) in Thebes. It was his majesty

My re-translation:

(3) (in the district just to) the south of Heliopolis, while A(mon-Ra, Lord of the thrones of the two lands was) in Heliopolis. It was his majesty

(4) who sailed south to offer (bread, beer, and everything good) and pure. Now after the offering (...)

(5) then attention was given in (...) this (district). Now then, the cult image (of this god)

(6) as his body was installed in this temple while he was in joy.

(7) Now then, this great god desired (...) His Majesty (...) while the gods declared their

(8) discontent. The gods (caused) the sky to come in a tempest of r(ain), with darkness in the western region and the sky being

Original translation:

(9) unleashed without (cessation, louder than) the cries of the masses, more powerful than (...), [while the rain raged] on the mountains louder than the noise of the

(10) cataract which is at Elephantine. Every house, every quarter that they reached (...)

My re-translation:

(9) unleashed without (cessation.) Blasphemy more powerful than (...), (...) on the pyramids, blasphemy of the

(10) Twin Peaks at Giza (Yabu). Every house, every quarter that they reached ... (... pummice?)

(11) floating on the water like skiffs of papyrus opposite the royal residence for a period of (...) days,

(12) while a torch could not be lit in the Two Lands [of Egypt]. Then his Majesty said: 'How much greater this is than the wrath of the great god, than the plans of the gods!' Then his majesty descended

(13) to his boat with his council following him, while the crowds on the East and West had hidden faces, having no clothing on them

Original translation:

(14) after the manifestation of god's wrath. Then his majesty reached the interior of Thebes, with gold confronting (?) gold for his statue so that he (Amon-Ra?) received what he desired.

My re-translation:

(14) after the manifestation of god's wrath. Then his majesty reached the interior of Thebes, with gold for the enemy, gold [from] the statue so that he [the Hyksos pharaoh] recieved that which he desired.

(15) Then his Majesty began to re-establish the Two Lands, to drain the flooded territories without his (...) to provide them with silver, with

(16) gold, with copper, with oil, and of every bolt [of cloth] that could be desired. Then his Majesty made himself comfortable inside the palace. (Life! Prosperity! Health!).

(17) Then his majesty was informed that the tombs had been entered [by the Hyksos], with the tomb chambers collapsed, the funerary mansions undermined and the pyramids fallen,

(18) having been made into that which was never made. Then his Majesty commanded to restore the temples which had fallen into ruin in this entire land: to refurbish

(19) the monuments of the gods, to erect their enclosure walls, to provide the objects in the noble chamber, to mask the secret places, to introduce

(20) into their shrines the cult statues which were cast to the ground, to set up the braziers, to erect the offering tables, to establish their bread offerings,

(21) to double the income of the personnel, to put the land into its former state. Then it was done in accordance with everything that his Majesty had commanded.

Theology flow-chart

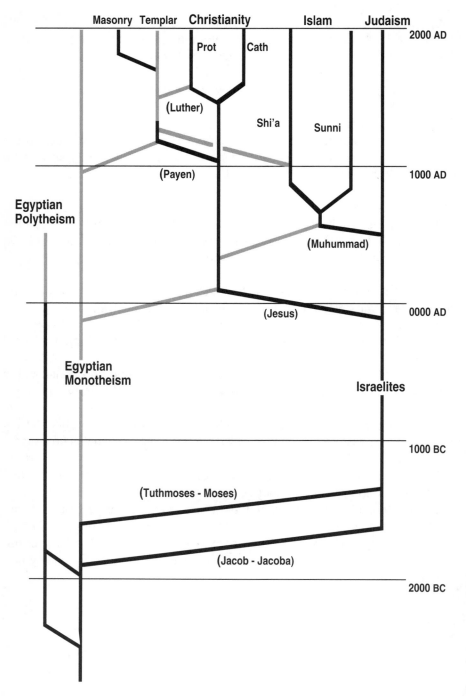

List of diagrams

List of diagrams

Photo credits

Plates 1 - 2. From the author's collection.

Plate 3.　　　Aya Sofia, Istanbul.　Corel.

Plate 4.　　　Taj-Mahal, India.　Corel.

Plate 5.　　　The *Tempest Stele*.
　　　　　　　Reproduction with kind permission from:
　　　　　　　Department d'archeologie, Universite catholique de Louvain, Belgium.

Plate 6.　　　Holy Communion.　Corel.

Plate 7.　　　From the author's collection.

Plate 8.　　　Stone altar from Megiddo.
　　　　　　　Ancient Art and Architecture Collection Ltd, Middlesex.

Plate 9.　　　Minoan altar. Ashmolean Museum, Oxford.

Plate 10-14. From the author's collection.

Plate 15.　　The Ka'ba at Mecca.　Associated Press, London.

Plate 16.　　Kilimanjaro, Africa.　David Jones, Images of Africa, Lichfield, UK.

Plate 17.　　Finding of Moses.　National Gallery.

Notes & references

Bible: All references taken from the King James edition, although the text is often modernised for clarity.

Josephus: AA = Against Apion, Ant = Antiquities, JW = Jewish war, L = Life. Page references are to the Loeb Classical Library system. Quotes taken from William Whiston's translation, which was first published in 1736, some references are from the Penguin Classics edition by G. Williamson, first published 1959.

Manetho All page numbers are taken from the LCL edition, editor G. Goold.

Within the referencing system in this book, some of the reference numbers are prefixed with letters. This is to give the reader an idea of the source of the reference, without having to look up that particular reference. This only applies to the more popular reference works, but the following have been prefixed:

<div align="center">

B = Bible, M = Manetho, J = Josephus,
T = Talmud, N = Nag Hammadi.

</div>

All references to Egyptian words and their meanings are taken from:

An Egyptian Hieroglyphic Dictionary, E A Wallis Budge, Dover Publications.

The entries in the dictionary are substantially in alphabetical (glyph) order, and so the references are easy to find and have not been listed in the references by their page number.

Chapter 1

1. Bible Exodus 24:13.
2. Oxford History of Ancient Egypt, Ian Shaw p 194, 212.
3. Koran 6:78.
4. Bible Exodus 6:3.
5. Koran 21:53 6:80.
6. Ibid 21:63.
7. The Two Brothers, Ennana. AE Literature, M Lichtheim.
8. Bible Genesis 39:7-21.
9. Bible Exodus 12:21.
10. The Destruction of Mankind, AE Literature, M Lichtheim.
11. Bible Exodus 7:20.
12. Hieroglyphic Dictionary, W Budge p958.
13. Josephus AA 250.
14. Josephus Ant 2:294.

15. Instruction of Ankhsheshonq, Chapter 21 verse 5.
16. Bible Jeremiah 13:23.
17. Inscription of Wennofer, AE Literature, M Lichtheim.
18. Bible Matthew 14:28.
19. The God of the Egyptians, W. Budge p 128.
20. Bible Mathew 6:7.
21. Ibid 6:9.
22. Egyptian Book of the Dead, W Budge p 88.
23. Gods of the Egyptians, W Budge p 167.
24. Bible Genesis 28:12.

Chapter 2

1. Prophesies of Nerferti, AE Literature, M Lichtheim.
3. Admonitions of Ipuwer, AE Literature, M Lichtheim.
4. Josephus AA 249.
5. Famine Stele, AE Literature, M Lichtheim.
6. Bible Genesis 41:54.
7. Josephus Ant 2:252.

Chapter 3

1. Texts, Storms, and the Thera Eeruption, K Foster, R Ritner, Yale University.
2. Une Tempete sous le regne d'Ahmosis, Revue d'Egyptologie 19 (1967).
3. Fire in the Sea, W Friedrich p69.
4. Michael 1978, Meuengracht 1981.
5. Dye 3 ice core, Sigurdsson 1990.

6. K Minoura, Tokyo University.
7. Volcanic shards from Santorini in the Nile Delta of Egypt, Stanley & Sheng, Nature 320 1986.
8. Bible Exodus 9:23, 9:18.
9. Josephus Ant 2:308, 2:305.
10. Koran 7:90.
11. Une Tempete sous le regne d'Ahmosis, Revue d'Egyptologie 19 (1967).
12. Bible Exodus 32:21.
13. Ibid 25:3.
14. Josephus AA 250.
15. Josephus AA 1:88.
16. Bible Exodus 11:2, 12:35-36.
17. Josephus Ant 2:314.
18. Koran 26:49.
19. Une Tempete sous le regne d'Ahmosis, Revue d'Egyptologie 19 (1967).
20. Koran 21:56.
21. Josephus AA 249.
22. Josephus Ant 2:313.
23. Bible Exodus 12:30.
24. Ibid. 32:27, 28.
25. Koran 7:137.
26. Bible Exodus 7:7-11.
27. Koran 26:34.
28. Josephus Ant 2:286.
29. Une Tempete sous le regne d'Ahmosis, Revue d'Egyptologie 19 (1967).
30. Bible Exodus 7:15.
31. Koran 26:23.
32. Ibid 20:56.
33. Bible Exodus 10:22.
34. Fire in the Sea, W Friedrich.
35. Josephus Ant 1:161.
36. Texts, Storms, and the Thera Eruption, K Foster, R Ritner, Yale University.
37. Fire in the Sea, W Friedrich.

Notes & references

Chapter 4

1. Bible Genesis 46:34.
2. Ibid 28:30.
3. Tutankhamen, C Desroches-Noblecourt, p 86, 183.
4. Bible Genesis 30:37.
5. Ibid 31:1.
6. Josephus Ant 4:63.
7. Bible Psalms 23:4.
8. Master Christian Library, Greek English Concordance, J B Smith.
9. Bible Exodus 28:9.
10. Josephus Ant 3:218.
11. Ibid 3:186.
12. Bible Exodus 28:30.
13. Josephus Ant 3:165.
14. Hodder Bible Handbook, p 144.
15. Bible Exodus 25:13.
16. Three Tales of Wonder, Westcar Papyrus, M Lichtheim.

Chapter 5

1. Clarke's commentary on the Bible.
2. Moses, Pharaoh of Egypt, A Osman.
3. Bible Exodus 6 :3.
4. Ibid 3:1.
5. Josephus JW 5:217.
6. Hieroglyphic Dictionary, W Budge p817
7. Ibid p75.
8. The World Religions, Lothar Schmalfuss.
9. Hieroglyphic Dictionary, W Budge p76.
10. Legend, D Rohl p 206.
11. Bible Exodus 3:14.

12. Minoan Religion, M Nilsson p220.
13. Bible Exodus 3:13.

Chapter 6

1. Bible Exodus 13:5.
2. Josephus Ant 3:79.
3. Bible Exodus 32:28.
4. Josephus Ant 3:75.
5. Bible Exodus 3:1.
6. Bible Numbers 20:27.
7. Bible Exodus 19:12.
8. Ibid 19:24.
9. Bible Deuteronomy 2:12.
10. Ibid 33:2.
11. Bible Numbers 10:12.
12. Ibid 20:23
13. Ibid 20:27.
14. Bible Exodus 24:12.
15 Ibid 34:32.
16. Bible Leviticus 26:46.
17. Ibid 27:34.
18. Bible Exodus 24:10.
19. Koran 7:170.
20. Ibid 18:16.
21. Ibid 18:8.
22. Ibid 18:18.
23. Stele of Taimhotep, Ptoleomaic period.
24. Koran 18:17.
25. Ibid 18:19.
26. Bible Joshua 3:25.
27. Josephus Ant 3:31.
28. Gods of the Egyptians, Budge p264.
29. Ibid p42.
30. Bible Exodus 3:2.
31. Koran 20:10, 27:4, 28:29.
32. Bible Genesis 15:17.

33. Koran 20:76.
34. Ibid 28:44.
35. Bible Exodus 16:1.
36. Bible Numbers 13:26, 20:22, 27:14, 33:37, 33:36.
37. Bible Deuteronomy 32:51.
38. Bible Exodus 17:6.
39. Bible Deuteronomy 1:19, 1:2.
40. Bible Genesis 45:10.
41. Bible Joshua 11:16.
42. Josephus Ant 3:82.
43. Bible Exodus 3:6.
44. Ibid 19:18.
45. Bible Deuteronomy 1:46.
47. Bible Genesis 25:25, 25:30.
48. Josephus Ant 1:258.
49. The Egyptian Book of the Dead, W Budge, p 95.
50. Story of Piye, M Lichtenheim.
51. Book of the Dead, W Budge p10, p31.
52. Bible Genesis 49:25.
53. Bible Leviticus 9:20.
54. Bible Genesis 28:18, 35:20.
55. Bible Leviticus 8:29.
56. Bible 1Kings 7:21.
57. White Goddess, R Graves p174.
58. Gods of the Egyptians W Budge p 156.
59. Ibid.
60. Bible Judges 16:29.
61. Book of the Dead, W Budge App4.
62. Minoan Religion, M Nilsson.
63. De Heilige horens in den oudkretenzischen godsdienst, Prof W Kristensen.
64. Two cults of the Old Kingdom, Prof Newberry p24.
65. Josephus Ant 3:212.
66. Bible Exodus 13:21.
67. Ibid 19:18.
68. Bible Numbers 10:33.
69. Bible Exodus 40:38.
70. Bible Leviticus 16:2.
71. Oxford History of Ancient Egypt, p187.
72. Bible Genesis 11:31.
73. Josephus Ant 1:239.

Chapter 7

1. Josephus 2:304.
2. Bible Genesis 14:7.
3. Ibid 19:5.
4. Josephus Ant 1:194.
5. Critias, Plato ch5.
6. Bible Genesis 19:24.
7. Timaeus, Plato par25.
8. Bible Genesis 18:33.
9. Koran 51:32.
10. Ibid 11:83.
11. Bible Ezekiel 4:1.
12. Thera, Chistos G Doumas p138.
13. Jason and the Golden Fleece, Hunter, Bk4, 1655
14. Ibid, Bk4, 84. Quoted from W Friedrich for brevity.
15. The End of Atlantis, J V Luce.
16. Critias, Plato.
17. The End of Atlantis, J V Luce quoted for brevity from:
 Fire in the Sea, W Friedrich.
18. Story of Sinuhe, Ancient Near-Eastern Texts, James Pritchard.
19. The Egyptian Book of the Dead, W Budge pl15, chLXII.
20. Ibid Chaps lvi.
21. War Against the Hyksos (II) Ancient Near-Eastern Texts,

Notes & references

James Pritchard.

22. The Expulsion of the Hyksos,
Ancient Near-Eastern Texts,
James Pritchard.

23. A satirical letter,
Ancient Near-Eastern Texts,
James Pritchard.

24. Campaigns of Ramesses II,
Ancient Near-Eastern Texts,
James Pritchard.

25. Bible I Kings 20:14.

26. Scenes of Asiatic Commerce
Ancient Near-Eastern Texts,
James Pritchard.

27. Autobiography of Ahmose,
Son of Abana,
Ancient Near-Eastern Texts,
James Pritchard.

28. Josephus AA 1:86.

29. Bible Genesis 33:18.

30. Ibid 34:25.

31. Ibid 34:30.

32. Josephus Ant 1:180.

33. Koran 16:120.

34. Ibid 21:57.

35. Josephus Ant 1:165.

36. Ibid 40:26.

Index

Index

An ~ 176, 183. *See also* Heliopolis.
Anatolia ~ 217.
Ani ~ 193, 225.
Annu ~ 181.
Anpu ~ 151, 156, 158, 226.
 solstice ~ 157.
Ant ~ 183.
Ant-enut ~ 183.
Antiquities ~ 58.
Anu ~ 183.
Anubis ~ 151, 152, 156, 157, 158, 160,
 161. *See* Anpu or Ap-uat.
 Sirius ~ 161.
 two forms of ~ 156.
Ap-uat ~ 156, 158, 160, 161, 226.
 Asert Tree ~ 158.
 Hapi ~ 157.
 solstice ~ 157.
Apepi ~ 179, 229.
Apis ~ 13, 86, 90, 123, 140, 194, 227.
Aquarius ~ 100.
Arabia ~ 204, 206, 207, 208.
 Happy ~ 206.
Arah ~ 106.
Ararat ~ 108, 110.
Aries ~ 85, 86, 87, 88, 100, 115, 117, 140,
 217.
 Golden Fleece ~ 217.
Ark of Noah ~ 107, 108, 109, 148.
 Solar Boat ~ 108.
Ark of the Covenant ~ 47, 61, 64, 68, 102,
 103, 104, 105, 106, 107, 111, 140, 177,
 178, 195, 196, 204, 232, 238, 239.
 boats ~ 106.
 cubit ~ 130.
Ark of Tutankhamen ~ 102.
Asert tree ~ 157, 158, 161.
ash ~ v, 35, 53, 70, 79, 195, 209, 217, 238.
 light fall ~ 79.
Ash-t ~ 160.
Asher ~ 100.
asher ~ 161.
asher-t ~ 161.
Asia ~ 219.
Asiatic ~ 6, 37, 38, 40.
Asser-t ~ 160, 161.
Assyrians ~ 235.
Atlantis ~ 214, 218, 219.
Aton ~ 10, 114, 121, 123, 124, 127, 134,
 153, 193.

Aton-Ra ~ 124.
Atonai ~ 124.
Atum ~ 24, 153, 179, 180.
Avaris ~ 63, 78, 138, 140, 197, 198, 199,
 201, 220, 227, 229, 231, 233. *See also*
 Avarice.
 Avarice ~ 75, 138.
 battle ~ 233, 235.
 name of ~ 232.
axe ~ 128, 223.
Aya Sofia ~ 190.

B

Ba ~ 171, 172.
Ba-aa ~ 121.
Ba-Akh-Ka ~ 172.
Baakkah ~ 172.
Babylon ~ 6, 7, 28, 69, 113, 116, 206, 208,
 212, 233, 236. *See also* Kadesh.
 Kheraha.
 Egyptian ~ 208.
Babylon of Egypt. *See also* Kheraha.
Bakhau ~ 189.
Balearic islands ~ 190.
barley ~ 79.
Bata ~ 11, 12.
Bedouin ~ 228.
Benben ~ 146, 176, 190.
 mosque ~ 190.
Benjamin ~ 100.
Bennu ~ 180, 181. *See also* Phoenix.
Bent Pyramid. *See* Vega Pyramid.
Bible ~ xiv, 29, 55, 56, 58, 60, 62, 67, 70, 71,
 157, 160, 217.
 Ark ~ 109.
 censorship ~ 29.
 chambers ~ 151.
 chronology ~ 60.
 crops survived ~ 79.
 exodus ~ 52.
 golden calf ~ 59.
 looting ~ 67.
 Mt. Sinai ~ 154.
 plagues ~ 52, 62.
 priests naked ~ 55, 58.
 priest's stole ~ 58.
 quote on stele ~ 56.
 river bank ~ 73.
 sea retreats ~ 53.
 Tabernacle ~ 61.

Index

Index

220.
half-solstice ~ 27.
Hall of Records ~ 219.
Hap ~ 183.
Hapi ~ 40, 157, 158, 183, 184, 208, 225, 226.
Happy ~ 206.
Har ~ 142, 155, 166, 172.
Har-An ~ 208.
Haran ~ 205, 206, 208, 236.
Haredef ~ 105.
Hatshepsut ~ 83, 84.
Hazezontamar ~ 212.
Heh ~ 191.
Heli ~ 115.
Heliopolis ~ 16, 17, 24, 29, 39, 59, 62, 82, 110, 135, 139, 146, 176, 177, 179, 180, 181, 183, 193, 208, 213, 228, 229.
 Abraham ~ 236.
 Ahmose I ~ 183.
 Amen ~ 24, 179.
 An ~ 183.
 Benben ~ 146.
 cosmic egg ~ 226.
 fornication ~ 213.
 Goshen ~ 165.
 Joseph ~ 133, 165.
 Moses ~ 16, 59, 62, 139.
 Mt. Ararat ~ 139.
 On ~ 16.
 Onias ~ 139.
 Paran ~ 208.
 Phoenix ~ 180, 181.
 pyramid of ~ 212.
 Yabu ~ 16, 29.
Helios ~ 115.
Henry VIII ~ 10.
Hep ~ 21, 157, 183. *See also* Hapi.
heq ~ 85.
Herakleopilis ~ 227.
Hermes ~ 113, 121, 132.
Hermopolis ~ 222, 227.
Herodotus ~ 26, 184, 188.
Herut ~ 222.
hesi ~ 74.
Het ~ 232.
Het-Uar ~ 232.
hibu ~ 121.
Hindu ~ 191.

holy mountian ~ 186.
Holy of Holies ~ 61, 65, 102.
Hor ~ 142, 143, 144, 155, 163, 164, 166, 167, 177, 178. *See also* Mt. Hor.
Horeb ~ 142, 144, 154, 163, 164, 167. *See also* Mt. Horeb.
Hori ~ 151.
Horim ~ 143, 144, 153, 154, 157, 174, 200, 206.
 Rosthau ~ 200.
Horites ~ 143. *See also* Horim.
Horus ~ 193.
Hreu ~ 222.
Hur ~ 155.
Hyk ~ 18, 197, 201.
Hykau ~ 200, 205.
Hyksos ~ 4, 5, 6, 7, 9, 10, 13, 15, 17, 18, 19, 24, 29, 37, 38, 39, 40, 50, 52, 59, 62, 63, 64, 66, 67, 69, 70, 72, 73, 74, 75, 76, 77, 78, 79, 81, 88, 90, 116, 179, 197, 204, 220, 221, 224, 227, 231. *See also* Israelite.
 Aamu ~ 198, 199.
 Abraham ~ 116.
 agreement ~ 238.
 Ahmose I ~ 39, 61.
 Ahmose related ~ 75.
 altar ~ 193.
 Amen ~ 24, 179.
 Ani ~ 193.
 Aries ~ 86.
 army ~ 5.
 Asiatics ~ 205.
 Avaris ~ 63, 229.
 battles ~ 233.
 blasphemy ~ 182.
 breasts ~ 187.
 civil war ~ 5, 38.
 conference ~ 70, 72, 137, 183.
 crook ~ 85.
 devastation ~ 66, 67, 239.
 dispute ~ 66.
 east and west ~ 72.
 Egyptian names ~ 5.
 enter tombs ~ 66.
 Esau ~ 174.
 exodus ~ 6, 15, 52, 59, 62, 79, 137, 165, 234.
 Giza ~ 202.
 gold ~ 75.

Index

Index

Z